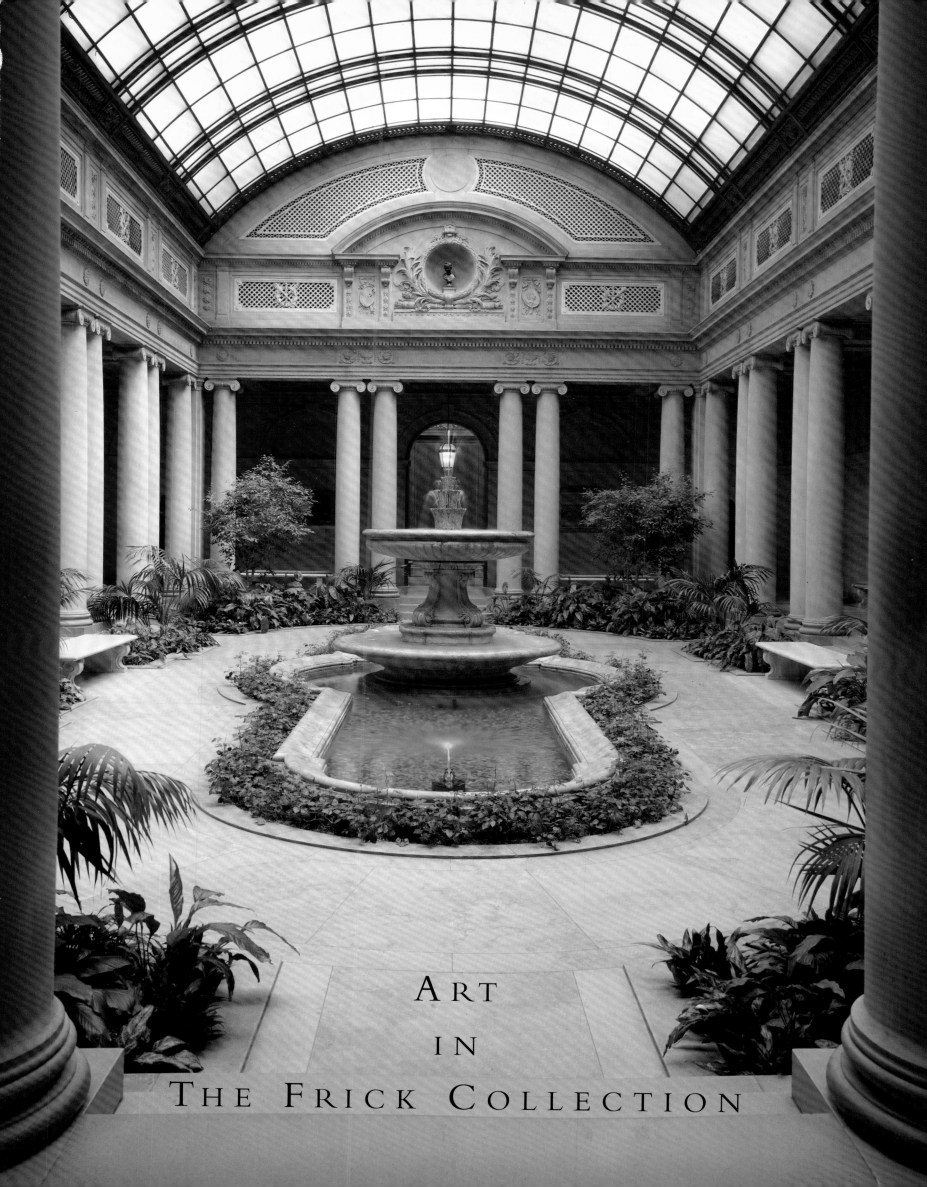

ART
IN
THE FRICK COLLECTION

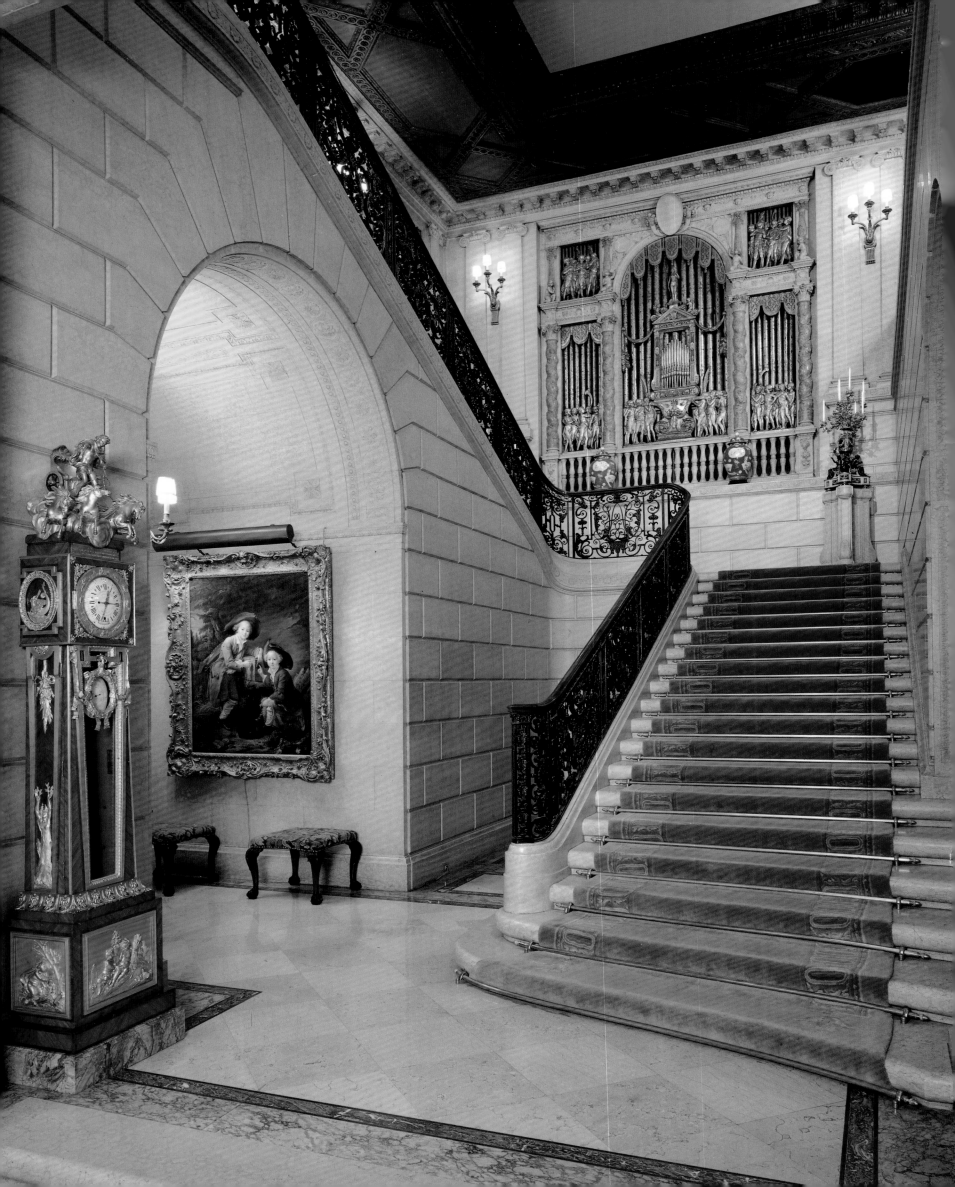

ART IN
THE FRICK COLLECTION

Paintings · Sculpture · Decorative Arts

By Charles Ryskamp,

Bernice Davidson, Susan Galassi, Edgar Munhall, Nadia Tscherny

Photography by
Richard di Liberto and John Bigelow Taylor
Edited by Joseph Focarino

HARRY N. ABRAMS, INC., PUBLISHERS
IN ASSOCIATION WITH THE FRICK COLLECTION

Half-title page: Garden Court
Frontispiece: Staircase
On the front cover: The Fragonard Room in The Frick Collection, New York.
Photograph by John Bigelow Taylor
On the back cover: Diego Rodríguez de Silva y Velázquez. *King Philip IV of Spain.*
Painted in 1644. Oil on canvas

Photographs of works of art and view of Garden Court on page 1 by Richard di Liberto
Photographs on pages 177 and 178 by Ed Watkins
Photographs of galleries by John Bigelow Taylor, assisted by Dianne Dubler

For Harry N. Abrams, Inc.:
Project Director: Adele Westbrook
Editor: James Leggio
Designer: Maria Learmonth Miller

Library of Congress Cataloging-in-Publication Data

Art in the Frick Collection : paintings, sculpture, decorative arts /
by Charles Ryskamp . . . [et al.].
p. cm.
Index.
ISBN 0–8109–1972–9 (cloth). —ISBN 0–8109–2668–7 (pbk.)
1. Art—New York (N.Y.)—Catalogs. 2. Frick Collection—Catalogs. 3. Frick Collection.
I. Ryskamp, Charles
N620.F6A53 1996
708.147′1—dc20 95–48353

Published in 1996 by Harry N. Abrams, Incorporated, New York
A Times Mirror Company

Printed and bound in Japan

TABLE OF CONTENTS

SCULPTURE

DECORATIVE ARTS

ACKNOWLEDGMENTS

Many persons have contributed to the present volume. Charles Ryskamp, Director of The Frick Collection, has provided the leadership for the book since its inception. Bernice Davidson directed and coordinated its production. Joseph Focarino was the Editor in charge for The Frick Collection.

Photographs of the works of art were taken by The Frick Collection photographer, Richard di Liberto, who also made the view of the Garden Court on the half-title page. Color photographs of the galleries were the work of John Bigelow Taylor, assisted by Dianne Dubler.

The text of the book depends heavily on the scholarship of many authors, especially those who contributed to the first eight volumes of *The Frick Collection: An Illustrated Catalogue*, published between 1968 and 1992. (A ninth and final volume is in preparation.) Charles Ryskamp's introductory chapter draws upon material from various Frick Collection publications as well as an article he prepared for the 1992 Grosvenor House Antiques Fair handbook in association with The Burlington Magazine Publications Ltd. The text for the section on paintings is based more directly on the entries compiled for *Paintings from The Frick Collection*, published in 1990; these entries, which have been revised and include several that are new, were written by Bernice Davidson, Edgar Munhall, and Nadia Tscherny. The section on sculpture, written by Bernice Davidson, relies on material in volumes III and IV (1970) of *The Frick Collection: An Illustrated Catalogue*, written by John Pope-Hennessy, assisted by Anthony F. Radcliffe, and by Terence W. I. Hodgkinson; Anthony Radcliffe has been particularly generous with help in bringing up-to-date the opinions and information on sculpture published twenty-five years ago. Susan Galassi was responsible for the section on decorative arts. Her entries derive from corresponding volumes of *The Frick Collection: An Illustrated Catalogue* written by Marcelle Brunet, Kathryn C. Buhler, Theodore Dell, Maurice S. Dimand, David DuBon, John A. Pope, and Philippe Verdier. She has also benefited from the expertise of Sophie Baratte, Winthrop Edey, Robert D. Mowry, Edgar Munhall, Suzanne G. Valenstein, and Sir Francis Watson.

Other staff members of The Frick Collection assisted in various capacities, especially Robert Goldsmith, Svetoslao Hlopoff, Adrian Anderson, Betsy Fleming, Martha Hackley, Robert Brady, and William Stout.

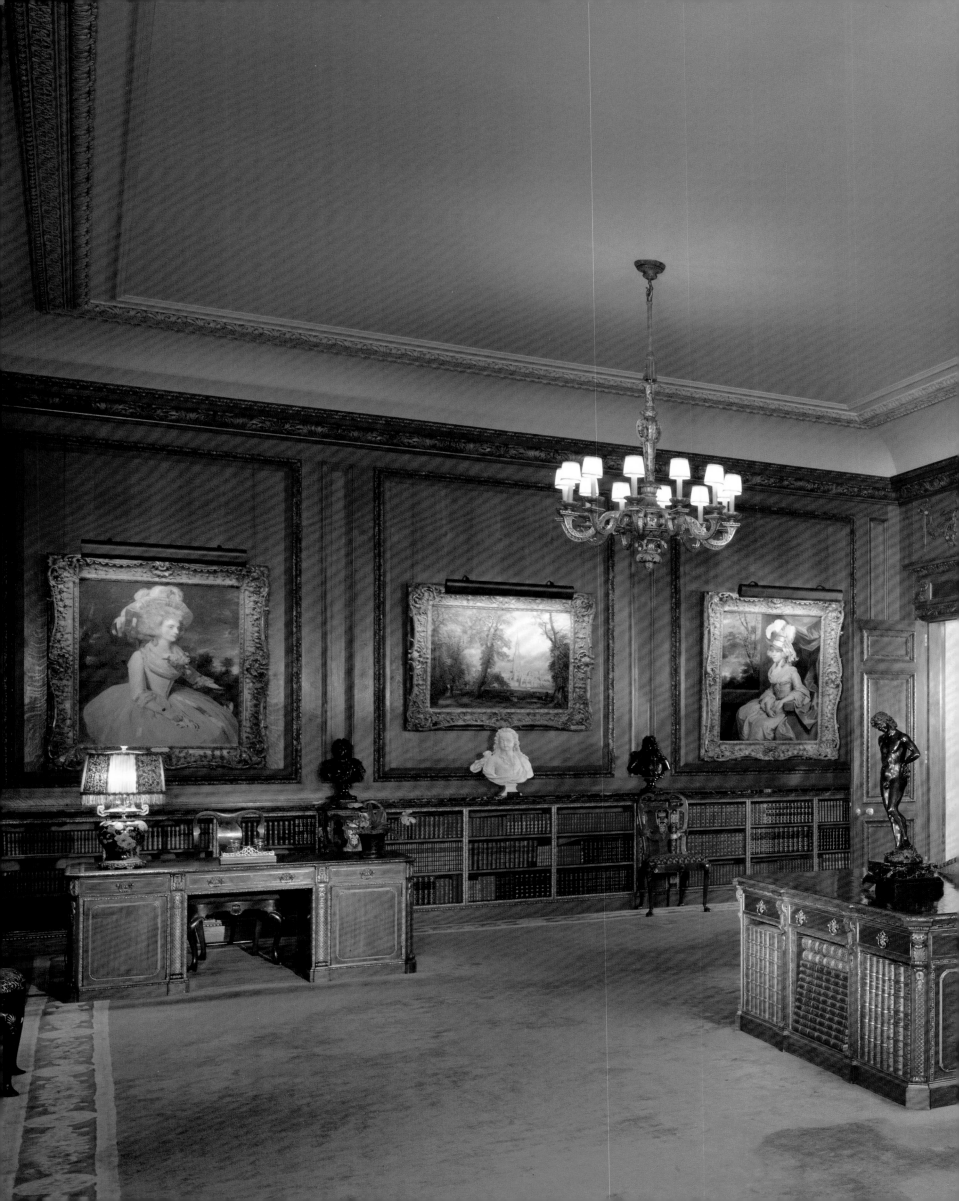

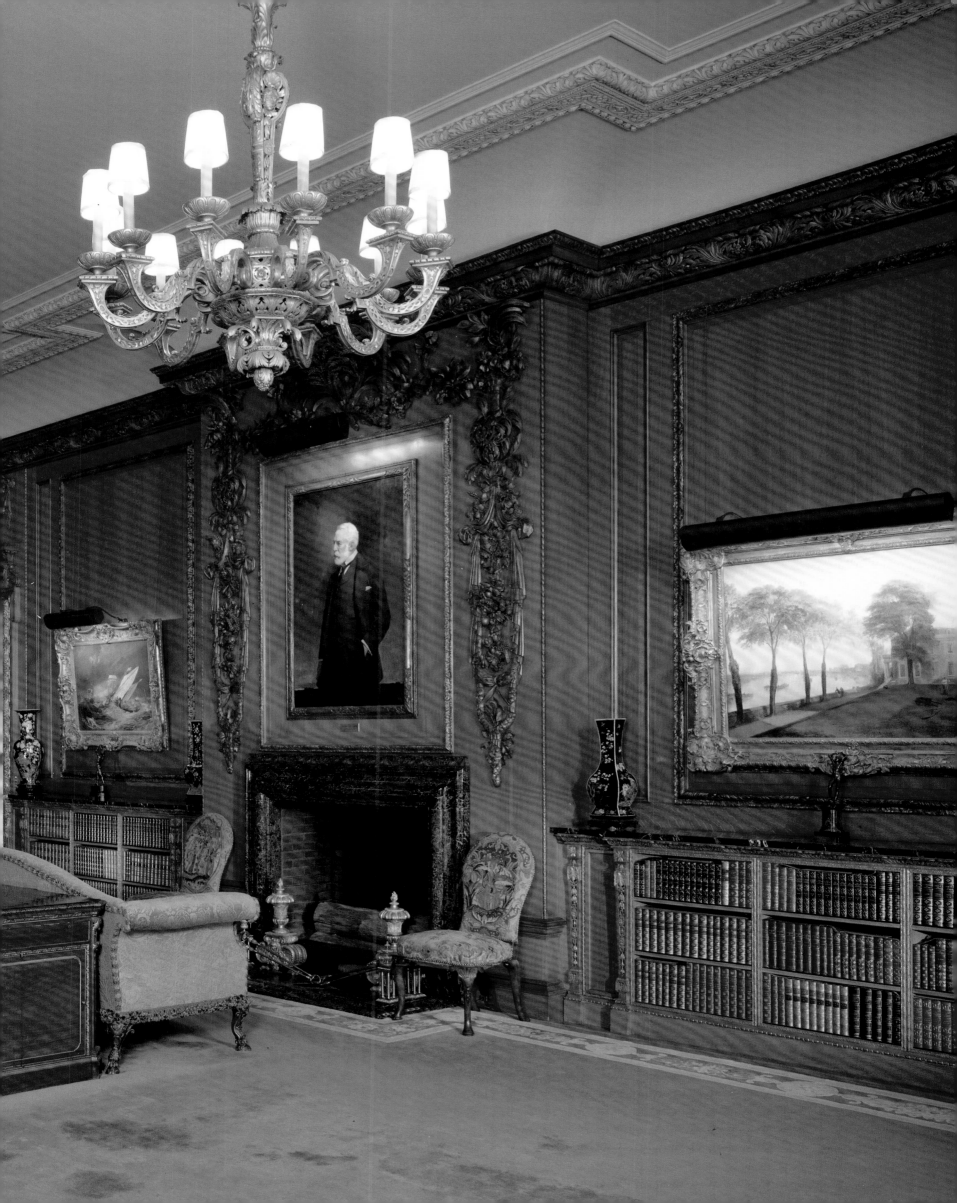

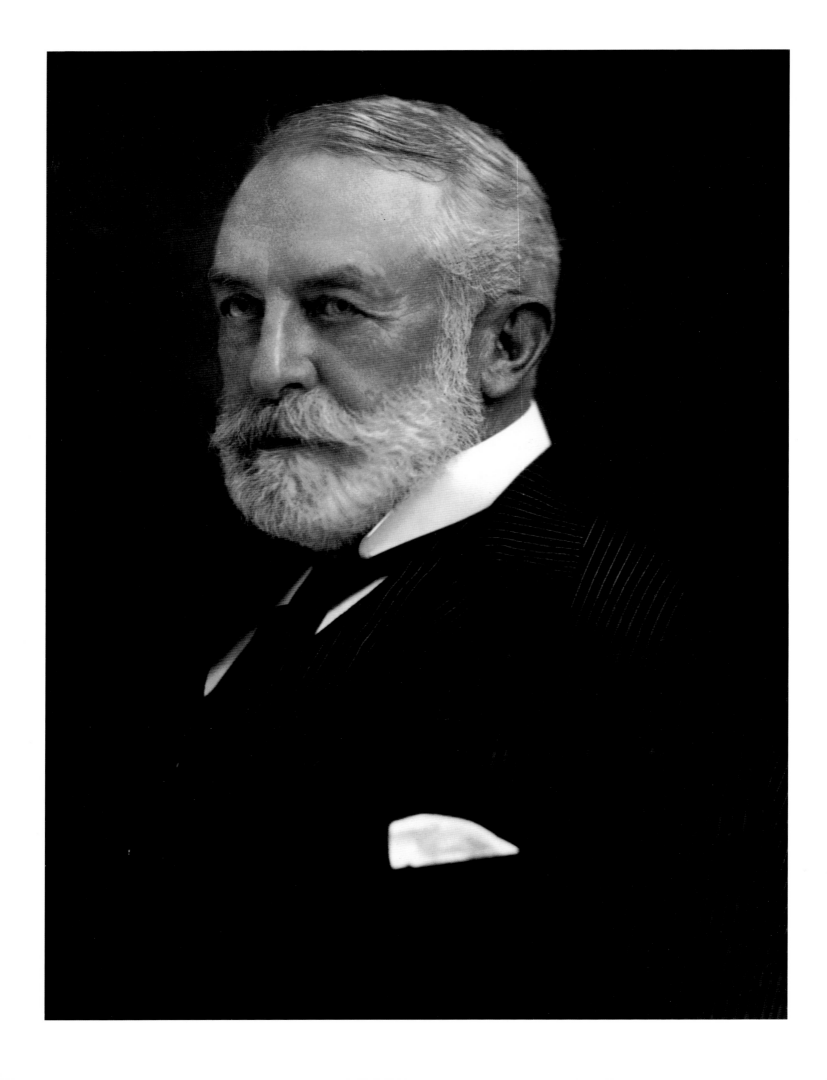

COLLECTOR AND COLLECTION

By Charles Ryskamp

Director

In the ancient book of Proverbs (24: 3-4) it is written:

*Through wisdom is an house builded; and by understanding it is established. And by
knowledge shall the chambers be filled with all precious and pleasant riches.*

This is such a story, of a house and a collection, of a collector and those who succeeded him; of
building and understanding, and of gathering and then filling up the house with extraordinary riches.
This is the story of a man who came to know the very best in art and who then gave it to the
public in the magnificent house built to enjoy it in an air of serenity and peace (fig. 1). Of this man,
Henry Clay Frick (1849–1919), it may be said, as one great Russian collector observed about another,
S. I. Shchukin: "He put [his collection] together masterpiece by masterpiece, as if he were stringing
a necklace."

If we begin with the scene of Mr. Frick's early life, a little springhouse next to his
grandparents' homestead in West Overton, Pennsylvania (fig. 2), we might say that almost anyone had
a better chance of becoming a collector and connoisseur than did Mr. Frick. The birthplace and the
circumstances were about as far away from that of a man like Pierpont Morgan as was possible in
America. Morgan came from two centuries of distinguished education, of wealth, power, international
travel, and sometimes very high living. Mr. Frick, in contrast, had only thirty months of formal
education between his eighth and seventeenth years. In southwestern Pennsylvania, when Frick was
a boy and a young man, there was little chance of seeing a painting of any quality: just landscapes and
portraits by local artists. One could know Old Masters only through engravings in books. That is all.

Nor were there much better opportunities in Pittsburgh, where Frick settled when he
was eighteen. Yet his enthusiasm for works of art was commented on already in 1871, when he was
twenty-one: the independent examiners for the Pittsburgh bank of T. Mellon and Sons, from whom
Frick was trying to arrange a loan, found that he might "be a little too enthusiastic about pictures but
not enough to hurt." From his earliest years he appears to have collected "prints and sketches,"
but he did not seriously try to acquire art until after his thirty-first birthday.

In Pittsburgh, he became a pioneer in the coke and steel industry and was a millionaire
by the time he was thirty. In that year he took his first trip abroad, traveling in Europe with Andrew
Mellon and two other friends, a trip which undoubtedly helped to lay the foundation of collecting
that resulted both in The Frick Collection and in the National Gallery of Art in Washington, D.C.

Only a few paintings were acquired by Mr. Frick before the year 1895, when he bought
some thirty pictures. Then in the five years from 1895 to 1900 he purchased another ninety-two.
During the first twenty-five years of his collecting, while he and his wife, Adelaide Childs Frick, were
living at Clayton, his home in Pittsburgh, he chiefly bought contemporary European paintings, or
works by Barbizon or American artists. He only rarely acquired Impressionist paintings. His first Old
Master was a *Still Life with Fruit* by van Os (bought in 1896); three years later he purchased the
Portrait of a Young Artist then attributed to Rembrandt. From the beginning, we find a predilection for
portraits and for landscapes, as one still sees in The Frick Collection, although few of the early

Pages 12–13:
*Library. A portrait of
Henry Clay Frick hangs
over the fireplace*

1. *Henry Clay Frick,
age sixty*

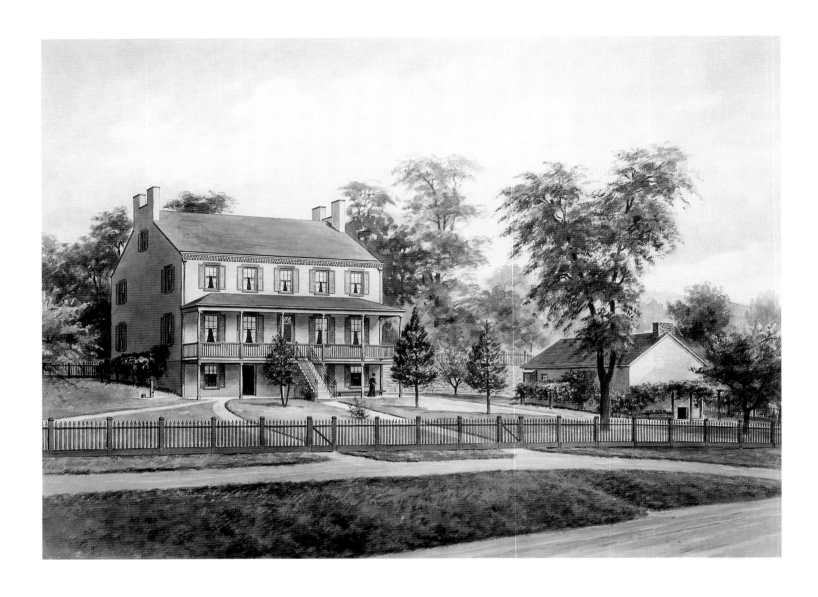

2. The Overholt
residence, West
Overton, with the
springhouse at right

purchases remain there. Some are at Clayton, which was recently restored and opened to the public;
many others were returned to dealers in exchange for finer works of art.

Mr. Frick meticulously recorded his acquisitions of paintings in his ledgers, along with
his coke and steel transactions. The earliest purchase that still remains in The Frick Collection is
Daubigny's *The Washerwomen* (1896); *Ville-d'Avray* by Corot, bought two years later, is the earliest one
to be seen in the public galleries today. Regarding that painting, we have the only known comment
by Mr. Frick concerning one of his works of art; this is in a letter from him to Andrew Carnegie:
"It is a Corot, not a large one in size, but immense in every other way, I think it is the gem of my
collection, and I am sure you will like it." The same remark, "immense in every other way," might be
made about one of the Collection's recent acquisitions (in 1991), the cabinet-sized *Portal of Valenciennes*
by Watteau, the first painting purchased by the museum in twenty-three years.

After 1900 Mr. Frick collected fewer mid-nineteenth-century and contemporary
paintings. He now preferred English eighteenth-century portraits and Dutch seventeenth-century
works. Several important oils by Turner were purchased and his first painting by Vermeer; also a second
Monet, as well as major paintings by Hobbema, Gainsborough, and Lawrence. Some of the essential
qualities of The Frick Collection were therefore established by Mr. Frick at the beginning of this
century. In 1905 he bought his first Italian Renaissance picture (the portrait of Pietro Aretino by
Titian), his first Van Dyck, El Greco's *St. Jerome*, and Cuyp's magical *Dordrecht: Sunrise*. In the autumn
of that year, he and Mrs. Frick rented the former William H. Vanderbilt residence at 640 Fifth Avenue

in New York. The house had a large picture gallery in which they could show their collection, which continued to expand rapidly.

The Fricks lived at 640 Fifth Avenue for the next nine years. During this time many masterpieces came into their collection: Rembrandt's largest and most monumental self-portrait and his *Polish Rider*; portraits of Frans Snyders and his wife by Van Dyck; three portraits by Hals; Vermeer's *Officer and Laughing Girl*; El Greco's *Purification of the Temple*; the portrait of King Philip IV at Fraga by Velázquez; Constable's *Salisbury Cathedral*; Turner's *Mortlake Terrace*; and important works by Hobbema, Gainsborough, Raeburn, and Romney. The years 1912–13 revealed an even greater range in Mr. Frick's collecting; he added such commanding portraits as Van Dyck's of the seventh Earl of Derby with his lady and child and El Greco's of Vincenzo Anastagi, and there were world-famous paintings like the two large allegories by Veronese, *Wisdom and Strength* and *Virtue and Vice*.

An extraordinary coup was the acquisition in 1912 of Holbein's celebrated portrait of Sir Thomas More. For fifteen years or more, American collectors had been tantalized in the hope of buying this painting, owned by the merchant banker and bibliophile Henry Huth and his family. Bernard Berenson urged Isabella Stewart Gardner to purchase it: "If anyone dispute its being the greatest Holbein in existence they will certainly not put another of Holbein's portraits above it." And again, ". . . you must put all other thoughts out of your head . . . you must beg, borrow, steal, do anything, but don't lose this opportunity of getting a masterpiece by one of the few greatest masters in existence." By 1903, however, the year after her museum in Boston was completed, Mrs. Gardner no longer had the money to compete with other rich Americans—like Morgan and Frick and Altman in New York, or Widener in Philadelphia. Again and again, no matter how greatly tempted she might be, she had insufficient funds to buy the works of art she coveted. She wrote to Berenson in 1907, "Woe is me! Why am I not Morgan or Frick?" After she could not afford the greatest paintings, and after Pierpont Morgan died in 1913, Mr. Frick in the last half dozen years of his life could almost always count on being the first to be offered the very best works.

In 1914, the Fricks moved from their rented quarters to their new house at Seventieth Street and Fifth Avenue, now The Frick Collection. It had been constructed in 1913–14 after designs by Thomas Hastings of the firm of Carrère and Hastings, who had been the architects of The New York Public Library at Forty-second Street. From the earliest plans for the residence, Mr. Frick thought of leaving the house and collection to the public, having been inspired by the Wallace Collection on an early visit to London.

He paid $2,400,000 for the Fifth Avenue property, but had to wait for five years, from 1907 to 1912, before the Lenox Library, which occupied that site, was torn down. He therefore had a considerable amount of time to plan the house and its galleries. In an interview, Thomas Hastings said that "Mr. Frick's orders to me were for a small house, with plenty of light and air and land." The architect's final plans were for "a free treatment of eighteenth-century English architecture, with something of the spirit of the Italians." Early designs showed an Italian palazzo (fig. 3), and an "Italian Gallery" for the largest and most important pictures (fig. 4). The architects also presented a sketch of a picture gallery in Henri II style (fig. 5). Ultimately, the main picture gallery of the house, the West Gallery, followed more closely the stylistic traditions of the architectural exterior of the house as we see it today; the illustration here shows the arrangement of furniture and pictures as it was about 1931, at the time of Mrs. Frick's death (fig. 6). The architects and the firm of White, Allom & Co. of London, responsible for the interior decoration and the modern furniture, created designs for every part and aspect of the house. To show the range of their work, earlier conceptions of the organ alcove and the table-desk for the Library are reproduced (figs. 7, 8).

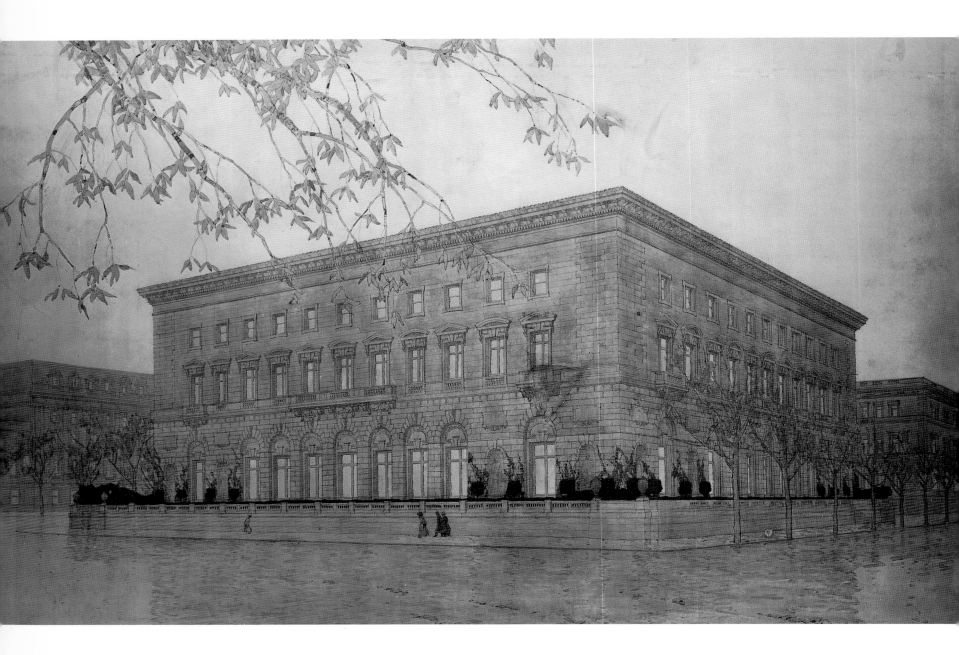

3. Proposed design for the Frick residence, c. 1912

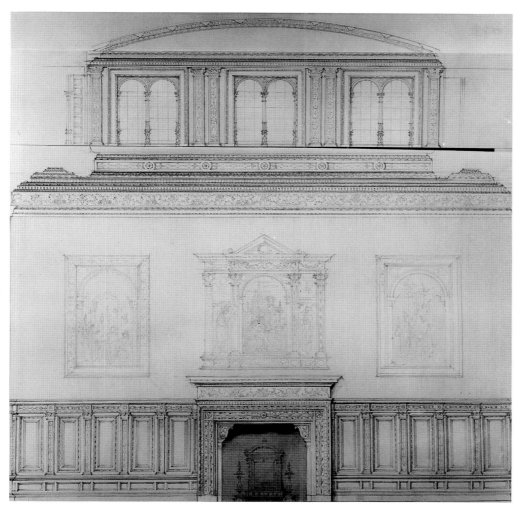

4. *Design for an "Italian Gallery," c.1912*

5. *Design for an "Henri II Picture Gallery," c.1912*

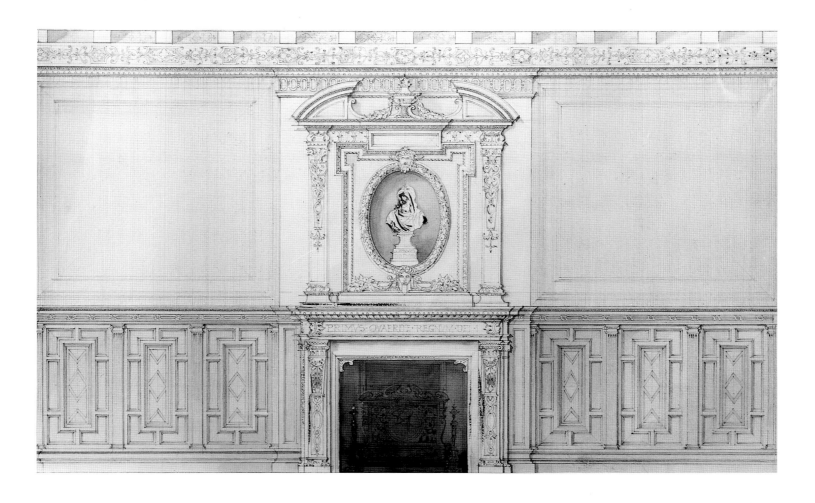

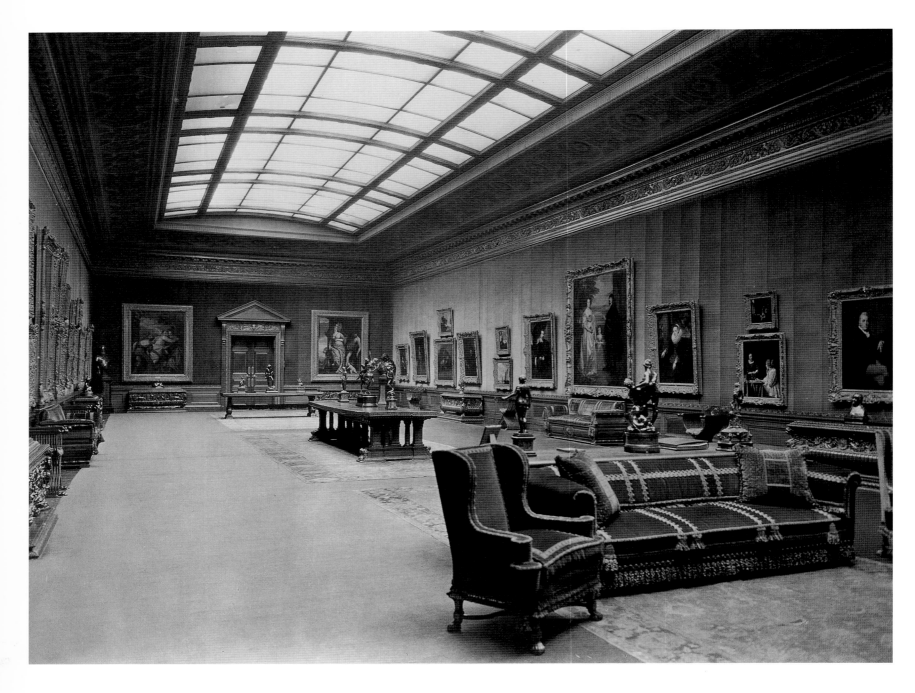

6. West Gallery, c. 1931

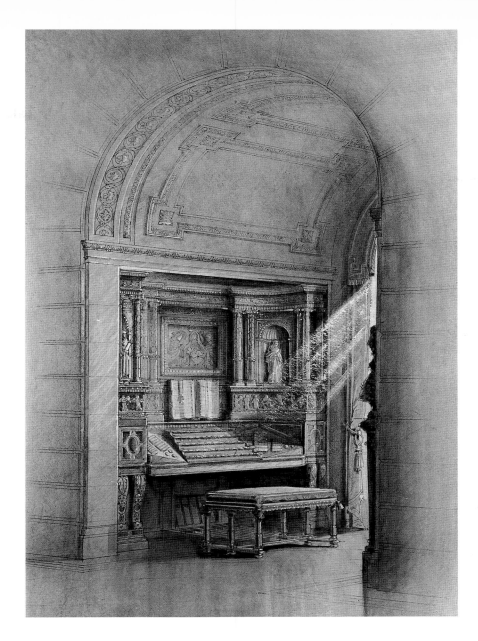

7. *Design for the organ console, White, Allom & Co.*

8. *Design for the center table-desk of the Library, White, Allom & Co., both c. 1913–1914*

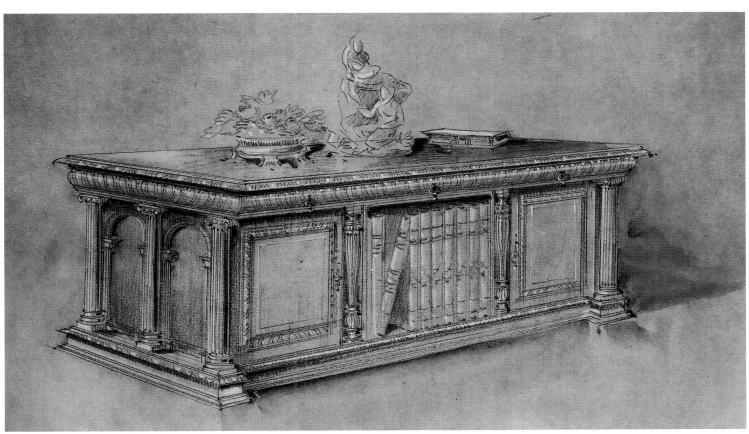

21

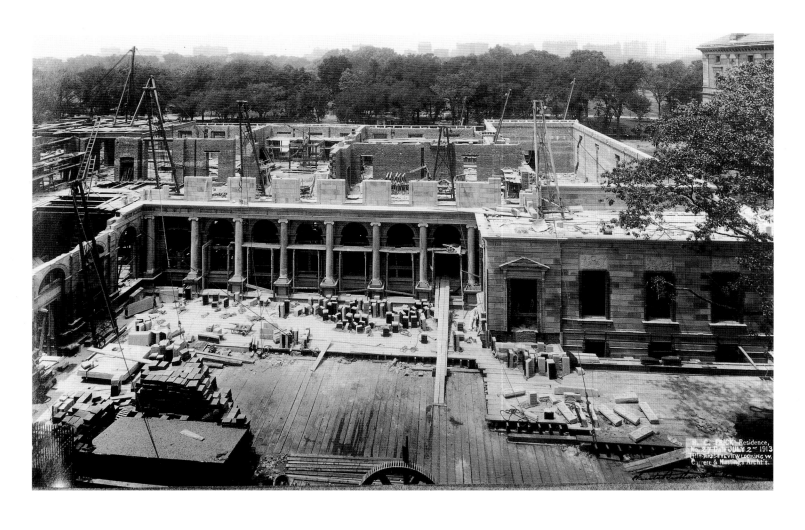

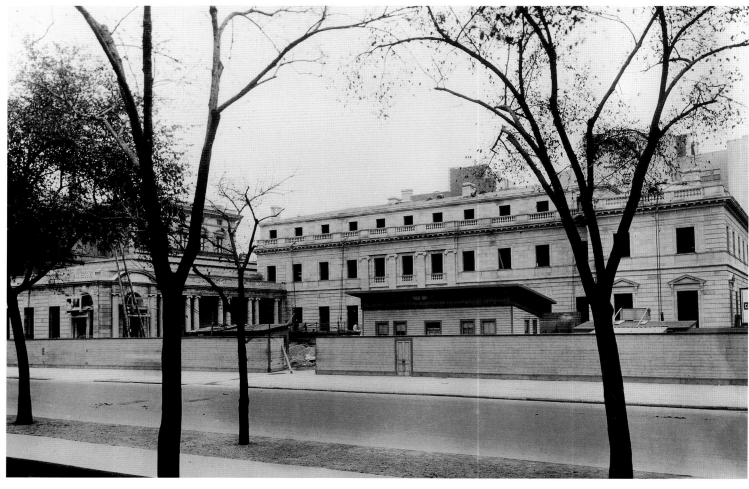

By August 1913, contracts were let for the interior furnishing of the principal rooms, and six months later for the wrought-iron balustrade of the staircase. In May 1914 Mr. Frick went to London to choose electrical fixtures, candelabras, torchères, settees, side tables, etc., for the various rooms; by August he was selecting carpets, and in November more furnishings. The commencement of World War I slowed but did not stop progress on the house (figs. 9 a–b). When finished the building was entered through gates on Seventieth Street (figs. 10, 11), and a drive led through outside courtyards from Seventieth to Seventy-first Streets (fig. 12). One of these courtyards was transformed in the early 1930s by John Russell Pope into the present interior Garden Court (fig. 13).

Mr. Frick changed the arrangements of the rooms as he acquired new works of art, and a great many were bought to fill the new house. Similar moves were made after his death whenever necessary; the one exception is the Living Hall, where the paintings have been in the same places throughout the past seventy-five years.

In 1914 and 1915 we find two years that were certainly amazing in the history of collecting—ones scarcely credible today. In the first of these Mr. Frick bought several works of art which were daring acquisitions for their time, like *The Forge* by Goya, *The Ocean* by Whistler, and *The Bullfight* by Manet. He also bought superlative portraits by Van Dyck (Paola Adorno), Hogarth

9. Construction of the Frick residence: (a) July 2, 1913; (b) September 17, 1913

10. Seventieth Street entrance to the Frick residence, c. 1931

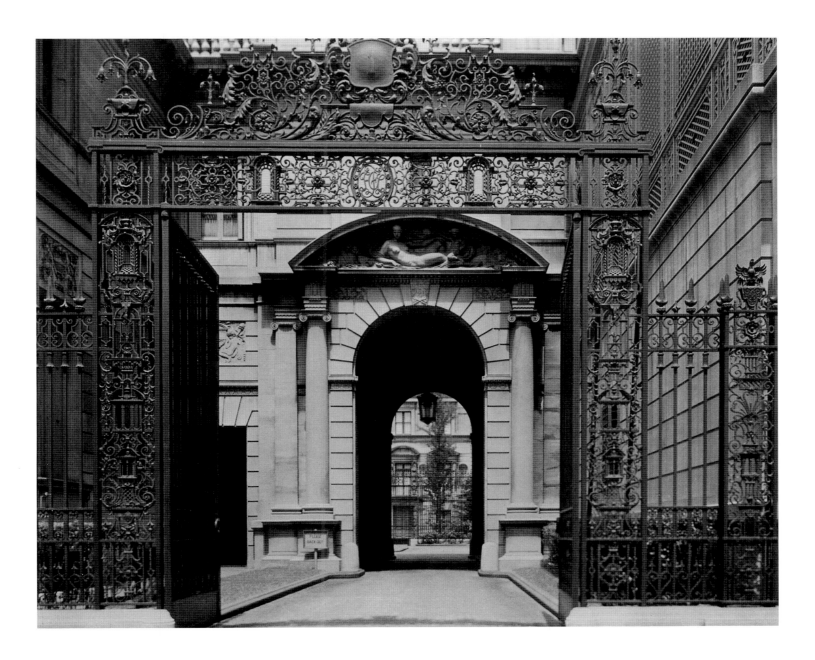

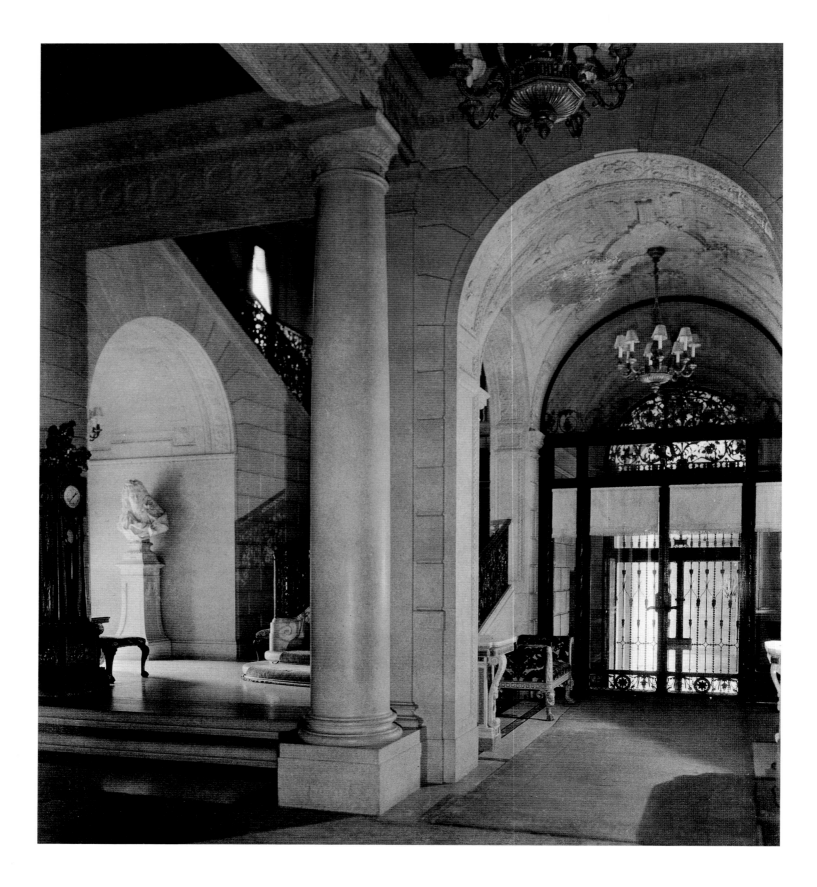

11. Entrance Hall of the Frick residence, c. 1931

(Miss Mary Edwards), and Gainsborough (Lady Innes), two portraits by Goya and two by Whistler, Renoir's *Mother and Children*, the two huge views of Cologne and Dieppe by Turner, Degas' *Rehearsal*, and Maris' *Bridge* (perhaps the finest painting of the Hague School in America). Today in one corner of the East Gallery we see these last two paintings together with a portrait by Whistler and Millet's *Woman Sewing by Lamplight*. They were all painted about 1870–85, and it is immediately clear not only that by this time in his life Mr. Frick collected some of the greatest

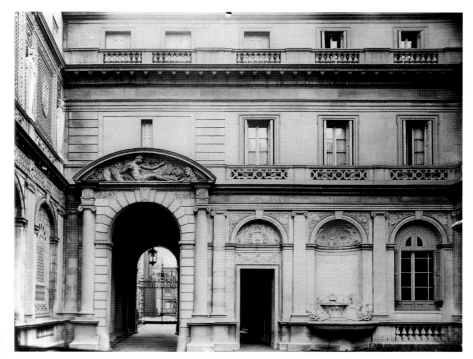

12. Courtyard of the Frick residence, c. 1931

13. John Russell Pope, design for the Garden Court (Peter A. Juley & Son, National Museum of American Art, Smithsonian Institution)

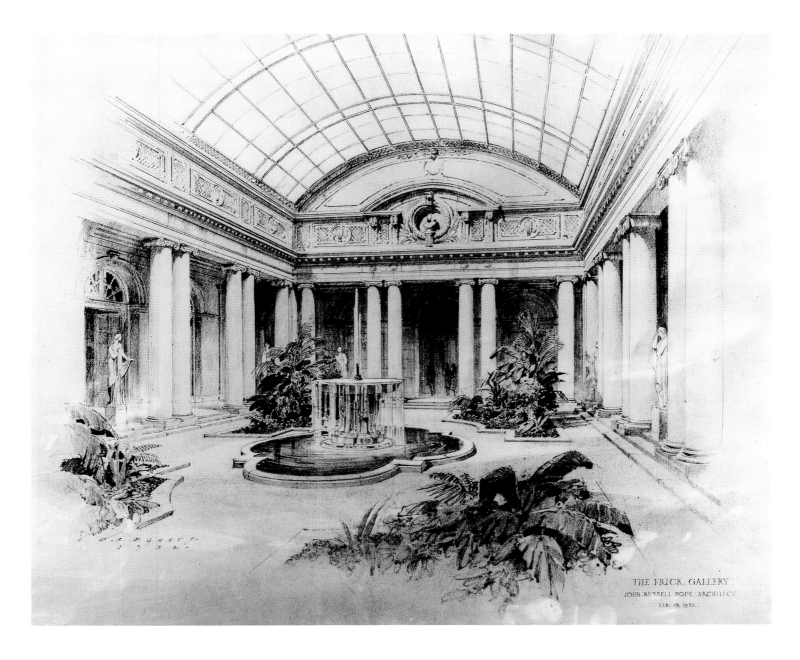

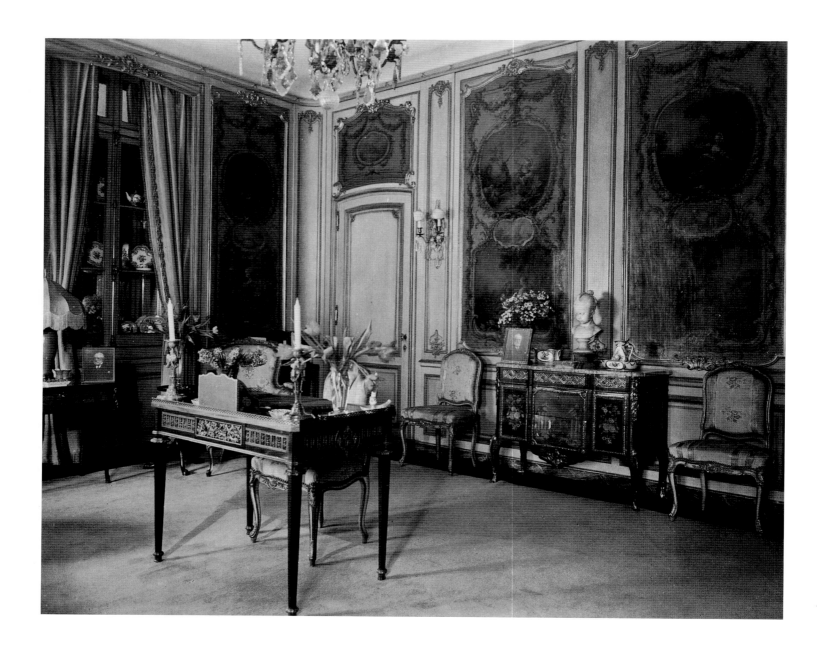

Old Masters in the world, but also that he had an unfailing eye for contemporary art, whether it be of the Barbizon School, the Hague School, paintings by an American, or Impressionist painting.

If it is possible to imagine, the year 1915 was even more remarkable than the preceding one. The series of supreme masterpieces by Fragonard, *The Progress of Love*, was added. Frick paid Duveen $1,250,000 for that group of paintings from J. P. Morgan's house in London. The price was set by Belle da Costa Greene, Director of the Morgan Library, and Duveen offered them at cost, no doubt to encourage the many other purchases the dealer had in mind for Frick from the Morgan estate.

Also acquired in 1915 were Gerard David's large *Deposition*, Titian's *Portrait of a Man in a Red Cap*, Bronzino's portrait of Lodovico Capponi, paintings by Holbein and Hoppner, and outstanding drawings and prints, marvelous bronzes and other sculptures, the finest French furniture, clocks, and porcelain. There was as well Bellini's *St. Francis in the Desert*. Three years before, Mrs. Bernard Berenson had written to recommend it to Isabella Stewart Gardner and to say that it was on view at Colnaghi in London: "the most beautiful Bellini in existence, the most profound and spiritual picture ever painted in the Renaissance."

In 1916 Mr. Frick bought the panels by Boucher personifying *The Arts and Sciences*, and they were installed on the second floor to decorate Mrs. Frick's boudoir (fig. 14); after her death, when

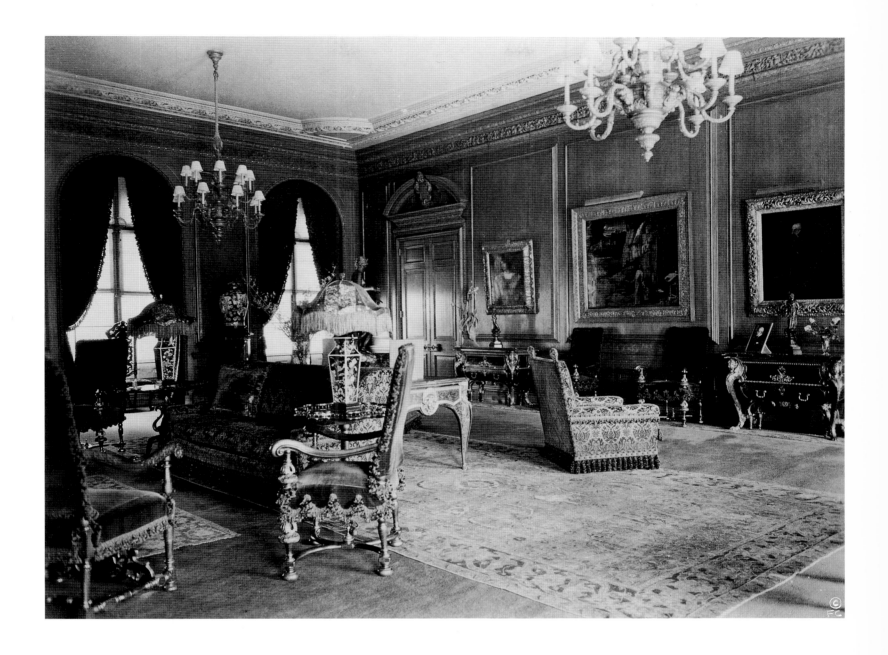

the house was converted to a museum, they were brought downstairs to their present location near the Entrance Hall of the Collection. In the same year Mr. Frick acquired one of the greatest paintings by Gainsborough, *The Mall in St. James's Park*, and in the next two years he purchased outstanding portraits by Van Dyck, Hals, Gainsborough, Gilbert Stuart, and Whistler, as well as the brilliant small oil sketch by Tiepolo for a ceiling in the Palazzo Archinto, Milan. His last acquisition, Vermeer's *Mistress and Maid*, is the only one recorded for 1919, the year of Mr. Frick's death. But in these final years he also bought many Renaissance bronzes and other sculpture, Limoges enamels, porcelains, furniture—both Renaissance and eighteenth-century—and a few drawings and prints. Once he began building his house on Fifth Avenue, he was determined to make the setting for his paintings and all of the art collections of the same superlative quality as his pictures (fig. 15).

Mr. Frick, like most American collectors of his time, thought of art primarily as paintings, and his successor Trustees continued to collect in the same way. But in the years when the house was being built and the Morgan bronzes were bought, Mr. Frick must have contemplated a room devoted only to sculpture. Architectural sketches for such a monumental gallery exist (fig. 16); this plan, however, was never carried out. Consequently, as Sir John Pope-Hennessy has written, "In The Frick Collection, alone of the great museums of the world, paintings and sculpture of comparable quality are

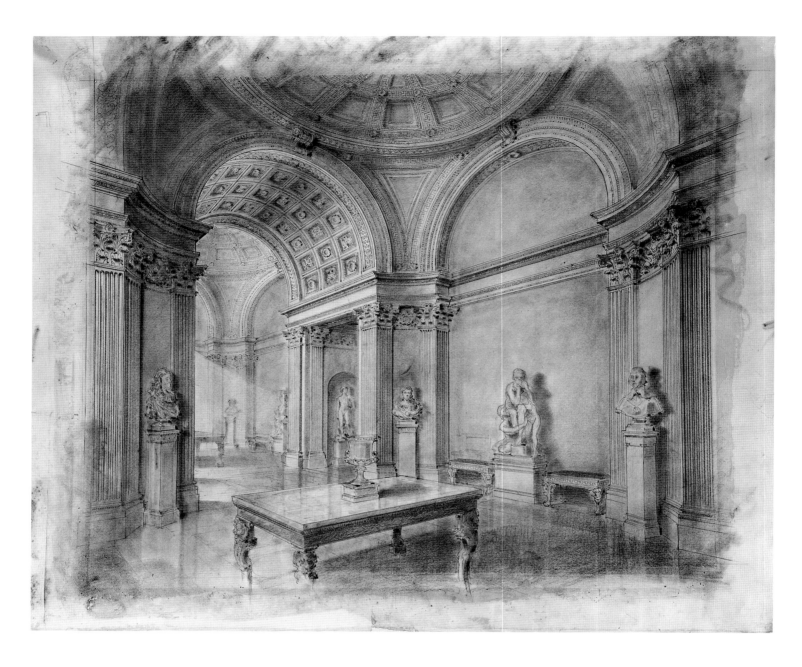

16. Design for a
sculpture gallery,
c. 1918

shown side by side." Sculpture is therefore perceived as part of the total effect of the rooms, but not as mere ornament. All of the sculpture (with the exception of a few works acquired since the Collection opened to the public) was bought in the last four years of Mr. Frick's life. Most of these pieces came from Duveen Brothers. The influence of Duveen on Mr. Frick, which has often been exaggerated, came late. (His first painting was not bought from Duveen until 1910, when Mr. Frick also bought his first fine furniture from him.) It resulted from Duveen's primary role in dispersing some parts of the art collections of J. Pierpont Morgan. Throughout his career as a collector, Mr. Frick had most frequently depended on the firm of M. Knoedler and Co. for purchasing paintings, but Duveen was important for Mr. Frick's acquisition of sculpture, enamels, and porcelain, as well as the two famous series of panels by Fragonard and Boucher. Most of the Italian furniture and all of the French Renaissance pieces were bought by him between 1914 and 1918 from Duveen Brothers. The most spectacular of the French eighteenth-century furnishings (among the most beautiful in America) were acquired from the estate of Mr. Morgan, through Duveen, or from the Paris collection of Sir John Murray Scott, through Jacques Seligmann and Elsie de Wolfe.

These large acquisitions in the last four or five years of Mr. Frick's life rarely constituted purchases *en bloc.* He was not like Pierpont Morgan, nor like a number of other celebrated American

collectors of this era. As has been frequently noted, Mr. Frick was diametrically opposed to a collector like John G. Johnson of Philadelphia, who sought comprehensiveness to create as broad and various a collection as possible. Although we do not know exactly how Mr. Frick chose sculptures from the Morgan collections, he clearly had the same kind of discrimination as in his choice of paintings, and he had the advice of Belle da Costa Greene, who had by far the best knowledge of these collections. "What resulted," Sir John Pope-Hennessy concludes, "was the finest collection of small bronzes in the United States and one of the finest collections of small bronzes in the world. Masterpiece after masterpiece was secured." Of the most important bronzes in Morgan's collection only one was not chosen, probably because Frick had bought a version of it a year earlier. It is related that when Mr. Frick's grandchildren came to call on him, he "was pleased to see them attracted to" the smallest bronzes "and allowed them to play with some of the pieces." The lesser bronzes bought by Frick remained in his house in Pittsburgh; other sculptures in the Morgan collection were bought by Henry E. Huntington.

Most of Mr. Frick's sculpture was from the Italian Renaissance: notable in the Collection are works by Vecchietta, Laurana, Francesco da Sangallo, Antonio Pollaiuolo, Riccio, and Severo da Ravenna. His earliest purchases of French sculpture seem to have been chosen to fit in with the decorative schemes of the house. Evidently the first sculpture he bought, in 1914, was the Lemoyne *Garden Vase* for the interior courtyard; later he obtained remarkable works by Coysevox, Houdon, and Clodion. A number of splendid early North European sculptures are also in the Collection, above all the bust of the Duke of Alba by Jonghelinck, the Multscher reliquary bust, and bronzes traditionally ascribed to Adriaen de Vries and Hubert Gerhard.

The total range of furniture in the house was not atypical of a grand New York residence at the beginning of this century (fig. 17); a comparable variety of periods and places of origin could be found among the furniture in the Morgan house and library. Brought together were Renaissance examples, French works of the late seventeenth and the eighteenth centuries, some English pieces in the Library and Dining Room and in the bedrooms, and furniture especially designed and made for the house by the architect or interior designer. All of the furniture in the Dining Room and most of it in the Library was designed and executed for Mr. and Mrs. Frick by Sir Charles Allom of White, Allom.

The ensemble of paintings, sculptures, and decorative art has a harmoniousness and serenity that create a unique experience. These qualities came from Mr. Frick's ultimately assured connoisseurship, as well, no doubt, as from his custom of living with paintings for months before he finally decided on their purchase. This was not only to insure his belief in their excellence, but also to be certain that they harmonized with the rest of his pictures. He reviewed and refined frequently and exchanged for what he believed to be—and clearly they usually were—superior works of art. He also had a fine eye for condition and seldom bought a work of art that was not remarkably well preserved.

Today The Frick Collection is unquestionably one of the most beloved museums in the world. But its marvelous union of works of the highest quality from the various fine and decorative arts has not always been perceived by critics and the public. When the Collection opened in 1935, the critic of *The New Yorker* (he can now be identified as Lewis Mumford) wrote about "the sculptural bric-a-brac," which he hoped the Trustees would put down in the cellar. The whole scheme of "converting a private mansion into a public museum" was for him a mistake. "The paintings are lost in the background. That may have satisfied the tastes of Renaissance princes, or even that of American millionaires during the first part of the present century, but it no longer meets today's standard of presentation" (*The New Yorker*, December 28, 1935).

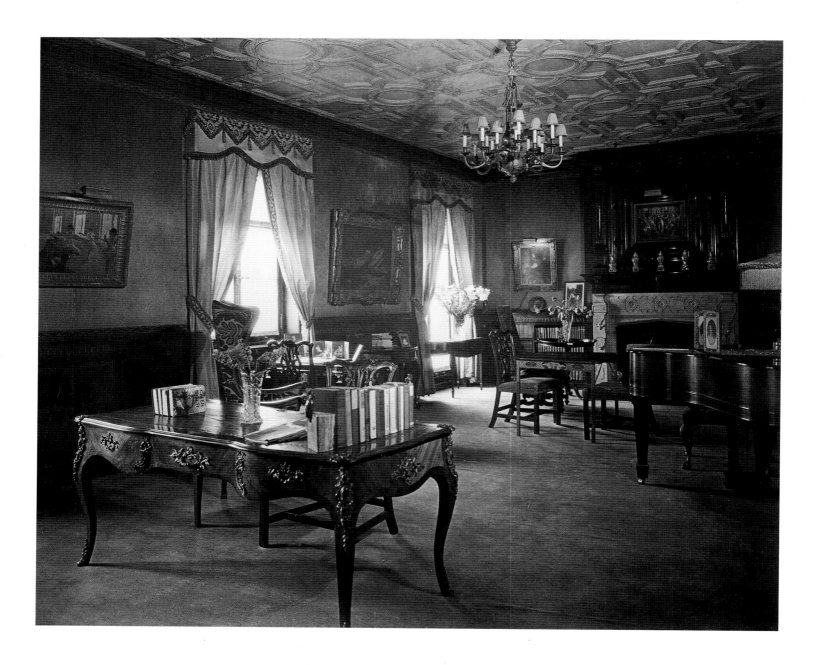

17. *Mr. Frick's study on the second floor, c. 1931*

The Trustees whom Mr. Frick had appointed during his lifetime, and their successors, together with the Directors and staff, have followed his taste. He set the standard, which has been carefully adhered to, and the boundaries and areas of concentration for the Collection have remained those he established. Contrary to widely held opinion, it is not static; at least a third of the paintings now on view were acquired after his death.

In his will, Mr. Frick left the house and all of the works of art in it together with the furnishings ("subject to occupancy by Mrs. Frick during her lifetime") to become a gallery of art called The Frick Collection. He provided an endowment of $15,000,000 to be used for the maintenance of the Collection and for improvements and additions. In an unusual provision of the will, "any surplus" income not needed for maintenance could be used for acquisitions of art. The Trustees waited about five years before they began to purchase art, although the Collection remained private until Mrs. Frick's death in 1931, by which time the endowment had increased to $25,000,000. But before that the Trustees had bought wonderful works by Fra Filippo Lippi and Chardin; in 1927 they acquired five paintings, among them two especially fine: Ingres' *Comtesse d'Haussonville* and Duccio's *Temptation of Christ;* and in 1930 came a rare Paolo Veneziano. A year after the Collection opened to the public in 1935, the Trustees bought the marvelous large figure of a saint by Piero della Francesca.

The Piero was a most important acquisition for the country as a whole; and it is doubtful that any American museum purchased a more important painting that year. Also in 1936, among the many paintings considered by the Trustees was a Vermeer—probably the *Allegory of Painting* now in the Kunsthistorisches Museum, Vienna. Thirteen pictures were seriously debated and rejected for various reasons; the Vermeer was not needed because, as a note explained, "Have three Vermeers."

During the early years of World War II, the Trustees had wished to husband their money and, so far as acquisitions were concerned, had really been forced to do so. But in 1943, Pierpont Morgan the younger died, and the Morgan family again found it necessary to sell works of art in order to have greater liquidity for the estate. The Frick was therefore able to acquire a number of masterpieces: Constable's *The White Horse*, Greuze's *The Wool Winder*, Reynolds' *General John Burgoyne*, Rembrandt's *Nicolaes Ruts*, Goya's *The Duke of Osuna*, and the sculpture of an angel, dated 1475, by Jean Barbet that once stood outside the Director's office of the Morgan Library. The total price was about $500,000—half of which was the cost of the sculpture. An immediate decision was called for due to the keen interest of other institutions and collectors. The Trustees voted at once to make a blanket purchase at the asking price. Few museums or collectors in history could have acted more wisely or bought a more impressive group of works of art.

Over the years there had been repeated requests from Board members to define an acquisitions policy; the members of the Acquisitions Committee, however, were unable to come to any agreement. When such a policy was finally adopted in 1952 (after more than twenty-five years of purchasing), it was as general as the brief statements of purpose in Mr. Frick's own will. "Resolved: That it is the policy of The Frick Collection to consider for acquisition only works of the highest quality and in excellent state of preservation, and then only if they 'belong' to The Frick Collection by harmonizing with existing exhibits."

Throughout all of the decades when The Frick Collection as a public institution was acquiring works of art, the Trustees consulted leading professors of art at Harvard and Princeton. These professors were not only very remarkable scholars, they were also distinguished collectors for themselves and ultimately for the university museums: Paul Sachs and Edward W. Forbes of Harvard; Frank Jewett Mather, Jr., of Princeton; and the collector Dan Fellows Platt. The Trustees profited enormously from this scholarly advice, and with it they created a collection that today has a quality, a beauty, a harmony that is almost without equal in the world. As a consequence, early and late acquisitions for the Collection appear to form a seamless whole.

After Mrs. Frick's death the Trustees commissioned additions to the original house, including two galleries (the Oval Room and East Gallery), a combination lecture hall and music room, and the enclosed courtyard, which so influenced the architecture of many later American museums. They converted the house into a museum without forfeiting the personal and residential atmosphere of the Frick home. The architect for the remodeling and the additions was John Russell Pope, who subsequently designed the National Gallery of Art in Washington. Because Mr. Frick had wished to "promote the general knowledge of kindred subjects among the public at large," lectures, concerts, and publications have played a vital part in the life of the Collection since it opened to the public in 1935. The concerts constitute one of the oldest series of distinguished quality in the United States; they are free and have been regularly broadcast for over fifty years. A fully revised and illustrated catalogue of the Collection began publication in 1968; eight volumes have now appeared, and the ninth and last is forthcoming. A more active publication program in general started a few years ago. To help support all of these programs of the Collection, an Association of Fellows was established in 1970 and one of Friends of The Frick Collection in 1989.

18. Mr. Frick
with his daughter
Helen Clay

Gardens and flowers have always been associated with the Collection: many of its rooms look out onto Central Park, and in all seasons the magnolia trees in the front garden are one of the treasures of the city. These trees have been a great influence on American gardening and an inspiration in the creation of twentieth-century gardens, including the Rose Garden of the White House. In 1977 a garden on Seventieth Street to the east of the Collection was designed by Russell Page, to be seen from the street and from the pavilion added at the same time to accommodate increasing attendance at the museum. This new Reception Hall was designed by Harry van Dyke, John Barrington Bayley, and G. Frederick Poehler. Two additional galleries were opened on the lower level of the pavilion to house temporary exhibitions. Most recently (in 1995) a Cabinet to show prints and drawings, or small pictures and sculptures, was created in an unused space off the Entrance Hall.

Mr. Frick's principal stipulation in his will was that he wished "to found an institution which shall be permanent in character and which shall encourage and develop the study of the fine arts." Because of this emphasis on "study," his daughter, Miss Helen Clay Frick (fig. 18), established in his memory a year after his death the Frick Art Reference Library. It was housed first in a bowling alley in the basement of the residence, and then in a small building located across the driveway from it (demolished to make room for the Oval Room and the East Gallery). In 1934 the Library moved to its present location adjoining the Collection: a thirteen-story structure designed by John Russell Pope, built under the auspices of the Trustees of The Frick Collection. During Miss Frick's lifetime, the Frick Art Reference Library was directed and financed by her. At her death in 1984, the Library came under the stewardship of the Collection's Trustees and Director.

The Frick Collection, although small, has played a very significant role in the United States. The types of paintings collected by Mr. Frick deeply affected the taste of Americans in the decades after his death—first and foremost, that of Andrew Mellon, his close friend, and other collectors who gave to the National Gallery of Art in Washington, which Mellon founded. Later, The Frick Collection was instrumental in determining the nature of the Kimbell Art Museum in Fort Worth. It was, and continues to be, the model, the touchstone, for many other collectors and institutions—whether or not they achieve the standards of collecting or the atmosphere of The Frick Collection as we know it today (fig. 19).

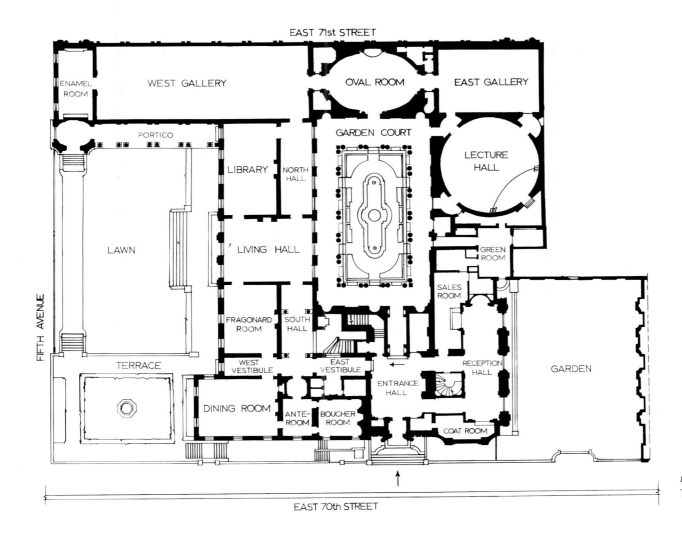

19. Floor plan of The Frick Collection today

Pages 34–35: *Living Hall today*

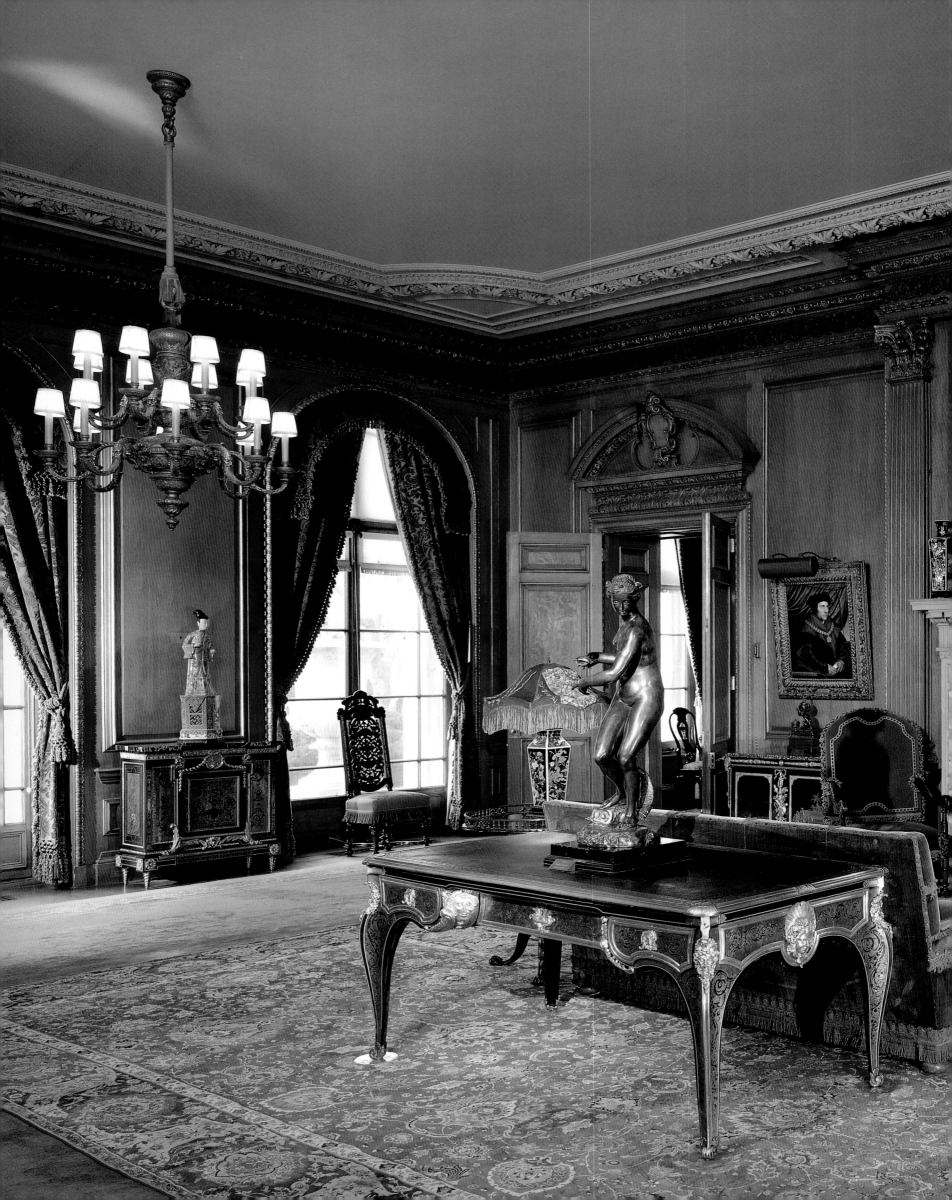

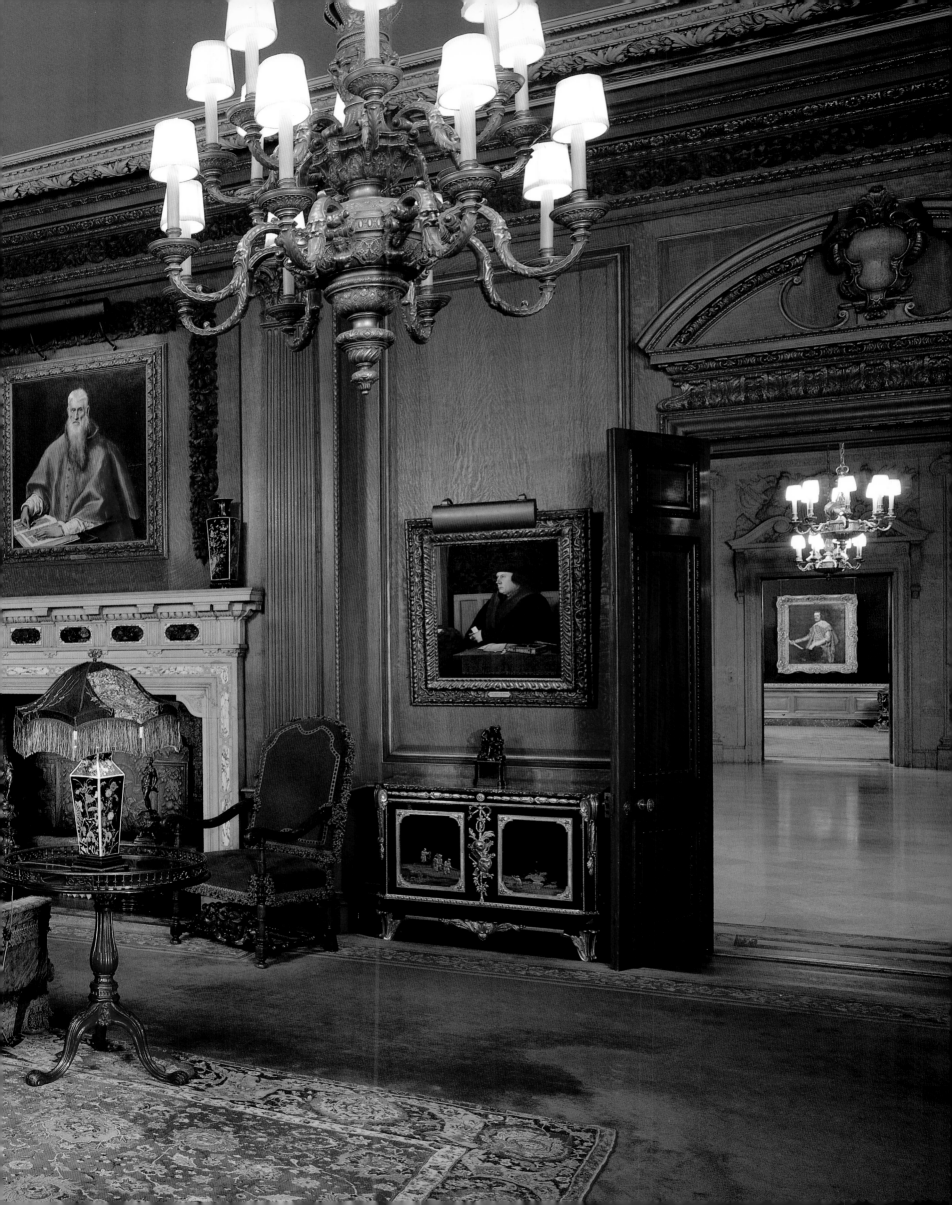

PAINTINGS

By

Bernice Davidson, Edgar Munhall,

Nadia Tscherny

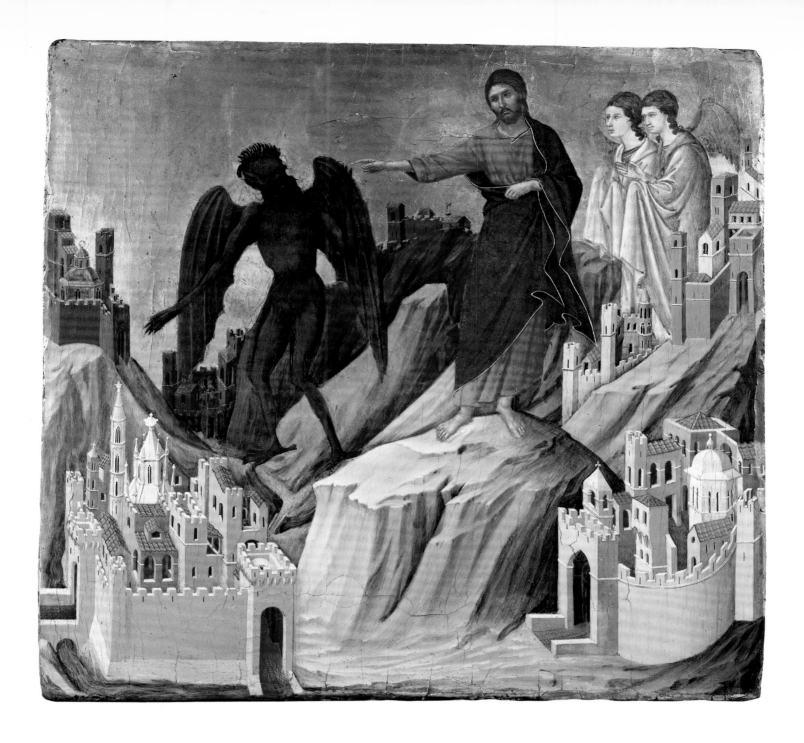

DUCCIO DI BUONINSEGNA

c. 1255–1319

Although Duccio was the leading Sienese master of his time, little is known about his life. The earliest record of the artist dates from 1278. In 1285 he received the commission for a painting believed to be the Rucellai Madonna *now in the Uffizi. His greatest work, however, is the* Maestà, *an altarpiece first mentioned in a document of 1308 and finished by June 9, 1311, when it was carried triumphantly through the city streets to the Cathedral of Siena.*

THE TEMPTATION OF CHRIST ON THE MOUNTAIN

Painted between 1308 and 1311
Tempera on panel
17 x 18 ⅛ in. (43.2 x 46 cm.)
Acquired in 1927

The Temptation of Christ is one of a series of panels illustrating the life of Christ painted for the *Maestà*, a huge double-sided altarpiece commissioned for the high altar of Siena's Cathedral. The importance of this monumental work for the history of Sienese painting can scarcely be exaggerated. The front of the complex altarpiece, now in the Museo dell'Opera del Duomo, Siena, consists of an enthroned Madonna and Child flanked by orderly rows of saints and angels, with half-length figures of Apostles above them and pinnacle scenes depicting the death and glorification of the Virgin; below is a predella narrating events from the birth and infancy of Christ. On the back of the altar were other small panels illustrating the life and Passion of Christ. For two hundred years Duccio's *Maestà* remained in its post of honor, influencing generations of artists in Siena, but thereafter it suffered a series of

vicissitudes, and eventually partial dismemberment. Although more than fifty panels have survived, most of them in Siena, several of the smaller panels have been dispersed or lost.

The original arrangement of the panels on the altarpiece and the question of what part assistants played in executing this radically innovative work are problems that may never be resolved. But Duccio himself must have been the guiding genius who designed the novel range of settings and compositions and who infused the familiar subjects with new drama and emotion.

In the Frick panel, a majestically towering Christ is shown rejecting the devil, who offers Him "all the kingdoms of the world" if Christ will worship him (Matthew 4:8–11). Duccio retains medieval conventions in depicting the figures as large and the spurned kingdoms as small, thus suggesting a scale of values rather than naturalistic proportions. Yet the story is presented in terms that are immediately meaningful. Christ expresses a sorrowful solemnity, and the cities in the foreground—packed with turrets, domes, and crenellations—vividly evoke the festive colors and crowded hillsites of Siena.

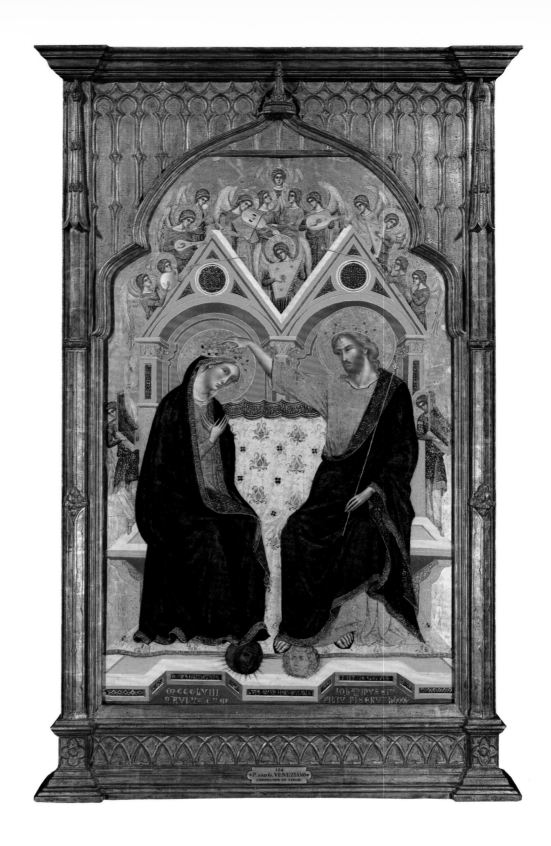

PAOLO AND GIOVANNI VENEZIANO
Paolo active 1321–1358

Paolo Veneziano is considered the leading figure of Venetian trecento *painting. Among his most important works is the painted cover for the Pala d'Oro in S. Marco, Venice (signed with his sons Luca and Giovanni and dated 1345). The 1358 Coronation of the Virgin in The Frick Collection is Paolo's last dated work. In addition to his brother Marco and his sons Luca and Giovanni, several other artists were trained in his influential workshop.*

THE CORONATION OF THE VIRGIN

Dated 1358. Tempera on panel
43 ¼ x 27 in. (110 x 68.5 cm.)
Acquired in 1930

The Coronation of the Virgin is recounted not in the New Testament but in the apocryphal story of the Virgin's death. In many Coronation scenes painted by Paolo and other Venetian artists a sun and a moon accompany the principal figures, the sun from early times being associated with Christ and the moon with the Virgin. The angels singing and playing musical instruments in the Frick panel symbolize the harmony of the universe; their instruments are the authentic components of a medieval orchestra, accurately depicted and correctly held and played. The inscription along the base of the throne is drawn from the Eastertide antiphon *Regina coeli*. The decorative sparkle of the surface—with its brilliant, expensive colors, patterned textiles, and lavish gold leaf—reflects the Venetians' love of luxury, a taste that enriches as well much of fourteenth- and fifteenth-century architecture in Venice.

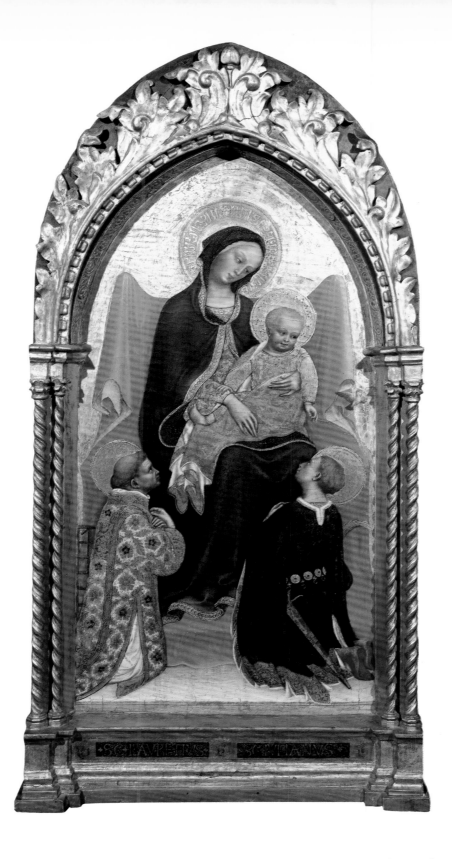

GENTILE DA FABRIANO

c. 1370–1427

Gentile was born in Fabriano, near Urbino.
Nothing is known of his youth or education,
which may have been as peripatetic as
his subsequent career. He is first recorded in
1408 in Venice, and he also worked in
Brescia and probably in other North Italian
towns. About 1420 he moved to Tuscany,
receiving important commissions from
churches and great families of Siena,
Florence, and Orvieto. By 1427 he had
left for Rome, where he worked for Pope
Martin V and members of the papal court.

MADONNA AND CHILD, WITH
STS. LAWRENCE AND JULIAN

Painted c. 1423–25. Tempera on panel
35 ¾ x 18 ½ in. (90.8 x 47 cm.)
Acquired in 1966

This small but richly painted altarpiece was
designed perhaps for some private family
chapel. It must be close in date to Gentile's
best-known work, the *Adoration of the Magi*
of 1423, now in the Uffizi. Like the *Adora-
tion,* this panel, with its lyrical linear patterns
and elegantly ornamented surface, perpetu-

ates late Gothic traditions, most obviously in
the gentle, graceful figures of the Madonna
and Child. The adoring saints, however,
seem more advanced than work of the same
date by Gentile's Florentine contempo-
raries; the portrait-like heads and solidly
modeled bodies are strikingly natural and
eloquent. St. Lawrence, the third-century
Roman deacon, kneels at left beside the
grate on which he was burned alive. At right
is St. Julian the Hospitaler, who built a
refuge for travelers in penance for unwit-
tingly murdering his parents. The artist's
name is inscribed on the frame.

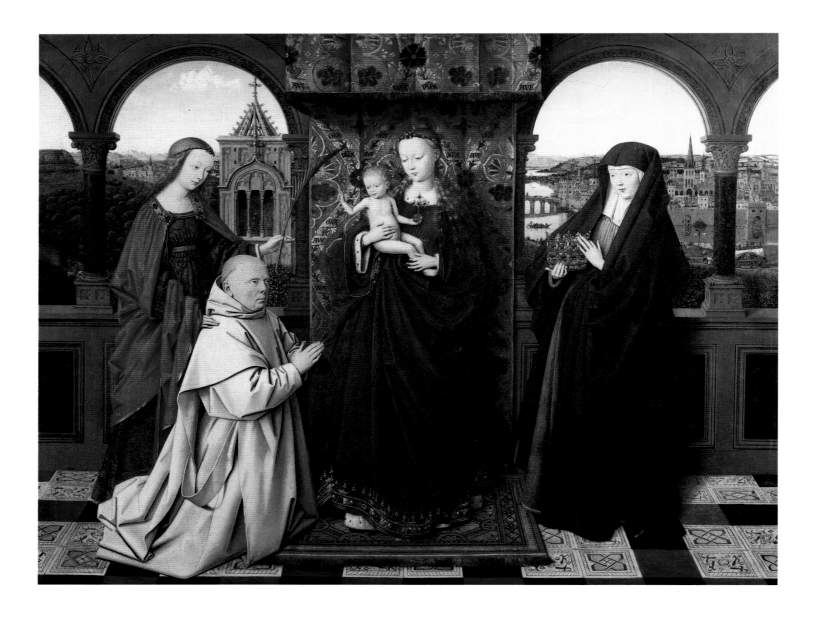

JAN VAN EYCK
AND WORKSHOP
active 1422–1441

Born probably at Maaseyck in the province of Limburg, Jan van Eyck is first recorded in 1422 working at The Hague for John of Bavaria, the Count of Holland. In 1425 he was named court painter and "valet de chambre" to Philip the Good, Duke of Burgundy, for whom he also undertook frequent diplomatic missions. Most of his datable paintings were executed during the 1430s in Bruges, where he spent the last decade or so of his life.

VIRGIN AND CHILD, WITH SAINTS AND DONOR

Painted c. 1441–43. Oil on panel
18 ⅝ x 24 ⅛ in. (47.3 x 61.3 cm.)
Acquired in 1954

The Virgin, holding the Child, stands in majesty on an Oriental carpet, enframed by a sumptuous brocade canopy and hanging inscribed AVE GRA[TIA] PLE[N]A (Hail [Mary] full of grace). She is attended by St. Barbara, with her attribute of the tower in which she was imprisoned rising behind her, St. Elizabeth of Hungary, who gave up her crown to become a nun, and a kneeling Carthusian monk. As yet no clear explanation has been found for the presence of the two saints. Elizabeth may have been included because she was the patron saint of Isabella of Portugal, the Duchess of Burgundy, who apparently made donations to Carthusian monasteries throughout the Netherlands and Switzerland. Barbara was protectress against sudden death and, among other roles, patron saint of soldiers, which may explain the statue of Mars visible in a window of her tower. She appears here as sponsor for the donor, and it is possible that both saints had

some particular association with his monastery or with his early membership in the Teutonic Order, a religious foundation with military ties.

The Carthusian monk has been identified as Jan Vos (d. 1462), Prior of the Charterhouse of Genadedal—or Val-de-Grâce—near Bruges, and a well-known figure in fifteenth-century monastic life in the Netherlands. He held various important posts in Carthusian houses before his appointment to Genadedal in 1441, the year of Jan van Eyck's death. Documents relate that the Frick painting was ordered as a "pious memorial of Dom Jan Vos, Prior of the Monastery," and that it was dedicated on September 3, 1443. Most scholars consider this one of Van Eyck's last paintings, begun by him in 1441 but completed after his death in his shop.

Many attempts have been made to identify the walled town beside the river at right. Such diverse cities as Maastricht, Prague, Lyon, Liège, and Brussels have been proposed. It has also been suggested that the large church to the right of St. Elizabeth represents old St. Paul's Cathedral in London. But despite the remarkably vivid details, the view appears to be imaginary.

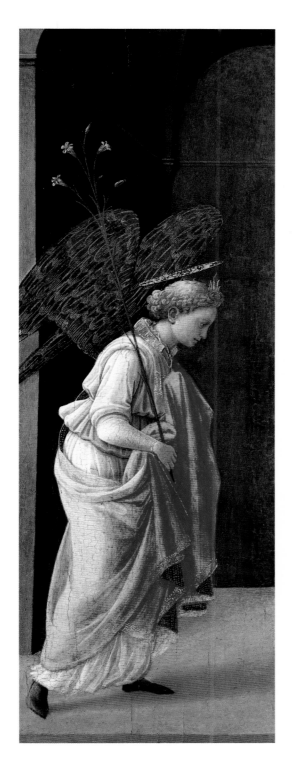 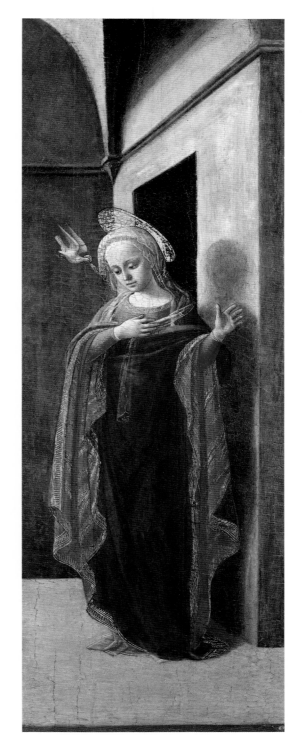

FRA FILIPPO LIPPI
c. 1406–1469

Florentine by birth, Fra Filippo took the vows of a Carmelite monk at about the age of fifteen. He was in Padua in 1434, but three years later he returned to Florence, where he was employed by the Medici and other prominent families. In 1452 he was invited to execute the choir frescoes for the Duomo in Prato. His last two years were spent in Spoleto painting frescoes in the Cathedral. Fra Filippo's son, Filippino, also became a noted painter.

THE ANNUNCIATION

Painted c. 1440. Tempera on panel
Left panel: 25 ⅛ x 9 ⅞ in. (63.8 x 25.1 cm.);
right panel: 25 ⅛ x 10 in. (63.8 x 25.4 cm.)
Acquired in 1924

The two panels that compose the Frick painting, now framed together, probably originally formed the wings of a small altar-piece of which the central panel has been lost. Around the middle of the fifteenth century, the subject of the Annunciation had become exceedingly popular in the art of

Florence. Fra Filippo, who often depicted the scene, usually placed the figures in elegant and complicated architectural settings, made festive with birds, flowering plants, and sunny landscapes seen in the distant background. The setting of the Frick *Annunciation* is instead bare and simple, painted in muted terracotta, violet, and gray, with nothing to distract the viewer from the gentle drama being enacted. The lily carried by the angel Gabriel symbolizes the Virgin's purity, while the dove represents the angel's words to her: "The Holy Ghost shall come upon thee."

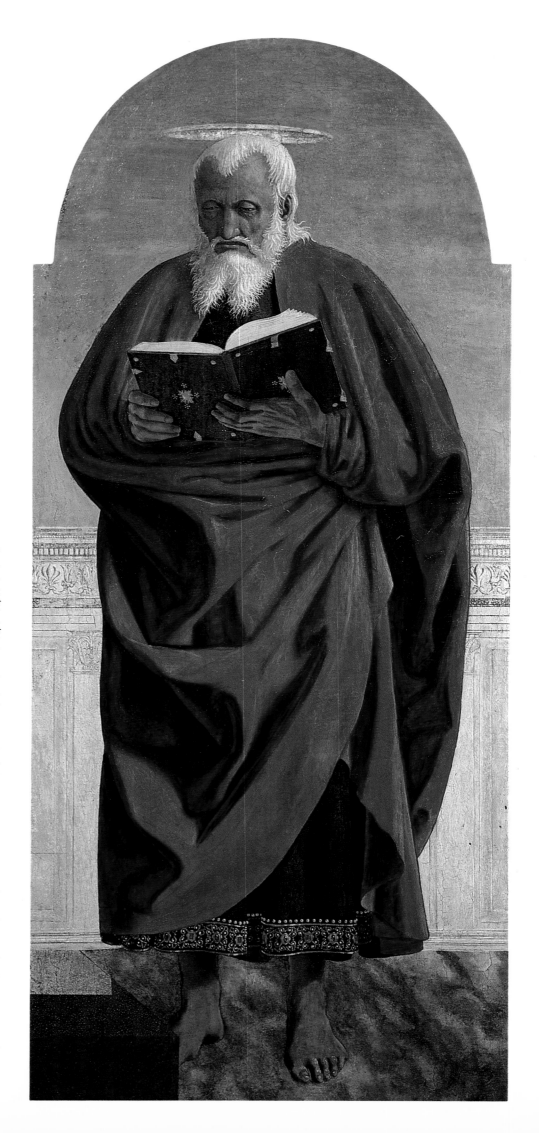

PIERO DELLA FRANCESCA

1410/20–1492

*Born in the Tuscan town of Borgo
Sansepolcro, Piero is recorded in 1439
assisting Domenico Veneziano in Florence.
He also worked in his birthplace and in
Ferrara, Rimini, Rome, Urbino, and
elsewhere. Piero's best-known paintings
form the celebrated fresco cycle depicting
the Legend of the True Cross in the church
of S. Francesco at Arezzo. In addition to
frescoes and altarpieces, Piero painted
a number of portraits.*

ST. JOHN THE EVANGELIST

Painted between 1454 and 1469.
Tempera on panel
52 ¾ x 24 ½ in. (134 x 62.2 cm.)
Acquired in 1936

In 1454 Angelo di Giovanni di Simone
d'Angelo ordered from Piero a polyptych
for the high altar of S. Agostino in Borgo
Sansepolcro. The commission specified that
this work, undertaken to fulfill the wish of
Angelo's late brother Simone and the latter's
wife, Giovanna, for the spiritual benefit of
the donors and their forebears, was to con-
sist of several panels with "images, figures,
pictures, and ornaments." The central por-
tion of the altarpiece is lost, but four lateral
panels with standing saints—St. Michael the
Archangel (National Gallery, London), St.
Augustine (Museu Nacional de Arte Antiga,
Lisbon), St. Nicholas of Tolentino (Museo
Poldi-Pezzoli, Milan), and the present panel
—have survived. Although the venerable
figure in the Frick painting was given no
distinctive attribute, he is presumed to rep-
resent St. John the Evangelist, patron of the
donors' father and of Simone's wife.

Evidence from a payment made to Piero
in 1469 suggests that the altarpiece was fin-
ished late that year, fifteen years after the
original contract. The lengthy delay resulted
no doubt from Piero's many other commit-
ments during this period, when he traveled
to towns all across Central Italy and con-
tracted obligations to patrons more impor-
tant—and more exigent—than the family
of Angelo di Giovanni and the Augustinian
monks of his own small town, Borgo Sanse-
polcro. But it is obvious as well from the
character of his art that Piero was not a
quick or facile painter. His deep interest in
the theoretical study of perspective and
geometry and his pondered, contemplative
approach to his paintings are apparent in all
his work, including the panels of the S.
Agostino altarpiece.

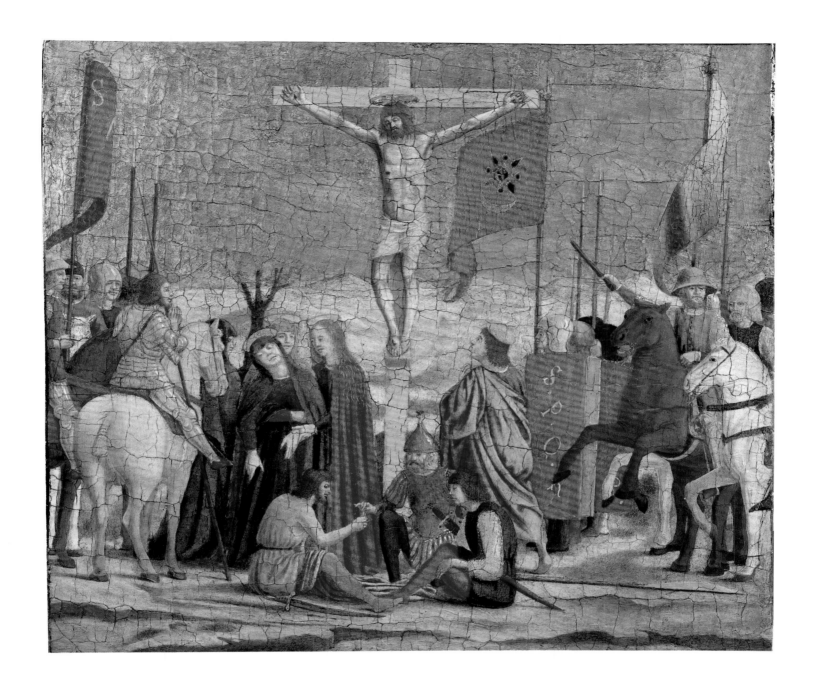

PIERO DELLA FRANCESCA

THE CRUCIFIXION

Date unknown. Tempera on panel (irregular)
14 ¾ x 16 ³⁄₁₆ in. (37.5 x 41.1 cm.)
Bequest of John D. Rockefeller, Jr., 1961

It has been proposed that this *Crucifixion,* like two panels also in The Frick Collection portraying an Augustinian monk and nun, originally formed a part of Piero's S. Agostino altarpiece. The first known reference to

The Crucifixion is found in a seventeenth-century document listing paintings in a collection at Borgo Sansepolcro. *The Crucifixion* is described there in considerable detail, together with three other subjects: a *Flagellation,* a *Deposition,* and a *Resurrection,* all three now lost. The writer did not claim that these panels came from the S. Agostino altarpiece, although in the same collection were four larger panels of standing saints that he specified did come from the high altar of S. Agostino. These larger panels may be identified with the four saints discussed in the preceding entry on Piero's *St. John.*

The seventeenth-century record does not, therefore, resolve the problem of whether or not *The Crucifixion* belonged to the same altarpiece. Piero did, after all, paint other works for his native town, which might have had predellas incorporating such scenes. The question of possible workshop participation in painting *The Crucifixion* is also an unresolved issue, made more difficult by its imperfect condition. Some scholars argue that an assistant was responsible for the execution, although certain passages of this small yet monumental composition are painted with great refinement.

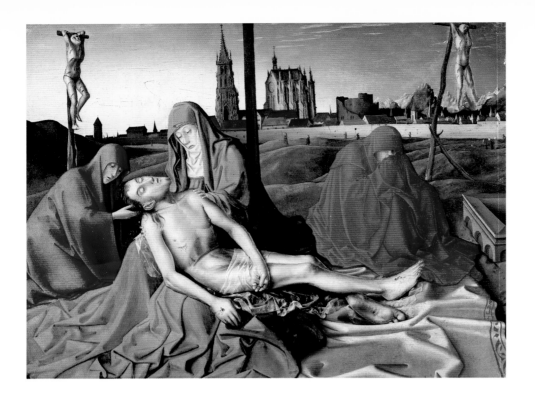

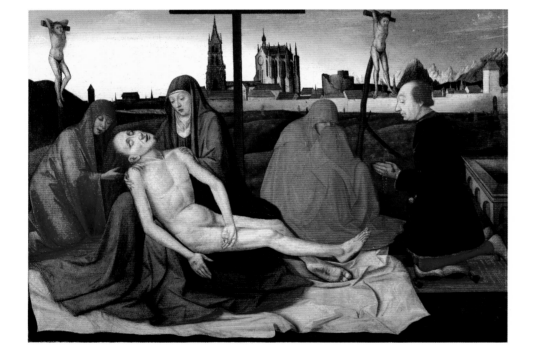

KONRAD WITZ, CIRCLE OF
Fifteenth century

P I E T À *(above)*

Date unknown. Tempera and oil (?) on panel
13 ⅛ x 17 ½ in. (33.3 x 44.4 cm.)
Gift of Miss Helen C. Frick, 1981

FRENCH, PROBABLY
SOUTH OF FRANCE
Fifteenth century

P I E T À W I T H D O N O R *(below)*

Date unknown. Tempera or mixed technique
on panel
15 ⅝ x 22 in. (39.7 x 55.8 cm.)
Acquired in 1907

The Pietà, a representation of the Virgin supporting the dead Christ in a pose that poignantly recalls the image of her holding the Child, is a motif that first appears in Germanic art in the fourteenth century. Here the figures are set in a landscape which includes Christ's sepulcher at right, a Gothic city representing Jerusalem, and distant snowcapped mountains.

The *Pietà* by a follower of Konrad Witz evidently was the model for the French variant, illustrated below, by a later artist who added a kneeling donor to the composition. Both paintings—individually and in their relation to each other—present many unsolved mysteries. The national origins of the two artists, the patrons who commissioned the panels, and the locations in which the works were executed are all unknown. Northern European characteristics seem stronger in the earlier version, which was long attributed to Witz himself. This *Pietà* is more dramatically intense, more emotional in the handling of the sharp-featured faces, the angular drapery folds, and the colder tonality of colors and light.

During the fifteenth century, artists of many nationalities traveled about to courts and towns throughout Europe, from Provence to Naples, from the Netherlands to Spain, blending in their works local and imported traditions. The authors of these two paintings may have been such itinerant artists.

(Opposite)

GERARD DAVID
active 1484–1523

David was born at Oudewater, near Gouda. By 1484 he was in Bruges, where in 1494 he became chief painter of the city. While documents show him working in Antwerp in 1515, he returned a few years later to Bruges, where he died.

THE DEPOSITION

Painted between c. 1510 and 1515.
Oil on canvas
56 ⅛ x 44 ¼ in. (142.5 x 112.4 cm.)
Acquired in 1915

The somber dignity of the mourning figures and the austere simplicity of this composition greatly impressed David's contemporaries, who produced a number of copies and vari-

ants of *The Deposition*. The work is among the earliest extant Northern European paintings executed in oil on canvas, rather than on panel; a water-based paint such as tempera is more commonly found in Flemish works on fabric supports at this period. In *The Deposition* the oil medium brings out the subtle ranges of the cold but vibrant hues and the nuances of the finely rendered details—seen, for example, in the skull and bones prominent in the foreground.

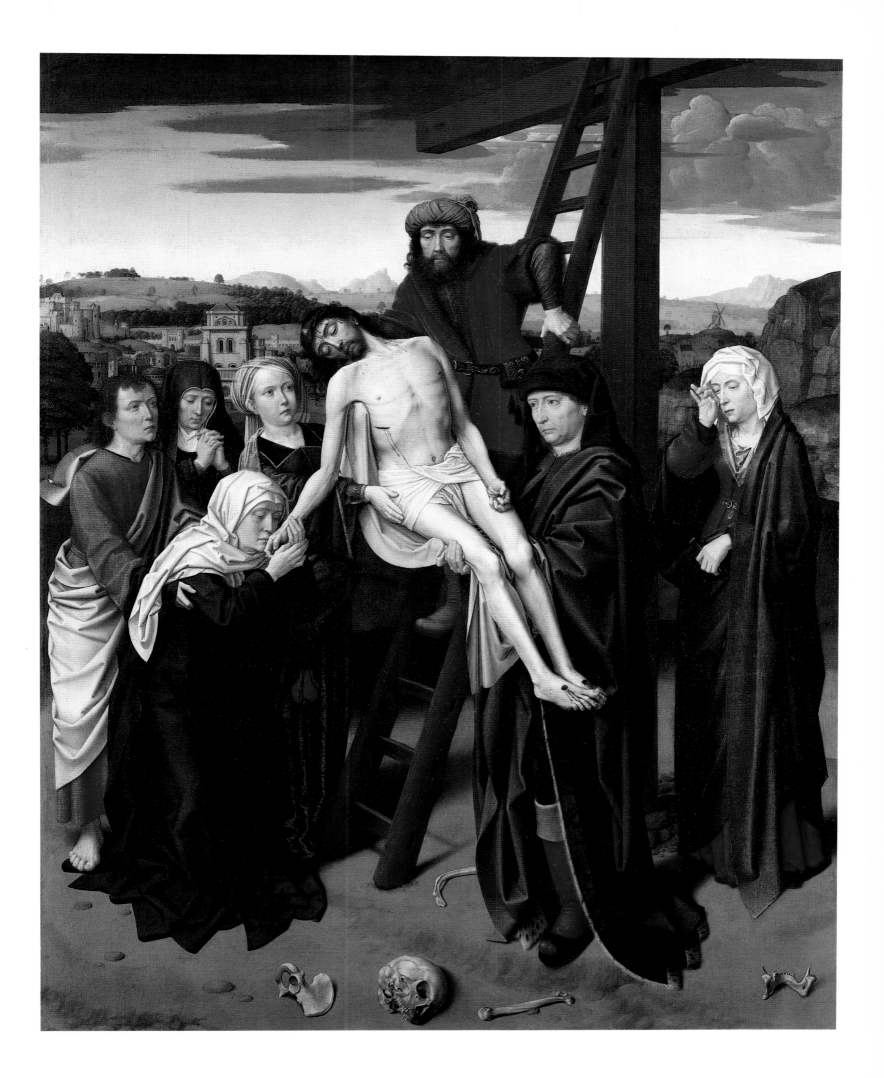

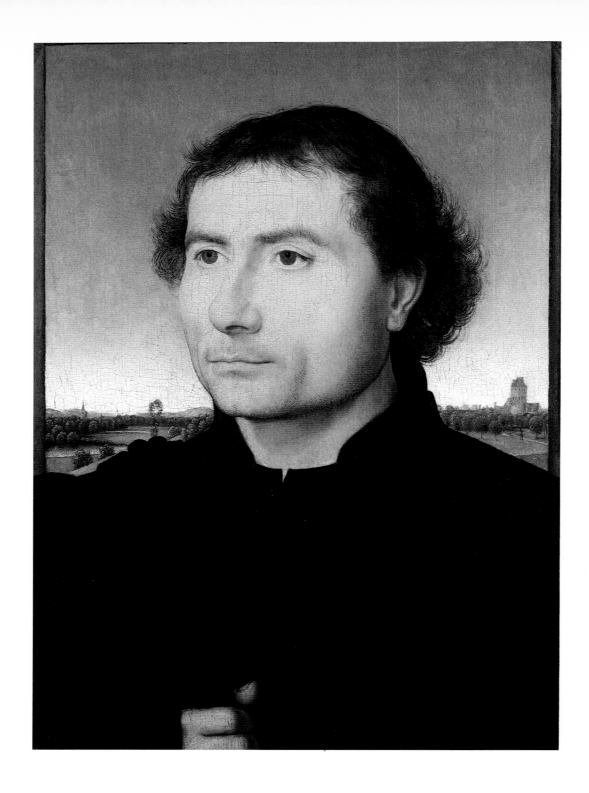

HANS MEMLING
c. 1440–1494

*Born at Seligenstadt, near Frankfurt,
Memling spent much of his life in Bruges,
where he was recorded as a new citizen in
1465. Documents show that he became one
of the city's more prosperous residents,
attracting a cosmopolitan clientele from all
over Europe. In addition to portraits,
Memling painted many religious subjects.*

PORTRAIT OF A MAN

Painted c. 1470. Oil on panel
13 ⅛ x 9 ⅛ in. (33.5 x 23.2 cm.)
Acquired in 1968

The thriving trade centers of the Nether-
lands provided an international market for
talented artists such as Memling. However,
the plain coat worn by the subject of this
portrait offers no clue to his nationality,
occupation, or rank. The serious, firmly
modeled head suggests a man who was not
only forceful but thoughtful. Although
physically he is placed close to the viewer,

his body pressed against the frame, he
appears aloof and removed from the world.
Panels such as this often served as covers or
wings for small private altarpieces, but it
seems probable that the Frick example, like
many others dating from the second half of
the fifteenth century, was commissioned as
an independent painting.

Memling was one of the most admired
portraitists of his day, in Italy as well as in
Northern Europe, owing both to his skill
in capturing physical likenesses and to his
even rarer gift of conveying, as in this por-
trait, the intellectual and spiritual character
of his subjects.

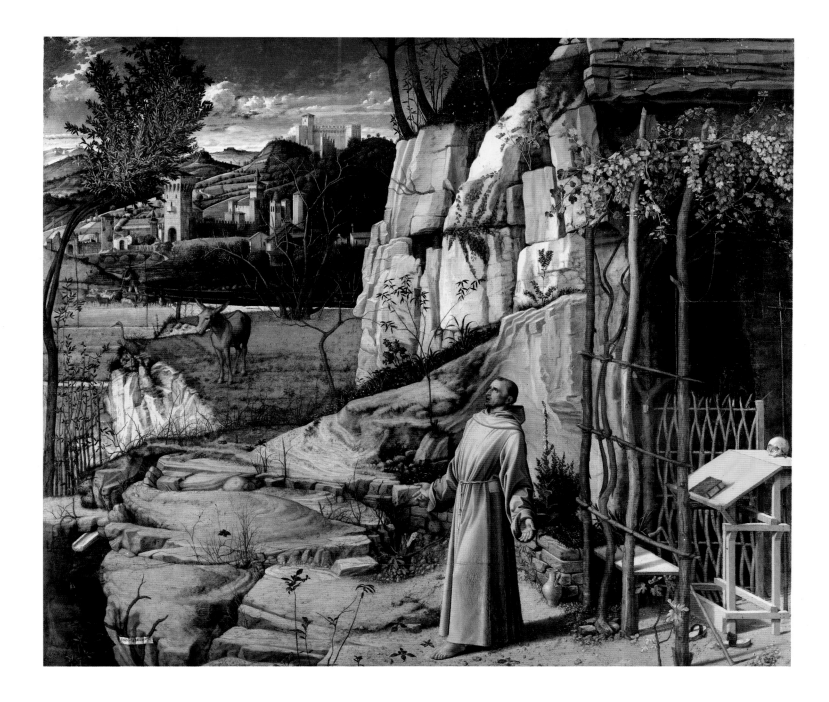

GIOVANNI BELLINI
c. 1430–1516

Giovanni Bellini began his career in the workshop of his father, Jacopo. First mentioned in Venice in 1459, he succeeded his brother Gentile as painter to the Republic in 1483. Thereafter he was constantly employed by the State, as well as by Venetian churches and private patrons. He was one of the first Italian artists to master the oil technique of the Northern European painters.

St. Francis in the Desert

Painted c. 1480. Tempera and oil on panel
49 x 55 ⅞ in. (124.4 x 141.9 cm.)
Acquired in 1915

St. Francis of Assisi (1181/82–1226), founder of the Franciscan order, is believed to have received the stigmata—the wounds of Christ's Crucifixion—in 1224 during a retreat on Mount Alverna in the Apennines. It may be this event that Bellini evokes here through the naturalistic yet transcendental imagery of rays of light flooding the foreground from an unseen source at upper left. However, alternative explanations for the scene have been proposed.

The wilderness—or desert—of Mount Alverna is compared in early Franciscan sources to the desert of the Book of Exodus, and Moses and Aaron were seen by the Franciscans as their spiritual ancestors, who were believed to have lived again in their founder. A parallel was seen between the

saint's stigmatization on Mount Alverna and Moses' communion with God on Mount Horeb. The quivering tree at upper left, shining in the mysterious light, may then be intended to recall not only the Cross but also the burning bush of Moses' vision at Horeb.

The landscape of Bellini's desert is filled with marvelous details—animals, birds, persons, plants, objects such as the skull and sandals, and strange rock formations—that yielded hidden meanings for those who understood their importance in Franciscan literature. The water trickling from a spout in the stones at left, for example, is compared to the miraculous fountain Moses brought forth from the rocks at Horeb, and the empty sandals behind the barefoot saint recall God's command to Moses to "put off the shoes from thy feet: for the place whereon thou standest is holy ground." It is perhaps this sense of significance in all things as well as the radiant light flowing over the landscape that imbues the painting with such magical appeal.

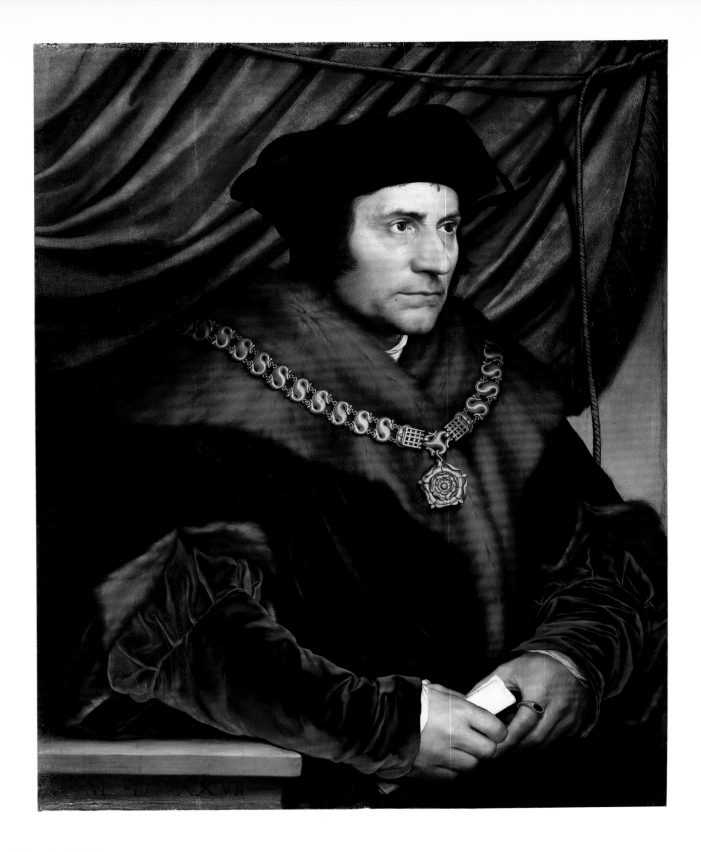

HANS HOLBEIN
THE YOUNGER
1497/98–1543

Son of the Augsburg painter Hans Holbein the Elder, who probably gave him his first training, Holbein was working by 1515 in Basel, where he achieved great success and was part of the humanist circle of Erasmus. It is probable that about 1519 he traveled to Italy, where the art of the Italian Renaissance may have inspired the classic monumentality of his own style. In 1524 Holbein visited France, and from 1526 to 1528 he worked in England. Four years later he returned to settle there, eventually becoming court painter to Henry VIII. A remarkably realistic yet decorative series of portraits of Henry's court and family is Holbein's great legacy. He died of the plague in London.

SIR THOMAS MORE

Dated 1527. Oil on panel
29 ½ x 23 ¾ in. (74.9 x 60.3 cm.)
Acquired in 1912

Thomas More (1477/78–1535), humanist scholar, author, and statesman, served Henry VIII as diplomatic envoy and Privy Councillor prior to his election as speaker of the House of Commons in 1523. The chain More wears in this portrait is an emblem of service to the King, not of any specific office. In 1529 More succeeded Cardinal Wolsey as Lord Chancellor, but three years later he resigned that office over the issue of Henry's divorce from Catherine of Aragon, and subsequently he refused to subscribe to the Act of Supremacy making the King head of the Church of England. For this he was convicted of high treason and beheaded. Venerated by the Catholic Church as a martyr, More was beatified in 1886 and canonized in 1935 on the four-hundredth anniversary of his death. Holbein's sympathy for the man whose guest he was upon first arriving in England is apparent in the Frick portrait. His brilliant rendering of the rich fabrics and adornments make this one of Holbein's best and most popular paintings. Various versions of the portrait exist, but this is undoubtedly the original.

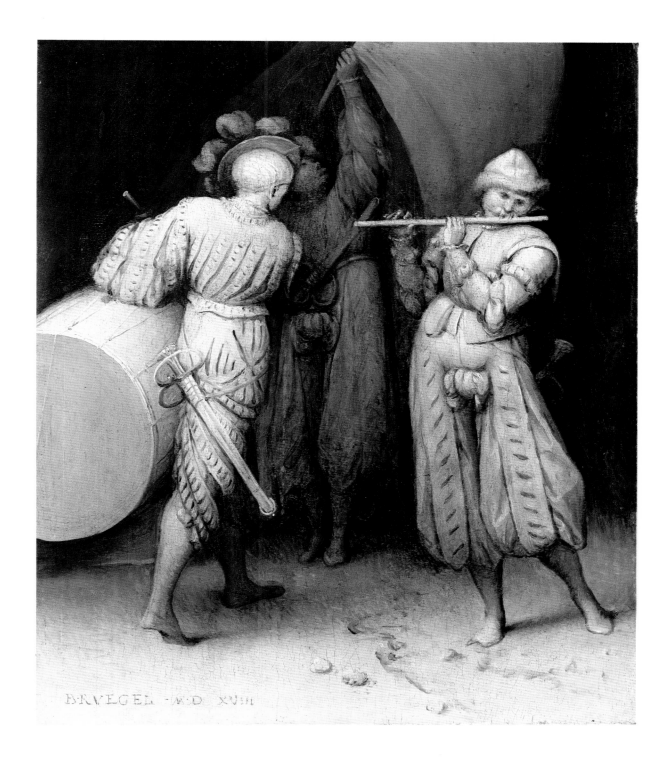

BRVEGEL · M·D· XVIII

PIETER BRUEGEL THE ELDER
active 1551–1569

Both the date and place of Bruegel's birth are uncertain. The earliest reference to him records his entry into the Antwerp painters' guild in 1551. He traveled to Italy around 1552, but by 1555 he was back in Antwerp. In 1563 he settled in Brussels, working thereafter both for eminent private patrons and for the city government. Bruegel's landscape paintings and peasant scenes had a powerful and lasting influence in the Netherlands.

THE THREE SOLDIERS

Dated 1568. Oil on panel
8 x 7 in. (20.3 x 17.8 cm.)
Acquired in 1965

Bruegel is best known for his large landscapes and town views populated by small, lively figures—often contemporary peasants —and illustrating biblical, allegorical, and folkloric subjects. In addition to the Frick example, only three other *grisailles* by Bruegel

are known, all on religious themes. This little panel, once in the collection of Charles I of England, represents a trio of *Landsknechte,* the mercenary foot soldiers whose picturesque costumes and swashbuckling airs provided popular images for printmakers in the sixteenth century. Bruegel may have executed the Frick *grisaille* as a model for such an engraving, although none is known, or simply as a cabinet piece. The attenuated grace of the figures in this painting may reflect currents in contemporary Italian art.

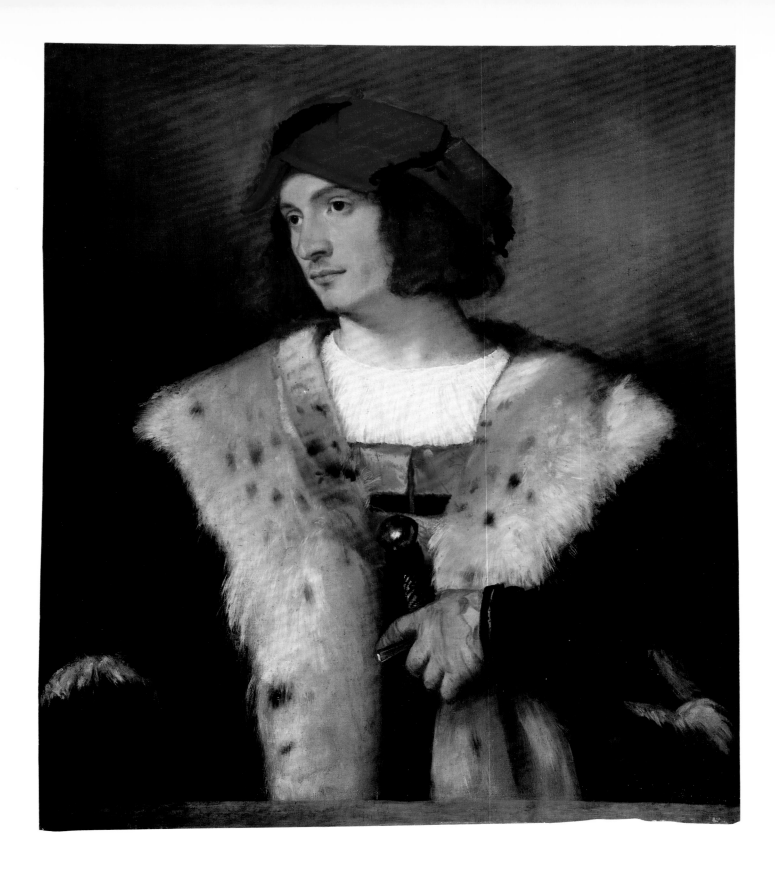

TITIAN (TIZIANO VECELLIO)
1477/90 – 1576

Titian was born in the Alpine town of Pieve di Cadore; the date of his birth is uncertain. He succeeded Giovanni Bellini, under whom he had studied, as painter to the Republic of Venice, and he included among his many illustrious patrons the emperor Charles V, Charles' son Philip II of Spain, and Pope Paul III. He died in Venice in the great plague of 1576. After Giorgione's death in 1510, Titian was considered the greatest painter of his day in Venice.

PORTRAIT OF A MAN IN A RED CAP

Painted c. 1516. Oil on canvas
32 ⅜ x 28 in. (82.3 x 71.1 cm.)
Acquired in 1915

Various identities for the richly dressed young man in this portrait have been proposed, but none with any certainty. Nevertheless, the portrait seems to have been well known, at least in the seventeenth century; Carlo Dolci included a copy of the figure in the background of his *Martyrdom of St. Andrew* (Palazzo Pitti, Florence). The painting is generally considered an early work of Titian. The contemplative mood of the subject and the diffused, gentle play of light over the broadly painted surfaces are strongly reminiscent of Titian's Venetian contemporary Giorgione. The canvas has in the past even been attributed to Giorgione. In mood, pose, and technique, the Frick portrait closely resembles the central figure of *The Concert* (Palazzo Pitti), a painting that also has been ascribed both to Titian and to Giorgione.

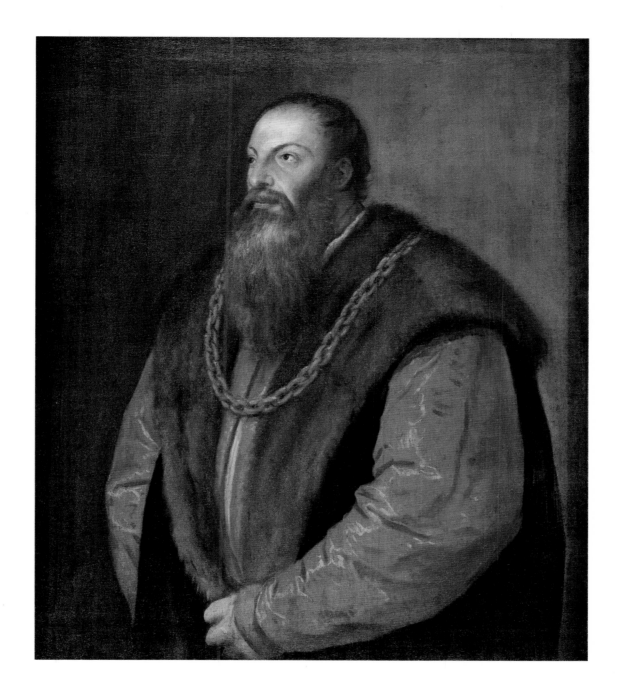

TITIAN

PIETRO ARETINO

Painted probably between 1548 and 1551.
Oil on canvas
40 ⅛ x 33 ¾ in. (102 x 85.7 cm.)
Acquired in 1905

Author of lives of saints, scurrilous verses, comedies, tragedies, and innumerable letters, Pietro Aretino (1492–1556) attained considerable wealth and influence, in part through literary flattery and blackmail. Lit-

tle is known of his early years, but by 1527 he had settled permanently in Venice. Among Aretino's friends and patrons were some of the most prominent figures of his time, several of whom gave him gold chains such as the one he wears in this portrait. Clement VII made Aretino a Knight of Rhodes, and Julius III named him Knight of St. Peter. He was on intimate terms with Titian, who painted at least three portraits of him. Here the artist conveys his friend's intellectual power through the keen, forceful head and his worldliness through the solid, weighty mass of the richly robed figure.

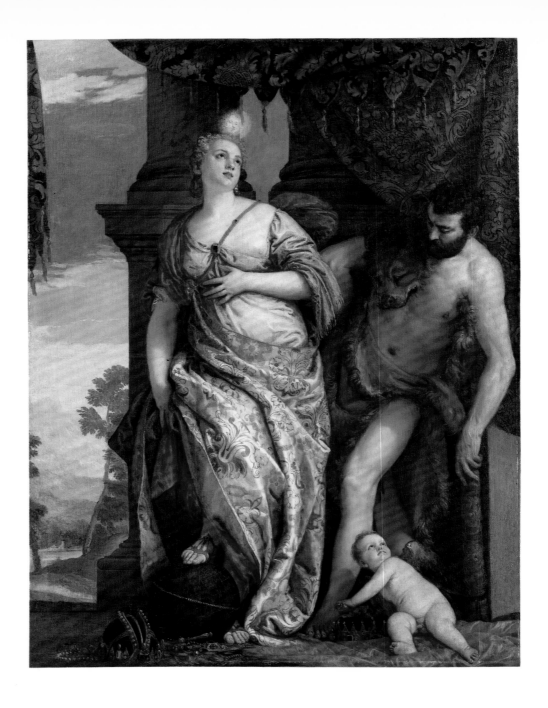

PAOLO VERONESE
(PAOLO CALIARI)
c. 1528–1588

Paolo Caliari was called Il Veronese after his birthplace, Verona. By 1553 he was painting in Venice at the Palazzo Ducale. Thereafter, apart from trips to Mantua and Rome during the 1550s and 1560s, he worked in Venice and in neighboring towns. Veronese painted monumental religious, mythological, and allegorical works as well as portraits and magnificent decorations for the villas of patrician families.

ALLEGORY OF
WISDOM AND STRENGTH

Painted c. 1580. Oil on canvas
84 ½ x 65 ¾ in. (214.6 x 167 cm.)
Acquired in 1912

All the splendor of Venetian color and light, of the Venetians' pleasure in beautiful landscapes, skies, and people, in lustrous silks and jewels, are brought together in the Frick's two large canvases by Veronese. Yet in spite of their fame and the series of prominent collectors who owned them, many uncertainties persist about their dates, provenance, and subject matter. Few of Veronese's works are firmly dated, and the evolution of his style is not easily traceable. The Frick paintings appear to be fairly late works, but probably not much later than 1580.

It has been proposed that the two were commissioned by Rudolph II, but although the paintings certainly belonged to the emperor, there is no firm evidence that Rudolph, an avid collector, actually commissioned them. It is also customarily assumed that the two pictures are pendants—chiefly because they have been together throughout their recorded history, not because of any close compositional or iconographic ties; the differences in the scale of the figures and in the types of canvas employed suggest that they may in fact not have been pendants, and the moralizing subjects of the pair are in no way interdependent.

Veronese expressed the moralizing theme of *Wisdom and Strength* in sumptuous fashion. The female figure gazing heavenward seems intended to represent Divine Wisdom. Hercules, his gaze turned instead downward, to the riches strewn over the ground, would appear here to symbolize worldly or physical power. The inscription OMNIA VANITAS (All is Vanity) at lower left is the keynote of the Book of Ecclesiastes, which stresses the supremacy of divine wisdom over worldly things and the labors that produce them.

ALLEGORY OF VIRTUE AND VICE
(THE CHOICE OF HERCULES)

Painted c. 1580. Oil on canvas
86 ¼ x 66 ¾ in. (219 x 169.5 cm.)
Acquired in 1912

At a crossroads, Hercules encountered Vice, who offered a path of ease and pleasure, and Virtue, who indicated a rugged ascent leading to true happiness—a moral lesson underlined by the motto on the entablature at upper left: [HO]NOR ET VIRTUS/[P]OST MORTE FLORET (Honor and Virtue Flourish after Death). The long talons of Vice have ripped the hero's stocking. A jagged knife leans against the breast of the sphinx supporting her throne.

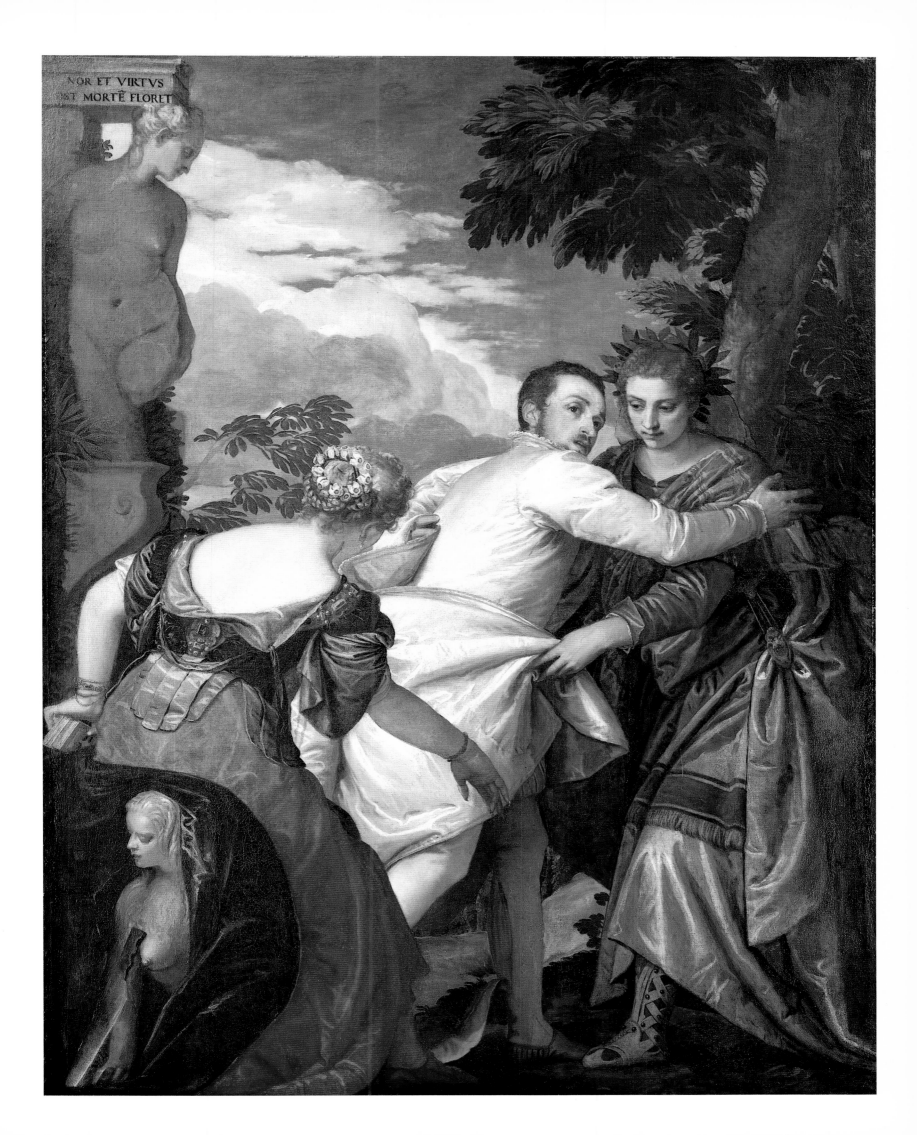

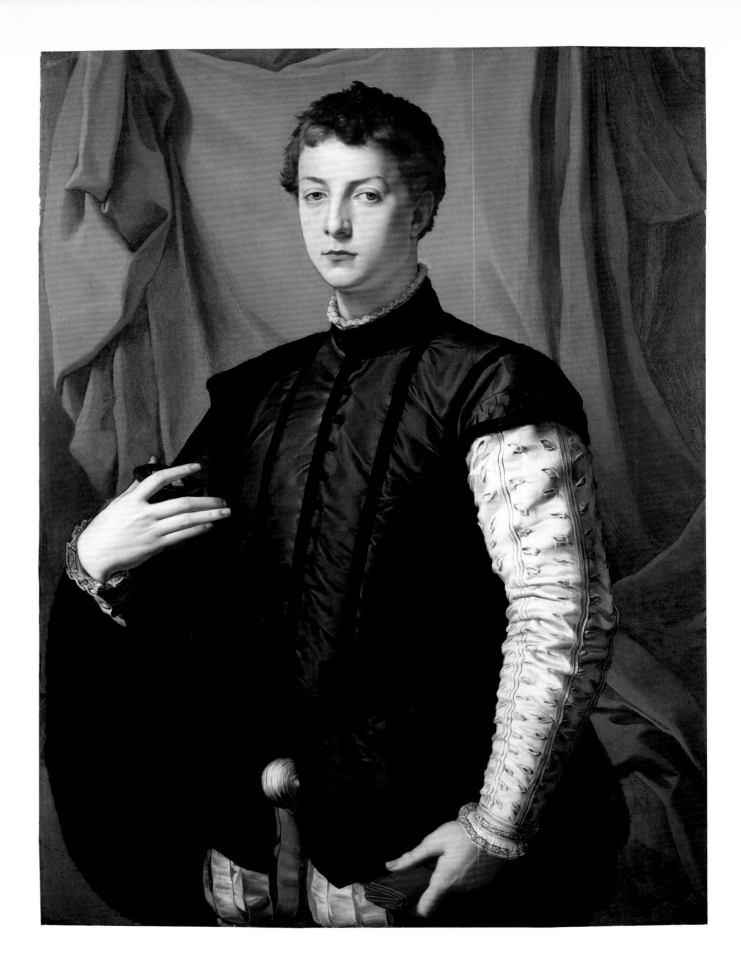

AGNOLO BRONZINO

1503–1572

Agnolo di Cosimo di Mariano, called Bronzino, was court painter to Duke Cosimo I de' Medici and became the foremost portraitist of Florence. He also executed religious and allegorical subjects as well as decorations for Medici festivities.

LODOVICO CAPPONI

Painted probably between 1550 and 1555.
Oil on panel
45 ⅞ x 33 ¾ in. (116.5 x 85.7 cm.)
Acquired in 1915

This proud young aristocrat is Lodovico Capponi (b. 1533), a page at the Medici court. As was his custom, he wears black and white, his family's armorial colors. His right index finger partially conceals the cameo he holds, revealing only the inscription SORTE (fate or fortune)—an ingenious allusion to the obscurity of fate. In the mid-1550s Lodovico fell in love with a young woman whom Duke Cosimo had intended for one of his cousins. After nearly three years of opposition, Cosimo, persuaded by his wife, Eleanora of Toledo, suddenly relented, but he commanded that their wedding be celebrated within twenty-four hours.

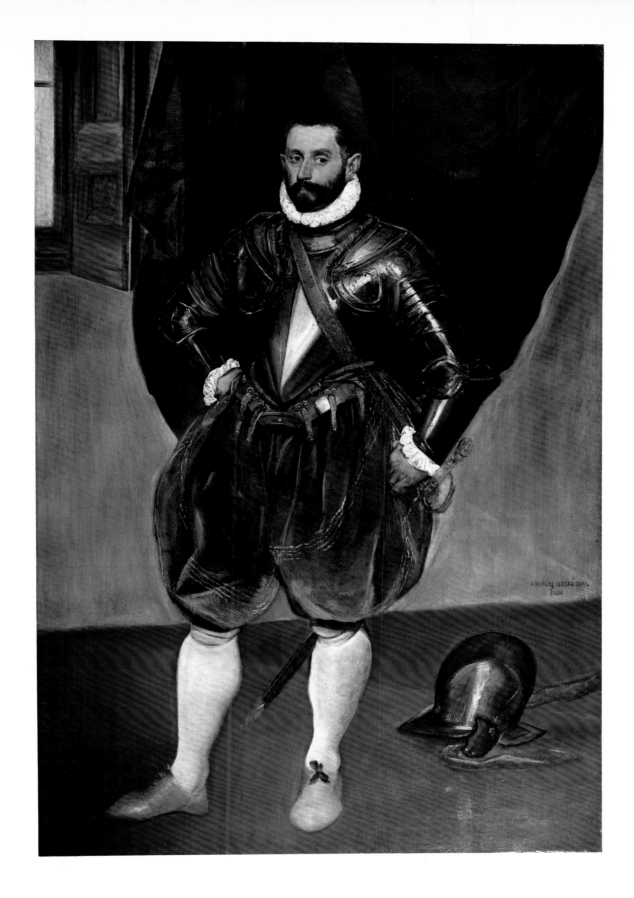

EL GRECO
1541–1614

*Domenikos Theotokopoulos, called El
Greco, was born in Crete, then a Venetian
dependency. He reputedly studied with
Titian in Venice, then moved to Rome
in 1570. By 1577 he had settled in Toledo,
where he spent his remaining years. His
extensive production consisted almost
exclusively of religious subjects and portraits.*

VINCENZO ANASTAGI

Painted between c. 1571 and 1576.
Oil on canvas
74 x 49 ⅞ in. (188 x 126.7 cm.)
Acquired in 1913

Born in Perugia, Vincenzo Anastagi (c.
1531–86) joined the Knights of Malta in
1563 and was a leader in the heroic defense
of that island during the massive Turkish
siege of 1565. After holding various other
responsible posts he was named Sergeant
Major of Castel Sant'Angelo in Rome.
Anastagi apparently was an expert on forti-
fications. This portrait, already characteristi-
cally intense and spirited in style, probably
dates from El Greco's last years in Italy.

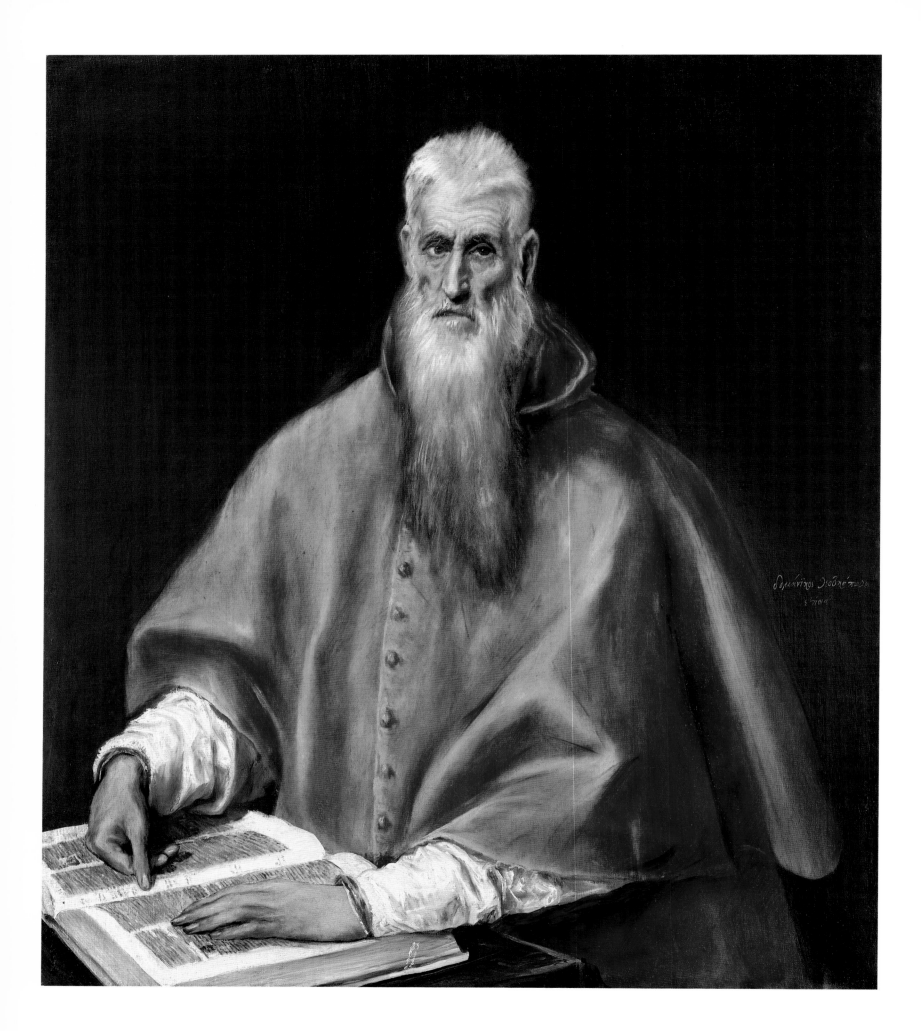

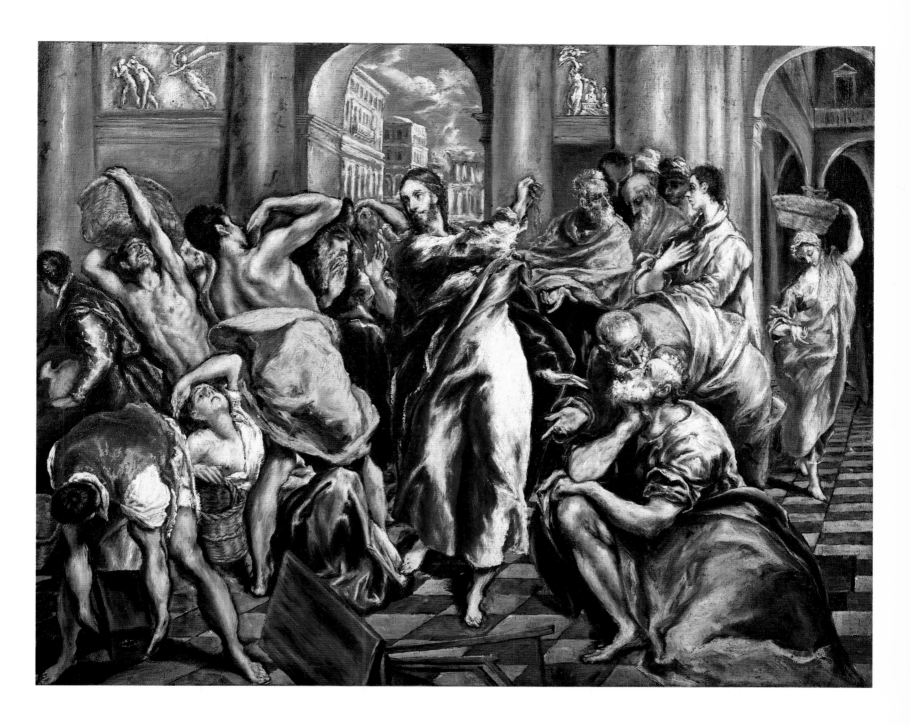

EL GRECO

ST. JEROME

Painted between c. 1590 and 1600.
Oil on canvas
43 ½ x 37 ½ in. (110.5 x 95.3 cm.)
Acquired in 1905

St. Jerome (c. 342–420), one of the four great Doctors of the Western Church, is venerated for his ascetic piety and for his monumental Latin translation of the Bible, represented here by the large volume on which he rests his hands. Following an old convention the artist depicts him in the robes of a cardinal. This composition proved popular and was produced in at least four versions by El Greco and his shop; one of these is in the Metropolitan Museum of Art, New York.

THE PURIFICATION OF THE TEMPLE

Painted c. 1600. Oil on canvas
16 ½ x 20 ⅝ in. (41.9 x 52.4 cm.)
Acquired in 1909

The subject of Christ driving the traders and moneychangers from the Temple assumed special significance during the Counter Reformation as a symbolic reference to the purification of the Church from heresy. El Greco has introduced, in the bas-reliefs on the Temple wall, the themes of the Expulsion of Adam and Eve from Paradise and the Sacrifice of Isaac. Beneath them, the figures in the painting are divided into two groups.

At left, under the Expulsion relief, are the frightened sinners. At right, the believers quietly observe the scene from beneath the Sacrifice of Isaac, an antetype of the Crucifixion. This configuration is evocative of the Last Judgment.

The theme of the Purification absorbed El Greco throughout his career, as demonstrated by the many versions of this composition that issued from his shop. Although the chronology of El Greco's work is far from clear, the Frick canvas appears to be one of the later examples. The painting is smaller in size than other similar versions, but it generates remarkable dramatic intensity through the explosive movement and cold but brilliant coloring.

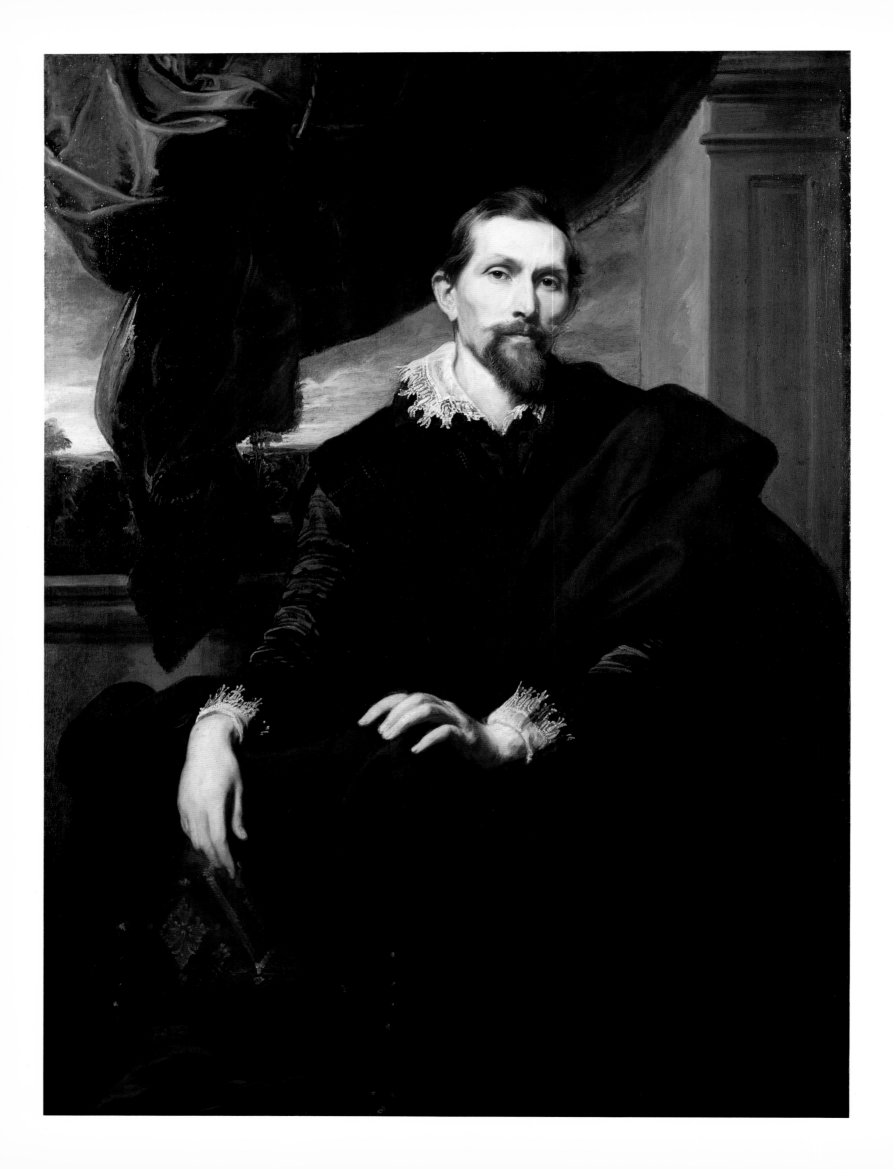

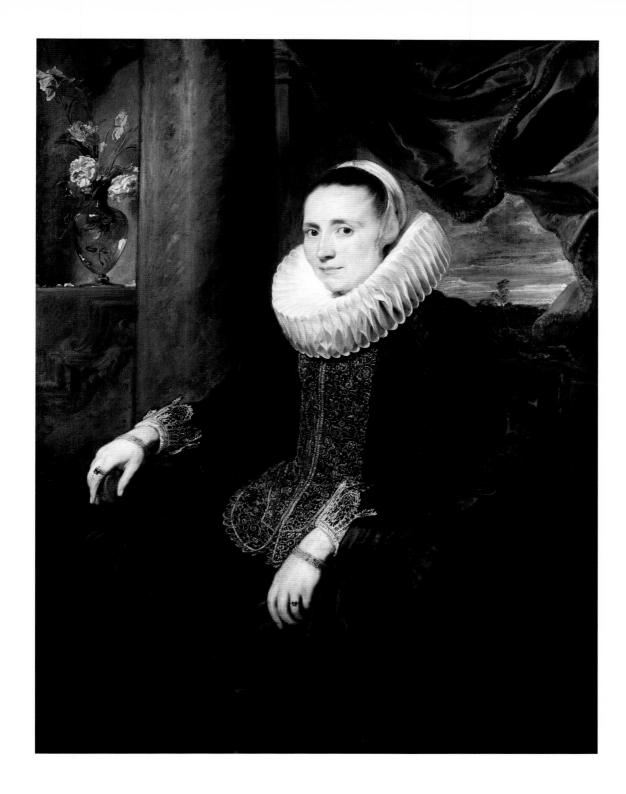

SIR ANTHONY VAN DYCK
1599–1641

Van Dyck was born in Antwerp, where he served an apprenticeship with Hendrik van Balen and was received as a master into the Guild of St. Luke by 1618. He visited London in 1620 and worked in Italy from 1621 until 1627, when he returned to Antwerp. From 1632 until his death he was active chiefly as a portrait painter in England.

FRANS SNYDERS

Painted c. 1620. Oil on canvas
56 ⅛ x 41 ½ in. (142.5 x 105.4 cm.)
Acquired in 1909

MARGARETA SNYDERS

Painted c. 1620. Oil on canvas
51 ½ x 39 ⅛ in. (130.7 x 99.3 cm.)
Acquired in 1909

These superb portraits represent Frans Snyders and his wife, Margareta de Vos. Snyders, a celebrated and prolific painter of still lifes, animals, and hunting scenes, was an intimate friend of Van Dyck. The influence of Rubens, whom Van Dyck assisted on occasion, is evident in these early portraits. The artist's sympathetic characterizations of his friends and the brilliantly painted details of clothing and settings confirm his precocious talent. Mr. Frick reunited these companion works, which had been separated since 1793.

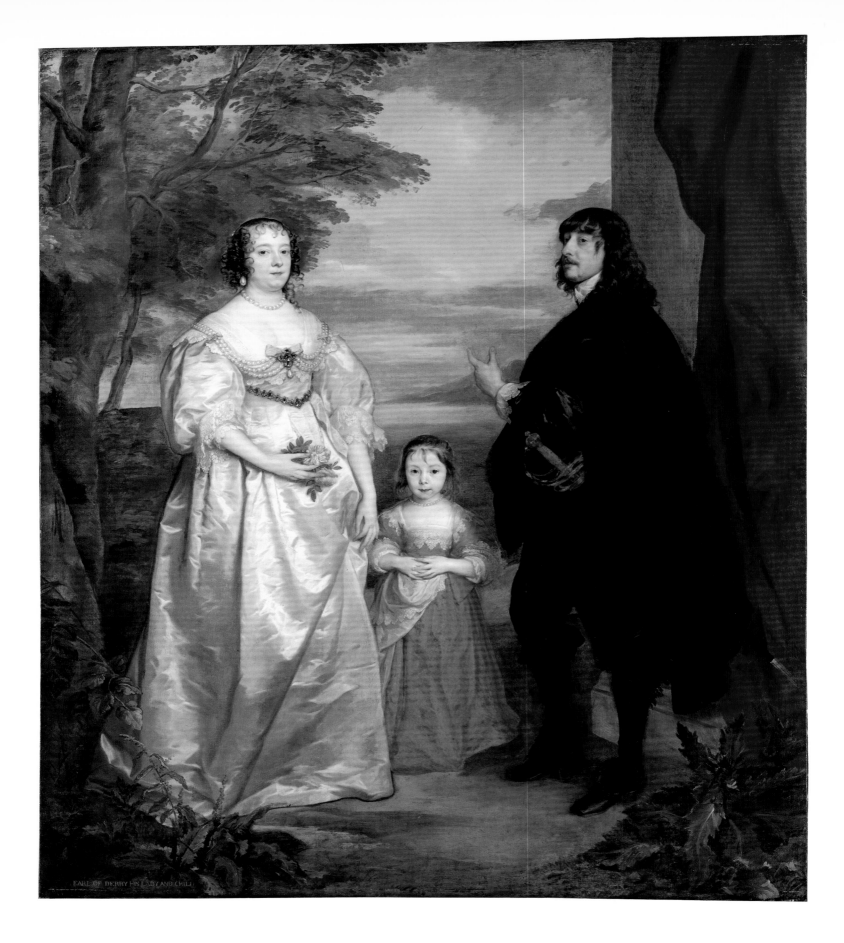

EARL OF DERBY HIS LADY AND CHILD

SIR ANTHONY VAN DYCK

JAMES, SEVENTH EARL OF DERBY, HIS LADY AND CHILD

Painted between 1632 and 1641. Oil on canvas
97 x 84 ⅛ in. (246.2 x 213.7 cm.)
Acquired in 1913

This imposing work, typical of the large group portraits Van Dyck painted during his last English period, represents James Stanley, seventh Earl of Derby (1607–51), with his wife Charlotte de la Trémoille (1599–1664) and one of their daughters. The Earl was a writer of history and devotional works as well as an ardent Royalist during the Civil War. He was captured and executed by Commonwealth forces in 1651. The Countess, who conducted a spirited defense of Latham House, the family's country seat, lived to see the Restoration of the Stuart crown. Among the emblematic details in their portrait are the distant landscape, thought to represent the Isle of Man, of which the Derbys were hereditary sovereigns, and the color of the child's dress, indicating her descent from the House of Orange.

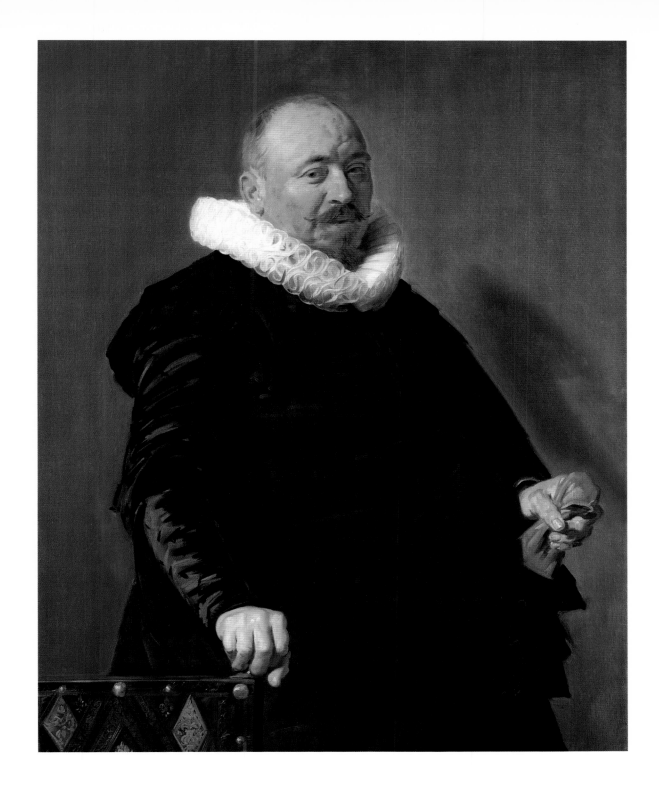

FRANS HALS
1582/83–1666

Documents show that Hals was born in Antwerp, probably in 1582 or 1583. He had moved to Haarlem with his parents (his father was a clothworker) by 1591, and at some time before 1603 he is thought to have studied with Carel van Mander. In 1610 he joined the Haarlem painters' guild; his first known dated work, a portrait, is from the following year. Hals worked in Haarlem until his death, chiefly painting portraits, including several group portraits of militia officers and governors of charitable institutions. His younger brother Dirck also was a painter, as were three of his sons.

PORTRAIT OF AN ELDERLY MAN

Painted between c. 1627 and 1630.
Oil on canvas
45 ½ x 36 in. (115.6 x 91.4 cm.)
Acquired in 1910

The technique of this portrait dating from Hals' early maturity is learned in part from Rubens. Halftones are superimposed in hatched strokes over lighter pigment applied in a thin, fluid coating. The warm but restricted color scheme and the subject's animated expression and self-confident air are typical of Hals' major works from this period. Matchmaking between male and female portraits is a popular pursuit among Hals scholars, who sometimes pair the Frick portrait with a female portrait dated 1633 in the National Gallery of Art, Washington. The evidence that the two were a couple is, however, far from conclusive.

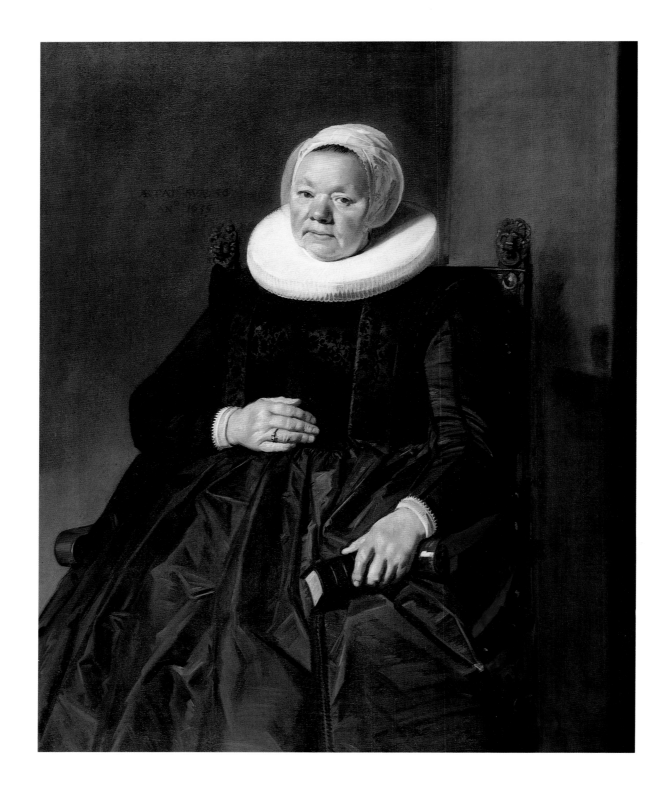

FRANS HALS

PORTRAIT OF A WOMAN

Dated 1635. Oil on canvas
45 ⅞ x 36 ¾ in. (116.5 x 93.3 cm.)
Acquired in 1910

An inscription at upper left gives the age of the unidentified sitter as fifty-six. Soberly but richly dressed in black silk, with a brocaded bodice, the ruddy-cheeked lady, holding a Bible or prayerbook, appears well-established in a comfortable existence. Her solid, rounded form and four-square setting enhance the sense of a life led in a secure position within her society. The portrait records her features with objectivity and with a blunt, vigorous brushwork that seems in itself to reflect her character. Like most of Hals' works, this one employs a plain, unadorned background perfectly suited to his style of portraiture. Various suggestions have been made for a male companion to the portrait, but no agreement on the match has been reached.

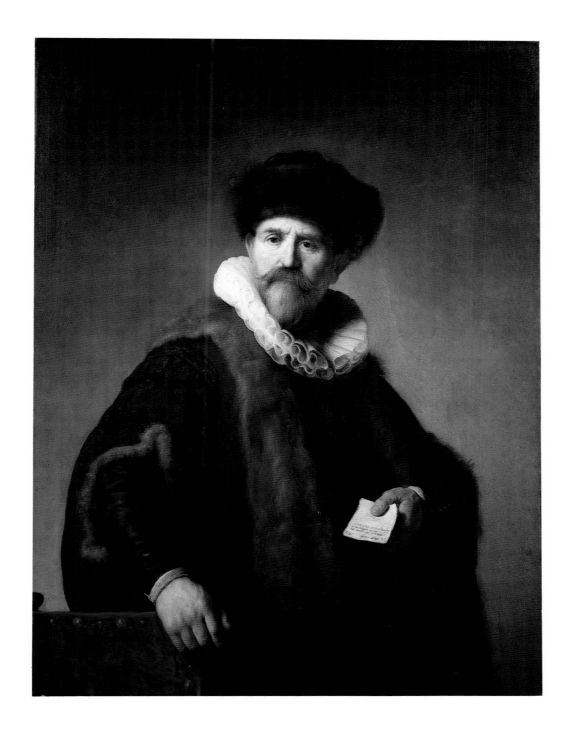

REMBRANDT
HARMENSZ. VAN RIJN
1606–1669

Rembrandt first studied art in his native Leyden and later worked under Pieter Lastman in Amsterdam. Around 1625 he returned to Leyden, but in 1631/32 he settled permanently in Amsterdam. Although he enjoyed a great reputation and pupils flocked to him, he suffered financial difficulties that led to insolvency in 1656. By 1660 most of his debts were settled, and his last years were spent in relative comfort. Rembrandt painted many portraits, biblical scenes, and historical subjects.

NICOLAES RUTS

Dated 1631. Oil on panel
46 x 34 ⅜ in. (116.8 x 87.3 cm.)
Acquired in 1943

Born in Cologne, Nicolaes Ruts (1573–1638) was a merchant who traded with Russia, the source, no doubt, of the rich furs in which he posed for this portrait. Rembrandt's likeness of him, perhaps the first portrait commission the artist received from someone outside of his own family, was painted presumably for Ruts' daughter Susanna. A 1636 inventory of her property listed the picture of her father as "the portrait of Nicolaes Ruts made by Rembrant." The dramatic contrasts in lighting and the detailed rendering of the varied textures are characteristic of Rembrandt's early work, differing markedly from the warm, diffused light and broad brushwork that distinguish the Frick *Self-Portrait* executed over a quarter of a century later.

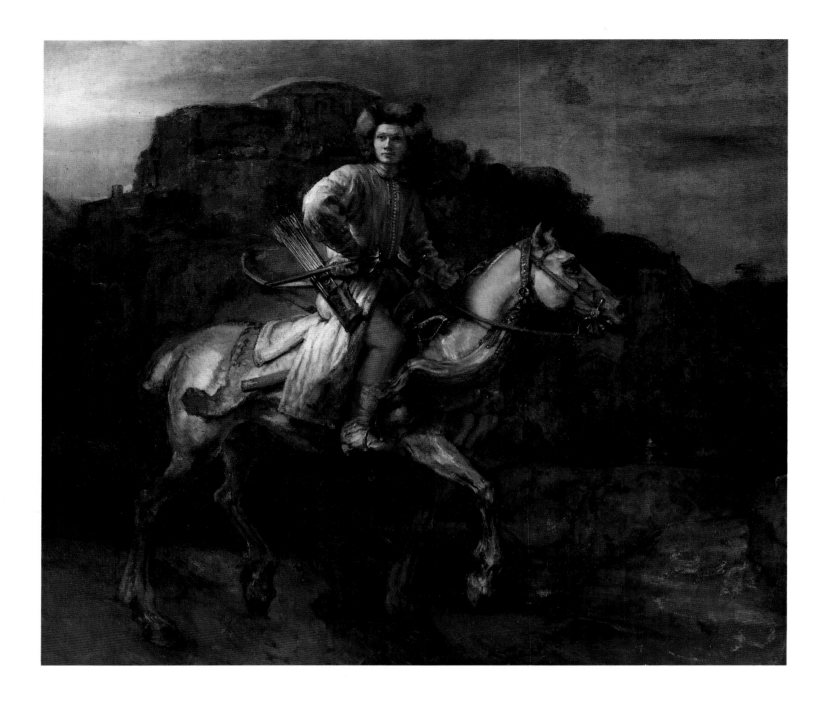

REMBRANDT HARMENSZ. VAN RIJN

THE POLISH RIDER

Painted c. 1655. Oil on canvas
46 x 53 ⅛ in. (116.8 x 134.9 cm.)
Acquired in 1910

The romantic and enigmatic character of this picture has inspired many theories about its subject, meaning, history, and even its attribution to Rembrandt.

Several portrait identifications have been proposed, including an ancestor of the Polish Oginski family, which owned the paint-ing in the eighteenth century, and the Polish Socinian theologian Jonasz Szlichtyng. The rider's costume, his weapons, and the breed of his horse have also been claimed as Polish. But if *The Polish Rider* is a portrait, it certain-ly breaks with tradition. Equestrian portraits are not common in seventeenth-century Dutch art, and furthermore, in the traditional equestrian portrait the rider is fashionably dressed, his mount spirited and well-bred.

The painting may instead portray a char-acter from history or literature, and many possibilities have been proposed. Candidates range from the Prodigal Son to Gysbrech van Amstel, a hero of Dutch medieval history, and from the Old Testament David to the Mongolian warrior Tamerlane.

It is possible that Rembrandt intended simply to represent a foreign soldier, a theme popular in his time in European art, especially in prints. Nevertheless, Rem-brandt's intentions in *The Polish Rider* seem clearly to transcend a simple expression of delight in the exotic. The painting has also been described as a latter-day *Miles Chris-tianus* (Soldier of Christ), an apotheosis of the mounted soldiers who were still defend-ing Eastern Europe against the Turks in the seventeenth century. Many have felt that the youthful rider faces unknown dangers in the strange and somber landscape, with its mountainous rocks crowned by a mysteri-ous building, its dark water, and the distant flare of a fire.

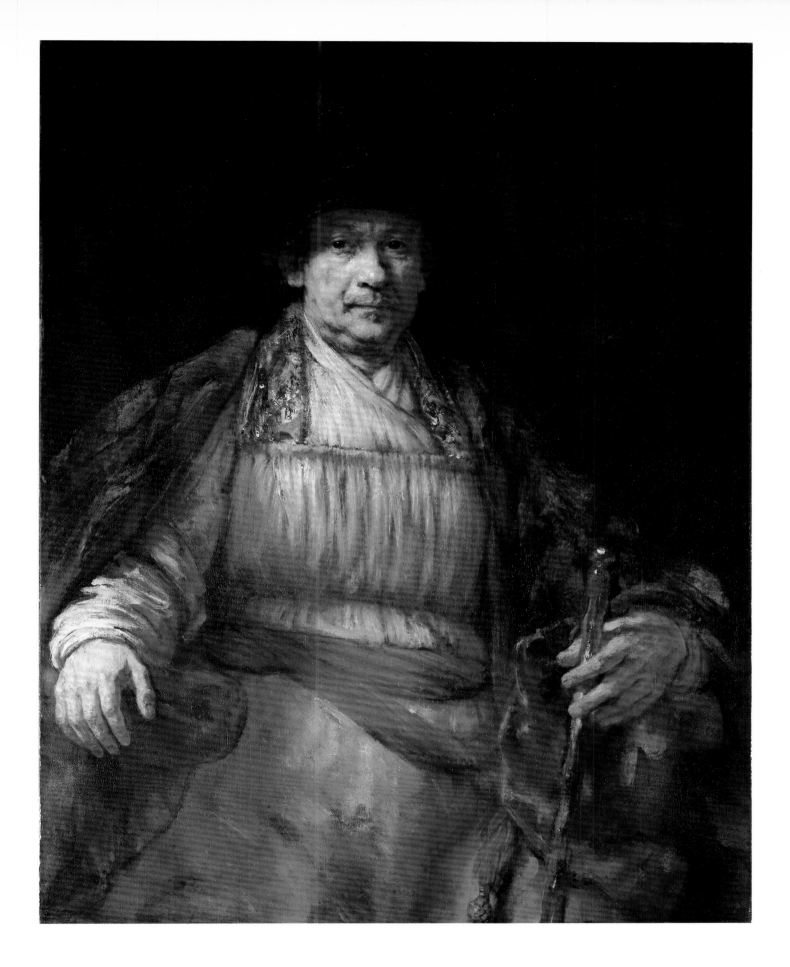

REMBRANDT HARMENSZ. VAN RIJN

SELF-PORTRAIT

Dated 1658. Oil on canvas
52 ⅝ x 40 ⅞ in. (133.7 x 103.8 cm.)
Acquired in 1906

Between 1625, the date of his earliest known work, and 1669, the year of his death, Rembrandt painted over sixty self-portraits and drew and etched his own likeness repeatedly. The portraits range as widely in character as in date. The artist's youthful self-portraits concentrated more on reproducing physical appearance, and many seem to have been experiments in which he practiced dramatic lighting effects or transitory facial expressions, using himself as a model. The later portraits are more subtle and searching.

In the Frick portrait, Rembrandt created an image of strength and worldly power that seems to contradict the external facts of his life. A small man, he portrayed his figure in monumental dimensions. Only fifty-two, he painted a face blurred and eroded by age, sorrows, and illness. A bankrupt, he pictured himself in a costume he seems elsewhere to have associated with ancient or Oriental kingship. The hieratic frontal pose, unusual in self-portraiture of the time, also suggests an enthroned ruler, and the artist holds his stick as if it were a scepter. It gleams as though made of gold, and the warm gold and vermilion colors of his garments further contribute to the impression of richness and power.

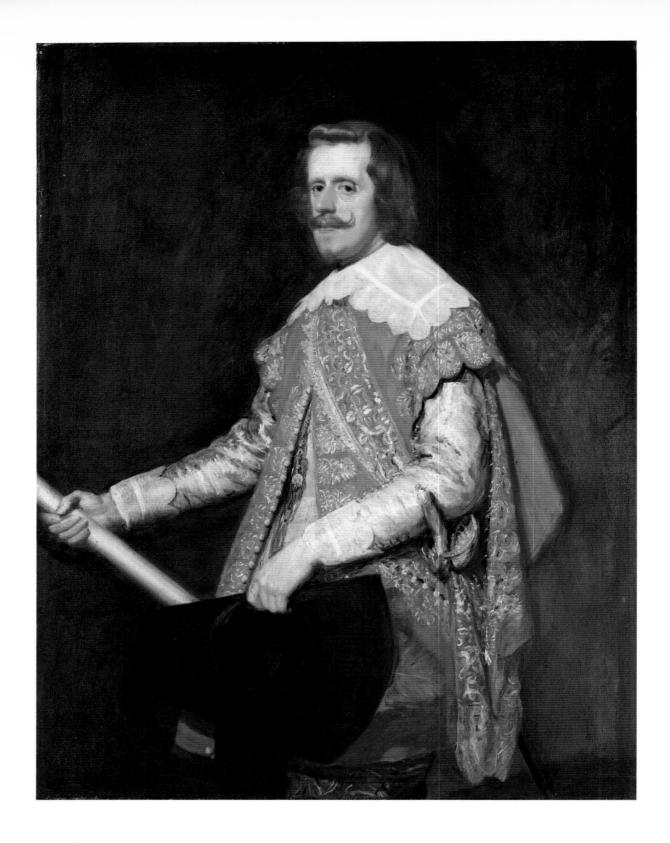

DIEGO RODRÍGUEZ
DE SILVA Y VELÁZQUEZ
1599–1660

*Born in Seville, the son of a lawyer of
Portuguese descent, Velázquez was
apprenticed at the age of eleven to the
painter Francisco Pacheco. In 1623 he was
called to Madrid, where he soon painted his
first portrait of King Philip IV. Velázquez
became not only court painter, but also a*

*close friend of the King, who ennobled him
and made him a knight of the Military
Order of Santiago and a gentleman in
waiting. His work undoubtedly profited
from study of the royal collection, which was
rich in works of the Venetians, and he
probably also was influenced by Rubens
during the latter's visit to Madrid in 1628–29.
Apart from sojourns in Italy in 1629–31
and 1649–51, Velázquez remained at the
Spanish court until his death.*

KING PHILIP IV OF SPAIN

Painted in 1644. Oil on canvas
51 ⅛ x 39 ⅛ in. (129.8 x 99.4 cm.)
Acquired in 1911

Philip IV (1605–65), who succeeded to the
throne in 1621, was a weak ruler but a lavish
patron of the arts and letters. He promoted
the Spanish theater, built the Palacio del
Buen-Retiro, enlarged the royal collections,
and was Velázquez' most ardent supporter. In
1644 Velázquez accompanied the King on a
campaign to Catalonia, where the Spanish
army led a successful siege of Lérida against
the French. In the town of Fraga, the King's
headquarters, in a dilapidated, makeshift stu-
dio, Philip posed for this portrait dressed in
the silver-and-rose costume he wore during
the campaign. Although Velázquez painted
numerous portraits of Philip IV, this is the
only one dating from the 1640s.

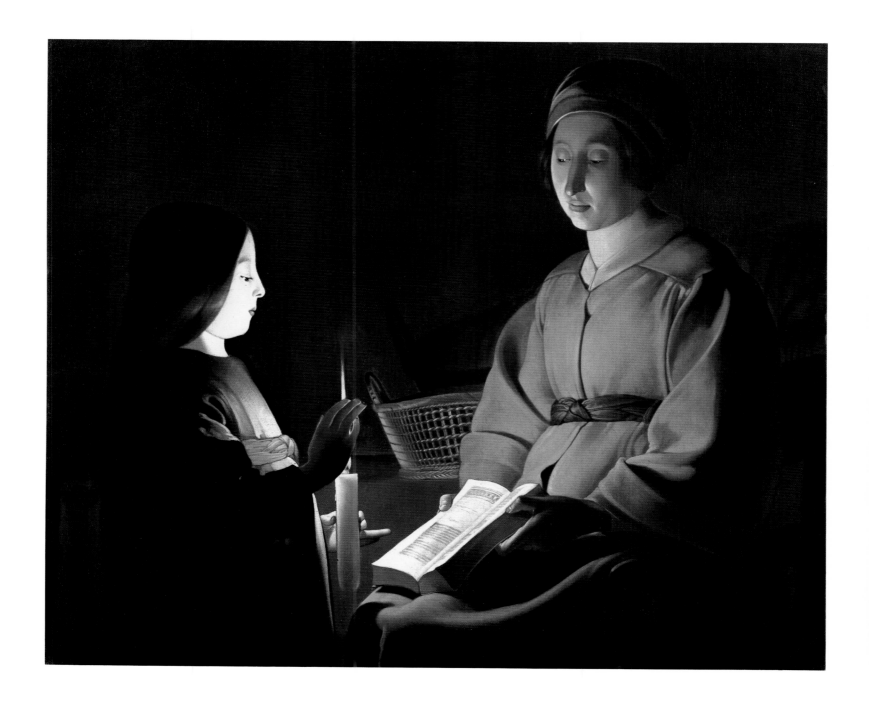

GEORGES DE LA TOUR
1593–1652
OR ÉTIENNE DE LA TOUR (?)
b. 1621

*Born in Lorraine, Georges de La Tour had
settled in Lunéville by 1620. A document of
1639 describes him as "Peintre ordinaire du
Roy." He visited Paris, and his style
suggests that he may have traveled to
Holland and Rome. Little is known of his
son Étienne except the date of his baptism
(1621) and the references that are made to
him as "painter" in 1646 and "master
painter" in 1652.*

THE EDUCATION OF THE VIRGIN

Painted c. 1650. Oil on canvas
33 x 39 ½ in. (83.8 x 100.4 cm.)
Acquired in 1948

The authorship of this painting has been
much debated. Recent studies of the several
surviving versions suggest that all may be
replicas of a lost original by Georges de La
Tour. Yet some scholars maintain that the
Frick canvas is the original; it has been
attributed to the artist's son Étienne primar-
ily because of the form of its signature. The
painter's striking use of light imbues the
popular genre motif of St. Anne teaching
her daughter to read the Bible with a
hushed aura of reverence.

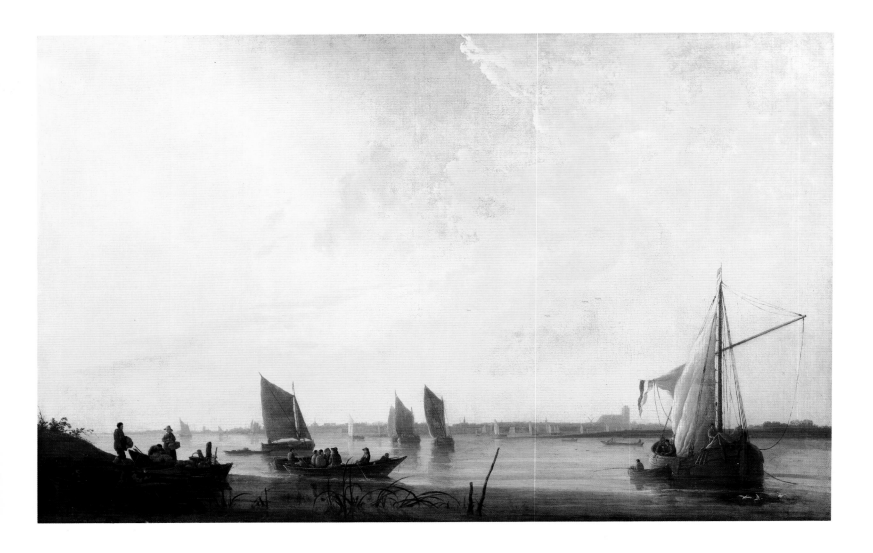

AELBERT CUYP
1620–1691

Cuyp was born in Dordrecht and spent his entire life there. His early pictures recall those of his father, Jacob Gerritsz. Cuyp, and of Jan van Goyen. In the 1640s, under the influence of the Italianized landscapes of Jan Both and others, he developed the luminous style that characterizes his best-known works. He produced landscapes and occasional portraits until the mid-1660s, when he appears to have ceased painting.

DORDRECHT: SUNRISE

Painted c. 1650. Oil on canvas
40 ⅛ x 63 ⅜ in. (102 x 161 cm.)
Acquired in 1905

This early morning scene, with its golden expanse of sky and water, is one of Cuyp's most ambitious attempts to render light and atmosphere. The painting may ultimately reflect the influence of Claude Lorrain, whose landscapes impressed many Dutch artists. Cuyp depicts the port city of Dordrecht as seen from the north, looking across the river Merwede. Most prominent among the recognizable buildings is the Groote Kerk, the church on the horizon to the left of the large boat in the foreground.

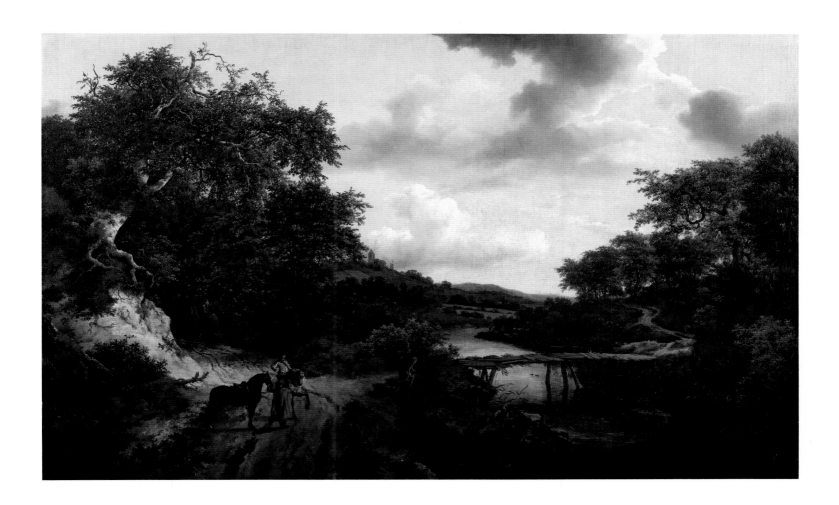

JACOB VAN RUISDAEL
1628/29–1682

Born in Haarlem, where he had an early exposure to painting through his father's art-dealing and framing business, Ruisdael entered the painters' guild there in 1648, presumably after studying with his uncle Salomon van Ruysdael. By 1657 he was living in Amsterdam, where he seems to have spent the rest of his life. His many paintings, drawings, and etchings are devoted entirely to landscape. Ruisdael depicted a broad range of scenery, from the flat, watery landscape around Haarlem to thickly wooded mountains and forests.

LANDSCAPE WITH A FOOTBRIDGE

Dated 1652. Oil on canvas
38 ¾ x 62 ⅝ in. (98.4 x 159.1 cm.)
Acquired in 1949

Although the exact locality of this landscape has not been determined, the hilly conformation of the countryside, as well as the date of the work, suggest that the site may have been in the province of Overijssel, near the Dutch-German frontier, where Ruisdael visited in 1650. Previously he had generally depicted the flatter countryside of central Holland. The painting demonstrates the youthful artist's special gift for rendering subtle effects of light, evident in the pale sun that filters through the clouds to dapple the landscape and reflect from the surface of the stream. The realistic treatment of the gnarled oak tree at left is typical of his close observation of nature. The figures apparently were added by another hand, as was Ruisdael's usual practice.

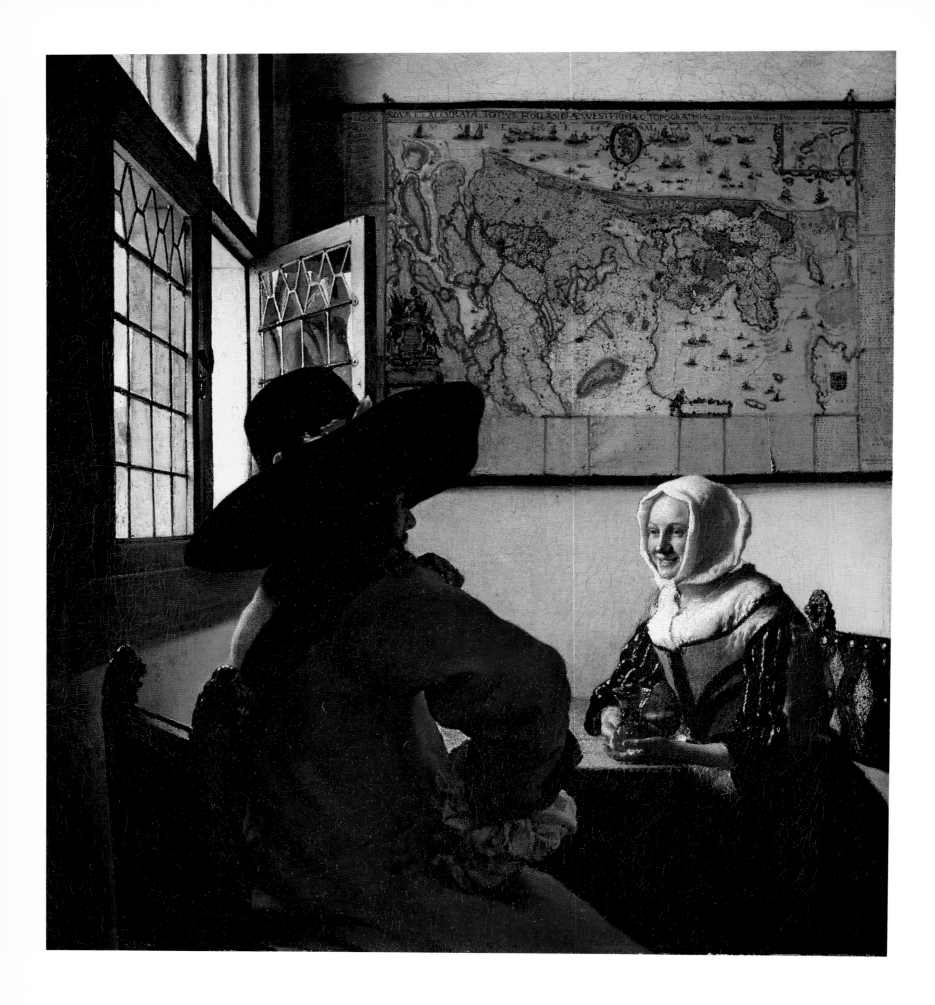

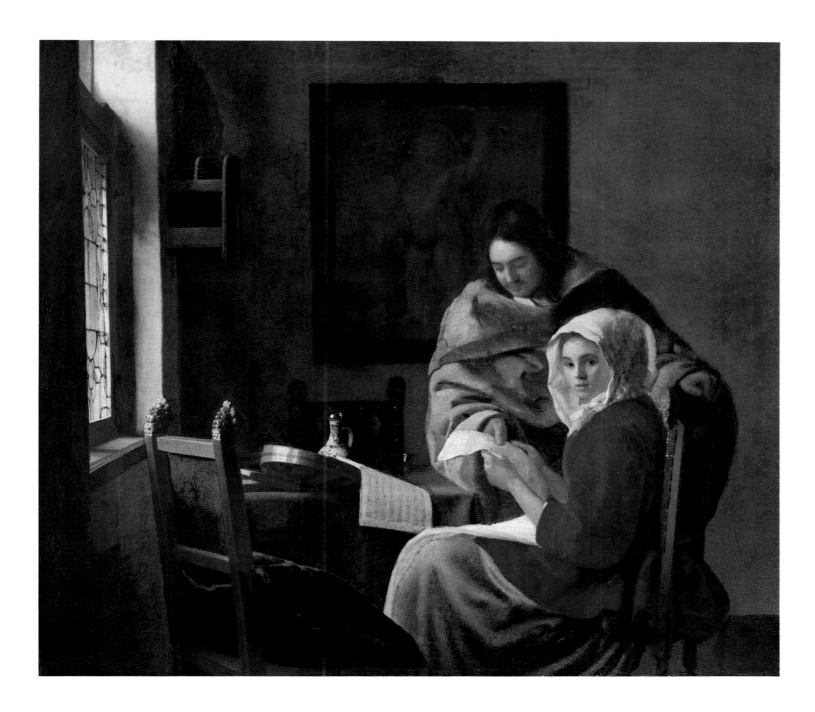

JOHANNES VERMEER
1632–1675

Vermeer was born in Delft and apparently spent his whole life there. Although nothing is known of his early years and training, he was influenced by the Caravaggesque painters of Utrecht and Carel Fabritius, who may have been his teacher. In 1653 he became a member of the Guild of St. Luke in Delft. Vermeer did not paint many pictures and sold very few, although he commanded high prices. He may have supplemented his income by art-dealing. In 1696, two decades after his death, his widow sold twenty-one of his works. Only about thirty-five paintings are now accepted as being by Vermeer.

OFFICER AND LAUGHING GIRL

Painted between 1655 and 1660. Oil on canvas
19 ⅞ x 18 ⅛ in. (50.5 x 46 cm.)
Acquired in 1911

In what may been one of the first works of his mature style, Vermeer transforms the theme of a young woman entertaining her suitor, already popular in Dutch art, into a dazzling study of light-filled space. The dark foil of the officer's silhouette dramatizes both the illusion of depth and the brilliant play of light over the woman and the furnishings of the chamber. The map of Holland on the far wall, drawn with west at the top, was first published in 1621. Both the map and the chairs appear in other paintings by Vermeer.

GIRL INTERRUPTED AT HER MUSIC

Painted c. 1660. Oil on canvas
15 ½ x 17 ½ in. (39.3 x 44.4 cm.)
Acquired in 1901

Music-making, a recurring subject in Vermeer's interior scenes, was associated in the seventeenth century with courtship. In this painting of a duet or music lesson momentarily interrupted, the amorous theme is reinforced by the picture of Cupid with raised left arm dimly visible in the background; the motif is derived from a popular book on emblems of love published in 1608 and symbolizes fidelity to a single lover.

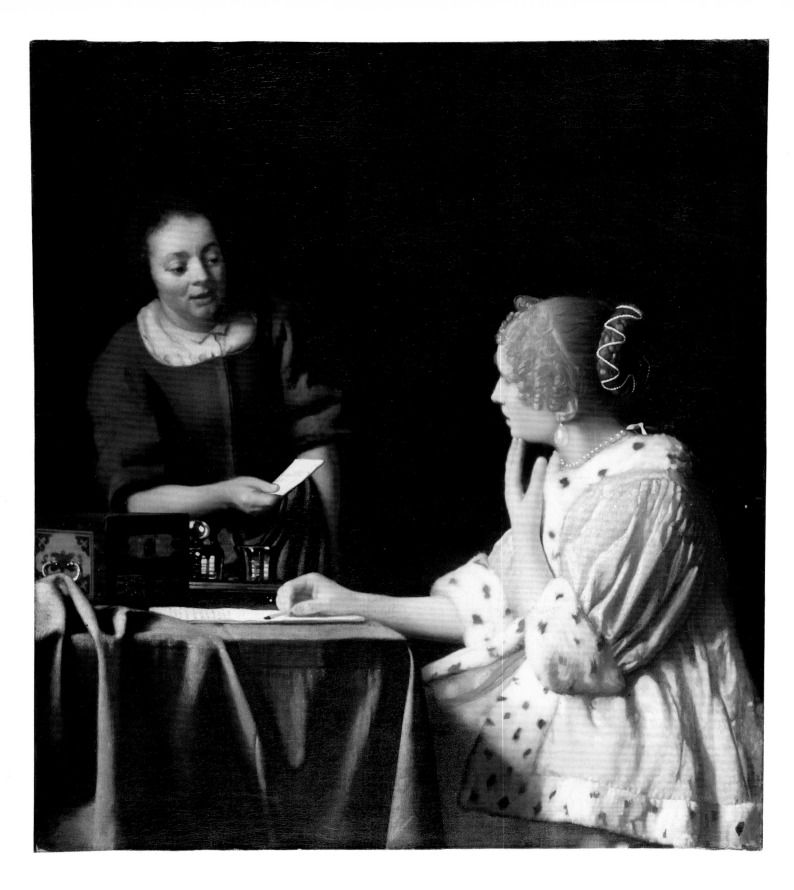

JOHANNES VERMEER

MISTRESS AND MAID

Painted probably between 1665 and 1670.
Oil on canvas
35 ½ x 31 in. (90.2 x 78.7 cm.)
Acquired in 1919

The subject of writing and receiving letters, which recurs frequently in Vermeer's work, is given an exceptional sense of dramatic tension in this painting of two women captured at some moment of mysterious crisis. The artist seldom if ever surpassed the subtly varied effects of light seen here as it gleams from the pearl jewelry, sparkles from the glass and silver objects on the table, and falls softly over the figures in their shadowy setting. Bought by Mr. Frick in 1919, the year of his death, this painting was his last purchase and joined Rembrandt's *Self-Portrait*, Holbein's *Sir Thomas More*, Bellini's *St. Francis*, and Velázquez' *King Philip IV* among his favorite acquisitions.

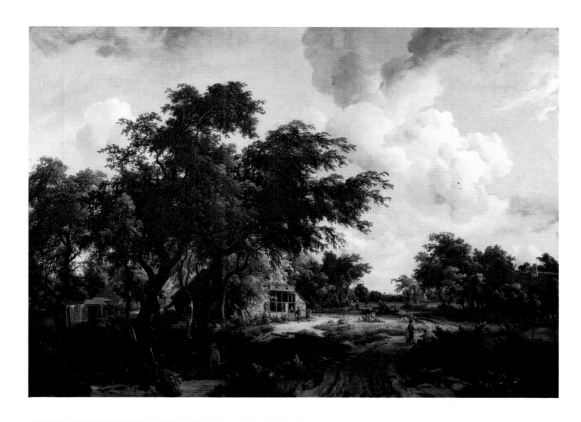

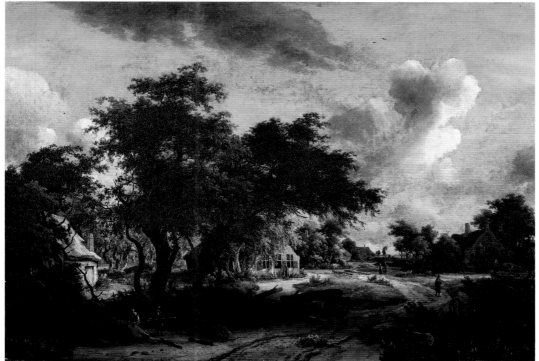

MEYNDERT HOBBEMA
1638–1709

In 1657 Hobbema was apprenticed in his native Amsterdam to Jacob van Ruisdael, whose style and subject matter had a profound influence on him. Hobbema painted landscapes prolifically until 1668, when he was appointed municipal assessor of wine-measures. Relatively few works appear to date from his last forty years.

VILLAGE WITH WATER MILL AMONG TREES

Painted probably between 1660 and 1670.
Oil on canvas
37 ⅛ x 51 ⅛ in. (94.3 x 129.8 cm.)
Acquired in 1911

VILLAGE AMONG TREES

Dated 1665. Oil on panel
30 x 43 ½ in. (76.2 x 110.5 cm.)
Acquired in 1902

Elements the artist repeated throughout his career—variegated foliage, picturesque cottages, a winding road, and a sky with windswept clouds—can be seen in both of these landscapes. But if Hobbema's repertory of motifs was limited, he managed nevertheless to invest his paintings with considerable freshness and variety.

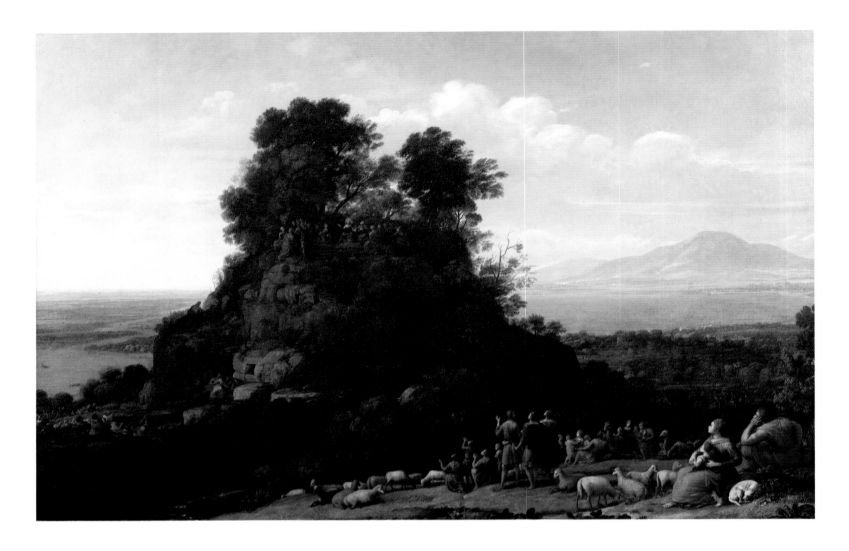

CLAUDE LORRAIN
1600–1682

Claude Gellée, who was called Lorrain after his native province of Lorraine, settled in Rome perhaps as early as 1613 and spent nearly all of his adult life there. His early work was chiefly in fresco, of which little remains, but his fame is based on landscape canvases, often with biblical or mythological subjects. Patronized principally by the Italian nobility, he also enjoyed an international reputation. Among the many later painters influenced by his work, the most vocal admirer was Turner.

THE SERMON ON THE MOUNT

Painted in 1656. Oil on canvas
67 ½ x 102 ¼ in. (171.4 x 259.7 cm.)
Acquired in 1960

Christ, surrounded by the Twelve Apostles, is shown preaching to the multitude from the wooded summit of Mount Tabor, as described in the Gospel of Matthew (5:1–2): "When he saw the crowds he went up the hill. There he took his seat, and when his disciples had gathered round him he began to address them." It was in this discourse that Jesus set forth the principles of the Christian ethic through the Beatitudes and instituted the Lord's Prayer. The crowds that Matthew described as "astounded at his teaching" are vividly depicted by Claude among the absorbed and gesticulating foreground figures, whose diminishing sizes enhance the dramatic spatial effects of the vast and airy landscape.

The artist has compressed the geography of the Holy Land, placing on the right the distant Mount Lebanon and the Sea of Galilee—with the towns of Tiberias and Nazareth on its shore—and on the left the Dead Sea and the river Jordan.

Executed for François Bosquet, Bishop of Montpellier, the painting later entered the collection of Alderman William Beckford at Fonthill House in Wiltshire, where it suffered minor damage in a fire that almost totally destroyed its companion picture, *Queen Esther Approaching the Palace of Ahasuerus.*

The Sermon on the Mount was the product of preparatory drawings ranging from topographical layouts to compositional and figural studies, including one showing the central group of Christ and the Apostles in a configuration somewhat different from that of the painting (Teylers Museum, Haarlem). Upon completing the picture, the artist made a careful copy of it in the *Liber Veritatis* (British Museum), an album of drawings in which he recorded his paintings in chronological sequence; it was there that he noted when and for whom it had been executed.

The Sermon on the Mount is unusual among Claude's landscapes both for its exceptional size and for its large central mass, but in its magical luminosity it is characteristic of his finest achievements.

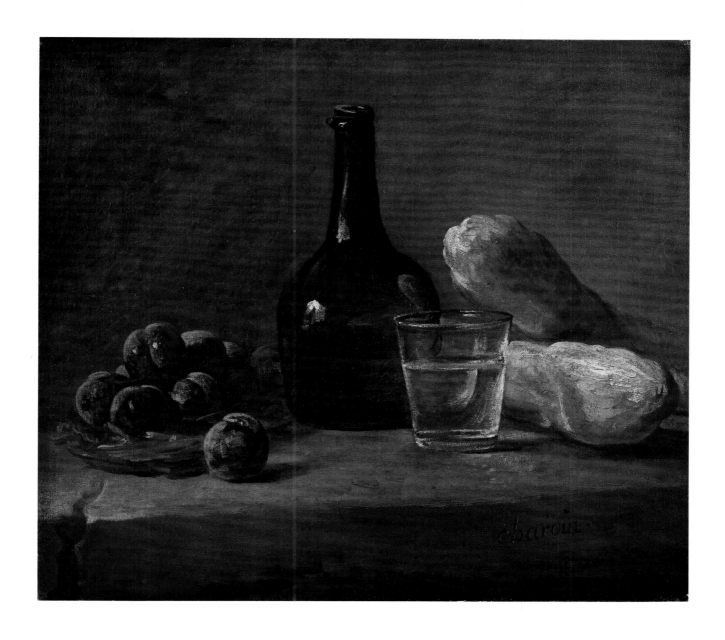

JEAN-SIMÉON CHARDIN
1699–1779

The son of a cabinetmaker, Chardin was born in Paris and never strayed far from the capital. Trained probably under Cazes and Coypel, the young artist was associated first with the Academy of St. Luke in 1724, but four years later he was received into the Royal Academy as a "painter of animals and fruits." By his first wife, Marguerite Saintard—who died in 1735, only four years after their marriage—he had a son, Jean-Pierre, who would develop as a painter and die under mysterious circumstances in Venice in 1767; his second marriage, in 1744, was to Françoise-Marguerite Pouget. Chardin's work appeared at the Salon for the first time in 1737 and thereafter

regularly until the year of his death. The artist participated actively in the affairs of the Academy, occupying for nearly twenty years the post of Treasurer, which entailed the delicate responsibility of deciding how each Salon would be hung. Louis XV honored him with commissions, pensions, and lodgings in the Louvre. Chardin's still lifes and domestic scenes were esteemed equally by the general public and by contemporary connoisseurs throughout Europe.

STILL LIFE WITH PLUMS

Painted probably c. 1730. Oil on canvas
17 ¾ x 19 ¾ in. (45.1 x 50.2 cm.)
Acquired in 1945

The only still life in The Frick Collection is a classic example painted by an undisputed master of the genre, probably quite early in his career. Shunning the lavish and complex productions of his Dutch and Flemish predecessors, Chardin simplified the number and type of ingredients in his still lifes, then arranged these familiar household objects in compositions of an architectonic order. The Claude Lorrain illustrated on the preceding page is one of the largest paintings in the Collection, while Chardin's *Still Life* is one of the smaller canvases. Nevertheless, Chardin's assemblage of plums, squash, and domestic containers seems almost as monumental and solid as Claude's mountain. It was the illusionistic realism of such pictures that the artist's contemporaries marveled at, and that led Diderot to speak of their "magic." It was to Diderot that Chardin revealed the source of his prodigious tactile sense, saying it was by touch and not by sight that he judged, say, the roundness of pine kernels (or here, of plums), rolling them gently between his thumb and forefinger. Modern eyes appreciate too the subtle coloring and the rich, creamy surfaces of his paintings, which seem to breathe and have a life of their own.

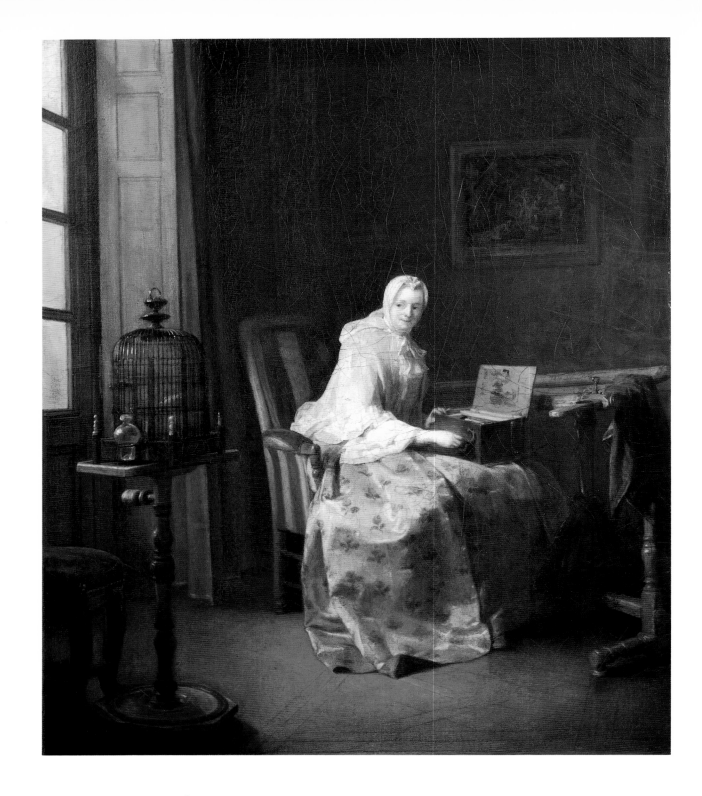

JEAN-SIMÉON CHARDIN

LADY WITH A BIRD-ORGAN

Painted in 1753(?). Oil on canvas
20 x 17 in. (50.8 x 43.2 cm.)
Acquired in 1926

It is curious that the artist's first royal commission—in 1751—should also have been his last figural composition. In fact, Chardin would afterward paint nothing but still lifes or an occasional portrait, not even completing the companion picture to the *Lady with a Bird-Organ* that had been ordered for Louis XV. In the Frick canvas, which may well be a replica Chardin made in 1753 of the original painting delivered to the King two years earlier and now in the Louvre, the artist has depicted a middle-class lady—perhaps his second wife—training a caged canary to sing by playing a device known as a bird-organ. The title of the picture when exhibited at the Salon of 1751, *A Lady Varying Her Amusements,* refers to the subject's having put aside her embroidery to pass a few moments with the songbird.

As the final example of Chardin's depictions of figures in interiors, the *Lady with a Bird-Organ* contrasts markedly with his earlier images of robust servants whose simple forms dominate their picture space. Different too are the porcelain-like finish of this picture (albeit abraded) and its muted, silvery coloration. One might almost assume that the artist felt obliged to be on his best behavior in presenting his work to his monarch, but these qualities are actually deliberate echoes of seventeenth-century Dutch masters then much in vogue.

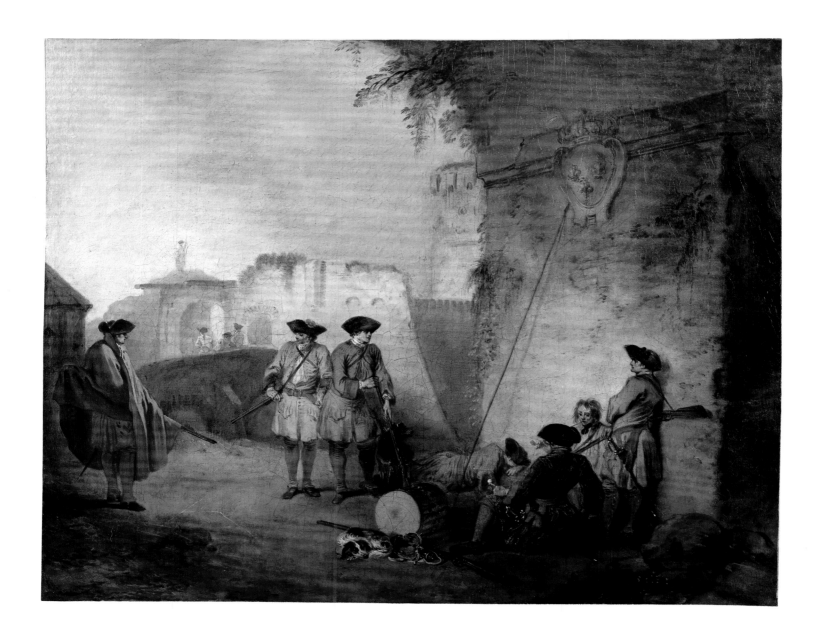

JEAN-ANTOINE WATTEAU
1684–1721

Born at Valenciennes, Watteau, who early displayed an interest in drawing, left for Paris to study art in 1702. After a harsh struggle to survive, he won recognition in 1709, when he garnered second prize in a student competition at the Academy. Three years later he was invited to join the Academy, and success followed swiftly. His patrons, who came from diverse levels of society, included dealers, antiquaries, and such connoisseurs as the great collector Pierre Crozat. Long frail of health, Watteau died from tuberculosis soon after a visit to London, at the age of thirty-seven.

THE PORTAL OF VALENCIENNES

Painted 1709–10. Oil on canvas
12 ¾ x 16 in. (32.5 x 40.5 cm.)
Purchased with funds from the bequest of
Arthemise Redpath, 1991

The location depicted in this small painting appears to be outside the fortifications of Valenciennes, Watteau's birthplace in northern France, where he returned for a visit in 1709. Soldiers are portrayed in the foreground, dozing or lounging in the early morning light. Abandoned on the ground beside them are such martial trappings as a drum and musket, guarded by a dog, asleep. A pike propped behind the drum leans against the wall, pointing to the French royal coat of arms. The unspoken creates a sense of mystery and hidden messages in this seemingly undramatic genre subject. Between 1709 and 1714, Watteau painted a series of military scenes, sights that were familiar to him, for his native countryside had long been a battleground. Far from glorifying military life, these works dwell on the peripheral incidents and activities of warfare. The subtle hues and warm light of this quiet picture, as well as the delicate touch of the artist's brush in rendering the details of figures, costumes, and setting, look ahead to the more familiar scenes of theater and romantic dalliance painted later in Watteau's career.

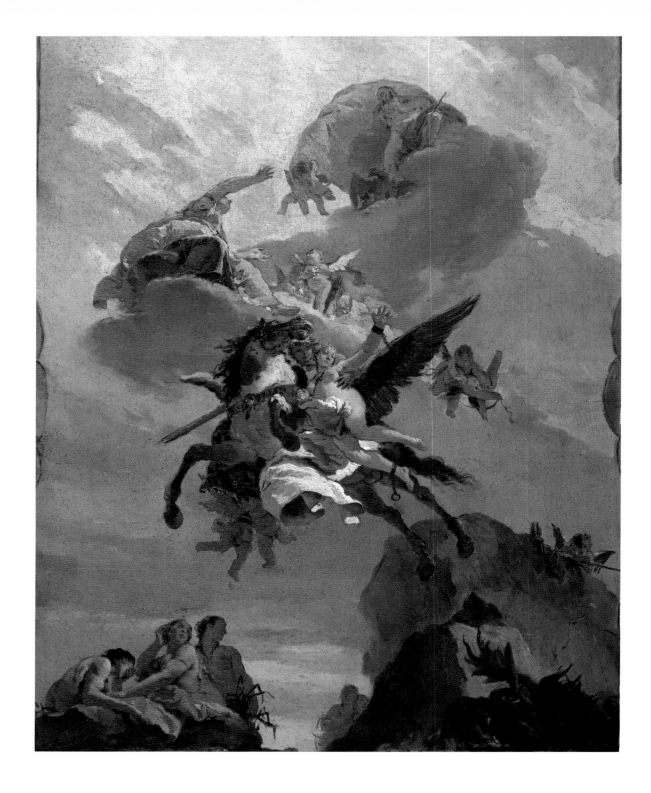

GIOVANNI BATTISTA TIEPOLO
1696–1770

Tiepolo's brilliant talents, especially as a decorator of palaces, villas, and churches, won him fame far beyond his native Venice; already by the age of thirty he was referred to as "celebre Pittor." Tiepolo worked for patrons not only throughout Northern Italy but also in Würzburg and Madrid. A prolific artist, he painted—both in oils and in fresco—religious, historical, and mythological subjects.

PERSEUS AND ANDROMEDA

Painted probably in 1730.
Oil on paper, affixed to canvas
20 ⅜ x 16 in. (51.8 x 40.6 cm.)
Acquired in 1918

The painting is a study for one of Tiepolo's four ceiling frescoes in the Palazzo Archinto, Milan, which was destroyed by bombing in 1943. A fresco in the main salon, representing an *Allegory of the Arts,* bore the date 1731.

According to legend, Cassiopeia, Queen of Ethiopia, had angered the Nereids by boasting that she and her daughter Andromeda were as beautiful as they. To punish her presumption, Neptune sent flood waters and a sea-monster to ravage the land. Learning from an oracle that his daughter must be sacrificed to the monster in order to save his people, King Cepheus had Andromeda chained to a rock by the sea. The hero Perseus saw her and, moved by her beauty, rescued Andromeda, sweeping her skyward on his winged horse, Pegasus. The luminous heavens, illusionistically conceived to be seen from below, open to reveal Minerva and Jupiter seated on gold-tinged clouds.

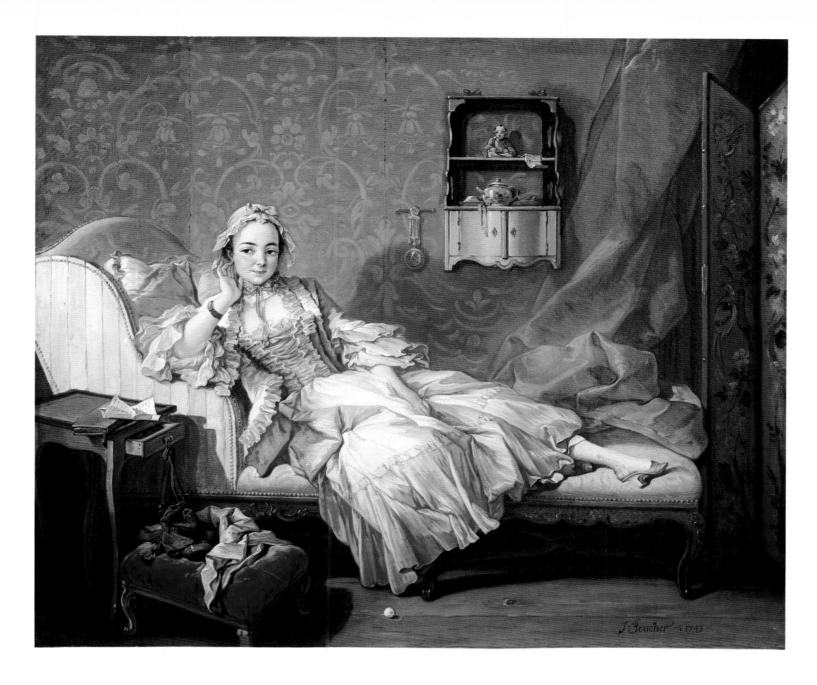

FRANÇOIS BOUCHER
1703–1770

The son of a painter, Boucher was born in Paris and trained first with his father, then briefly with François Lemoine. In 1723 he won the Academy's first prize for painting but was denied the sojourn in Rome that normally resulted from the competition. To earn his living the young artist produced reproductive engravings throughout the 1720s, notably after drawings and paintings by Watteau. Returning from a prolonged stay in Rome—where he had gone on his own—Boucher was accepted into the Academy in 1731, and three years later he was made a full member. Eventually he held the Academy posts of Professor, Rector, and finally Director. Boucher's marriage in 1734 resulted in two daughters, who married the artists Deshays

and Baudouin, and a son, Juste-Nathan, who would specialize in drawing architectural fantasies. Boucher's work appeared at the Salon of 1737 and frequently thereafter. While his virtuoso productions were much admired, the artist had his critical detractors as well, particularly Diderot, who lamented his lack of naturalness. Boucher was awarded many commissions by the King (including the painting of his Easter eggs) and by Madame de Pompadour. He also held high posts at both the Beauvais and Gobelins tapestry factories and was named "premier peintre" to Louis XV in 1765. Although the content and style of Boucher's art suggest a sybaritic character, the artist often worked twelve hours a day. He died in his studio in the Louvre. Among his many pupils were Deshays, Fragonard, Gabriel de Saint-Aubin, and Ménageot.

MADAME BOUCHER

Dated 1743. Oil on canvas
22 ½ x 26 ⅞ in. (57.2 x 68.3 cm.)
Acquired in 1937

When Marie-Jeanne Buseau (1716–after 1786) posed so pertly for this informal portrait ten years after her marriage to Boucher, she was twenty-seven and the mother of three children. She frequently served as model for her husband, and in later life she painted miniature reproductions of his more popular pictures and made engravings after his drawings. Besides offering such a candid image of the artist's wife, the portrait provides a fascinating glimpse of a room in the apartment to which the family had moved the year before Boucher signed this canvas —on the Rue de Grenelle-Saint-Honoré. The porcelain figurine and tea service on the hanging étagère reflect Boucher's taste for the Oriental bric-a-brac so fashionable throughout the eighteenth century. In its composition the portrait is a witty parody of the classical Renaissance depictions of Venus by Giorgione and Titian, and as such the picture has acquired the sobriquet "Boucher's Untidy Venus."

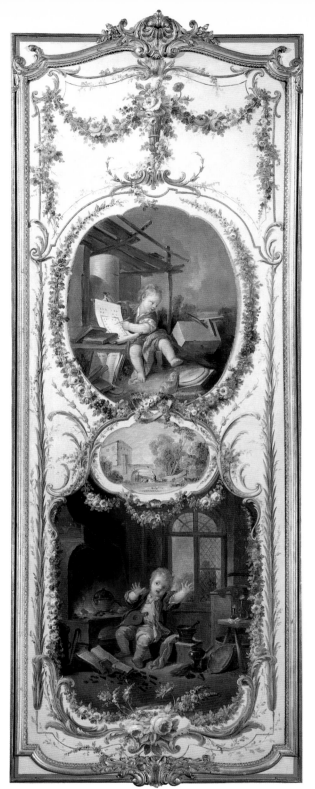

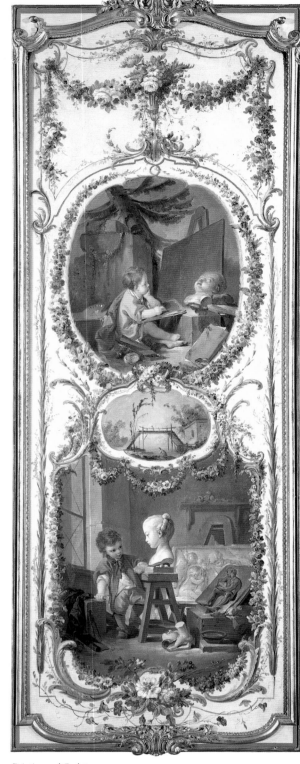

Architecture and Chemistry *Painting and Sculpture*

FRANÇOIS BOUCHER

THE ARTS AND SCIENCES

Painted probably between 1750 and 1752.
Oil on canvas
Four of the panels 85 ½ x 30 ½ in.
(217.2 x 77.5 cm.), remaining four
85 ½ x 38 in. (217.2 x 96.5 cm.)
Acquired in 1916

Although many details concerning the origins of Boucher's delightful *Arts and Sciences* panels remain unclear, it seems likely that they once decorated an octagonal library adjoining Madame de Pompadour's bedroom in the Château de Crécy, near Chartres, the first property the Marquise acquired after her official recognition as royal mistress in

1745. The panels were referred to in the press during the spring of 1752, two of their subjects were copied on a gold box dated 1753–54, and *Fishing* appeared on a Sèvres flowerpot in 1754. Tapestries were woven after them by Neilson at the Gobelins manufactory in the spring of 1752; they were upholstered to furniture frames delivered to Bellevue, another of Madame de Pompadour's residences at the time, and examples of them have survived to this day.

The subjects of the panels probably were chosen more to flatter their patron than to follow any traditional iconographic pattern. Almost every one can be interpreted as an allusion to Madame de Pompadour's patronage of the arts and sciences, including her support at just this time of the Diderot–d'Alembert *Encyclopédie*, whose range of inquiry may also be reflected in the paint-

ings. Thus, one can note in reference to each of the sixteen subjects some relevant detail concerning Madame de Pompadour: for *Astronomy*, the twenty books on that subject in her library and the presence of a telescope at her Château de Saint-Ouen; for *Hydraulics*, the ingenious waterworks and fountains at Crécy, recently designed by the physicist Deparcieux; for *Poetry*, the hundreds of volumes of French verse that constituted the most extensive segment of her library; for *Music*, her remarkable skill at the clavichord; for *Fowling*, the Marquise's collection of rare and exotic birds, as well as the humble hens that the King especially liked; for *Horticulture*, her knowledge of botany and her supervision of the new gardens at Crécy, designed by Garnier de l'Isle; for *Fishing*—a subject difficult to relate to the Marquise—conceivably a reference to her

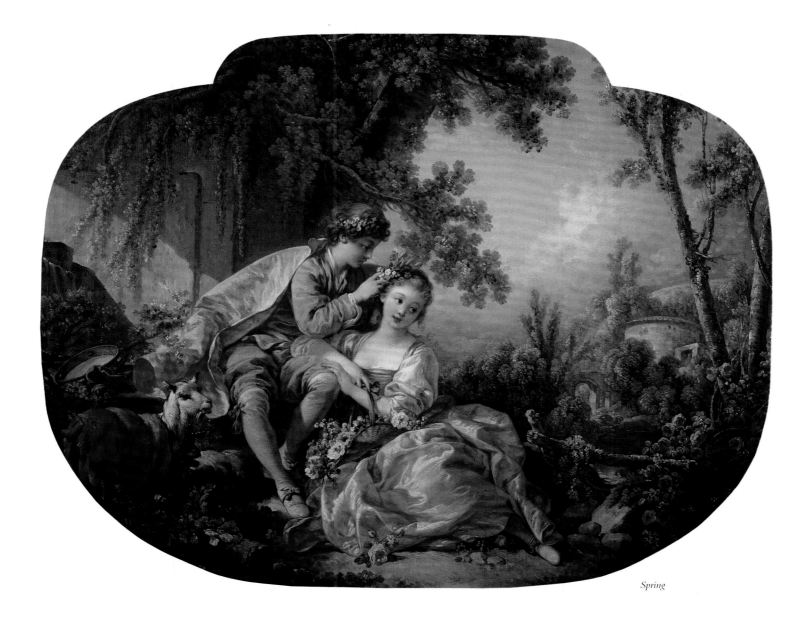

Spring

FRANÇOIS BOUCHER

THE FOUR SEASONS

Dated 1755. Oil on canvas
Average dimensions 22 ½ x 28 ¾ in.
(57.2 x 73 cm.)
Acquired in 1916

Jean Daullé's engravings after *The Four Seasons* identify the owner of the paintings as Madame de Pompadour. The four canvases probably were designed as overdoors for one of the Marquise's many residences, but it is not known which one. Boucher's shield-shaped compositions, of which three are dated 1755, were later extended by another hand onto rectangular canvases; the present curvilinear templates expose only the original body of each.

In these representations of the age-old subject of the Four Seasons, Boucher broke

maiden name, Poisson ("fish"); for *Hunting,* one of the chief occupations of the court and the King's favorite pastime; for *Architecture*—a lifelong passion of Madame de Pompadour—her current project with the architect Lassurance for the enlargement of Crécy; for *Chemistry,* her interest in the experiments at the porcelain factory of Vincennes, as well as her investments in the glass factory at Bas-Meudon; for *Painting* and *Sculpture,* the extensive patronage of both these arts by the Marquise, who herself drew and engraved; for *Comedy* and *Tragedy,* the evidence of her performances in both private and court theaters, as well as her patronage of dramatic authors; for *Singing* and *Dancing,* her voice training with Jéliotte of the Opéra and her innumerable appearances at court balls.

One final personal reference in these panels to their patron may be noted. Visitors to the Boucher Room at The Frick Collection will find there a copy of the marble bust of a girl by François-Jacques-Joseph Saly that Boucher introduced into the scene of *Sculpture.* Although opinions on the identity of the subject of the bust have varied, her appearance in so many paintings by Boucher suggests that the girl was none other than Madame de Pompadour's beloved daughter, Alexandrine d'Étiolles (1744–54).

with the tradition of depicting the labors performed at various times of the year, characteristically choosing to illustrate pleasant pastimes instead. The amorous subjects of *Spring* and *Autumn,* described as *pastorales* in the sale catalogue of the collection of the Marquis de Marigny (Madame de Pompadour's younger brother and heir), recall the *fêtes galantes* invented by Boucher's great predecessor Watteau, whereas the sledding scene of *Winter,* with the heroine swathed in furs and accompanied by a Tartar, evokes the eighteenth-century European fascination with the glamour of Russia. Both *Autumn* and *Winter* closely resemble compositions by Watteau that Boucher had engraved in his youth, but the backgrounds of all of the *Seasons,* especially the frosted one of *Winter,* reveal Boucher's particular skills as a landscapist. The bathers of *Summer* depend from a far older pictorial tradition that would subsequently be continued by Renoir, Cézanne, and Picasso.

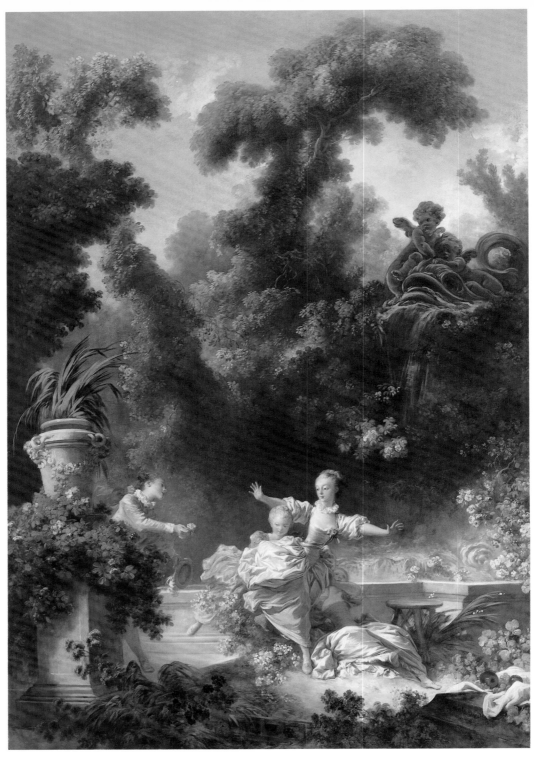

The Pursuit

JEAN-HONORÉ FRAGONARD
1732–1806

Born in Grasse, Fragonard was still a child when his family moved to Paris. He studied briefly with Chardin, then entered the atelier of Boucher. In 1752 he won the Prix de Rome, and after three years of preparation under Carle Vanloo he left to study in Italy. His Coroesus Slays Himself to Save Callirhoe, *which was bought by Louis XV in 1765, won the artist membership in the Academy, a residence in the Louvre, and the title "peintre du roi." In 1773–74 he made a second trip to Italy. His activity as an illustrator, etcher, and painter of romantic subjects continued until the Revolution. Because of ill health Fragonard retired to Grasse in 1790, but a year later he was back in Paris. Under the sponsorship of David he held various administrative posts at the Muséum des Arts—the present Musée du Louvre. His new eminence was short-lived, however; he died poor and almost forgotten.*

THE PROGRESS OF LOVE

Four panels painted in 1771–73, remaining ten in 1790–91. Oil on canvas
Heights of the ten taller panels c. 125 in. (317.5 cm.), of the four overdoors depicting putti c. 59 in. (150 cm.); various widths
Acquired in 1915

The Progress of Love is generally regarded as the artist's collective masterpiece and is considered one of the greatest decorative ensembles of the eighteenth century.

The history of the paintings is linked with the career of the Comtesse Du Barry, the mistress of Louis XV, who received from her lover in 1769 a property at Louveciennes, a village near Versailles. After making certain changes to the old château that stood there, Madame Du Barry commissioned Claude-Nicolas Ledoux to design a pavilion on the estate that could be used for entertaining. This building, instantly acclaimed for its neoclassical modernity, was inaugurated on September 2, 1771. For its apse-shaped gaming room Fragonard was commissioned, probably early in that same year, to paint four large canvases that would be described in an inventory of 1772 as depicting "the four ages of love." These are the panels now known as *The Pursuit, The Meeting, The Lover Crowned,* and *Love Letters.*

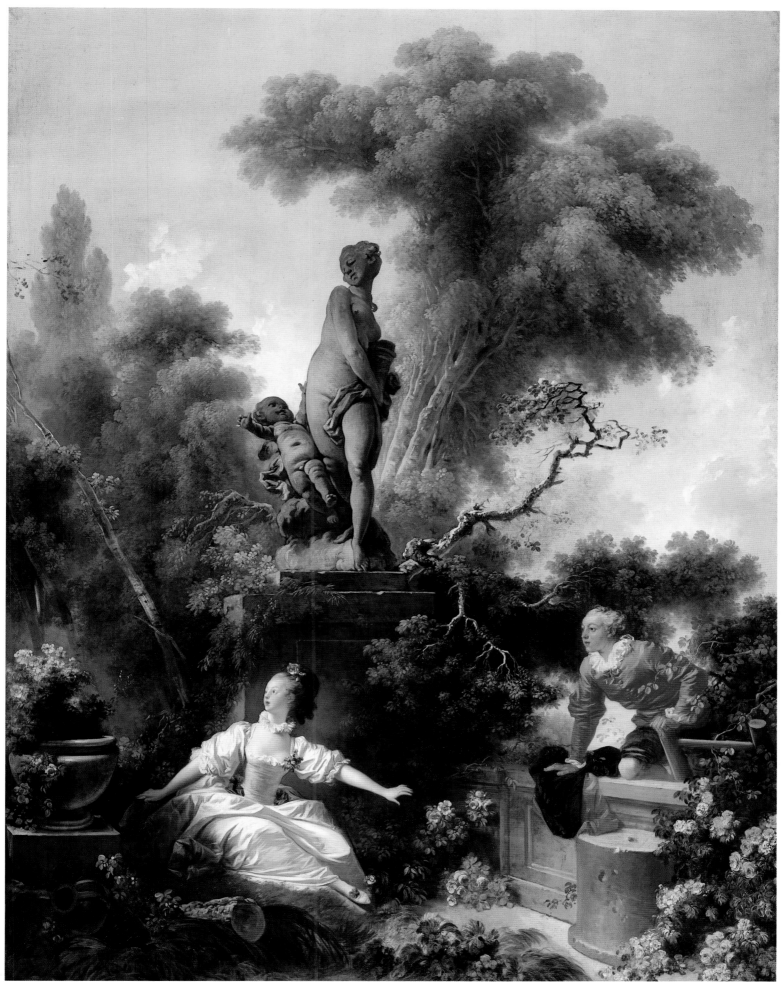

The Meeting

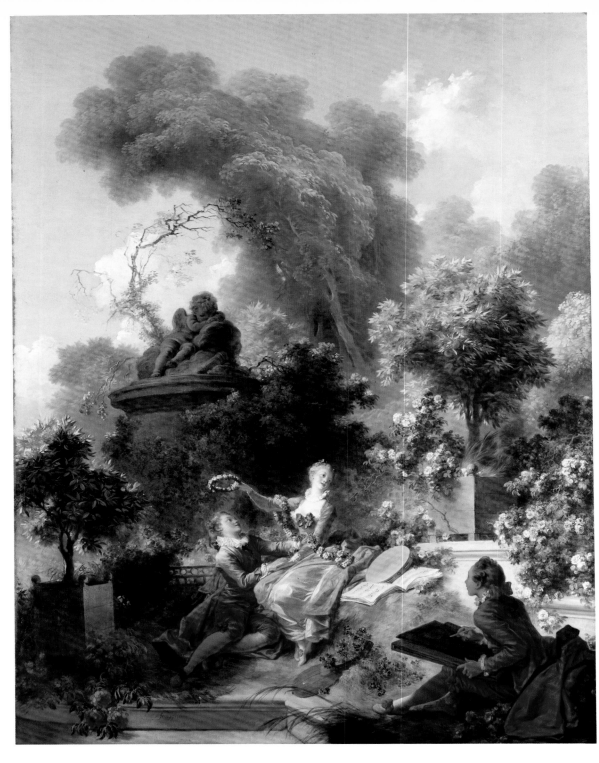

The Lover Crowned

It is known that Fragonard was working on these canvases during 1771. By July of 1772, Bachaumont, a chronicler of current events, was writing of the paintings as being in place at Louveciennes. But an inventory of Louveciennes in 1774 described Fragonard's canvases as having been returned to the painter and replaced by works of Joseph-Marie Vien, two of which had been exhibited at the Salon the previous year. Ironically, the title *The Progress of Love* now assigned to Fragonard's series was that originally given to the paintings by Vien that came to supplant them.

What happened? In addition to possible temperamental difficulties between artist and patron that might have led to this rejection of the paintings, two other causes seem likely. Bachaumont's sly remark in 1772 that Fragonard's paintings "seem to be allegorical references to the adventures of the mistress of the house," joined to the undeniable resemblance between contemporary portraits of Louis XV and the red-coated lover scal-

ing the wall in *The Meeting,* could justifiably have alerted Madame Du Barry that her decorations might be a source of embarrassment to the monarch, whom she was trying to lure into marriage at this time. On the other hand, as one obsessed with fashion Madame Du Barry may have come to see Fragonard's exuberant work as outmoded within the context of Ledoux's avant-garde pavilion, for which Vien's deliberately classicizing work, albeit insipid, appeared more obviously in harmony.

Whatever the case, Fragonard retained the paintings until 1790, rolled up or possibly, as has recently been suggested, installed in his studio. During the year he passed in his cousin Maubert's villa at Grasse, he painted ten additional canvases to complete the ensemble, and sold them to his host.

The closest one can come to understanding the artist's intentions with *The Progress of Love* is to see, in what is now the Musée Fragonard at Grasse, the copies La Brély made of the panels in 1898, installed

where the originals had been. The initial impression is of being transported into a lush, natural panorama, as the four *Hollyhocks* panels and the backgrounds of the large canvases merge with the landscape visible through the windows. Within this magic garden, the four original canvases from Louveciennes can be seen as romantic incidents that advance from an attempted seduction *(The Pursuit),* to an assignation *(The Meeting),* to consummation or marriage *(The Lover Crowned),* and then to the calm prolongation of a happy union *(Love Letters).* *Love Triumphant* dominated the room from its position over the central fireplace, where the fiery lower portion of the panel merged illusionistically with the real flames beneath it. The four overdoors of putti added their witty allusions to various moods or states of love—carefree, giddy, determined, angry. Finally, with *Reverie* the embittered artist may well have had his revenge on Madame Du Barry, by evoking the solitude of a mistress whose lover was now dead.

FRANÇOIS-HUBERT DROUAIS
1727–1775

Drouais was of Norman extraction but spent all of his life in and around Paris. After studying with his father, a miniaturist, he worked in the studios of Carle Vanloo, Natoire, and Boucher. In 1757 he executed his first royal commission, and the following year he was received as a full member in the Academy. Succeeding Latour and Nattier, Drouais became the most prominent French portraitist of the mid-eighteenth century, painting courtiers, foreign aristocrats, writers, and fellow artists. Drouais' son, Germain-Jean, was a promising history painter who died at twenty-five.

THE COMTE AND CHEVALIER DE CHOISEUL AS SAVOYARDS

Dated 1758. Oil on canvas
54 ⅞ x 42 in. (139.4 x 106.7 cm.)
Acquired in 1966

The standing boy with a hurdy-gurdy at his back is Marie-Gabriel-Florent-Auguste, Comte de Choiseul-Beaupré (1752–1817). Beside him, pointing to a peep-show box, sits his younger brother, Michel-Félix-Victor, Chevalier de Choiseul-Daillecourt

(1754–1815). The boys were cousins of the celebrated Duc de Choiseul, foreign minister under Louis XV. In costuming his subjects as Savoyards, the itinerants from Savoy who wandered over France working at odd jobs and in street fairs to support the families they left at home, Drouais probably intended to depict the brothers as models of filial devotion—a conceit reinforced by the presence of the faithful dog. It may be noted that the boys' disheveled garments are made of sumptuous velvet and that their buttons are of gold.

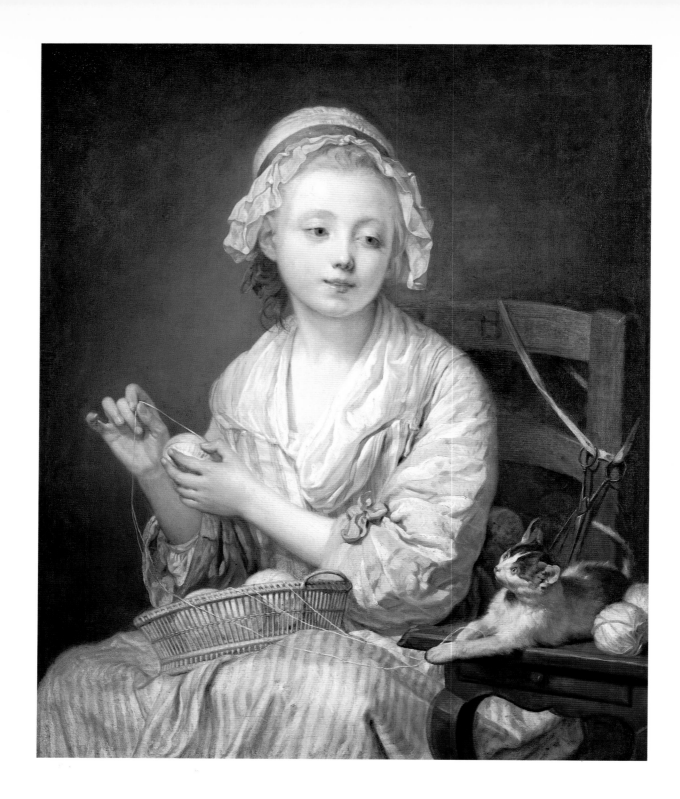

JEAN-BAPTISTE GREUZE
1725–1805

Greuze left his native Burgundy for Paris about 1750 and studied with Natoire at the Academy. Named an associate member in 1755, he first exhibited at the Salon that same year and a few months afterward began a long sojourn in Italy. He was made a full Academy member in 1769, but only in the category of genre painters, despite his efforts to be recognized as a history painter. Stung by this incident, Greuze dissociated himself from the Academy and its exhibitions until 1800. The artist's dramatic and often moralizing genre scenes, his brilliant drawings, and his incisive portraits won him wealth, great popular acclaim, and the enthusiastic support of Diderot.

THE WOOL WINDER

Painted probably in 1759. Oil on canvas
29 3/8 x 24 1/8 in. (74.6 x 61.3 cm.)
Acquired in 1943

Like much of Greuze's early work, *The Wool Winder* owes something to Chardin's genre pictures of the 1730s, which in turn recall the Dutch seventeenth-century genre scenes the French were collecting avidly in the early eighteenth century. But Greuze's pictures are usually, as here, more whimsical and anecdotal, as well as more refined in execution. The letter B carved into the top rail of the chair suggests that the subject may have been a younger sister of the artist's wife, Anne-Gabrielle Babuti, whom he married in January of 1759. *The Wool Winder*, exhibited the same year, is related to a series of portraits of his new family that Greuze exhibited in 1759 and 1761—likenesses of his wife, of her brother, and of her father, in addition to one of himself.

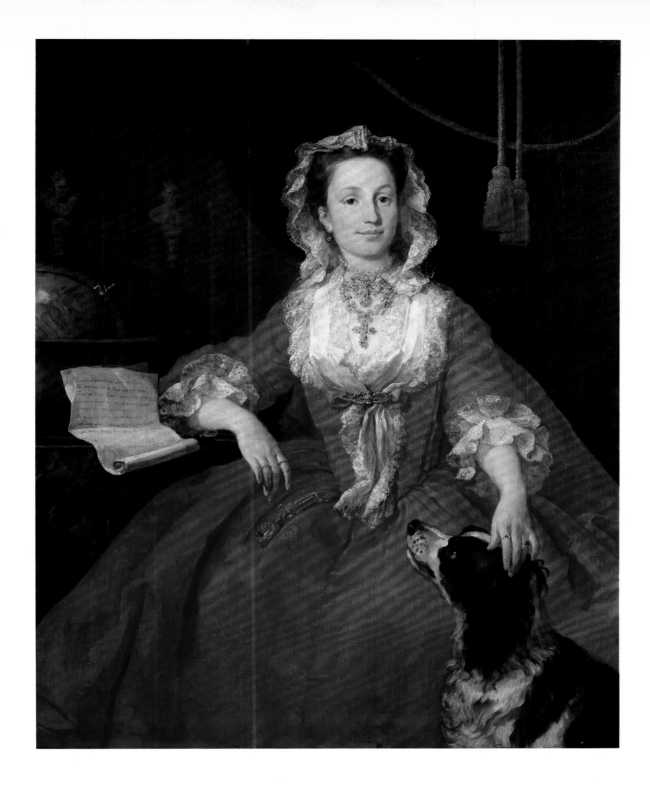

WILLIAM HOGARTH
1697–1764

A life-long resident of London, Hogarth was apprenticed to an engraver of silver plate at fifteen and later studied drawing with Thornhill. His fame among his contemporaries derived chiefly from the series of moral satires that he engraved after his own oil paintings and disseminated to a wide public. Hogarth was a leading figure at the St. Martin's Lane Academy and the author of an autobiography and a treatise on aesthetics.

MISS MARY EDWARDS

Dated 1742. Oil on canvas
49 ¾ x 39 ⅞ in. (126.4 x 101.3 cm.)
Acquired in 1914

Mary Edwards (1705–43), one of the richest women of her time, repudiated her marriage to an extravagant husband, although this was tantamount to declaring her son illegitimate. She was Hogarth's friend and arguably his most significant patron during the decade 1733–43. The monumental portrait of Miss Edwards, wearing magnificent jewels and a striking red dress, is a masterpiece in the series of Hogarth's commanding middle-class portraits, which includes the famous *Captain Coram*. The open scroll prominently displayed beside the subject champions the virtues of liberty and property that she would have appreciated as manager of a great fortune.

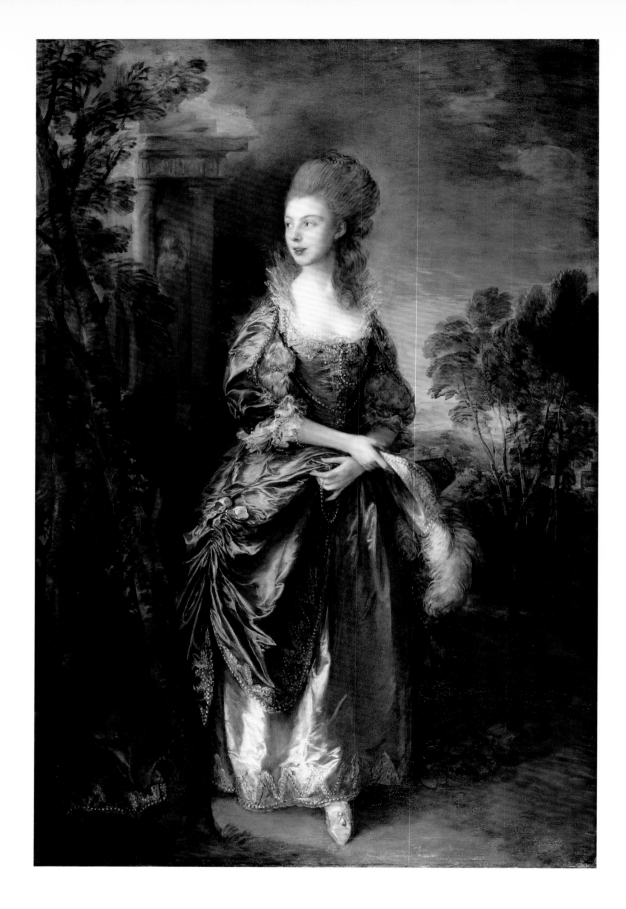

THOMAS GAINSBOROUGH
1727–1788

A native of Suffolk, Gainsborough was
trained in London in the milieu of Hogarth
and the popular French rococo. He worked
in Sudbury and Ipswich and rose to fame
as a portrait painter in the fashionable resort
of Bath. Gainsborough joined the Royal
Academy as a founding member and in
1774 returned to London, where he became
Reynolds' major competitor. He later was

patronized by the royal family. Although
he claimed to prefer landscape painting to
portraiture, Gainsborough excelled at
capturing the likenesses of Georgian society.

THE HON. FRANCES DUNCOMBE

Painted c. 1777. Oil on canvas
92 ¼ x 61 ⅛ in. (234.3 x 155.2 cm.)
Acquired in 1911

Frances Duncombe was born in 1757, the
only daughter of Anthony Duncombe and

Frances Bathurst. Gainsborough's portrait of
her reveals the artist's admiration for Van
Dyck, not only in its elegant proportions,
graceful pose, and Arcadian setting, but even
in the costume, which recalls fashions of the
seventeenth century. It was probably painted
while the subject was living with the family
of the Earl of Radnor, into which her step-
mother married; the Earl commissioned
from Gainsborough a number of portraits in
the grand style to complement his collec-
tion of Old Masters. In 1778 Frances mar-
ried John Bowater of Woolwich, who suf-
fered various reverses and went to debtors'
prison despite the considerable fortune she
brought him. Frances died seventeen years
after her husband in 1827.

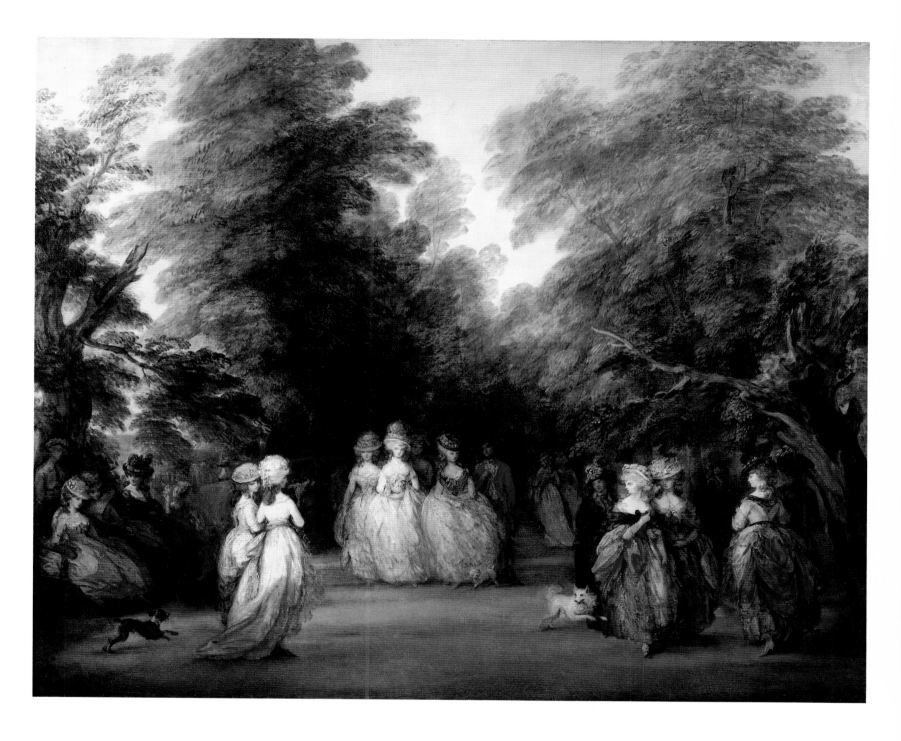

THOMAS GAINSBOROUGH

THE MALL IN ST. JAMES'S PARK

Painted probably in 1783. Oil on canvas
47 ½ x 57 ⅞ in. (120.6 x 147 cm.)
Acquired in 1916

St. James's Park was near Gainsborough's London residence, Schomberg House, in Pall Mall. The long tree-lined avenue called the Mall, which runs south of St. James's Palace, was a fashionable place for strolling in the eighteenth century. This composition is unusual among the artist's later works and recalls, as several contemporary critics remarked, the *fêtes galantes* of Watteau. The feathery foliage and rhythmic design led one observer to describe the painting as "all aflutter, like a lady's fan." Another reported that the artist composed the painting partly from dolls and a model of the park.

The large proportion of the canvas devoted to the setting testifies to Gainsborough's abilities as a landscape painter and to his pioneering interest in the picturesque. Attempts to identify the ladies in the central group as the daughters of George III and the background figure under the tree at right as the artist himself are attractive but unsubstantiated.

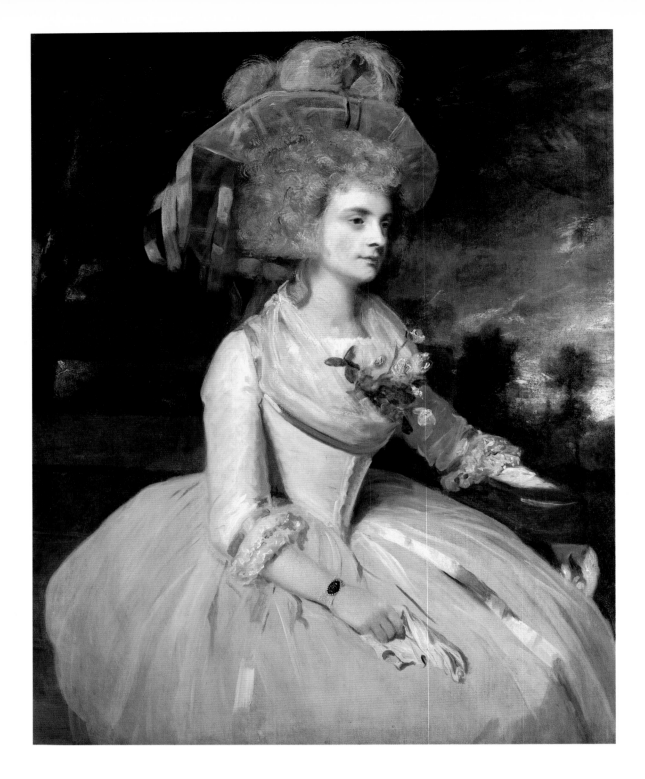

SIR JOSHUA REYNOLDS
1723–1792

Born at Plympton, Devonshire, Reynolds served a brief apprenticeship under Thomas Hudson in London before launching his career as a portrait painter in Plymouth. Between 1749 and 1752 he was in Italy, where the study of ancient art and the Italian masters profoundly affected his style. Soon after his return he became the most fashionable portraitist in London. Reynolds was a prolific painter whose variety of approach was envied by his rival, Thomas Gainsborough. As the first President of the Royal Academy, Reynolds delivered a series of "Discourses" that were highly influential in shaping British aesthetic theory. He was a close friend of some of the leading personalities of his time, including Dr. Johnson, Goldsmith, Burke, and Garrick.

LADY SKIPWITH

Painted in 1787. Oil on canvas
50 ½ x 40 ¼ in. (128.3 x 102.2 cm.)
Acquired in 1906

Selina Shirley (1752–1832) was married in 1785 to Sir Thomas George Skipwith of Newbold Hall, Warwickshire. Lady Skipwith had a reputation as a skilled horsewoman, and a nephew recorded that "there was something rather formidable in her powdered hair and [the] riding habit or joseph which she generally wore." Reynolds' notebooks show that he painted her in May of 1787. The natural pose and setting and the fresh, free handling of paint are typical of the artist's late style, partly in response to the work of Gainsborough.

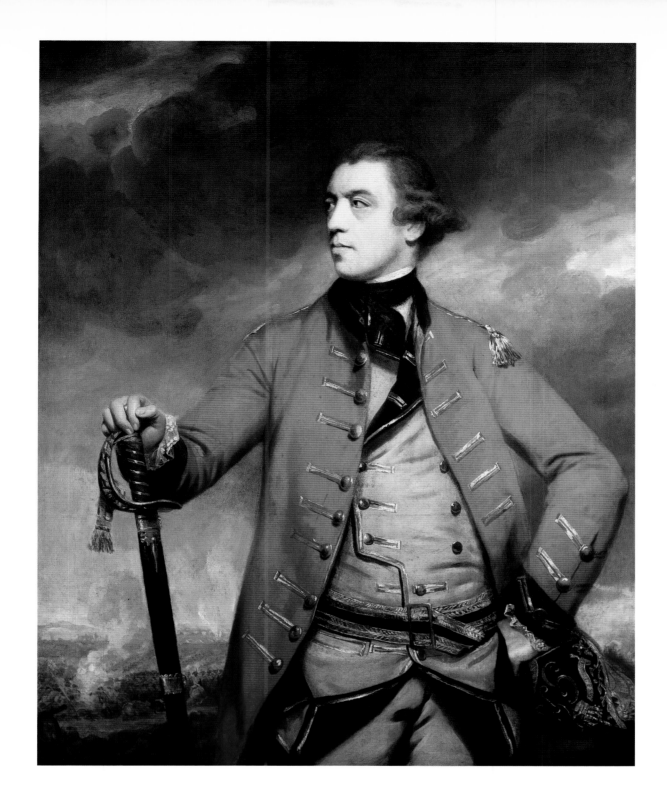

SIR JOSHUA REYNOLDS

GENERAL JOHN BURGOYNE

Painted probably in 1766. Oil on canvas
50 x 39 ⅞ in. (127 x 101.3 cm.)
Acquired in 1943

Best remembered as the British commander who in 1777 surrendered to American forces at Saratoga, John Burgoyne (1722–92) was also known in his day as a dandy, gambler, actor, amateur playwright, and Member of Parliament. This portrait may have been commissioned by his senior officer, Count La Lippe, as a memento of their Portuguese campaign of 1762. It is presumably the portrait that resulted from a sitting by General Burgoyne noted in Reynolds' ledger for May of 1766; Burgoyne's uniform is that of the Sixteenth Light Dragoons as it was worn until that month. The composition, with the dashing figure silhouetted before a low horizon and cloudy sky, was to become a classic type in Romantic portraiture of the later eighteenth century.

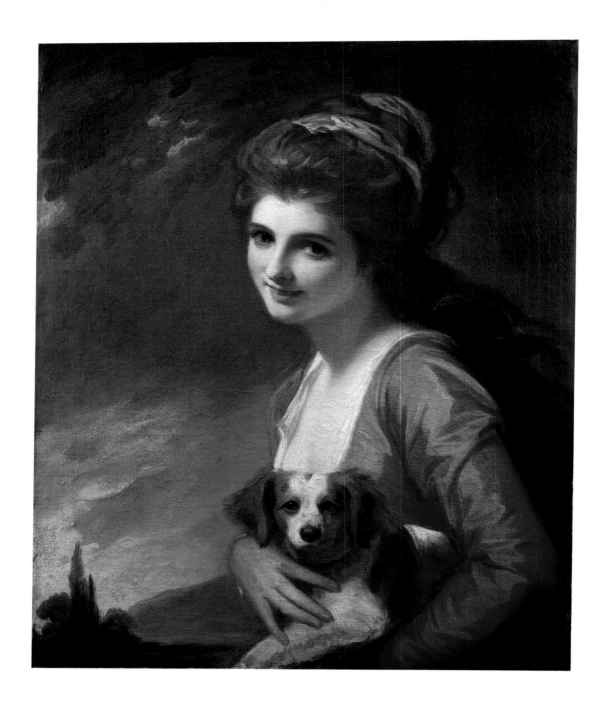

GEORGE ROMNEY

1734–1802

*Largely self-taught, Romney practiced
in London after traveling to Paris and Italy.
Although he never joined the Royal Academy,
he became one of the most fashionable
portraitists of his time. Romney's ambitions
to be a history painter, evident in his many
drawings, were never realized in his
painted work.*

LADY HAMILTON AS 'NATURE'

Painted in 1782. Oil on canvas
29 ⅞ x 24 ¾ in. (75.8 x 62.9 cm.)
Acquired in 1904

Emma Hart (1765–1815) was a woman of
great beauty and charm who rose from
humble origins to international fame.
Charles Greville, whose mistress she was and
who commissioned this portrait, educated
her in music and literature, and Greville's
uncle, Sir William Hamilton, British ambas-
sador to Naples, brought her to Italy, where
they were married. There she entertained
company with her "attitudes"—a kind of
Romantic aesthetic posturing achieved with
the aid of shawls and classical draperies.
Emma attracted the attention of Lord Hor-
atio Nelson, with whom she had a notori-
ous romantic liaison until his death at the
Battle of Trafalgar. Although she inherited
money from both Hamilton and Nelson,
her extravagance led her into debt, and she
died in poverty. This portrait was the first of
more than twenty that Romney painted of
his "divine lady," many in the guise of charac-
ters from history, mythology, and literature.

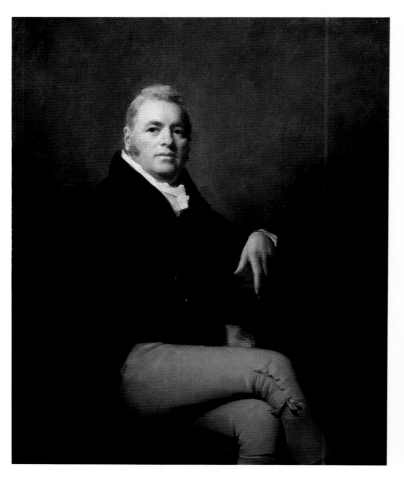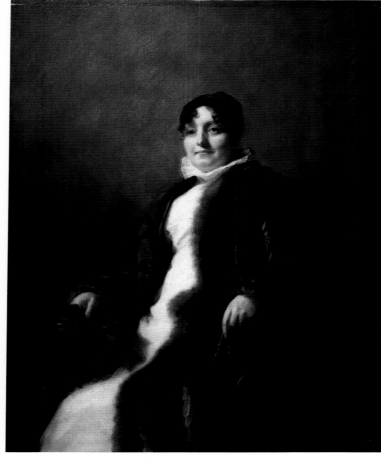

SIR HENRY RAEBURN
1756–1823

*Born at Stockbridge, now a part of
Edinburgh, Raeburn received his earliest
training as a goldsmith's apprentice and
may have gotten his start as a draftsman
producing miniatures for the jeweler's
lockets. By the age of twenty he had painted
his first full-length portrait in oils, but little
is known about this early period of his
career. His marriage around 1780 made him
financially independent. In 1784 Raeburn
spent two months in Joshua Reynolds'
studio in London and then, on the master's
advice, traveled to Rome to broaden his
experience. He returned to Edinburgh in
1786 and soon earned a reputation as the
foremost Scottish portrait painter. The Royal
Academy elected Raeburn to membership
in 1815, and in 1822 he was knighted by
George IV and named His Majesty's
Limner for Scotland.*

JAMES CRUIKSHANK

Painted between c. 1805 and 1808.
Oil on canvas
50 x 40 in. (127 x 101.6 cm.)
Acquired in 1911

MRS. JAMES CRUIKSHANK

Painted between c. 1805 and 1808.
Oil on canvas
50 ¾ x 40 in. (128.9 x 101.6 cm.)
Acquired in 1905

James Cruikshank (d. 1830), of Langley
Park, Montrose, Forfarshire (now County
Angus), was a businessman who made a
large fortune from sugar plantations in the
British West Indies. In 1792 he married
Margaret Helen (d. 1823), daughter of the
Rev. Dr. Alexander Gerard of Aberdeen.
They had six children. No record for the
commission of these pendant portraits has
been found, but a dating of between 1805
and 1808 has been suggested on stylistic
grounds. Raeburn took a very straightfor-
ward approach to his sitters and developed a
distinctive technique in which broadly
brushed detail and strong unmodulated
contrasts of light and dark give his figures a
luminous quality. In 1801, Joseph Farington
described Raeburn's portraits as having "an
uncommonly true appearance of Nature."

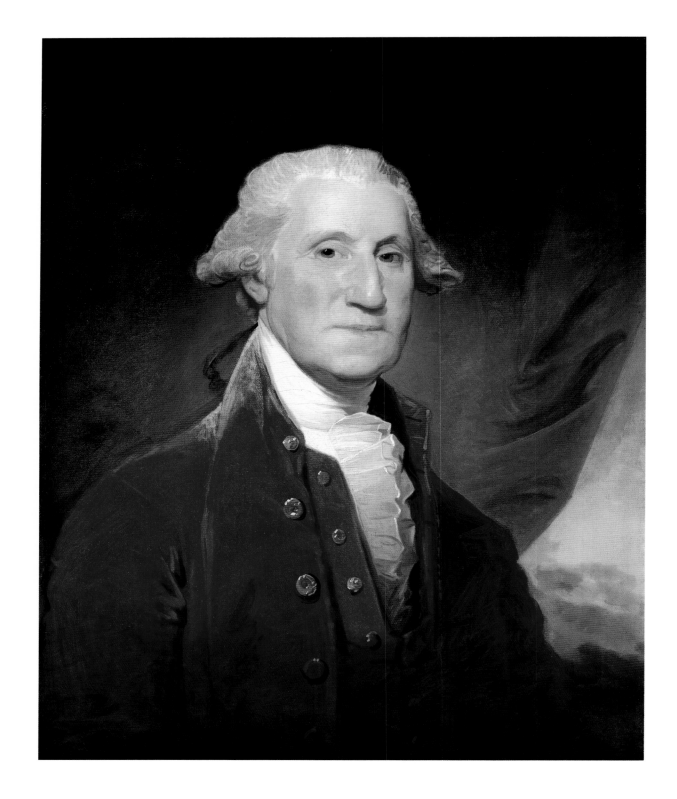

GILBERT STUART

1755–1828

Stuart was born in North Kingstown,
Rhode Island, and received his first training
in Newport with the Scottish painter Cosmo
Alexander. He accompanied Alexander
to Scotland, but after his teacher's death in
1772 he returned to America. In 1775 Stuart
moved to London, where soon afterward
he entered the studio of his compatriot
Benjamin West. Back in America in the
early 1790s, Stuart became the leading
portraitist of his day in New York,
Philadelphia, and Boston.

GEORGE WASHINGTON

Painted 1795–96. Oil on canvas
29 ¼ x 24 in. (74.3 x 60.9 cm.)
Acquired in 1918

Stuart earned a fortune producing replicas
of the three portraits he painted from life of
the first President of the United States. The
Frick canvas is thought to be one of two
copies painted by the artist for the Philadel-
phia merchant John Vaughan. It belongs to
the group known as the "Vaughan type,"
although it differs from the related versions
in the color of the coat and in the treatment
of the background. Stylistically the portrait
recalls the work of Stuart's English contem-
poraries, such as Romney and Hoppner.

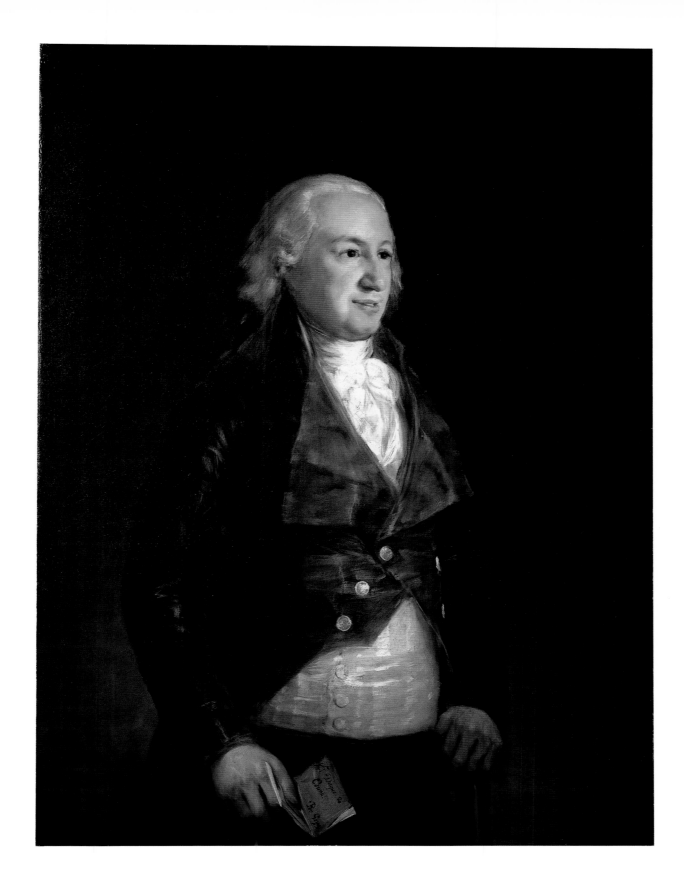

FRANCISCO DE GOYA Y LUCIENTES
1746–1828

Born in Fuendetodos, Goya served his apprenticeship in nearby Saragossa and then studied with Francisco Bayeu in Madrid. He was in Italy in 1770/71, and in 1774 he became a designer for the Royal Tapestry Factory. Appointed court painter to Charles III in 1786, he continued to hold that post under Charles IV and Ferdinand VII.

In addition to portraits, Goya painted historical, religious, and genre subjects, bitter satires, and demonological fantasies; he also was a brilliant graphic artist. In 1824, out of favor with the court, he left Spain and settled in Bordeaux, where he died.

DON PEDRO, DUQUE DE OSUNA

Painted probably between 1790 and 1800.
Oil on canvas
44 ½ x 32 ¾ in. (113 x 83.2 cm.)
Acquired in 1943

Don Pedro de Alcántara Téllez-Girón y Pacheco (1755–1807), ninth Duque de Osuna, was one of Spain's wealthiest and most talented noblemen during the reigns of Charles III and Charles IV. An enthusiastic and enlightened patron of the arts and sciences, the Duke seems in this portrait to exhibit the responsive, keen-witted personality that made him a popular figure with the intelligentsia of his day. After the royal court, he and his wife were Goya's most faithful patrons, commissioning more than twenty-four works including portraits, religious subjects, and a famous set of decorative canvases for their country palace outside Madrid.

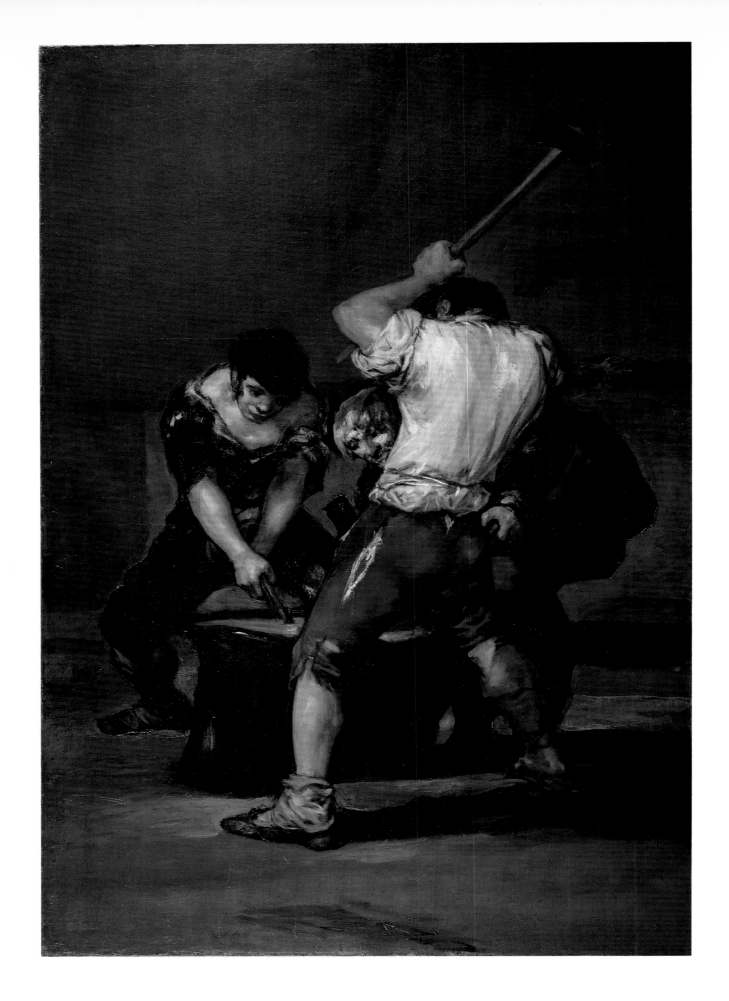

FRANCISCO DE GOYA Y LUCIENTES

THE FORGE

Painted between c. 1815 and 1820.
Oil on canvas
71 ½ x 49 ¼ in. (181.6 x 125.1 cm.)
Acquired in 1914

The composition of this great canvas derives from traditional depictions of the forge of Vulcan, the metalworker of the Olympian gods. Goya translates that mythological theme into contemporary language, using sturdy laborers in working clothes as a subject suitable for dignified, monumental treatment. The rough, vigorous application of paint and the somber coloring heighten the power and intensity of the figures and their actions.

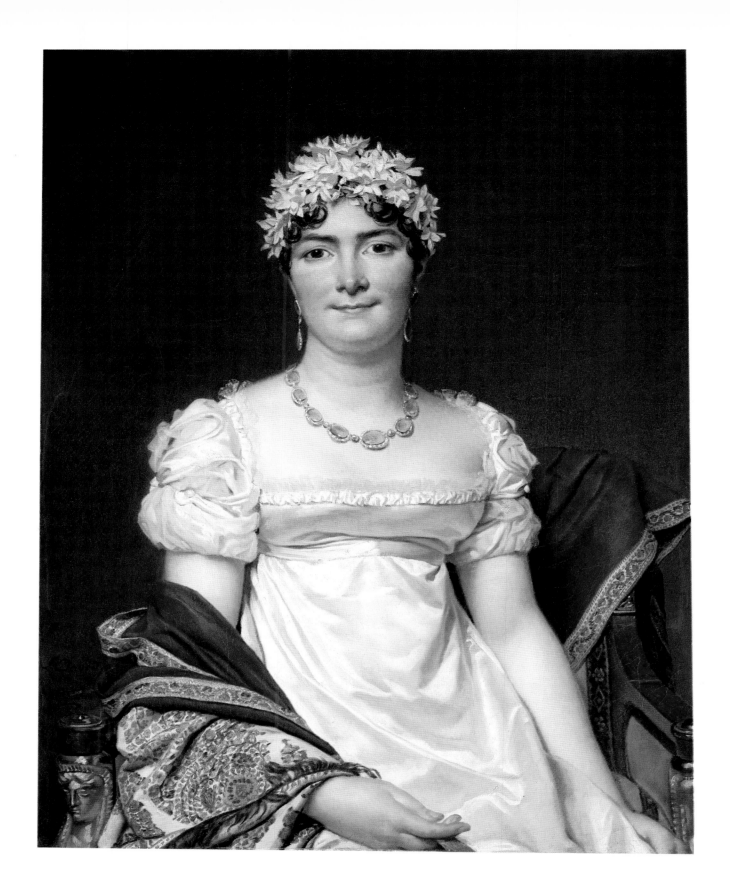

JACQUES-LOUIS DAVID
1748–1825

Born in Paris, David studied with Vien, whom he accompanied to Italy after winning the Prix de Rome in 1774. The leading painter of France a decade later, he played a major political role in the Revolution and set down some of its greatest images. David served Napoleon as his official painter. After the Emperor's fall, he went into exile in Brussels, where he died.

THE COMTESSE DARU

Dated 1810. Oil on canvas
32 ⅛ x 25 ⅝ in. (81.6 x 65.2 cm.)
Acquired in 1937

David signed this portrait at four o'clock on March 14, 1810. He had executed it as a surprise for Comte Daru, who had obtained for David his payment for *Le Sacre,* the vast painting of the coronation of Napoleon and Josephine. The subject's character, so sympathetically conveyed by David, was characterized by her admirer Stendhal as "forceful, frank, and jolly."

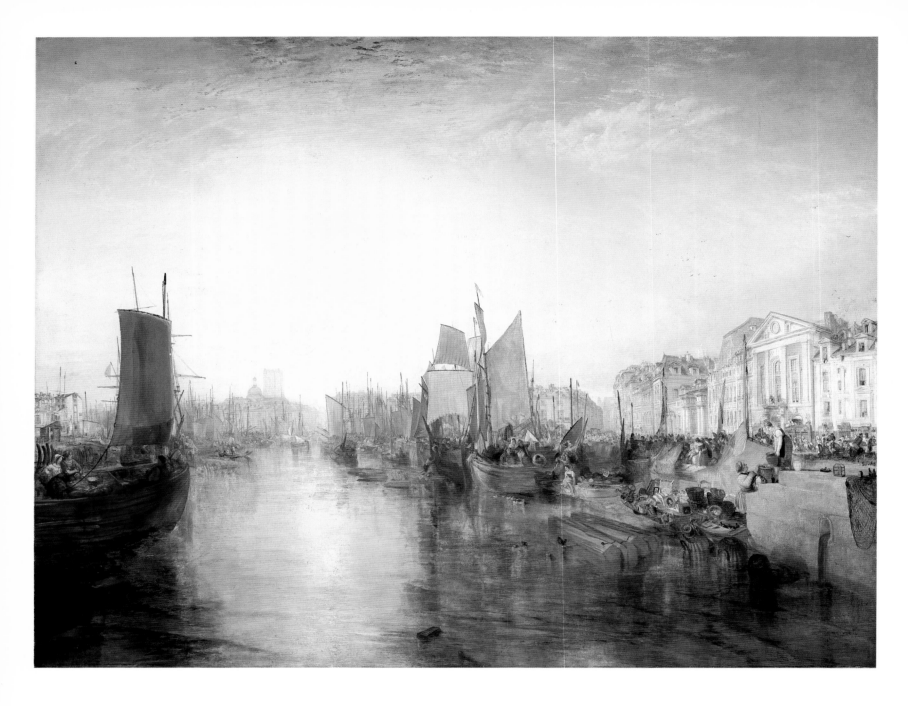

JOSEPH MALLORD WILLIAM TURNER
1775–1851

*Turner entered the Royal Academy Schools
at the age of fourteen and began his career
painting watercolors. His first employment
was as a topographical draftsman, in
which capacity he traveled around England
in the early 1790s. In 1796 he exhibited
his first oil painting, and by 1799 he was
an associate member of the Royal Academy.
He became a full Academician in 1802.
Influenced by Reynolds and the eighteenth-
century landscapist Richard Wilson, Turner
intended to unite landscape with the noble
genre of history painting. He traveled*

*extensively in England and on the
Continent and made innumerable sketches,
many of which he used as the basis for
paintings and prints. Turner's style changed
considerably over his long career, but, while
his late works demonstrate the increasing
dominance of abstract pictorial qualities,
he never abandoned his interest in subject
matter. His pictures have a poetic depth that
is unsurpassed in British landscape painting.*

THE HARBOR OF DIEPPE

Dated 182[6?]. Oil on canvas
68 ⅜ x 88 ¾ in. (173.7 x 225.4 cm.)
Acquired in 1914

Dieppe is one of Turner's three large exhibi-
tion pieces representing northern Conti-
nental ports, another being his scene of
Cologne now also in The Frick Collection.
Sketches for the present painting date from
the late summer of 1821 and record a num-
ber of buildings that still stand. When *Dieppe*
was shown in the Royal Academy exhibi-
tion of 1825, it received mixed reviews.
The intense luminosity of the painting was
deemed inappropriate for a northern climate
and displeased some contemporary critics,
one of whom called it a "splendid piece of
falsehood." Another, however, wrote: "Not
even Claude in his happiest efforts, has
exceeded the brilliant composition before
us." The apparent inconsistency of the
inscribed date with the picture's exhibition
in 1825 may indicate that Turner reworked
The Harbor of Dieppe at the same time he
exhibited *Cologne* in 1826.

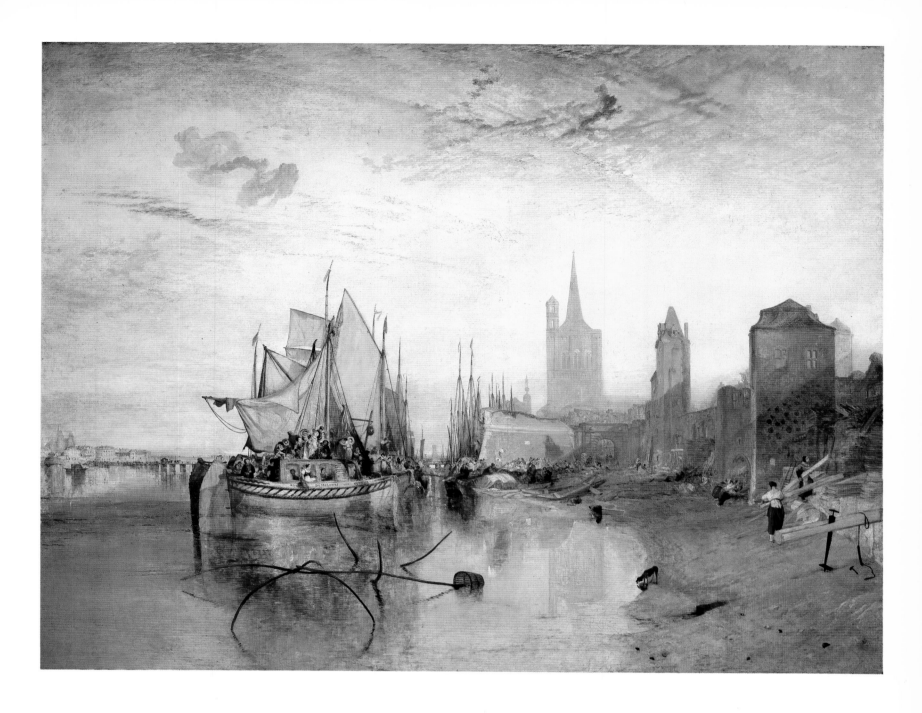

JOSEPH MALLORD WILLIAM TURNER

COLOGNE: THE ARRIVAL OF A PACKET-BOAT: EVENING

Painted in 1826.
Oil and possibly watercolor on canvas
66 ⅜ x 88 ¼ in. (168.6 x 224.1 cm.)
Acquired in 1914

The composition is based on sketches Turner made while touring the Rhine in 1817 and again in 1825. Among the discernible structures are, from the foreground back: the Kostgasseporte gate before the Frankenturm; the sixteenth-century Bollwerk and the archway over the entrance to the Zollstrasse; the Stapelhaus; and the church of Gross St. Martin. Turner achieved the high-keyed color and transparency of watercolor painting in this monumental canvas, and it is possible that he did combine the media of oil and watercolor, as suggested in a letter in which he warned his father: "you must not by any means wet it, for all the colour will come off." A questionable story associated with the painting was recorded by Ruskin, who described how Turner quixotically covered the golden sky with a wash of lampblack at the start of the Royal Academy exhibition of 1826 in order not to detract from two portraits by Lawrence that hung to either side of it. A contemporary reference to the painting's "glitter and gaud" casts doubt on this anecdote.

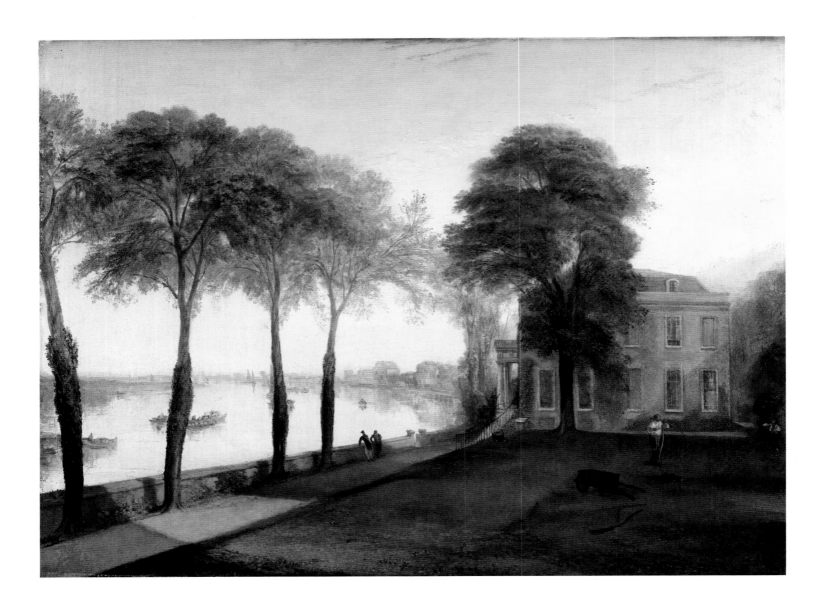

JOSEPH MALLORD WILLIAM TURNER

MORTLAKE TERRACE: EARLY SUMMER MORNING

Painted in 1826. Oil on canvas
36 ⅝ x 48 ¾ in. (93 x 123.2 cm.)
Acquired in 1909

This canvas painted for William Moffatt depicts his estate at Mortlake, on the Thames just west of London. Like so many of Turner's works, it is based on numerous preparatory drawings, in which the artist recorded the topography and studied various ways of balancing the mass of the house and land against the open river and sky. A companion view of the terrace and river on a summer evening as seen from a ground-floor window of the house is in the National Gallery of Art, Washington. Shown in the same Royal Academy exhibition of 1826 as the more ambitious painting of Cologne, *Mortlake Terrace* was praised for its "lightness and simplicity." Turner's penchant for a luminous shade of yellow is again a dominant feature of the painting.

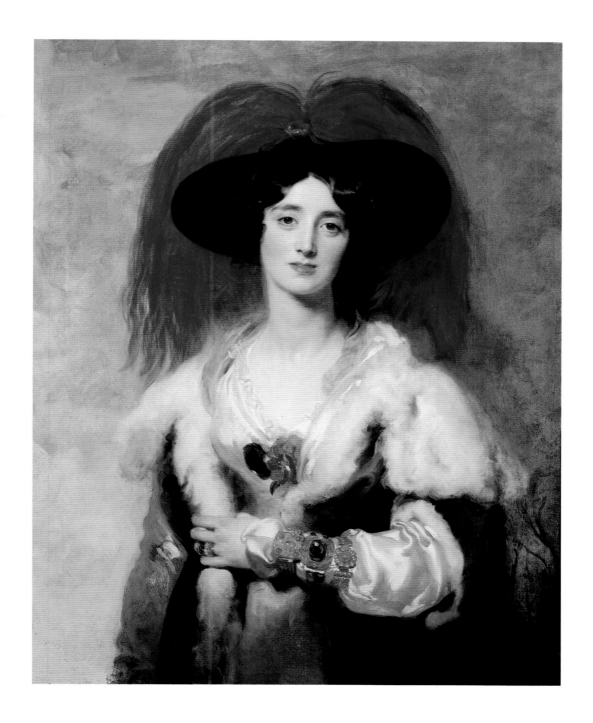

SIR THOMAS LAWRENCE
1769–1830

Born in Bristol, Lawrence spent his childhood in Devizes, Oxford, Weymouth, and Bath. His remarkable artistic talent was recognized when he was only ten. In 1787 he moved to London and entered the Royal Academy Schools, where he received great encouragement from Sir Joshua Reynolds. Upon Reynolds' death Lawrence was appointed Painter to the King, George III,

and in 1820 he became President of the Royal Academy. Lawrence was also patronized by the King's son, the Prince Regent—the future King George IV—who commissioned an important series of portraits of sovereigns, statesmen, and generals that hangs in the Waterloo Chamber at Windsor Castle. From 1790 to 1830, Lawrence received a steady stream of commissions, and his portraits earned him a reputation on the Continent unequaled by any earlier British painter.

LADY PEEL

Painted in 1827. Oil on canvas
35 ¾ x 27 ⅞ in. (90.8 x 70.8 cm.)
Acquired in 1904

Julia Floyd (1795–1859) was married in 1820 to the British statesman Sir Robert Peel, who twice served as Prime Minister and was an avid patron of Lawrence. The Frick portrait apparently was inspired by Rubens' painting of Susanna Fourment known as the *Chapeau de paille*, which Peel had acquired in 1823. When Lawrence's *Lady Peel* was first exhibited at the Royal Academy in 1827, a critic claimed it to be among "the highest achievements of modern art." Lawrence's flamboyant and virtuoso style has come to epitomize the spirit of the Regency period.

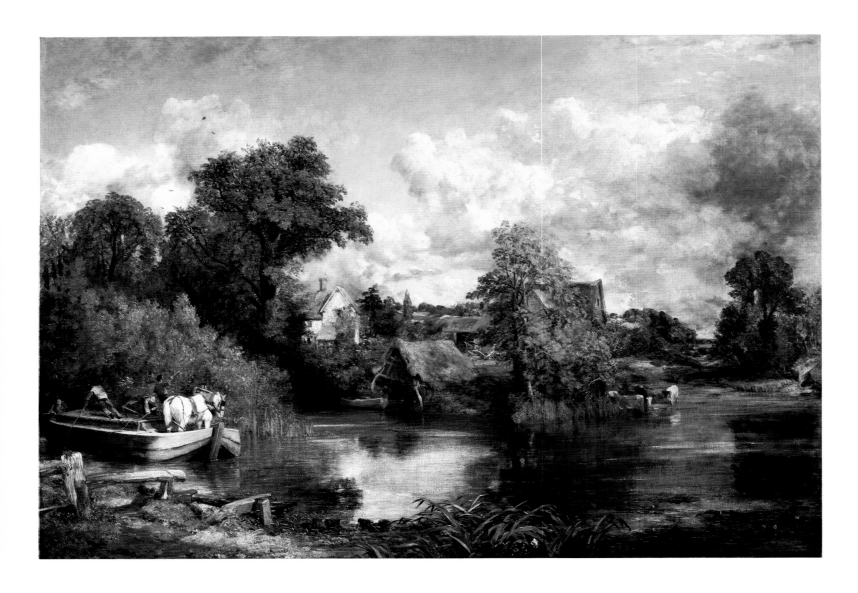

JOHN CONSTABLE
1776–1837

Constable left his native Suffolk in 1799 to study at the Royal Academy, of which he became an associate in 1819 and a full member only in 1829. His landscapes, which depict chiefly the Suffolk countryside, had a deep influence on his contemporaries, particularly the French. His elaborately finished exhibition pieces were based on numerous sketches painted outdoors directly from nature. The naturalism and simplicity of Constable's approach to the English landscape have been compared to the poetry of his early Romantic contemporaries, such as Wordsworth.

THE WHITE HORSE

Dated 1819. Oil on canvas
51 ¾ x 74 ⅛ in. (131.4 x 188.3 cm.)
Acquired in 1943

The painting depicts a tow-horse being ferried across the river Stour in Suffolk, just below Flatford Lock at a point where the tow-path switched banks. Constable, who described the scene as "a placid representation of a serene, grey morning, summer," went on in later years to comment: "There are generally in the life of an artist perhaps one, two or three pictures, on which hang more than usual interest—this is mine." The painting was well received when it was shown at the Royal Academy exhibition of 1819, and it was purchased by Constable's friend Archdeacon John Fisher. Constable bought back the painting in 1829 and kept it the rest of his life. There is a full-scale oil sketch for *The White Horse* in the National Gallery of Art, Washington.

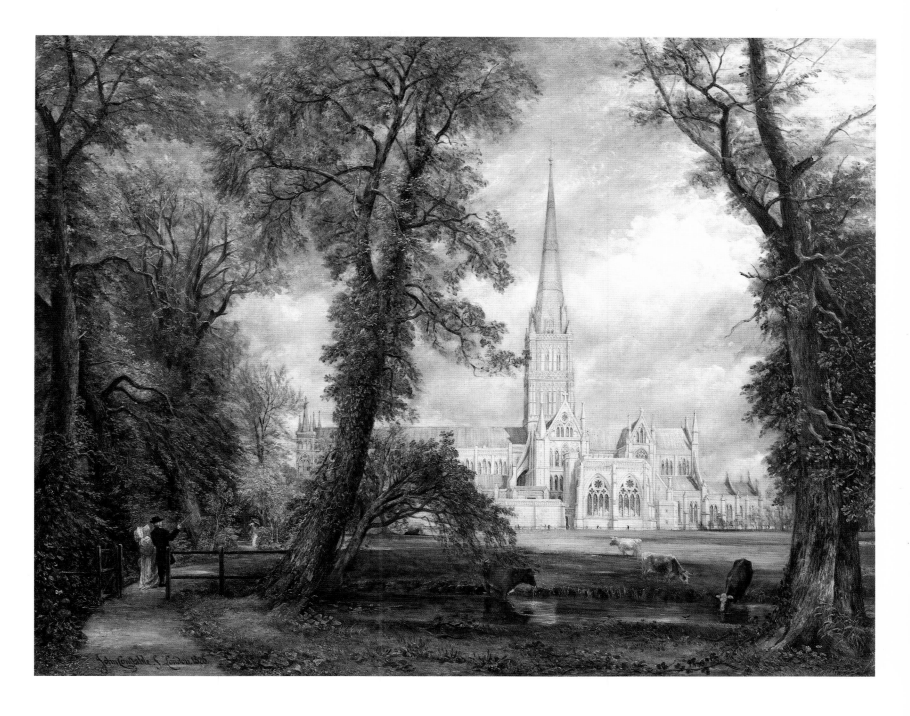

JOHN CONSTABLE

SALISBURY CATHEDRAL FROM THE BISHOP'S GARDEN

Dated 1826. Oil on canvas
35 x 44 ¼ in. (88.9 x 112.4 cm.)
Acquired in 1908

Constable painted several views of the south façade of Salisbury Cathedral for his intimate friends Dr. John Fisher, Bishop of Salisbury, and the Bishop's nephew Archdeacon John Fisher, who had purchased *The White Horse*. An oil sketch of the Cathedral is in the National Gallery of Canada, Ottawa. Another canvas, done for the Bishop (now in the Victoria and Albert Museum, London), had a dark, cloudy sky. In response to the owner's objections to its ominous atmosphere, Constable painted this version with a sunnier sky and a more open composition. As in the earlier canvas, Constable included the figure of the Bishop pointing out the Cathedral's spire to his wife, and beyond them a young lady holding a parasol, presumably one of their daughters. The Bishop had died by the time the picture was completed, but it was acquired by his family. Two favorite subjects of nineteenth-century artists—a medieval ecclesiastical monument and a dramatic landscape—are particularly well united through the arrangement of tree trunks and branches echoing the rising lines of the Cathedral spire.

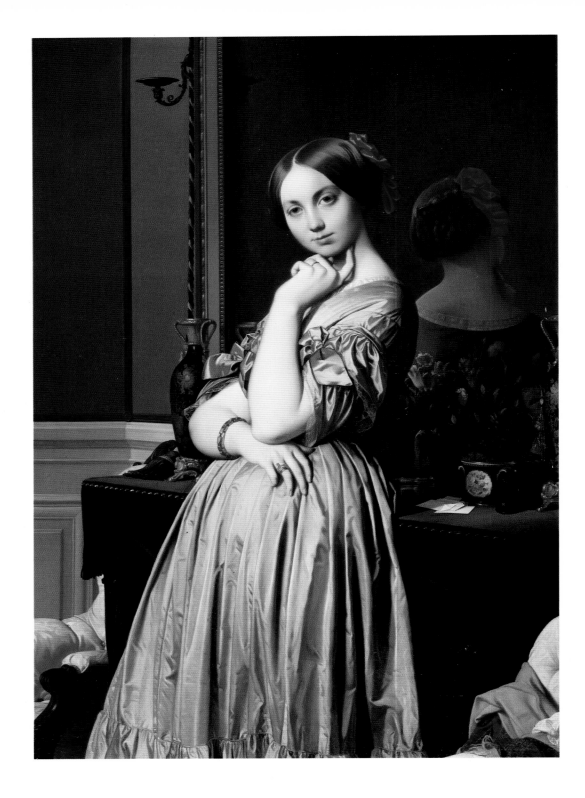

JEAN-AUGUSTE-DOMINIQUE INGRES
1780–1867

Born in Montauban, Ingres studied first in nearby Toulouse and then with David in Paris. He won the Prix de Rome in 1801 and was in Italy from 1806 until 1824, when his Vow of Louis XIII *was exhibited with great success at the Salon. He spent the following decade in Paris, where he received official honors and attracted many pupils, but his work was severely criticized in 1834. He then returned to Rome for seven years as Director of the French Academy. His final years were spent in Paris.*

THE COMTESSE D'HAUSSONVILLE

Dated 1845. Oil on canvas
51 ⅞ x 36 ¼ in. (131.8 x 92 cm.)
Acquired in 1927

Louise, Princesse de Broglie (1818–82) and granddaughter of Madame de Staël, married at the age of eighteen. Her husband was a diplomat, writer, and member of the French Academy, and she herself published a number of books, including biographies of Robert Emmet and Byron. For her time and her class, she was outspokenly independent and liberal. This portrait, begun in 1842, was the fruit of several false starts and a great many preparatory drawings, including full-scale studies of the raised left arm, the head, and its reflection. According to a letter written by the artist, the finished work "aroused a storm of approval" among her family and friends. In it Ingres appears to have surprised the young lady in the intimacy of her boudoir, where she leans against an upholstered fireplace, having just discarded her evening wrap and opera glasses.

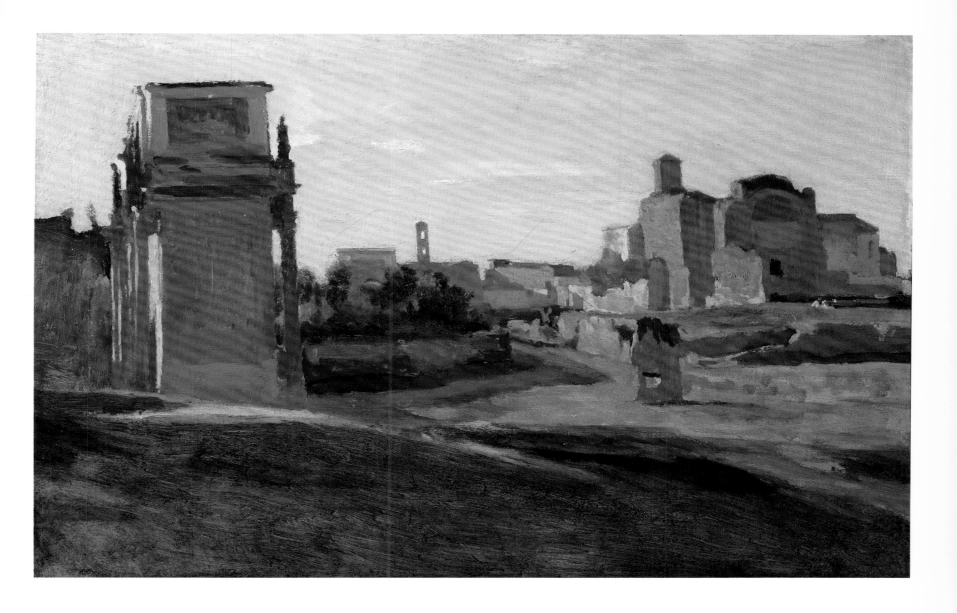

JEAN-BAPTISTE-CAMILLE
COROT
1796–1875

Corot was born in Paris and studied there with the classicizing painters Michallon and Bertin before leaving in 1825 for the first of three visits he made to Italy. His many oil studies painted outdoors provided him with a library of landscape motifs that he often incorporated into canvases with more traditional classical or religious subjects intended for exhibition. Corot traveled elsewhere in Europe and widely in France, working in the vicinity of Rouen, in the forest of Fontainebleau, and at Ville-d'Avray, near Paris, where his father had a house. Though he exhibited frequently in the Salons and won many honors, he remained a man of great simplicity, remembered for his many benefactions toward fellow artists.

THE ARCH OF CONSTANTINE
AND THE FORUM, ROME

Painted in 1843.
Oil on paper, mounted on canvas
10 ⅝ x 16 ½ in. (27 x 41.9 cm.)
Gift of Mr. and Mrs. Eugene Victor Thaw, 1994

Corot probably painted this small oil study on paper while at the site, facing northwest along the main axis of the Roman Forum. The view was one admired and recorded by other artists—for example, J. M. W. Turner. A late afternoon sun illumines and silhouettes the famous monuments, which include the Arch of Constantine, the Arch of Titus, the ruins of the Temple of Venus and Rome, the stubby remains of an ancient fountain called the Meta Sudans, and the distant campanile of the Palazzo Senatorio on the

Campidoglio. A crystalline light and the cool, pale hues of green, blue, and buff suggest that the season is late spring or early summer, before Roman heat turns the Forum into a dusty oven.

According to the artist's friend Alfred Robaut, the sketch was executed on the last of Corot's three trips to Italy. In 1826, during his first trip, Corot had painted two larger, panoramic views of the Forum as seen from above at a distance. Both of the earlier paintings, now in the Louvre, are more composed and finished than the Frick study. Like so many of his predecessors, such as Valenciennes, Bertin, and Michallon, Corot often referred to his sketches when back in his studio, where he prepared his larger canvases for sale or exhibition. The freshness and immediacy of the open-air oil sketches are qualities increasingly admired today.

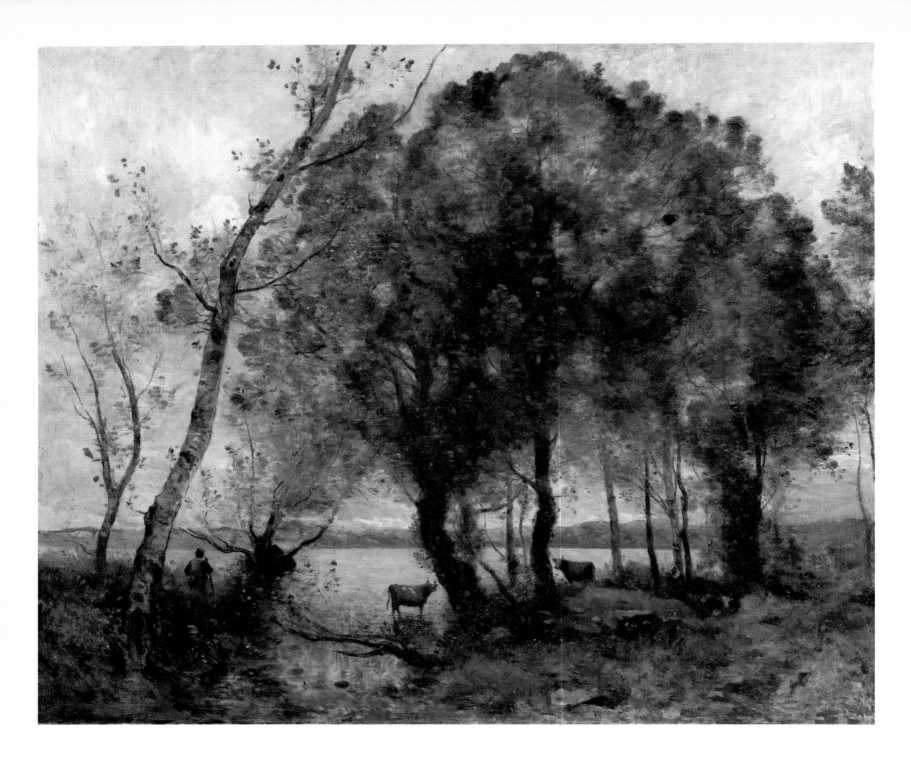

JEAN-BAPTISTE-CAMILLE COROT

THE LAKE

Painted in 1861. Oil on canvas
52 ⅜ x 62 in. (133 x 157.5 cm.)
Acquired in 1906

Corot exhibited this large, nearly mono-chromatic picture at the Salon of 1861. Critical reactions to it varied. The critic J. A. Castagnary evoked most clearly the artist's approach to painting at this time, saying: "*The Lake* is a ravishing landscape, simple in composition and full of grandeur. . . . When he sets himself before his canvas it is—like a musician seating himself at the piano—in order to give voice to the inspiration that torments him. What he wants is to express his personal feelings, not nature that inspired them in him." But another reviewer, Théophile Thoré, was less sympathetic to this approach, remarking of *The Lake:* "Mist covers the earth. One is not sure where one is and one has no idea where one is going. Corot's work is perhaps poetic, but it is not varied."

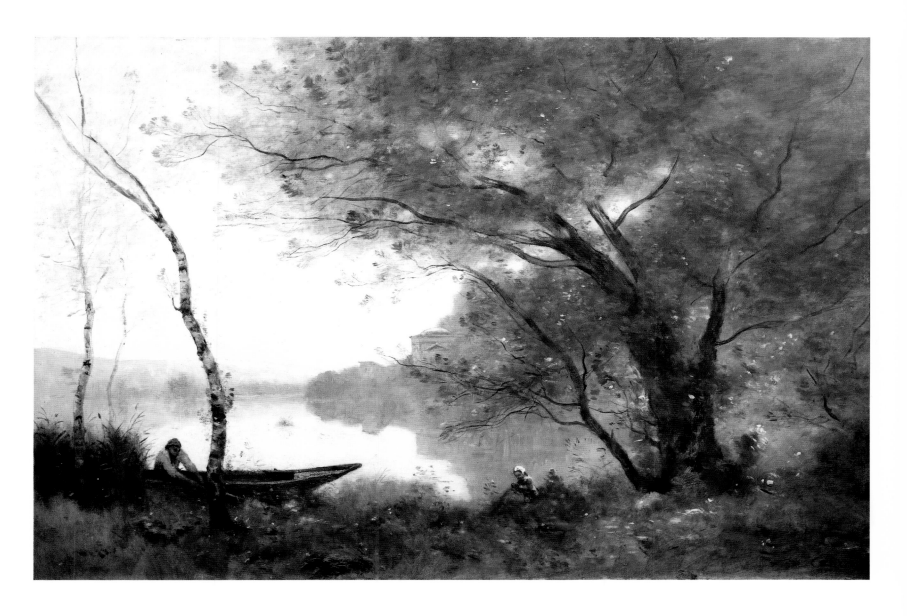

JEAN-BAPTISTE-CAMILLE COROT

THE BOATMAN OF MORTEFONTAINE

Painted between 1865 and 1870. Oil on canvas
24 x 35 ⅜ in. (60.9 x 89.8 cm.)
Acquired in 1903

The park of Mortefontaine, north of Paris, was laid out "à l'anglaise" in the eighteenth century and offered inspiration to Corot for a great many related landscape paintings. One of these, *Souvenir de Mortefontaine,* which he sent to the Salon in 1864, was purchased by Napoleon III and is now in the Louvre. The Frick canvas, known as *The Boatman of Mortefontaine,* takes up the basic motifs of the Louvre painting but plays variations on a theme, adding a little temple to the point of land across the water, a man in a boat at left instead of the figures around a tree in the Louvre painting, and a woman seated on the ground. Along with these

changes, Corot opened up the dense center of *Souvenir* and elongated the point of land and its reflection, shapes that were then echoed in reverse in the slender silhouette of the boat.

Comparison of the various paintings evoking the park of Mortefontaine and the sketches Corot made for them reveals much about how the artist created his landscapes. To Corot, landscape motifs were compositional building blocks in a carefully constructed design which he arranged almost abstractly, working to harmonize line and shape, tonalities and silhouettes, distance and foreground, solid mass and reflections. The Frick Collection owns two drawings for paintings from the Mortefontaine series, one for the Louvre *Souvenir de Mortefontaine* and the other for a painting entitled *Après l'orage.* Both demonstrate the carefully designed substructure underlying these intensely poetic, often romantic, images of nature. Corot's work, while rooted in the classicism of Claude and Poussin, led directly to Monet and developments in late nineteenth-century landscape painting.

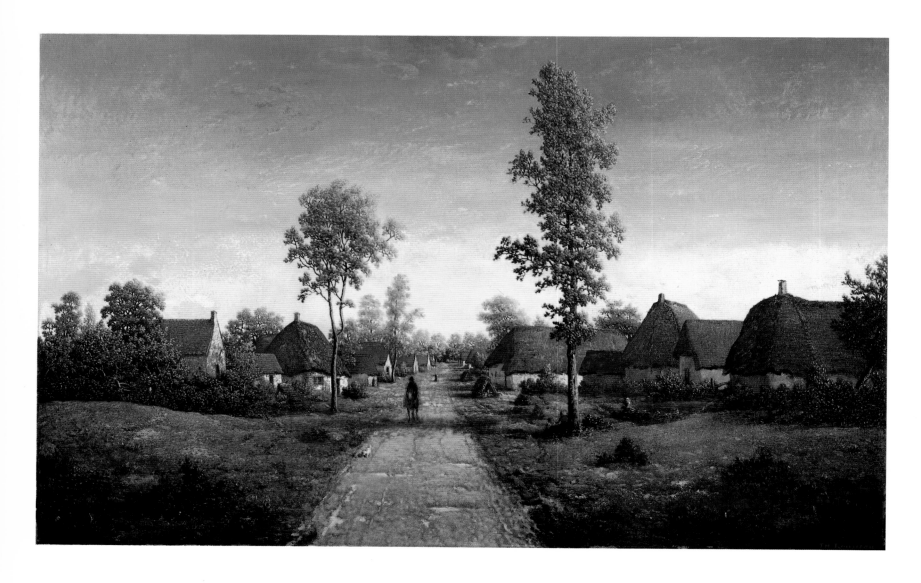

PIERRE-ÉTIENNE-THÉODORE ROUSSEAU
1812–1867

Rousseau was born and trained in Paris, where he studied first with Charles Rémond, then with Guillon Lethière. At an early age he began working from nature, inspired by the Dutch seventeenth-century landscapes he saw in the Louvre. He first exhibited at the Salon in 1831, but he had little success with his non-Academic landscapes until 1849, when he won a first-class medal. After the Revolution of 1848, Rousseau settled in the village of Barbizon with Millet, Daubigny, and others of the group that came to be known as the Barbizon School.

THE VILLAGE OF BECQUIGNY

Painted between 1857 and 1864. Oil on panel
25 x 39 ⅜ in. (63.5 x 100 cm.)
Acquired in 1902

During a trip through Picardy in 1857, Rousseau was much taken by the unchanged, rustic appearance of Becquigny, a village not far from Saint-Quentin. With its low thatch-roof huts it seemed to him a strange survival from an ancient past. The artist's first rendering of the village road, so reminiscent of Hobbema's famous *Avenue at Middelharnis* (National Gallery, London), delighted his friends with its freshness and brilliance, but Rousseau was less satisfied. In a letter to his friend and biographer Alfred Sensier, he stated that while the "outline" of the picture had been settled, its "composition" was unfinished, adding: "but I understand by composition that which is within

us and which penetrates as far as possible into the external reality of things...."

The recipient of this letter noted that the day before Rousseau sent the painting to the Salon of 1864 (entitled simply *A Village*), he repainted the whole sky. Influenced by the first Japanese prints he had seen, he changed it to a clear sapphire blue—a meteorological effect rarely witnessed in the skies of northern France. Although the picture attracted attention, the sky was widely criticized. Even Sensier noted that in it the artist had shown "an excess of invention." As a result of all this, Rousseau began to rework the sky once again, ultimately restoring its original softer tones.

The first owner of this important landscape, Frédéric Hartmann, succeeded in taking possession of his promised acquisition only by going with Sensier to Rousseau's Paris studio the day before the artist died and claiming it.

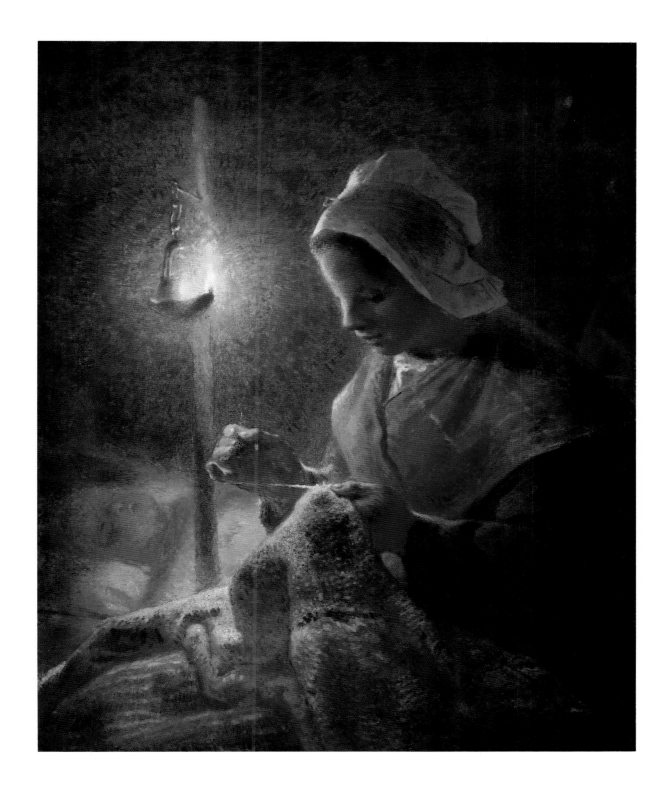

JEAN-FRANÇOIS MILLET
1814–1875

The son of Norman peasants, Millet studied in Cherbourg and then Paris. His work was shown in several Salons in the 1840s, but it was not until the Winnower *of 1848 that he began to exhibit the peasant subjects that made him famous. In 1849 he moved to Barbizon, where he spent most of his remaining years.*

WOMAN SEWING BY LAMPLIGHT

Painted in 1870–72. Oil on canvas
39 ⅝ x 32 ¼ in. (100.7 x 81.9 cm.)
Acquired in 1906

It has been suggested that Millet's many scenes of peasant women and their families working by lamplight were inspired by his fondness for Latin bucolic poetry, especially certain lines from Virgil's *Georgics*. Similar treatments by Rembrandt and other Dutch painters may also have influenced his choice of themes, but ultimately this picture relates most closely to what the artist was witnessing in his own home, as he wrote to a friend the year the canvas was completed: "I write this, today, November 6th at 9 o'clock in the evening. Everyone is at work around me, sewing, and darning stockings. The table is covered with bits of cloth and balls of yarn. I watch from time to time the effects produced on all this by the light of the lamp. Those who work around me at the table are my wife and grown-up daughters."

In addition to this important painting by Millet, Mr. Frick owned ten drawings and pastels by the artist.

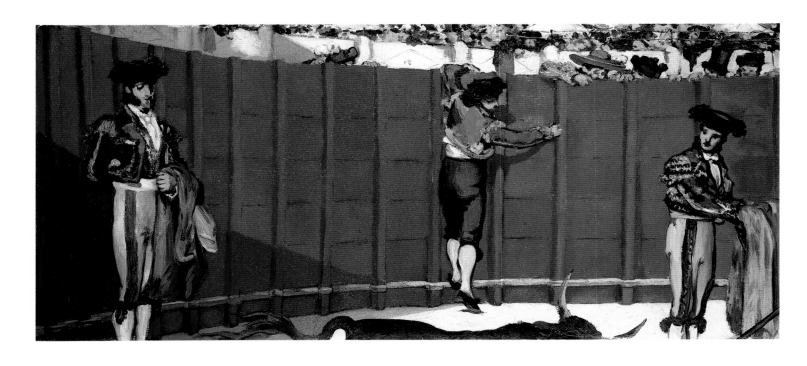

ÉDOUARD MANET
1832–1883

Born into a prosperous Parisian household, Manet studied with Couture between 1850 and 1856. After that he developed an individual technique utilizing half-tones as little as possible and employing a restricted palette rich in black. His subjects were drawn from contemporary life, often from its lower ranks. Although his early work included many Spanish themes and his style was influenced by Velázquez and Goya, Manet did not visit Spain until 1865. He first exhibited at the Salon in 1861, but two years later he showed at the Salon des Refusés, where his work was received with the ridicule that it would provoke throughout most of his career.

After 1870 Manet adopted an Impressionist technique and palette and treated more lighthearted subjects than during the previous decade; nevertheless, he refused to take part in the Impressionist exhibitions organized by Degas. Baudelaire and Zola eventually became his friends and defenders, but the official recognition he longed for came to Manet only in the year before his death, when he was awarded the Legion of Honor.

THE BULLFIGHT

Painted in 1864. Oil on canvas
18 ⅞ x 42 ⅞ in. (47.9 x 108.9 cm.)
Acquired in 1914

In 1864 Manet exhibited at the Salon a painting entitled *An Incident in the Bullring.* The work was savagely caricatured and criticized, one writer describing its subject as "a toreador of wood killed by a horned rat." After the picture was returned from the Salon, Manet cut out two separate compositions from the canvas, possibly because he accepted the criticism as justified. The lower, larger section, now known as *The Dead Toreador,* is in the National Gallery of Art, Washington. Both sections of the original canvas were subsequently reworked by the artist, the head of the bull being added to his back in the Frick segment after the painting had been divided.

Unlike some of his American contemporaries, Mr. Frick showed little interest in the Impressionists. His acquisitions in this area were limited to this work by Manet, the paintings by Renoir and Degas reproduced here, and two landscapes by Monet, one of which he sold back. The other—*Banks of the Seine, Lavacourt*—has always remained in his Pittsburgh residence.

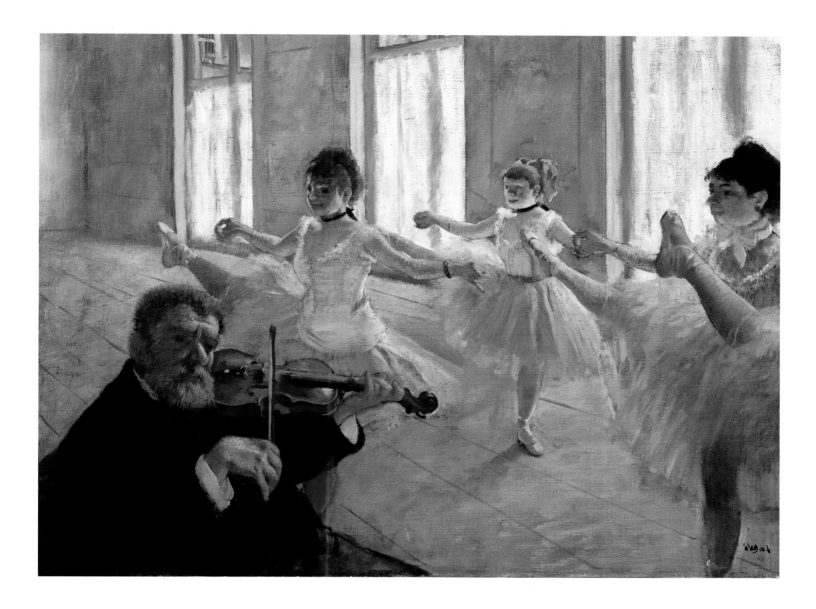

HILAIRE-GERMAIN-EDGAR DEGAS
1834–1917

Born in Paris, Degas entered the École des Beaux-Arts in 1855 to work with Louis Lamothe, one of Ingres' former pupils. He visited Italy the following year, resettled in Paris—where from 1865 until 1870 he exhibited at the Salon—and in 1872 went to New Orleans to live with relatives for several months. After his return to France he exhibited for eight years with the Impressionists. Degas' varied subjects, motifs drawn largely from urban life, encompassed dancers, working girls, women bathing, and racehorses, but also included occasional landscapes. The artist experimented throughout his life with a variety of media, including oil, pencil, charcoal, pastel, watercolor, etching, lithography, monotype, photography, and sculpture. His last public exhibition was held at Durand-Ruel's in 1893. Degas made occasional trips to Italy and England, and in 1880 he visited Spain and Tangier. He died, solitary and almost blind, in Paris.

THE REHEARSAL

Painted probably in 1878–79. Oil on canvas
18 ¾ x 24 in. (47.6 x 60.9 cm.)
Acquired in 1914

This painting is probably the canvas entitled *École de danse* that Degas entered in the fourth exhibition of the Impressionists in 1879. It then belonged to the artist's close friend Henri Rouart, and it was sold after Rouart's death in 1912 along with a number of other important works by Degas. Mr. Frick was the next private individual to own it, acquiring the painting a year and a half later.

The Rehearsal is one of many compositions devoted to the dance that the artist produced in the 1870s, apparently fascinated with the mechanization of the human body that the rigorous discipline of the ballet imposed. In the same exhibition of 1879 Degas showed two other pictures of dancers practicing with a violinist. In all of them the unidentified musician appears divorced from the events surrounding him, his age and stolid form providing a touching contrast to the doll-like ballerinas.

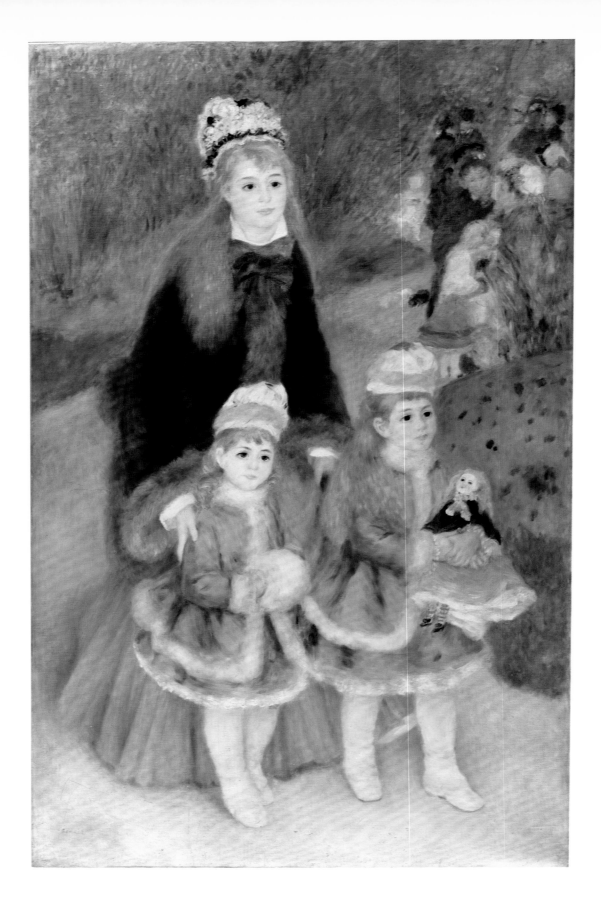

PIERRE-AUGUSTE RENOIR
1841–1919

Born in Limoges, Renoir was four when his family moved to Paris. He began his career as a painter of porcelain, but at twenty-one he entered Gleyre's studio and enrolled at the École des Beaux-Arts. He first showed at the Salon in 1864, and ten years later he took part in the inaugural Impressionist exhibition, which he hung. After visits to Algeria and Italy in 1881–82 his work began to diverge from that of the Impressionists toward a more classical tradition. Crippled with arthritis in old age, he nevertheless continued to paint and to produce sculpture. Renoir died at Cagnes.

MOTHER AND CHILDREN

Painted probably c. 1876–78. Oil on canvas
67 x 42 ⅝ in. (170.2 x 108.3 cm.)
Acquired in 1914

The subjects of this delightful portrait have never been identified, but according to a plausible tradition they were two daughters of a prosperous Parisian family of Italian origin and their nurse, whom Renoir encountered in the park adjoining the church of La Trinité, not far from his studio. In quality and scale, and probably in date, the portrait is to be compared with Renoir's *Madame Charpentier and Her Children* (Metropolitan Museum of Art, New York), painted in 1878 and exhibited with great success the following year. The Frick portrait does not figure in the list of pictures shown either by the artist's dealer, Durand-Ruel, or by Renoir himself in public exhibitions prior to the twentieth century. Before belonging to Mr. Frick, *Mother and Children* was for a brief time in Potter Palmer's celebrated collection.

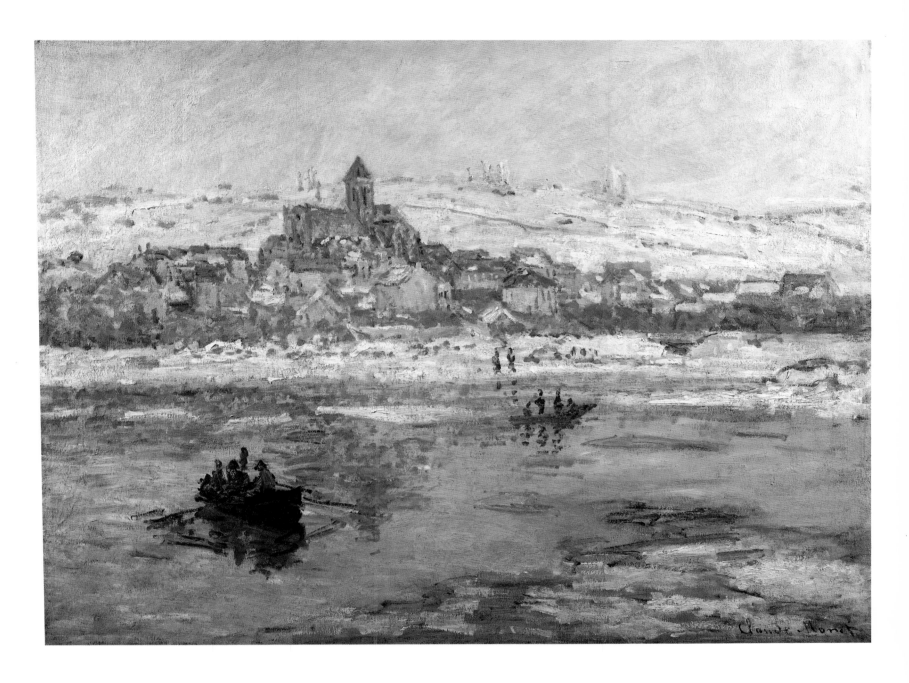

CLAUDE-OSCAR MONET
1840–1926

Parisian by birth, Monet was still a child when his family moved to Le Havre. There he later met Boudin, who convinced him to become a landscape painter. His artistic studies were interrupted by two years of military service in Algeria, but in 1862 he returned to Paris and worked briefly in Gleyre's studio, where he met Renoir, Bazille, and Sisley. He showed in the Salons of 1865 and 1866. In 1870, at the outbreak of the

Franco-Prussian War, he went to England. Monet's Impression—Sunrise *was greeted with derision at the first Impressionist exhibition in 1874, and its title would be adopted mockingly to name the whole movement of Impressionism. Although extremely poor for many years, the artist gradually won recognition, comfort, and fame. He painted along the Seine, on the Riviera, by the English Channel, in Brittany, the Midi, Holland, London, and Venice, and, especially in his last years, in his own elaborate garden at Giverny. Monet died at Giverny.*

VÉTHEUIL IN WINTER

Painted in 1878 or 1879. Oil on canvas
27 x 35 ⅜ in. (68 x 89.4 cm.)
Acquired in 1942

In 1878 Monet moved down the Seine from Argenteuil to Vétheuil, a small town on a bend in the river. Over the next few years he would paint Vétheuil from different points of view and in every season, as seen from the riverbanks, from the meadows, and from a boat he had arranged as a kind of floating studio. It was during the winter of 1878/79 that Monet executed this picture, looking back across the ice floes of the Seine toward Vétheuil's medieval church tower. On December 12, 1879, Dr. de Bellio, an avid collector of Monet's work, wrote to the artist that this was one canvas that would never leave his possession.

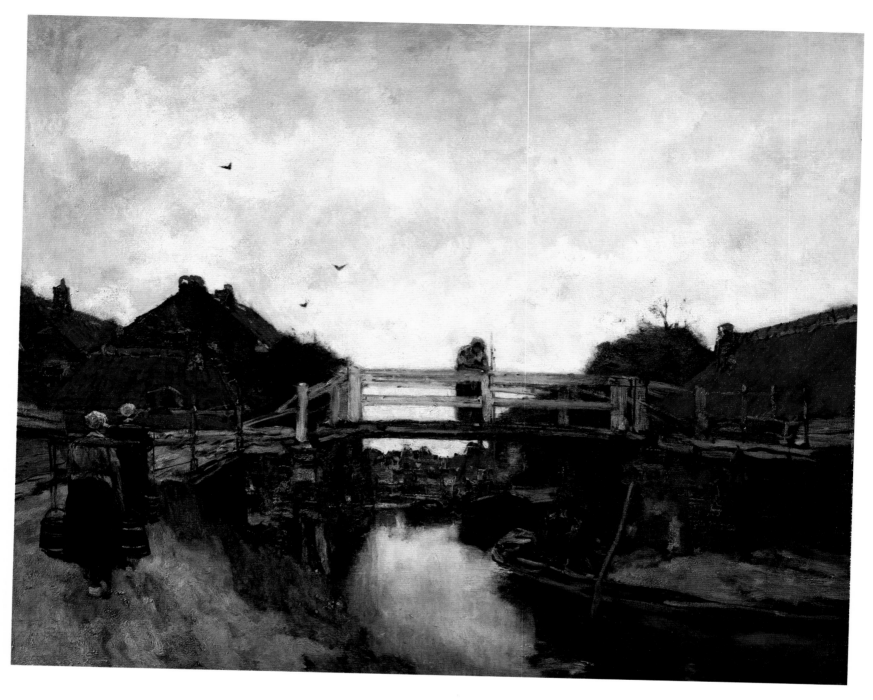

JACOBUS HENDRIKUS MARIS
1837–1899

Maris was born in The Hague and received his first training there. He studied in Antwerp, then went back to The Hague in 1857. During the late 1860s he worked in Paris, where he was influenced by the landscapes of the Barbizon painters. He returned to his native city in 1871, and subsequently became a leading figure in the Hague School of painting, as were his younger brothers Matthijs and Willem.

THE BRIDGE

Painted in 1885. Oil on canvas
44 ⅜ x 54 ⅜ in. (112.7 x 138.1 cm.)
Acquired in 1914

Looking at the somber grays and blacks of this village scene, with its shimmering silver-surfaced canal, it is hard to believe that a contemporary of Maris had complained of the extreme vividness of the colors in the painting. This critic later learned from Maris that he expected his pigments to reach a mellow maturity only after ten or twelve years from the time of their application. The artist clearly understood his craft, for today the subdued tones of the picture greatly enhance this powerful portrait of an ordinary, even drab, Dutch town, blanketed under clouds stirred by damp, gusty winds.

The site depicted is said to be near Rijswijk, on the outskirts of The Hague. A number of similar compositions by Maris, which include both oil sketches and a wash drawing, may be preparatory studies for the picture. An impression of Maris' own etching of this subject is in The Frick Collection.

Artists of the Hague School were much in fashion during Mr. Frick's years of collecting. He purchased a total of five paintings and three works on paper by Maris, as well as several paintings and drawings by other artists of his circle. In 1908 Mr. Frick sold *The Bridge,* but, evidently regretting his decision, he bought back the painting in 1914. The Hague School was to have a formative influence on the young Van Gogh and, somewhat later, on Mondrian.

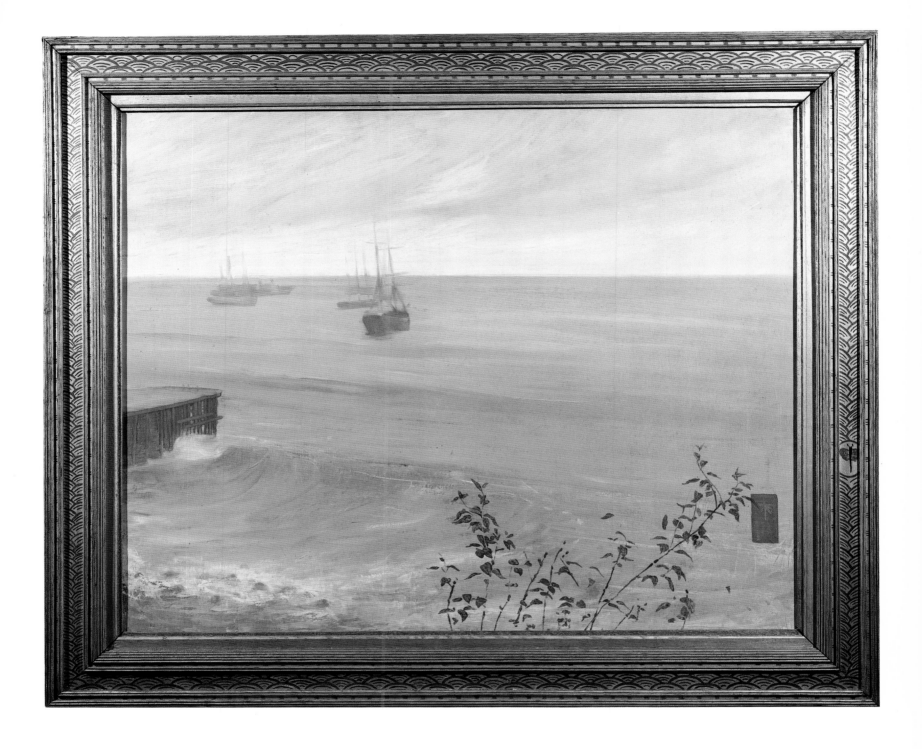

JAMES McNEILL WHISTLER
1834–1903

Born in Lowell, Massachusetts, Whistler spent part of his childhood and most of his mature life in Europe. After three years at the West Point Military Academy, he went in 1855 to Paris, where he worked for two years in Gleyre's studio and later became an associate of Fantin-Latour, Legros, and Courbet. He exhibited in the Salon des Refusés in 1863, and throughout his career he associated with his more experimental contemporaries. Whistler's colorful personality and advanced style of painting involved him in many lively controversies.

SYMPHONY IN GRAY AND GREEN: THE OCEAN

Painted in 1866. Oil on canvas
31 ¾ x 40 ⅛ in. (80.7 x 101.9 cm.)
Acquired in 1914

This painting, exhibited in London in 1892, was one of several seascapes Whistler painted in 1866 during a visit to Valparaiso, Chile. The influence of Japanese prints on his work is apparent here in the high horizon, the decorative arrangement of bamboo sprays, and the butterfly monogram that appears both on the picture and on the frame, which was of Whistler's own design.

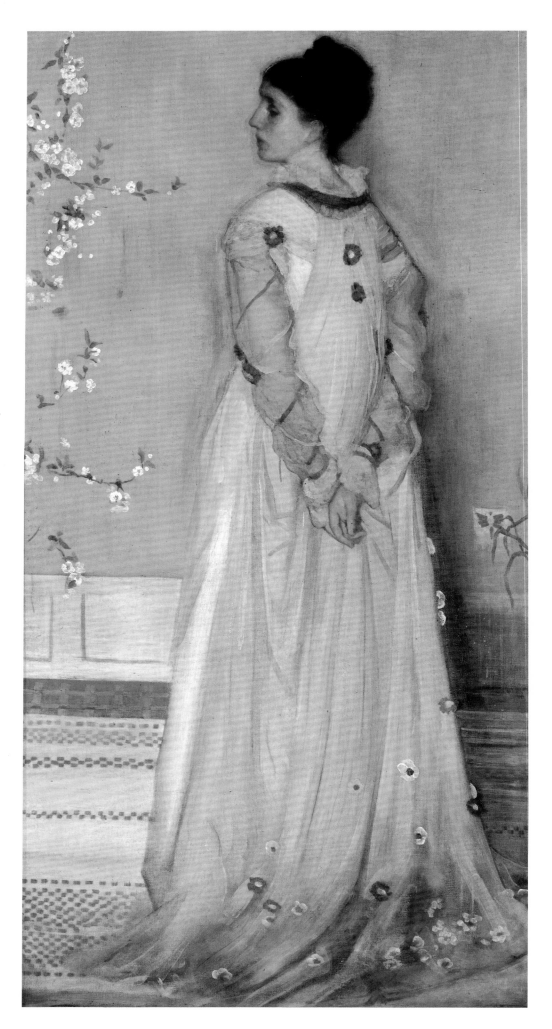

JAMES McNEILL WHISTLER

SYMPHONY IN FLESH COLOR AND PINK: PORTRAIT OF MRS. FRANCES LEYLAND

Painted in 1872–73.
Oil on canvas
77 ⅛ x 40 ¼ in. (195.9 x 102.2 cm.)
Acquired in 1916

Frances Dawson (1834–1910) married in 1855 Frederick R. Leyland, a major Liverpool shipowner, telephone magnate, and art collector, who was one of Whistler's chief patrons before the two quarreled bitterly over the decoration of the famous Peacock Room, once the dining room of the Leylands' London townhouse and now in the Freer Gallery of Art in Washington.

Commissioned in the fall of 1871, this portrait was shown at Whistler's first one-man exhibition in 1874 (an event sponsored by Leyland), but was never considered by the artist to be totally finished. Within its predominantly pink color scheme, intended to set off Mrs. Leyland's red hair, the subject is depicted wearing a multi-layered gown designed by the artist. The abstract, basketweave patterns of the matting at the base are repeated on the frame, also designed by the artist; they offset the naturalistic flowering almond branches at the left, which suggest Whistler's deep interest in Japanese art at this time. Like the following portrait of Montesquiou, that of Mrs. Leyland is signed with Whistler's emblematic butterfly, a pattern based on his initials JMW, and, like it, is imbued with the formalistic preoccupations of the nineteenth-century aesthetic movement. The portrait is in fact so totally a work of exquisite design that Whistler's contemporary Dante Gabriel Rossetti wrote of it, with some reason: "I cannot see that it is at all a likeness."

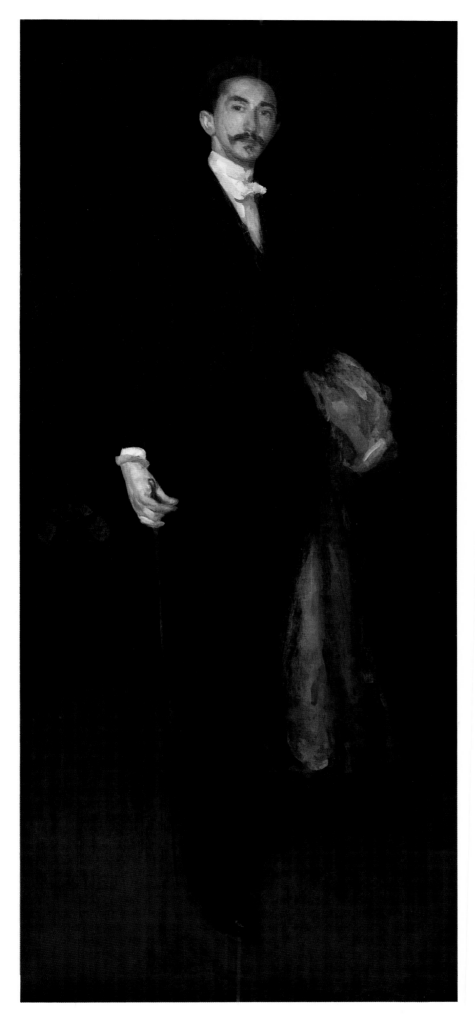

JAMES McNEILL WHISTLER

ARRANGEMENT IN BLACK AND GOLD: COMTE ROBERT DE MONTESQUIOU-FEZENSAC

Painted 1891–92. Oil on canvas
82 ⅛ x 36 ⅛ in. (208.6 x 91.8 cm.)
Acquired in 1914

This portrait of Comte Robert de Montesquiou-Fezensac (1855–1921), a prominent figure in the social, artistic, and intellectual circles of Paris, is the most modern painting in The Frick Collection, as well as one of the last large canvases Whistler finished. Though the artist and his subject had known one another since 1885, it was not until the spring of 1891 that work was begun on the portrait in Whistler's London studio. After countless posing sessions, it was completed the following summer in a studio Whistler was renting in Paris. It languished there for another two years, before being exhibited at the Salon of the Champ-de-Mars in 1894, where it provoked a flood of critical reviews, mostly enthusiastic.

The painting's extreme simplicity and somber palette recall the full-length portraits of Velázquez and anticipate certain reductive tendencies of twentieth-century abstraction, yet its spiritualistic character— many contemporaries described it as being like an apparition—relates it to Symbolist currents of the 1890s. Whistler's desire to capture the soul of Montesquiou is suggested by his final words to the exhausted model: "Look at me for an instant longer, *and you will look forever!*"

The garment shown hanging over the count's left arm was a chinchilla cape belonging to his beloved cousin and muse, Comtesse Élisabeth Greffulhe. Today, Montesquiou is probably best remembered as one of the models for the personage of the Baron de Charlus in Proust's *A la recherche du temps perdu.*

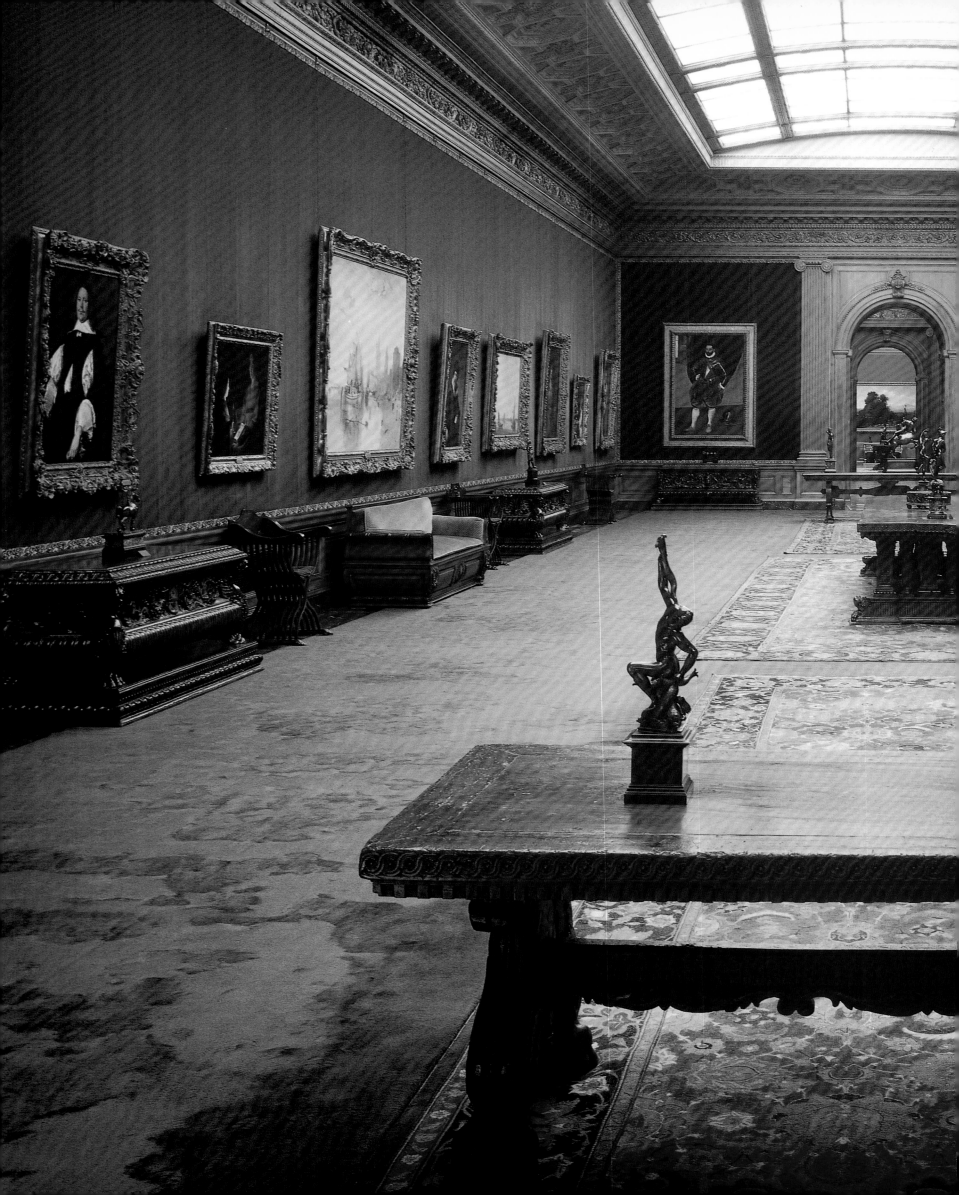

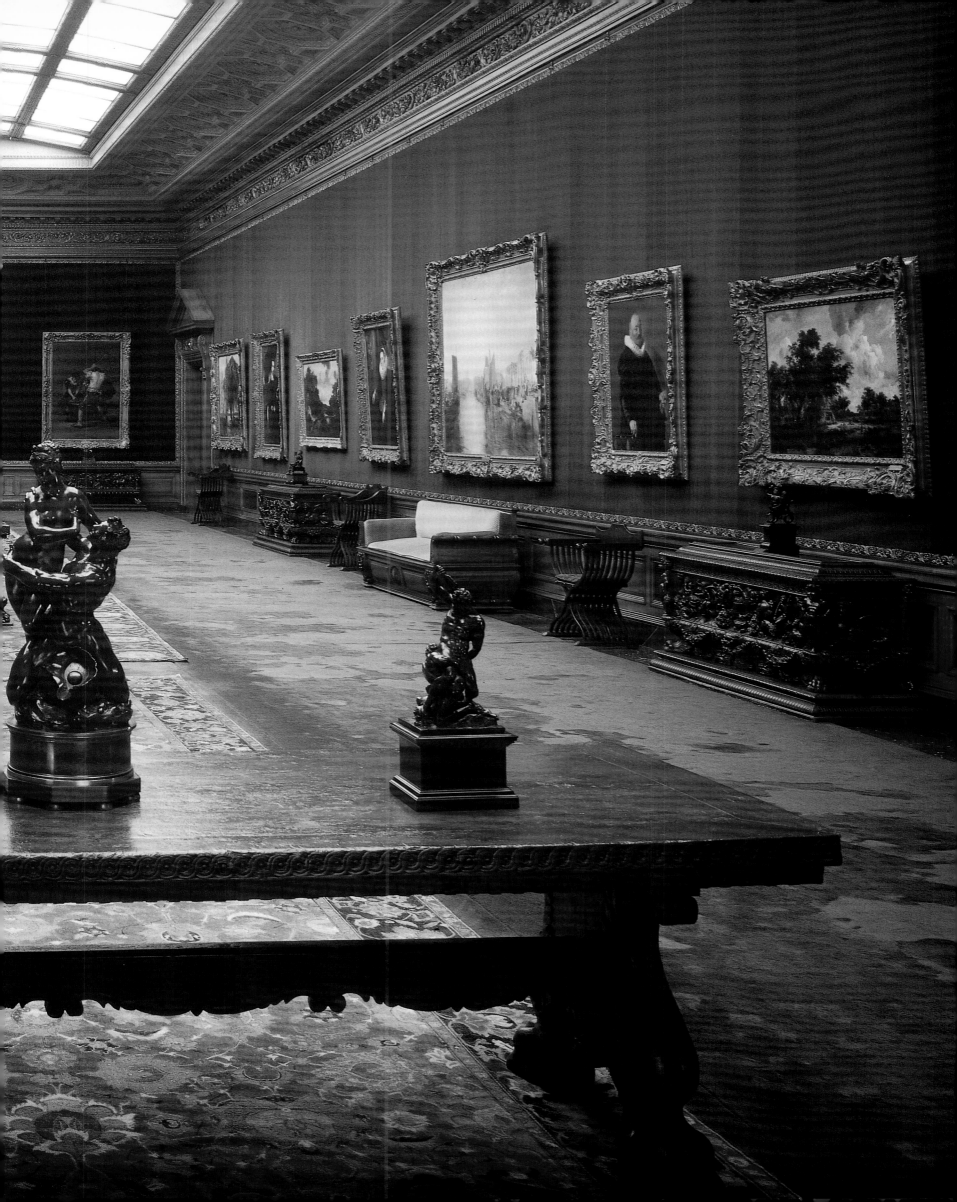

SCULPTURE

By Bernice Davidson

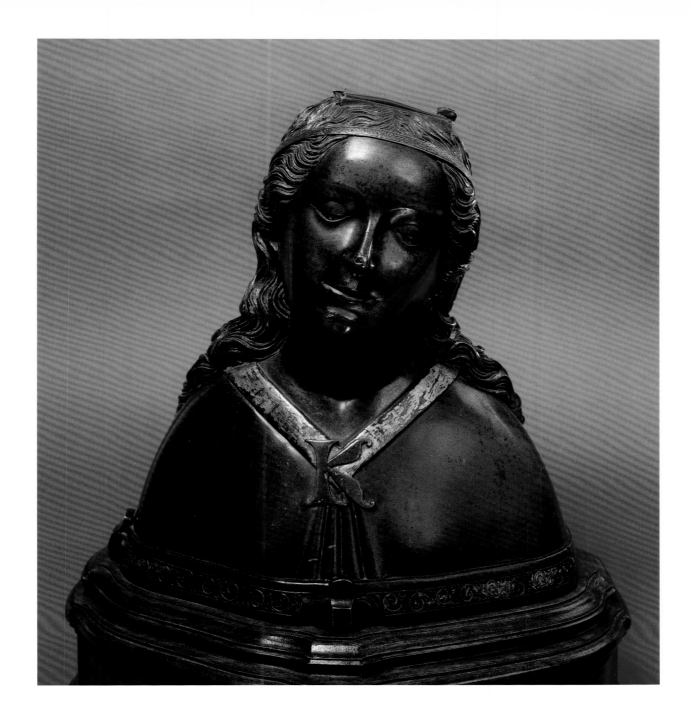

HANS MULTSCHER

c. 1400–1467

Multscher is believed to have traveled in his youth, perhaps to the Rhineland, Burgundy, and as far as the Netherlands. By 1427 he was recorded as a sculptor in Ulm. Multscher worked in other South German centers as well, producing both painting and sculpture, but his masterpiece may be the altar he made for a church in Sterzing (Vipiteno), in the South Tyrol near Bolzano.

RELIQUARY BUST OF A FEMALE SAINT

Made perhaps c. 1460.
Bronze, with traces of gilding
H. 12 ⅝ in. (32 cm.); W. 11 ⅞ in. (30.2 cm.);
D. 7 ⅛ in. (18.1 cm.)
Acquired in 1916

In the fifteenth century, Ulm, Augsburg, and several of the smaller towns of Swabia attracted many skilled painters and sculptors, but for the most part their identities are lost. Hans Multscher is an outstanding exception in this crowd of nameless artists, a master celebrated even beyond his home territory. The Frick reliquary, said to have come from a church in Galicia (now southeastern Poland), is attributed to him through comparison with his documented works in stone and wood—as are, although with less unanimity, a few bronze statuettes and plaquettes.

Sculpture made of bronze was rare in South Germany, metal casting being confined chiefly to utilitarian objects such as scales, weights, or bells. Lacking the rich heritage of antique bronzes that offered Italian artists inspiration and high standards of competence, German contemporaries were slow to adopt bronze as a medium for sculpture. The actual maker of this reliquary bust may have been a bell founder. The artist would have provided the bronze caster with a model, possibly carved in wood or stone, and may have played some role in the finely finished results. The gentle tilt of the head, the luxuriant flow of cascading curls, the delicate lines drawn from the corners of the eyes, the fringe of tiny dots suggesting lashes on the lower lids, all denote an artist of exceptional grace and imagination. Similarities between the reliquary bust and the female saints from Multscher's large altarpiece at Sterzing (1456–58) have prompted a late dating for the bronze, perhaps about 1460.

The initial K fastened to the gilded collar suggests that the bust once contained purported relics of St. Katherine of Alexandria, a widely loved and admired saint, said to have been a fourth-century noblewoman and martyr who dreamed that she became the bride of Christ. The saint's relics would have been placed inside the bronze through the rectangular opening at the top of the head.

JEAN BARBET

active 1475–d. 1514

Barbet's name is first recorded in 1475, inscribed on the wing of the bronze Angel *discussed below. In 1491 he was named "Cannonnier du Roy" at Lyon, where, in documents referring to him at subsequent dates, he appears to have been responsible for supervising the city's artillery and for casting cannon and cannonballs.*

ANGEL

Dated 1475. Bronze
H. overall 46 ¹¹⁄₁₆ in. (118.6 cm.)
Acquired in 1943

The inside of the *Angel's* left wing bears the highly unusual inscription: "*le xxvii¹ jour de mars / lan mil cccc lx + xv jehan barbet dit de lion fist cest angelot*" (on the 28ᵗʰ day of March in the year 1460 + 15 Jean Barbet, called of Lyon, made this angel). Barbet probably was not the artist who designed the *Angel* but the proud master craftsman who cast it so expertly that only minor flaws are visible in its beautifully burnished surface. Barbet's occupation had equipped him with the relevant skills, for after all, a founder who made defective cannons would not have had a brilliant career. Test cleaning patches suggest that the present dark patina of the sculpture veils a lighter, more golden hue, proper to the original bronze. The *Angel's* wings are attached by means of pins inserted through sockets, but the rest of the figure appears to have been cast as a single piece; the left hand may once have held a staff or cross.

Neither the name of the *Angel's* designer, assuming it was not Barbet, nor its destination or purpose is known. Floods, war, and the destruction wreaked upon Lyon during the Revolution obliterated almost all of the city's early artistic heritage, leaving records with names of its many sculptors but little of their work for comparison. Perhaps the bronze survived only because it was made in or for some other location; no provenance earlier than the nineteenth century has been traced, although an unconfirmed report asserted that it came from the Sainte-Chapelle in Paris. The intended function of this benign creature is equally enigmatic. It may have formed part of an altar or fountain complex. But similar pointing figures were employed as weathervanes, and a Gabriel pointing toward the Virgin is found in Annunciation groups. The *Angel's* serene expression and the quiet, contained dignity of the columnar figure bring to mind the paintings of a Flemish contemporary; the *Angel* could almost be a Memling cast in bronze.

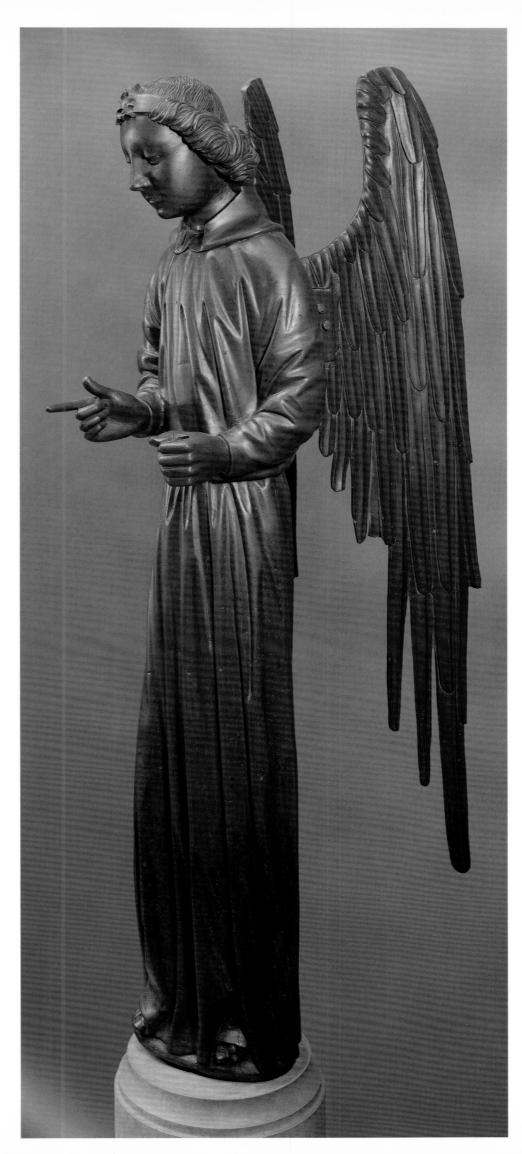

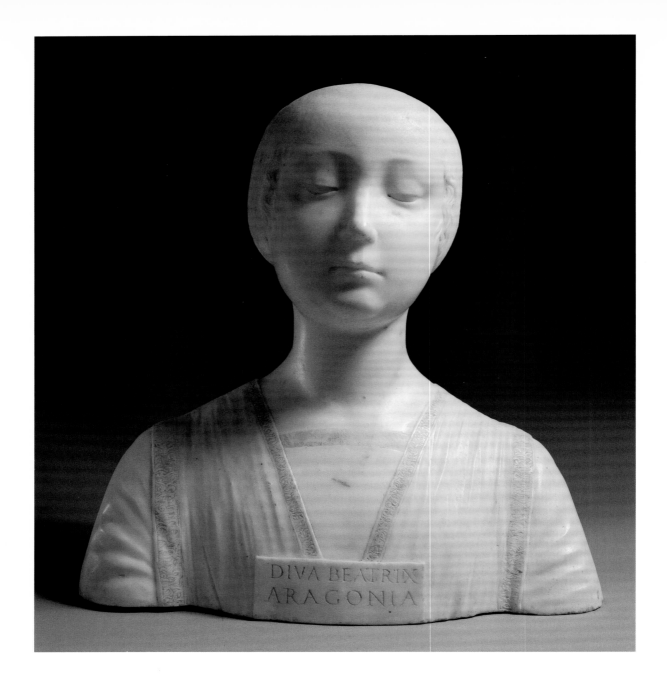

FRANCESCO LAURANA

c. 1430–c. 1502

The sculptor was born probably in the small town of Urena (or Laurena), near modern Zadar on the coast of Croatia in what was then the Venetian territory of Dalmatia. He was first documented in 1453 working at Naples for Alfonso I of Aragon. From 1461 to 1466 Laurana was in France, employed chiefly at the court of René of Anjou, where he returned after periods of activity in Naples and Sicily. Documents mention Laurana in Avignon and Marseille from the 1470s through the 1490s.

BEATRICE OF ARAGON

Made probably in the 1470s. Marble
H. 16 in. (40.6 cm.); W. 15 ⅞ in. (40.4 cm.);
D. 7 ⅞ in. (20 cm.)
Bequest of John D. Rockefeller, Jr., 1961

Beatrice (1457–1508), daughter of Ferdinand I, King of Naples, had suffered through several attempts to marry her off before she became the third wife of Matthias Corvinus, King of Hungary. An outstanding soldier and statesman, Matthias presided over a court that was a magnet for artists and writers. Beatrice herself was well-educated and fluent in languages, with strong artistic and intellectual interests. She remained in Hungary until 1501, long after her husband's death in 1490. She died, childless, in Naples. Laurana probably portrayed Beatrice before her marriage and coronation in 1476. Indeed, her delicate features look almost childlike, although hints may be detected already of the thickening nose and double chin so pronounced in the more mature likeness of her in the Museum of History, Budapest. It is possible that the portrait bust was prepared for one or another of Beatrice's prospective bridegrooms.

Although recent archival discoveries have enlarged Laurana's slender dossier, the chronology of his peripatetic career has many gaps. Attempts to identify examples of his early sculpture in Dalmatia have unearthed promising but inconclusive candidates. And although he is recorded in Naples in 1453, probably working on the entrance archway of the Castelnuovo, his possible contributions to that complex are conjectural. Dated medals by Laurana place him at the court of René of Anjou from 1461 to 1466, while documented sculptures reveal that he was working in Sicily on various projects in 1468 and 1471, that he was in Naples in 1474, and that shortly thereafter he returned to France, where he seems to have spent most of his remaining years.

Because much of Laurana's work at these scattered sites has been lost and most of the larger surviving monuments are in locations seldom visited by the average traveler, he is best known for his idealized marble busts of women. The formal abstraction characteristic of these busts derives in part from late Gothic sculpture—from such works as Multscher's *Reliquary Bust*, the Barbet *Angel*, and the medieval reliquaries of Laurana's native Dalmatia. But his simplified shapes go beyond inherited tradition and seem the result of a conscious, consistent striving toward a geometric perfection of form that relates his work to such Italian Renaissance artists as Piero della Francesca.

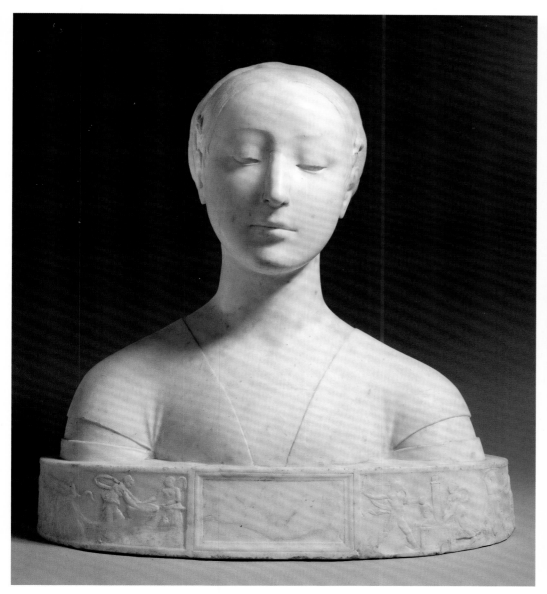
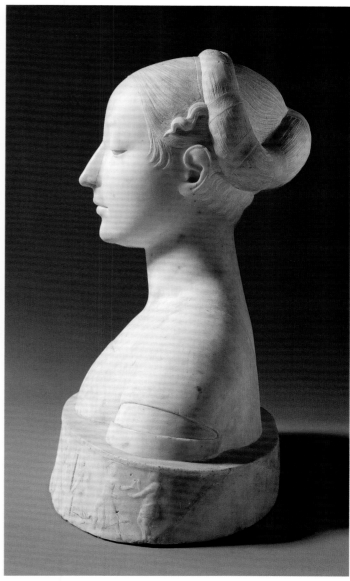

FRANCESCO LAURANA

BUST OF A LADY

Date unknown. Marble
H. 18 ¾ in. (46.6 cm.); W. 18 in. (45.8 cm.);
D. 9 ⅜ in. (23.9 cm.)
Acquired in 1916

Far fewer male portraits are attributed to Laurana than portrait busts of women, possibly because the men are more varied and less easily recognized. Laurana's male heads —such as those in the large marble relief of *Christ Carrying the Cross* in the church of Saint-Didier, Avignon, and certain portraits in Sicily—are strongly characterized, even idiosyncratic. The surviving female busts are far more consistent in type and style. These include two named by inscriptions (one being the preceding *Beatrice of Aragon*), several tentatively identified through compari-

son with other portraits, and at least two others known to be idealized, posthumous commemorations. Because they are so similar and so abstract, it is difficult to judge from the works themselves how closely they approximate a living likeness.

The lady portrayed in the present marble bust has not yet been identified. If the enigmatic reliefs decorating the base offer clues to her identity, their message has resisted translation, although many theories have been proposed. As the bust was discovered in Marseille, the work may date from after Laurana's return to France in 1477, and the sitter might be French. This portrait retains even fewer traces of individual particularity than the *Beatrice of Aragon*. The marble is composed entirely of harmonious shapes, suavely orchestrated curves, and smoothly flowing surfaces. Like Multscher's saint and Barbet's angel, Laurana's aristocratic ladies with their downcast eyes seem to withdraw from the quotidian distractions of life.

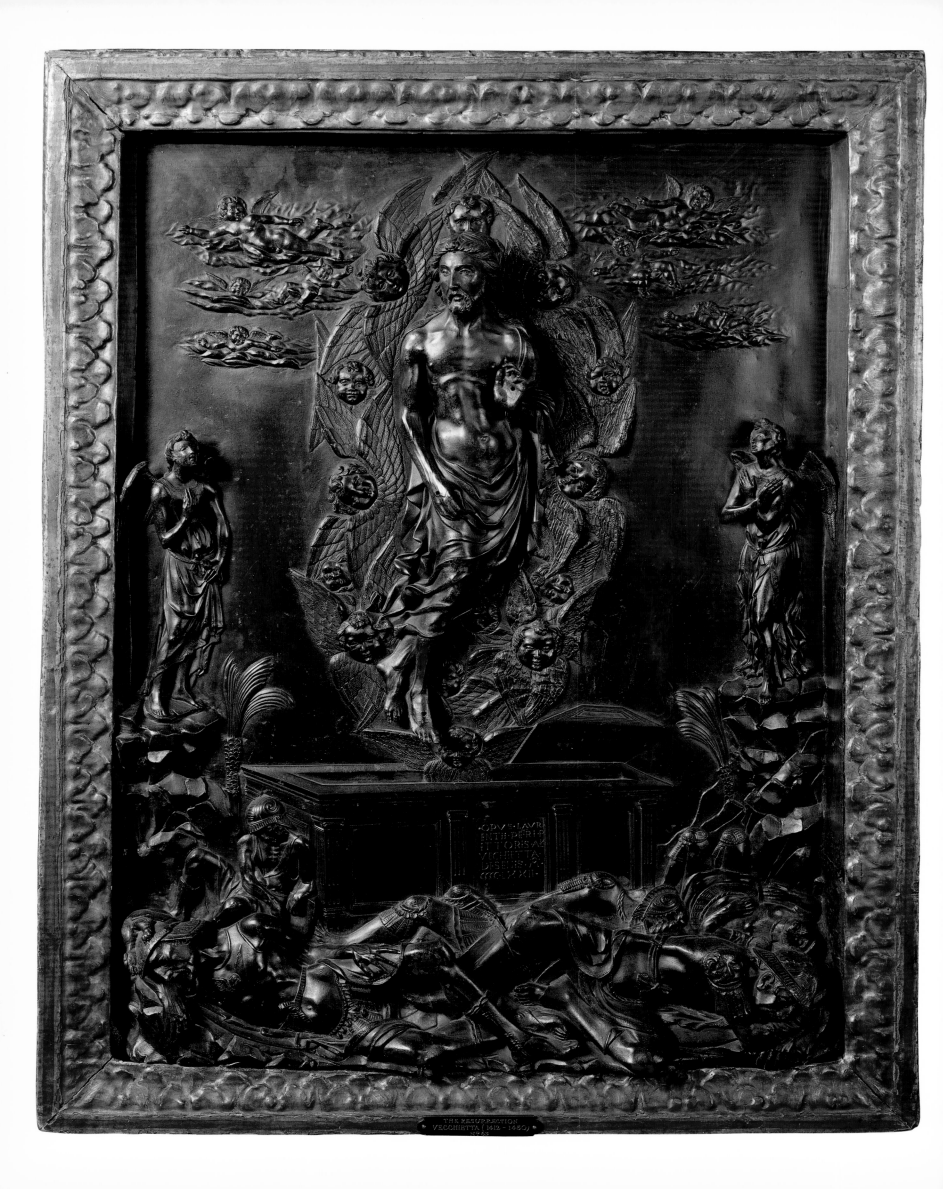

VECCHIETTA (LORENZO DI PIERO DI GIOVANNI) 1410–1480

Lorenzo di Piero di Giovanni, known from an early age as Vecchietta, or "little old woman," was prominent as both painter and sculptor in Siena. First noted for his sculpture in polychrome wood, he later turned to bronze, influenced by the example of Donatello, who worked in Siena during the 1450s. Vecchietta also received commissions elsewhere in Tuscany and in Rome, which he visited at least twice. The election in 1458 of a Sienese compatriot to the papacy as Pius II no doubt enhanced his career.

THE RESURRECTION

Dated 1472. Bronze relief
H. 21 ⅜ in. (54.3 cm.); W. 16 ¼ in. (41.2 cm.)
Acquired in 1916

Small bronzes almost always present problems of attribution. A bronze is rarely signed, dated, or otherwise documented—for example by a provenance leading directly back to an early inventory, by accounts of payments identifying it, or by contemporary letters describing the work. Most attributions rest on tradition, on close parallels with other, authenticated, sculpture by the artist, or simply on the eye and experience of the connoisseur attaching a name to the piece. Only two works in The Frick Collection belong to the unusual genus of bronzes that are both signed and dated: the Barbet *Angel* is one, the Vecchietta *Resurrection* the other. The original function of the *Resurrection* relief is unknown, although it may have served as the door to a tabernacle. Whatever its destination, the artist clearly took pride in his achievement, for he inscribed his name and the date prominently on Christ's tomb: OPVS·LAVR / ENTII·PETRI·P / ITTORIS·AL /VECHIETTA· / DE SENIS· M̄· / CCCC·LXXII. (The work of Lorenzo di Piero painter called Vechietta of Siena 1472).

In this late work Vecchietta demonstrates his awareness of the humanist currents of the day by the classicizing style of the sarcophagus and the antiquarian details of the Roman soldiers' armor. But the arbitrary scale of his figures and the tomb's skewed perspective look back to medieval conventions, seen, for example, in the Frick *Temptation of Christ*, painted by Duccio in Siena more than 150 years earlier (see p. 37). This blending of selected elements from the new style that was spreading from nearby Florence with local late Gothic traditions is characteristic of Sienese artists well into the sixteenth century.

For his composition Vecchietta seems to have studied a work executed over half a century earlier: Lorenzo Ghiberti's *Resurrection* on the North Door of the Florence Baptistry. But he modified the linear suavity of that still partially medieval bronze with a more dramatic, expressive sharpness and tension derived from Donatello. Vecchietta's career as a painter, referred to in the inscription, is suggested as well through the pictorial complexity of the bronze and its abundance of detail. Within the shallow recession of the relief he creates a surprising illusion of depth, moving back from the protruding, harshly angular crush of soldiers in the foreground to the low-relief angels swimming peacefully among the clouds. Realistic touches throughout help to place convincingly within the physical world an intensely spiritual apparition.

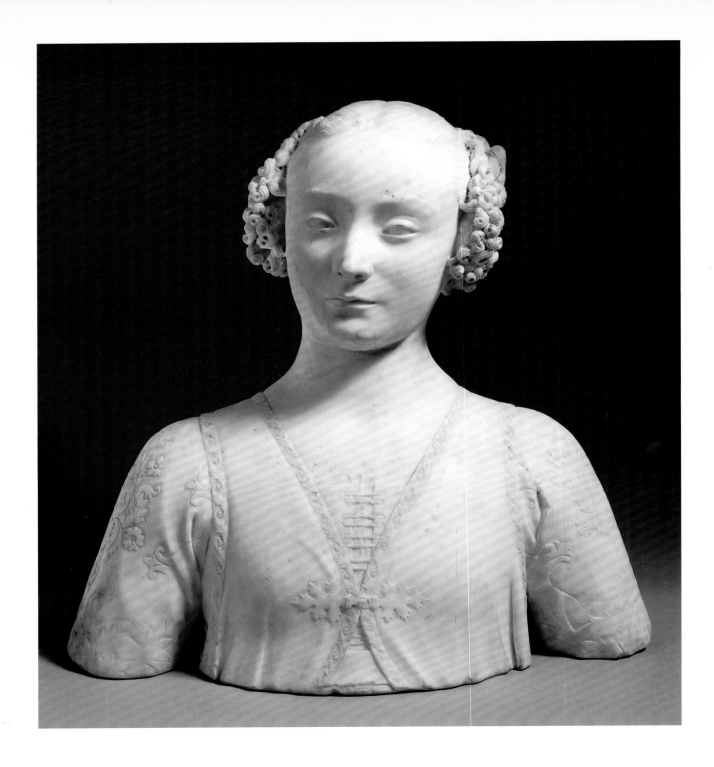

ANDREA DEL VERROCCHIO
1435–1488

Born and buried in Florence, Verrocchio worked in his native city and nearby towns until the last years of his life. Like many other Renaissance sculptors, he started his career as a goldsmith and became equally successful as a painter. His shop provided training for numerous Florentine artists, from Botticelli to Leonardo da Vinci. He was a favorite of the Medici, for whom he designed tombs in S. Lorenzo and the famous bronze figure of David now in the Bargello, Florence. Among other important commissions was the monumental bronze equestrian statue of Bartolommeo Colleoni, in Venice, which Verrocchio was working on at the time of his death.

BUST OF A YOUNG WOMAN

Date unknown. Marble
H. 18 ⅞ in. (48 cm.); W. 19 ³/₁₆ in. (48.7 cm.);
D. 9 ⅜ in. (23.8 cm.)
Bequest of John D. Rockefeller, Jr., 1961

Although it is neither signed nor documented, the marble bust is convincingly attributed to Verrocchio through comparison with other works known to be by him. Despite the coat of arms emblazoned on both her sleeves, the subject of the portrait has not been identified. Unlike any of the preceding figures discussed, whether saint, angel, or gentlewoman, this young lady decidedly belongs to the world she inhabits. She is a person with claims to wealth and fashion. Her elaborate coiffure of twists and ringlets is bound up with ribbons and rosettes. The laced bodice and the floral-patterned tunic of brocade or cut-velvet, fas-

tened with a foliate buckle, are all exquisitely detailed by the sculptor, who was noted for the precious clasps he made for copes. She herself has a physical presence, a body delicately but visibly shaped beneath the rich clothing, and she seems to respond to some external presence sharing her space. The slight tilt and twist of the head and her alert look suggest a mind actively engaged with its surroundings.

This sense of a fleeting moment captured—the animation, both physical and spiritual—is characteristic of Verrocchio's best-known sculpture, such as his *David* and the *Putto Clutching a Dolphin*, or the dramatic narrative of *Christ and St. Thomas* for Orsanmichele, Florence. More than any of his predecessors, Verrocchio could inspire his figures with an inner life, an achievement that his pupil Leonardo would explore in his paintings with unmatched complexity and subtlety.

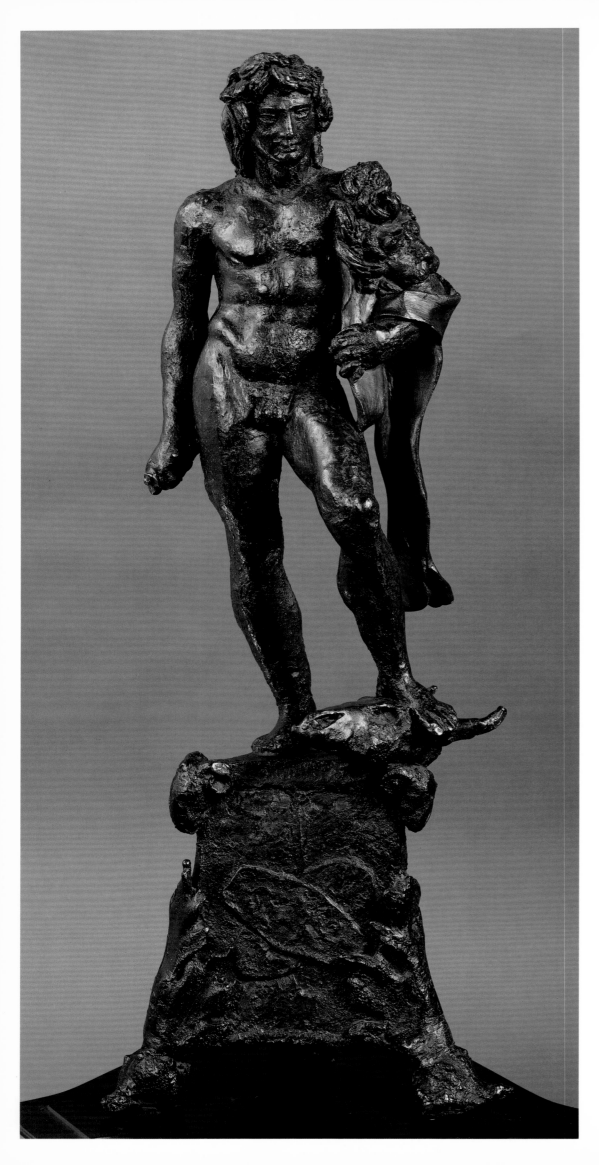

ANTONIO DEL POLLAIUOLO
1431/32–1498

Antonio Benci, called "del Pollaiuolo"
after his father's poultry business, excelled
in virtually all the arts: painting, sculpture,
drawing, enamelwork, objects in gold and
silver, as well as designs for everything
from embroidery to architecture. Like his
contemporary Verrocchio, Pollaiuolo was
a favorite of the Medici; Lorenzo de' Medici
once described him as "the principal master
of the city." He also worked for the Sforza
of Milan, and late in his career he went
to Rome, where, with the assistance of his
brother Piero, he made the magnificent
bronze tombs in St. Peter's for Popes
Sixtus IV and Innocent VIII.

HERCULES

Date unknown. Bronze
H. overall 17 ⅝ in. (44.1 cm.);
H. of figure 11 ¾ in. (30 cm.)
Acquired in 1916

Perhaps even more than Verrocchio, Pol-
laiuolo embodies what is thought of as the
quintessential Florentine Renaissance artist.
He was innovative and unsurpassed in any
branch of art he chose to practice. His
works seem to radiate a positive, energetic
attitude, combining with a new mastery of
the athletic male nude often dramatic
extremes of passion.

This virile bronze figure of *Hercules*
appears tough, confident, and triumphant—
a hardy progenitor of Michelangelo's colos-
sal *David*, icon of the next generation of the
Renaissance in Florence. The bronze, too,
seems a monument to a hero, however small
and roughly finished. As a personification
of virtue and fortitude, a warrior who
fought against tyranny, and as the legendary
founder of Florence, Hercules was a local
hero. Not only Florence but also the Medici
claimed him as their emblem. Pollaiuolo
created numerous images of Hercules,
among them a painted series of the *Labors of
Hercules*, now lost, for the Medici Palace.
Hercules and Antaeus (Bargello, Florence), a
bronze depicting a fierce mortal combat
that was revolutionary for its day, probably
also was made for the Medici.

Although the provenance of the Frick
Hercules has not been traced earlier than the
beginning of the twentieth century, the
attribution to Pollaiuolo has found almost
universal acceptance. The figure is solid-cast
in a single piece with the pedestal. Its rough
state has prompted speculation that it was
cast from a damaged wax model, perhaps
one that was left unfinished in the sculptor's
studio at his death. The figure, which betrays
a strong classical influence, may have been
conceived late in Pollaiuolo's career, during
the period when he worked on the papal
tombs in St. Peter's and could study Rome's
antiquities. The horned skull beneath the

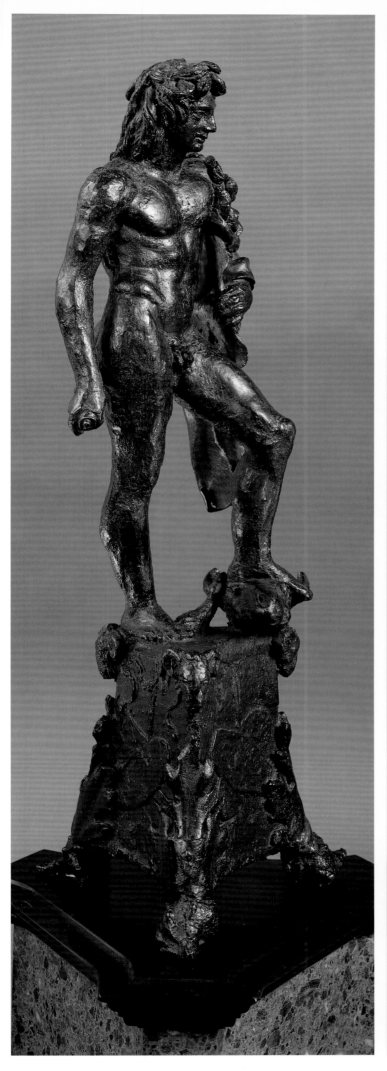

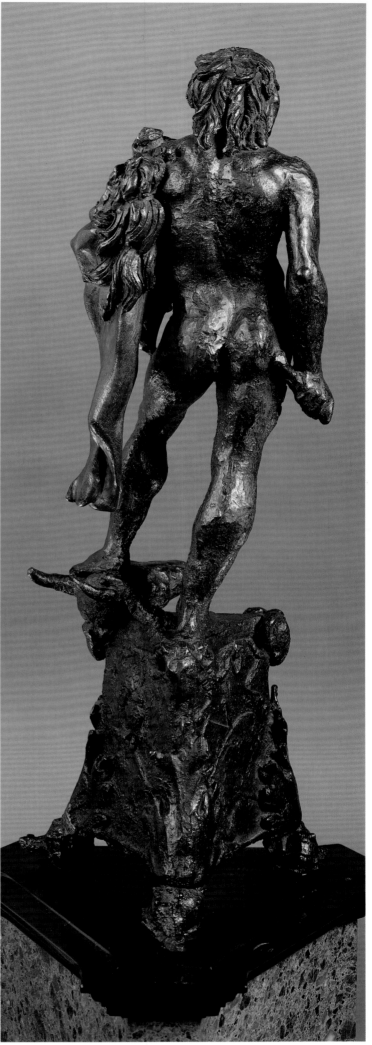

hero's left foot may signify that he represents Hercules Invictus (Unconquered), to whom a bull was sacrificed annually in ancient Rome.

Freestanding bronze statuettes began to be developed fully as an art form during the second half of the fifteenth century; Pollaiuolo was an early, influential master of the genre. Such small bronzes were often displayed on shelves or mantels above eye level, but many were intended to be picked up and handled, and thus, like the Hercules, to be seen from more than one side.

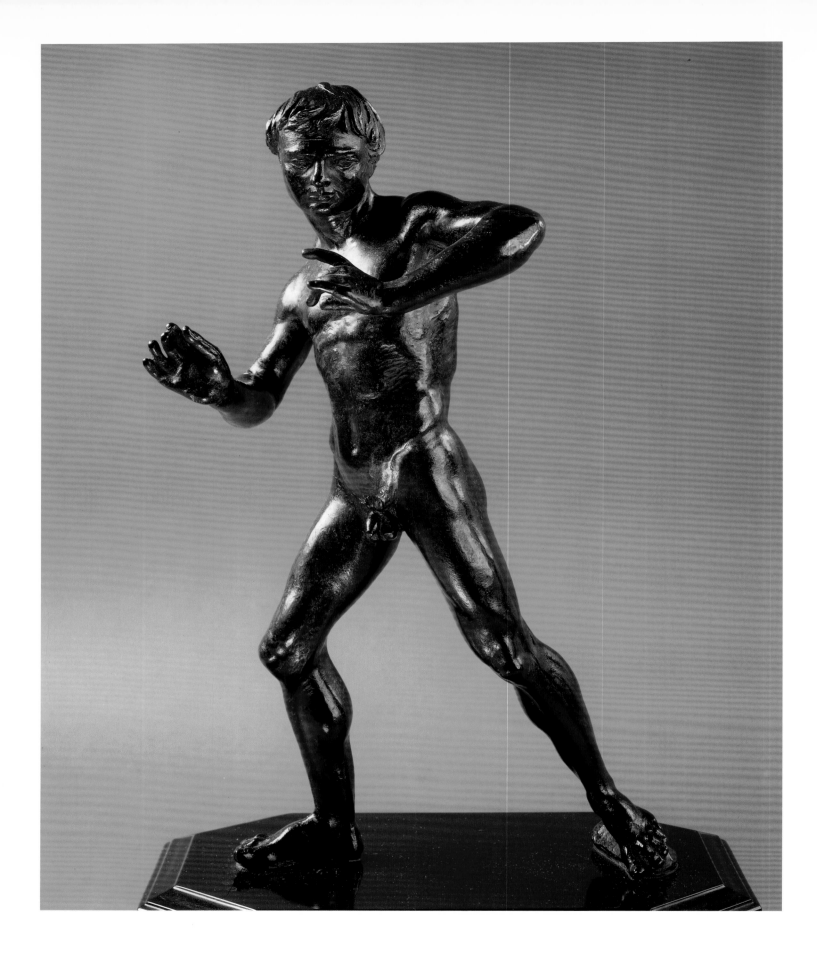

ANTONIO DEL POLLAIUOLO, STYLE OF

MARSYAS

Date unknown. Bronze
H. 13 ¾ in. (34.9 cm.)
Acquired in 1916

This lithe but sturdy figure is considered the finest variant of a popular model believed to be based on an antique prototype and to represent Marsyas. According to mythology, Marsyas was a satyr who picked up a flute discarded by Athena (because she felt that it distorted her face when she blew it) and became a skilled musician on the instrument. In some versions of the bronze, the subject wears the face bandage used by Greek and Roman flute players. The hands would originally have held a double flute. Images of and derivations from the type are also found in *quattrocento* frescoes and draw-

ings, from Florence to Padua, Pisa to Loreto.

Attributions to artists conceivably responsible for the present bronze have ranged with similar breadth, from Florence to North Italy, but whatever its authorship it seems likely that Pollaiuolo's taut, wiry nudes influenced the sculptor. The troubled brow and dodging stride of this young athlete may have led to identification of the model in some early inventories as "Paura" (Fear). Although inspired by an antique Marsyas, the Frick bronze lacks the little tail, horns, or pointed ears of a satyr and may indeed represent the state of fear.

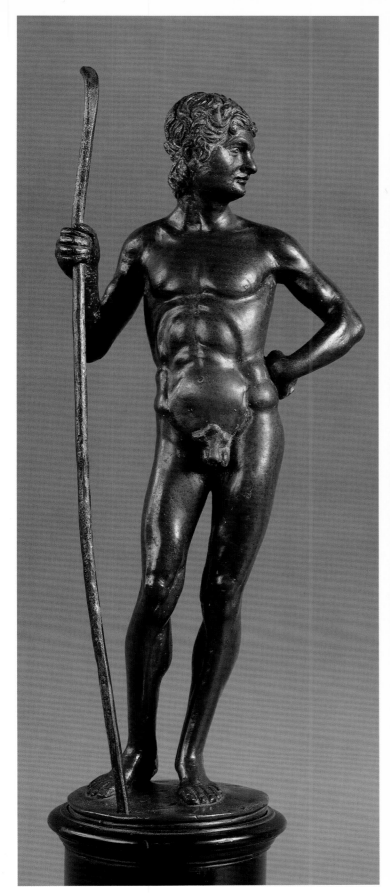
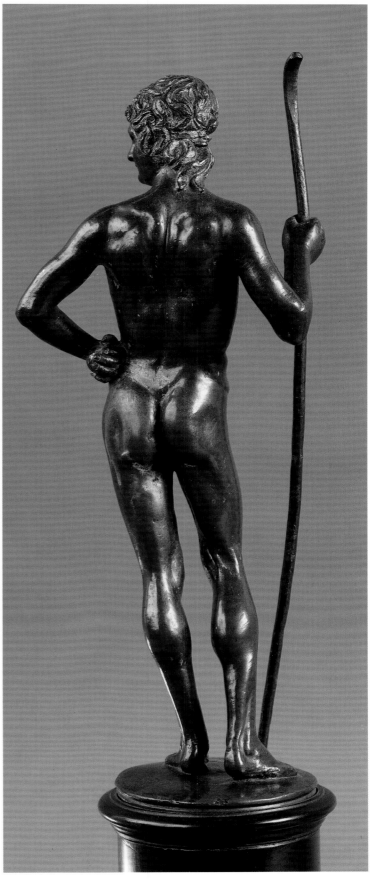

ANTONIO DEL POLLAIUOLO, STYLE OF

PARIS

Date unknown. Bronze, with traces of gilding
H. to top of staff 10 ¾ in. (27.4 cm.)
Acquired in 1916

Like drawings and prints, small bronzes traveled easily, and their influence spread widely. By the sixteenth century, emulations of Italian examples could be found in many European centers, and once methods of multiple reproduction were perfected, a thriving export trade in bronze statuettes developed. The dissemination of Italian models can complicate problems of attribution, as with this figure of *Paris*, which is sometimes believed to be a sixteenth-century German imitation of Pollaiuolo but seems more likely to be by a fifteenth-century Florentine sculptor. The lean, knobby-jointed figure, with its schematized musculature and jaunty pose, reflects a type of nude found repeatedly in the art of Pollaiuolo, particularly in works of various media, including paintings and drawings, believed to date earlier than the probable date of the Frick *Hercules*.

Paris, the Trojan prince reared as a shepherd, leans lightly on his curving shepherd's staff and holds in his left hand the apple of discord. Paris awarded the apple to Venus as prize in a beauty contest, thereby offending the other competitors, Juno and Athena, a judgment that led to the Trojan War. Some casts of this bronze have a companion figure of Venus. The Frick version is perhaps the finest of ten known casts of similar models.

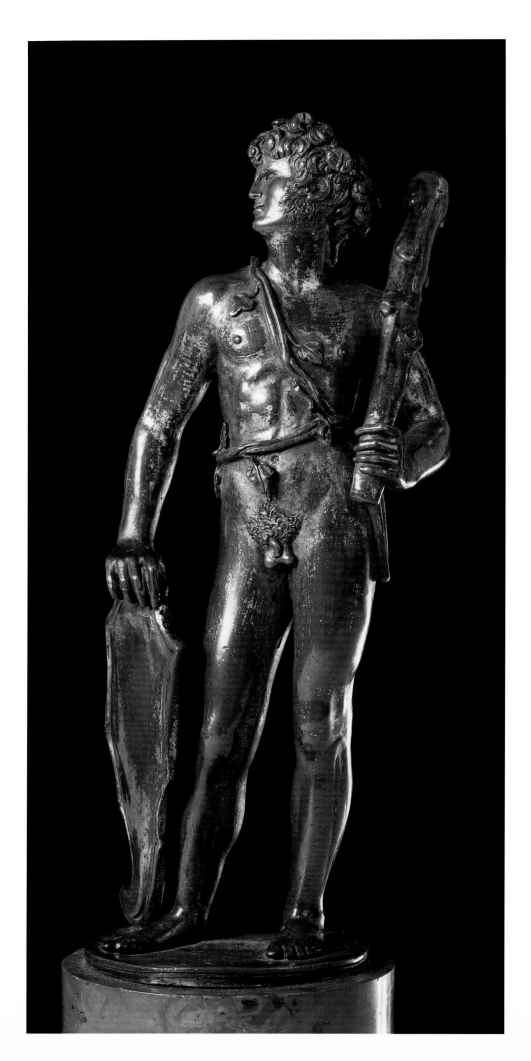

BERTOLDO DI GIOVANNI
1420/30?–1491

*Like Verrocchio and Pollaiuolo, Bertoldo
spent most of his life in Florence and
enjoyed close ties to the Medici household.
In his early years a disciple of Donatello,
Bertoldo in turn bridged the generations to
Michelangelo, to whom he is said to have
offered guidance in the Medici Gardens,
where many Florentine artists studied the
collection of ancient and modern sculpture.
Bertoldo's range, however, was limited,
for he evidently confined his attention to
sculpture alone, and to reliefs, medals, and
small bronzes rather than works on a
monumental scale.*

HERALDIC WILD MAN

Date unknown.
Bronze, with extensive traces of gilding
H. 8 13/16 in. (22.4 cm.)
Acquired in 1916

Less celebrated than his contemporaries
Pollaiuolo and Verrocchio, Bertoldo was
nevertheless cherished by Lorenzo de'
Medici. In his later years he lived in the
Medici Palace, and he died in Lorenzo's villa
at Poggio a Caiano. Bertoldo knew the
humanist scholars and literati of Lorenzo's
circle and was familiar with the ancient art
and literature so amply available in Medici
and other Florentine collections.

His gilded bronze shield bearer owes its
pose to some classical model, perhaps a sar-
cophagus relief of Apollo, and incorporates
other references to the ancient past. Unlike
the bronze perhaps representing either
Marsyas or "Fear," Bertoldo's figure does
sport the tail and horns (although not the
pointed ears) of a satyr. He carries a club, is
crowned with a wreath, and wears a garland
of vine leaves from which hangs at his hip a
set of panpipes. The shield he holds is a
modern replacement derived from one held
by a companion figure in the Liechtenstein
collection, Vaduz. Both figures have been
associated with a third bronze by Bertoldo
in the Galleria Estense, Modena, of a man
on horseback, thought to represent Hercules.

If indeed the three Bertoldo bronzes
were conceived as a group, with the shield
bearers flanking the equestrian, it has been
further hypothesized that this ensemble was
designed for Ercole d'Este, Duke of Ferrara,
who made reference to his name by tending
to favor Herculean imagery. The conflation
of so many classical motifs alluding to Her-
cules, wild men, and satyrs, and including
garlands and the bacchic accouterments of
vine leaves and pipes, suggests to some an
iconography associated with wedding cele-
brations. An interesting but highly specula-
tive theory? proceeds to link the commission
for the group with the marriage of Ercole
d'Este and Eleanora Gonzaga in 1473. With-
out documentation, however, the chain of
evidence is too slight to bear much weight.

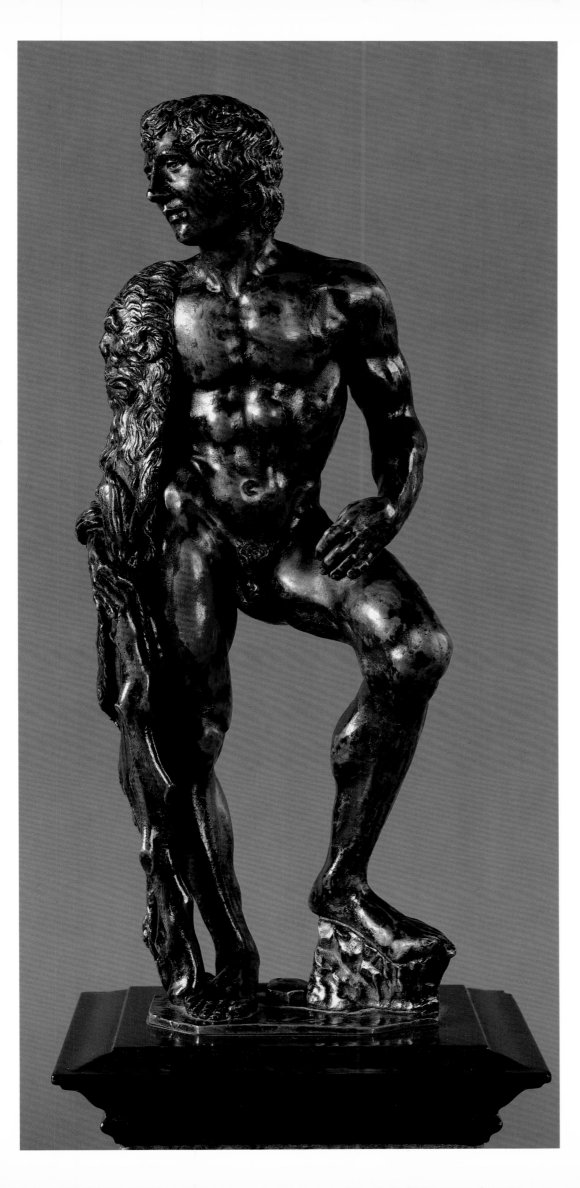

FLORENTINE
Early sixteenth century

HERCULES IN REPOSE

Date unknown. Bronze
H. 10 ¹⁄₁₆ in. (25.5 cm.)
Acquired in 1916

Attributions for this Hercules have ranged widely, with perceived connections to Bertoldo, Pollaiuolo, and particularly to Verrocchio favored. Some, however, have sought to place the bronze in the circle of Michelangelo, dating it as late as the second decade of the sixteenth century. Despite its awkward anatomy, the statuette's rude vigor of pose and strong, fluent modeling are attractive, and its faults are almost endearing. Hercules seems composed of mismatched body parts. Were he to shift his weight, the long left leg when straightened would leave its mate suspended in midair. The stunted torso is a poor fit to head and legs, and the huge feet should be attached to a much larger figure. Draped over the hero's shoulder is a lion skin, and juxtaposed to his youthful, rather pensive face is the head of a lion who looks like a somewhat grumpy old man.

It is hard to account for the manifest strengths and weaknesses combined in this powerful little figure, but surely lack of experience—whether due to the unknown artist's youth or to his unfamiliarity with the medium—must have played some part.

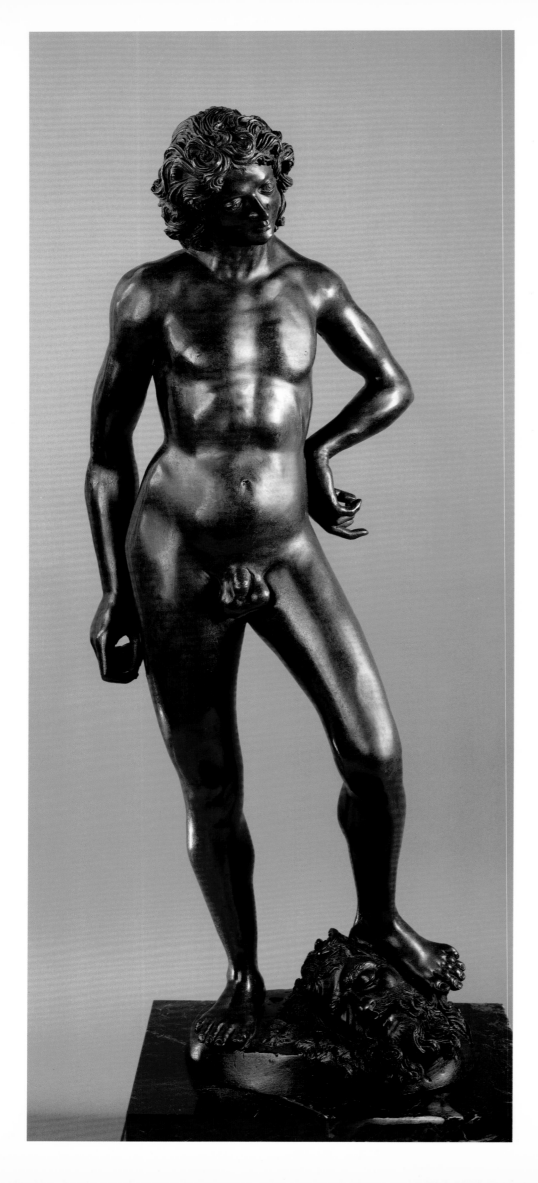

FLORENTINE
Early sixteenth century

DAVID

Date unknown. Bronze
H. 29 ½ in. (74.9 cm.)
Acquired in 1916

The preceding figure of *Hercules* and this *David* appear to have little in common: the one being squat, vigorous, and modeled with lively, rippling surfaces; the other, large for an early Renaissance bronze, of elongated stature, smoothly polished, faintly languid, and far more relaxed than *Hercules in Repose*. Yet this piece too has been attributed to Pollaiuolo and to Verrocchio as well as to Florentine sculptors of the next generation such as Baccio da Montelupo. The artist obviously was influenced by the two most celebrated *David* statues of the fifteenth century: the large bronze figures in the Bargello, Florence, by Donatello and Verrocchio. In his pose and the adolescent immaturity of his soft, unmuscular body, this *David* combines elements of both famous antecedents. Like Hercules, David was a civic icon for Florence, representing victory over tyranny and oppression; the two heroes were portrayed repeatedly in Florentine art.

Florentine bronzes until quite late in the sixteenth century were less advanced technically than sculpture made in the north of Italy, a region also noted for its production of arms and armor. Almost without exception, Florentine bronzes were cast directly from a wax model, a relatively simple method for accurately reproducing an artist's original work. When the model was encased in a clay mold and baked, the wax melted out through an exit channel, or sprue, and molten metal could then be poured into the clay mold to replace it. This procedure is known as the lost-wax method, since the original wax model dissolves and can never be reused. Once the metal cooled, the clay mold was cut away to reveal the enclosed bronze form, which was then chased, polished, and, if necessary, repaired. Solid casts of this sort were more susceptible to defects than hollow casts, as well as being more wasteful of costly metals. Variations in temperature or in thickness of parts could result in bubbles, cracks, and breakage. To produce a hollow cast, the wax model was built around a core of dried clay to which it was attached by pins, and the wax was then, as in making the solid cast, encased in a clay mold. When the molten metal was poured into the case to replace the wax model, the core remained within the metal shell; sometimes the core was chipped away and removed through an opening at the bottom of the bronze.

The figure of *David* is a direct cast, but it is hollow, with unusually irregular thickness of the bronze shell and several patches and repairs, suggesting perhaps a certain lack of experience in casting so large a piece. David's right hand may once have held his weapon, possibly a sling which had been cast separately.

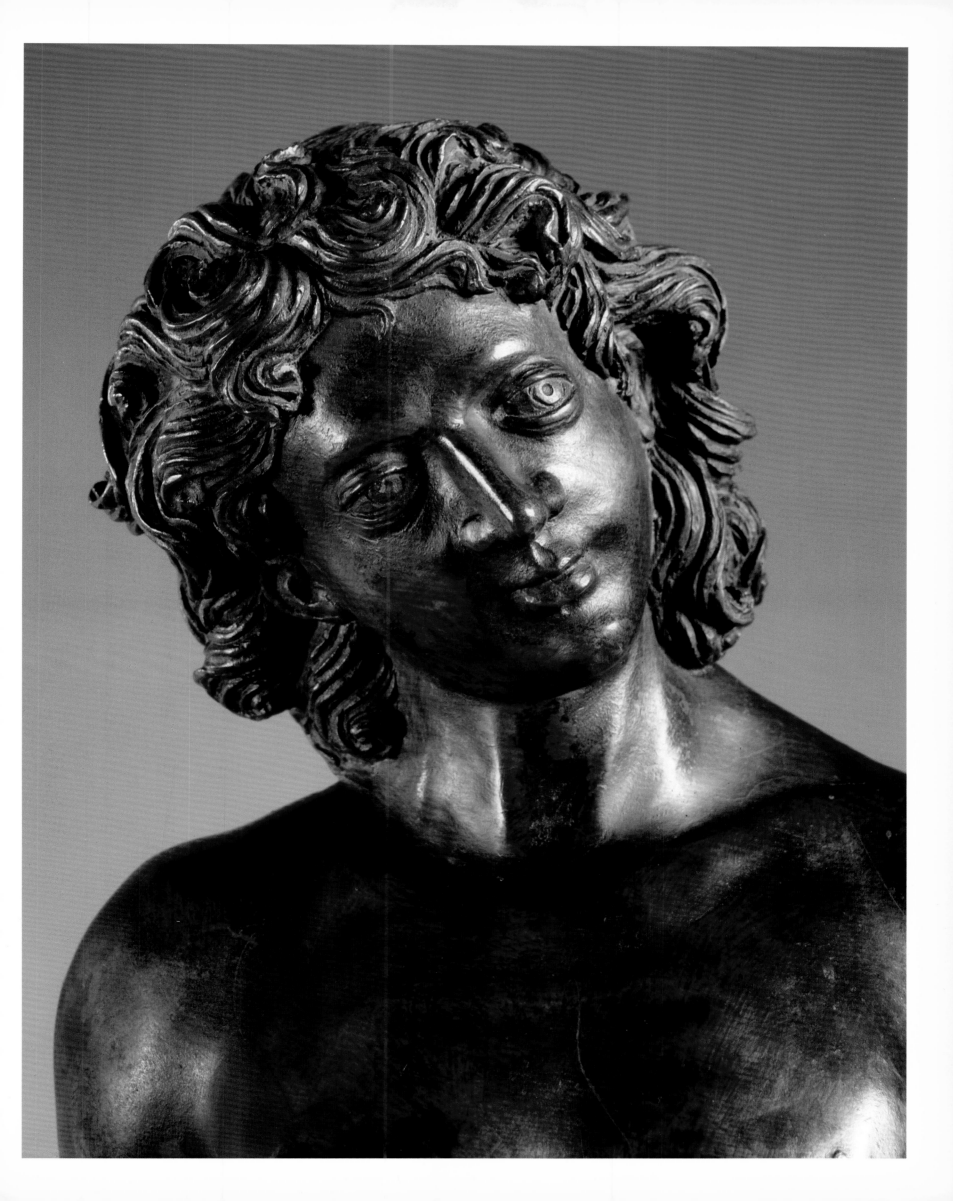

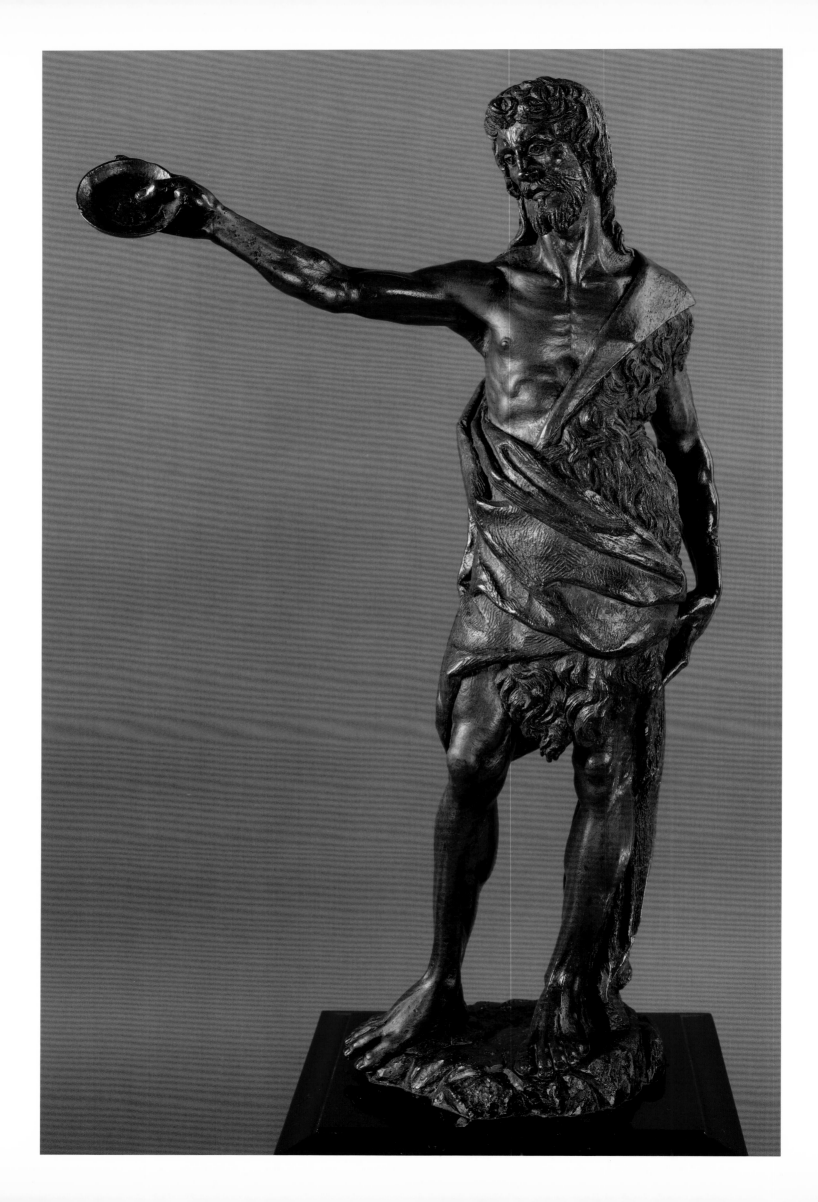

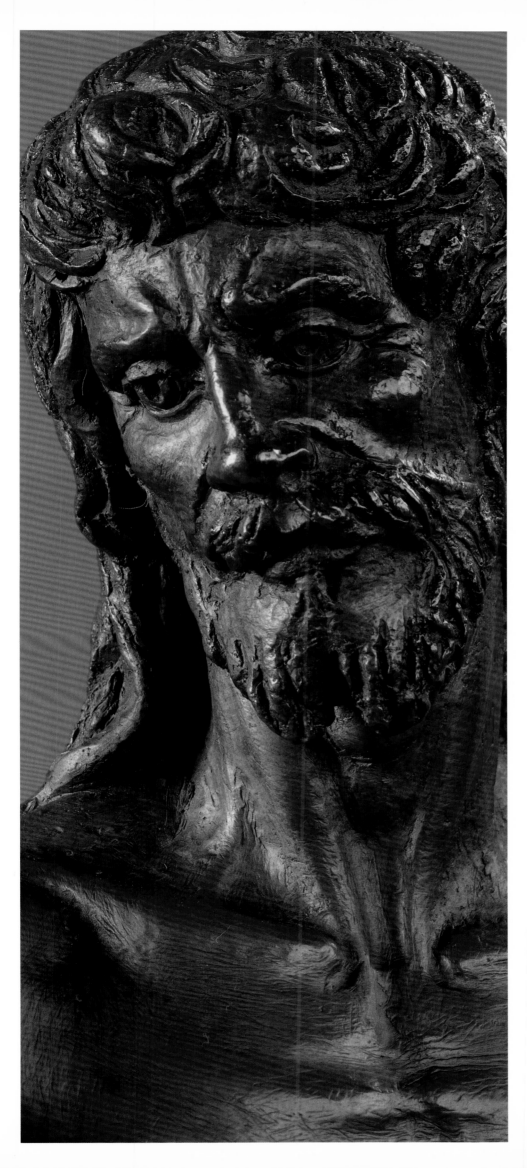

FRANCESCO DA SANGALLO
1484–1576

Member of an artistic family which included notable architects and sculptors, Francesco may have worked as both architect and military engineer, but he is known primarily as a sculptor in marble. He was a pupil of his father, Giuliano, and he assisted Andrea Sansovino with sculpture for the Santa Casa at Loreto. His first important commission, dated 1526, was a Madonna and Child with St. Anne *for Orsanmichele, Florence. Later sepulchral monuments by Francesco were sometimes eerily expressive and realistic.*

ST. JOHN BAPTIZING

Made probably between 1535 and 1538. Bronze
H. 20 ⅞ in. (53.1 cm.)
Acquired in 1916

To the forementioned civic heroes of Florence—Hercules and David—a third must be added: John the Baptist, patron saint of the city. Sangallo's bronze figure of this saint in the act of baptizing, a masterpiece of sixteenth-century Florentine sculpture, is the most profoundly expressive Renaissance bronze in The Frick Collection.

Sangallo is known to have produced a dozen medals during his long career, but *St. John* is his only authenticated bronze statue. Signed by the sculptor but not dated, the figure was made for the baptismal font of S. Maria delle Carceri at Prato, probably about 1535–38. It was sold by the church before the end of the nineteenth century, and a replica took its place. Other replicas also exist.

The bronze is solid cast and therefore very heavy. Problems during the casting produced flaws, the most obvious being one in the left arm. But any difficulties experienced in the production of this bronze were secondary to the success of its completed state. The surfaces of the figure are inventively finished, with a variety of textures described by means of diverse tools and techniques. The saint's hair falls in ropey locks, quite different from the coarse, curling hair of the animal hide forming his cloak, whose underside is striated to convey its roughness. Long, streaking tendons and muscles ripple through the saint's spare body. His large eyes, with their deeply hollowed pupils, set in a sorrowful face, portray the saint as one who sees beyond the present, as the prophet and precursor of Christ.

In his youth Francesco accompanied his father to Rome, where in 1506 he witnessed with the young Michelangelo the excavation of the *Laocoön*. A letter written much later in his life describes how lasting an impression the tortured marble group made upon him. The heightened realism and sometimes intense expressive content of Sangallo's sculpture may reflect the spell of that ancient sculpture.

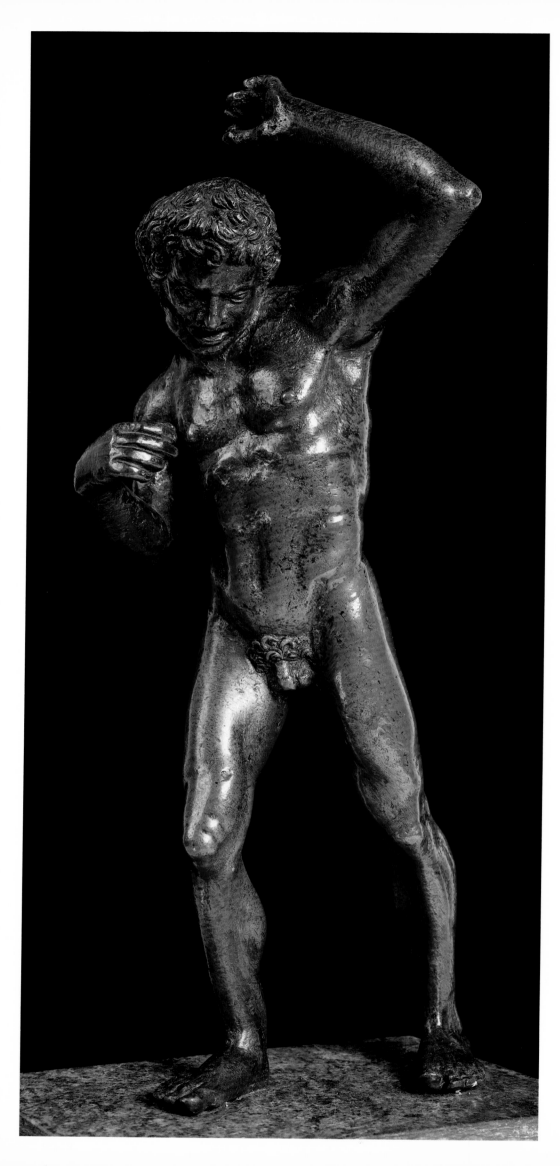

RICCIO (ANDREA BRIOSCO)
c. 1470–1532

Riccio, the son of a goldsmith, first trained in his father's shop in Padua and then studied sculpture with Bartolomeo Bellano. Riccio's twelve-foot-high Paschal Candlestick in the Basilica of S. Antonio, Padua, is considered his masterpiece, but he also executed other works in Padua and major bronzes for churches in Venice and Verona. His fame was so great both in his day and after his death that countless small bronzes were made in his manner, often derived from the myriad figures on the Candlestick.

NAKED YOUTH
WITH RAISED LEFT ARM

Date unknown. Bronze
H. 13 ¼ in. (33.6 cm.)
Acquired in 1916

Scholars have only recently begun to study Paduan sculptors with the care previously devoted to Florentines. Admittedly, many more Florentine sculptors were worthy of such attention, but the Florentines also blew their own trumpets louder and more often than the North Italian biographers and historians; much more is known about their artists than about the North Italians. The artistic identities of three sculptors whose careers overlapped in Padua—Bartolomeo Bellano, Riccio, and Severo da Ravenna— are only now being disentangled. In the process, the production of Riccio, who was the most gifted of the three, and of Bellano, appears to be shrinking rapidly, while Severo is credited with a veritable factory reproducing works by many artists, including Bellano and Riccio. The Frick Collection, for example, has a statuette of *David*, a variant of a bronze by Bellano, which is now thought to be the work of Severo's shop; on the other hand, the present bronze by Riccio of a *Naked Youth with Raised Left Arm* was once attributed to Bellano.

The influence of Florentine artists further blurs the regional and individual traits. Donatello, who has been cited as inspiration for this *Naked Youth,* had worked in Padua, and the authority of his example upon local artists was reinforced by Riccio's master, Bellano, who assisted Donatello both in Florence and in Padua. Bertoldo also spent two years on assignments in Padua, and Riccio himself in his youth resided for a time in Florence.

This splendidly modeled figure, believed to be an early work by Riccio, has the rugged virility of a Donatello sculpture and perhaps even greater intensity of emotion. The pose derives from an antique prototype sometimes thought to represent Marsyas at the moment he makes the regrettable decision to pick up the pipes discarded by Athena. His boastful pride over his musical talent soon angered Apollo and led to Marsyas being skinned alive by the god.

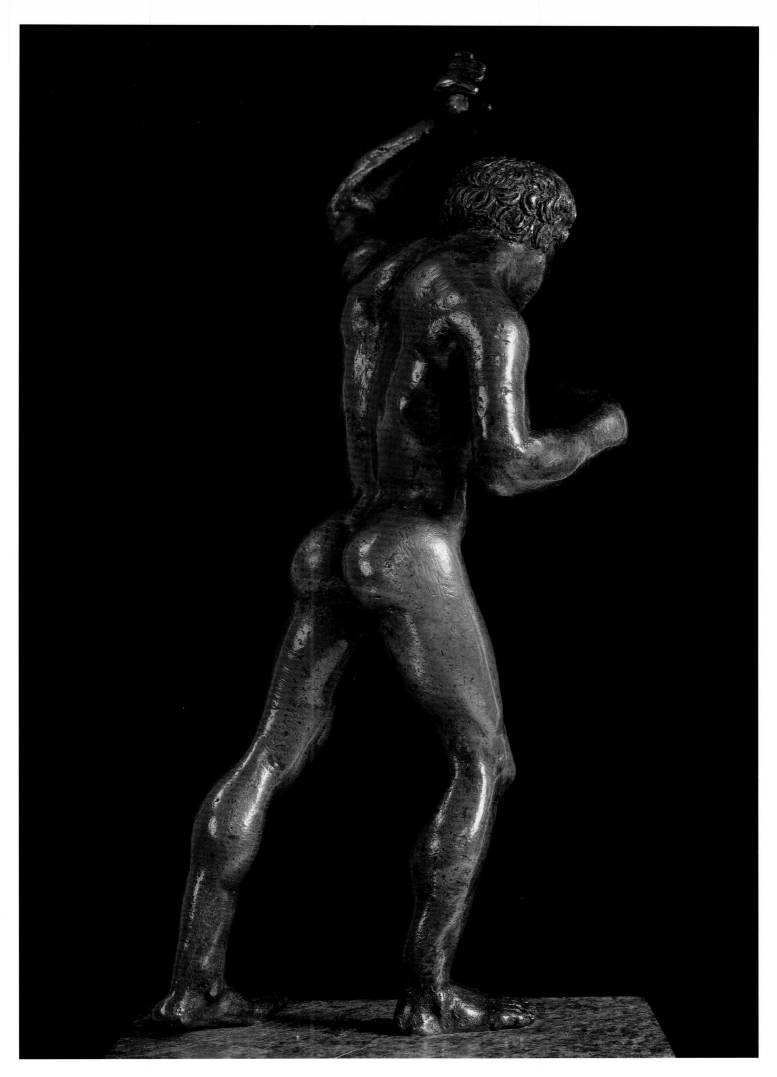

However, from the grimace of horror on the bronze youth's face, it seems more plausible that he is recoiling from something like a snake rather than from a fate he might have avoided had he foreseen it. Mantegna may have provided the immediate source for the subject, pose, and expression of Riccio's figure; Riccio's bronze closely resembles Mantegna's drawing in the British Museum of a faun attacking a snake and an engraving of the same motif from Mantegna's school.

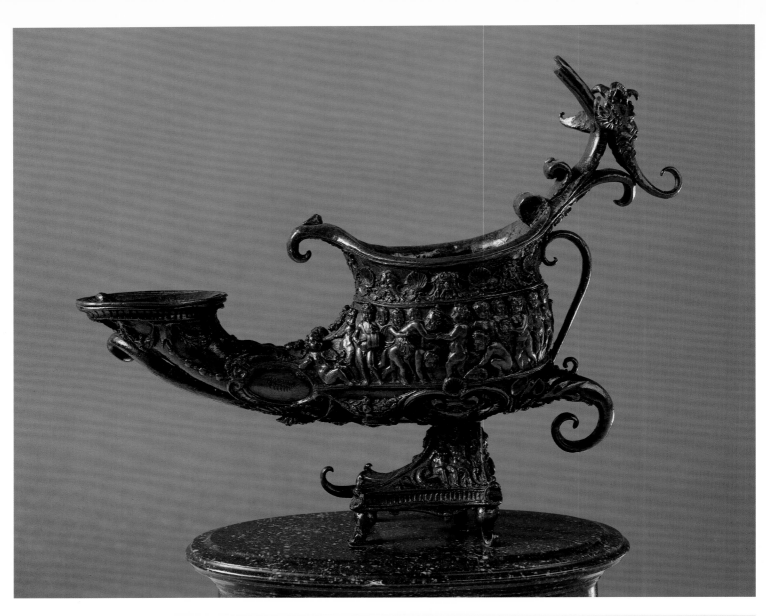

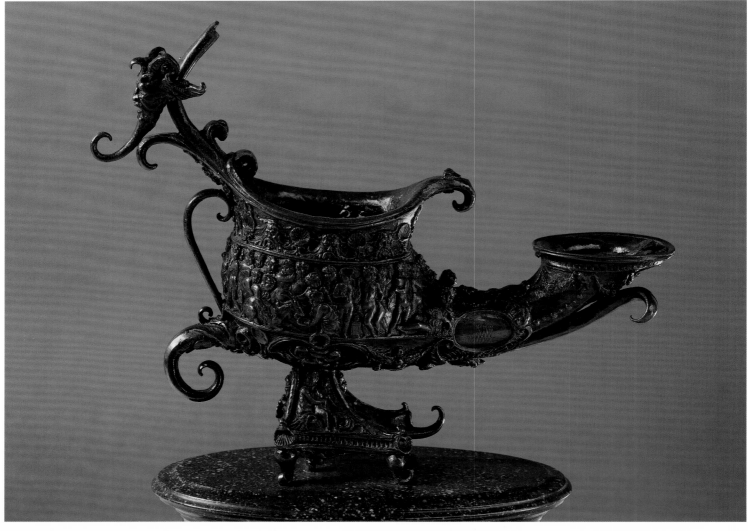

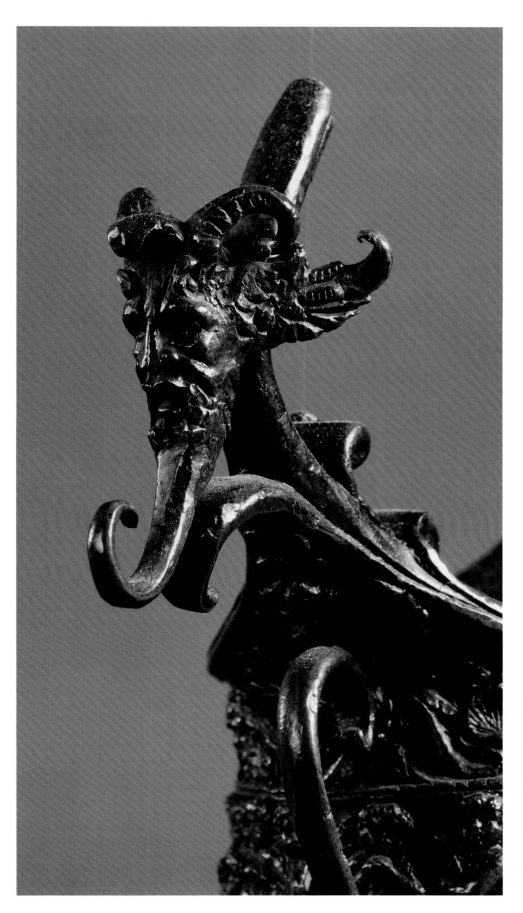

RICCIO

LAMP

Date unknown. Bronze
H. 6 ⅝ in. (16.9 cm.)
Acquired in 1916

Padua was the seat of a great university and a center for humanist studies. Riccio is known to have been versed in classical art and literature and to have found friends and patrons among the learned scholars of Paduan society. The form of this extraordinary bronze *Lamp*, the most elaborate of several he produced, is based on Roman prototypes, and its surface is encrusted with motifs drawn largely from antique sources.

While the other lamps by Riccio are shaped like ships, this one, inspired by the Roman half-boot, is designed as a bizarre shoe balanced on a pyramidal base. The lid is missing and certain elements have been broken, such as the uppermost scrolled handle, but one can readily visualize the fantastic effect of the *Lamp* when lighted. With its sprightly silhouette and glittering surface illumined by flames darting from the spout, it would have provided its possessor with much pleasure and entertainment. The *Lamp* is known to have belonged early in its history to a series of distinguished Paduan collectors.

The intricate reliefs covering the surface of the bronze are modeled with a goldsmith's refinement and crisp detail. The subjects evoke the populace of classical art and poetry, including a Nereid and Triton, Pan, harpies, and innumerable putti, along with goats, musical instruments, shells, masks, and garlands. The variety seems inexhaustible. The artist's imagination, both copious and controlled, is occasionally playful but more often touchingly melancholic. Although not even an inch high, the face of a satyr on the *Lamp*'s handle expresses fathomless grief.

On a minuscule scale, the *Lamp* includes many ornamental motifs that are found on the *Paschal Candlestick*, which Riccio began in 1507 and, after years of interruption, finally finished and installed in S. Antonio in 1516. The *Lamp* is presumed to date from that same period.

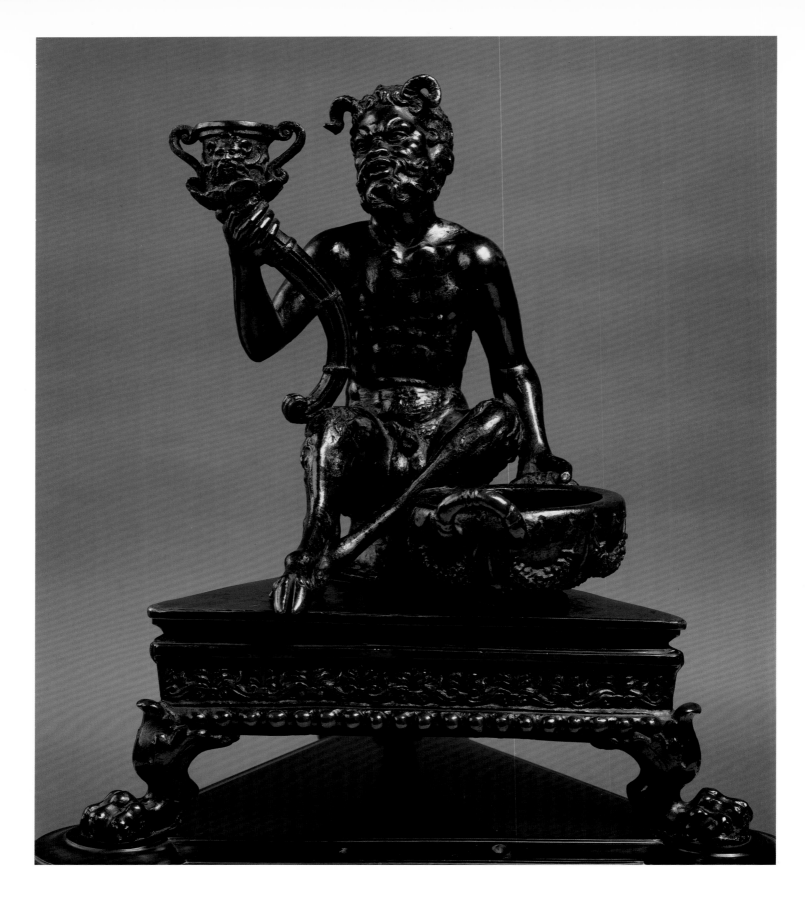

RICCIO, STYLE OF

SATYR WITH INKSTAND
AND CANDLESTICK

Date unknown. Bronze
H. 11 ¾ in. (29.8 cm.)
Acquired in 1916

SATYR WITH INKSTAND
AND CANDLESTICK

Date unknown. Bronze
H. 8 ⅜ in. (21.2 cm.)
Acquired in 1916

These two satyrs, serving as purveyors of candlesticks and ink pots, belong to a large group of similar but never identical figures, the best of which, including these, have been attributed to Riccio. Others of varying style and quality are more clearly derivative, made by less gifted Paduan imitators or possibly even by a posthumous continuation of Riccio's shop; the genre was highly popular. The ink bowl of the second, slightly smaller, of the Frick satyrs, reproduced at right, bears the coat of arms of a Paduan family, the Capodivacca.

The composition of the first satyr seems more complex, subtle, and satisfying than that of the second. Its elegant pattern of limbs linked by the sinuous cornu-

copia—the curves of which are repeated in those of the handles, bowl, and curlicue horns—is highly sophisticated. The modeling of this satyr's face is more elastic and mobile, his hair springier. Yet even he lacks the tragic appeal of the tiny satyr head on the handle of Riccio's *Lamp*. One suspects that, like others of the group, this example too may simply reflect an original bronze by the master, wherein the pose that hints at supplication and the tormented expression would have been more finely focused. According to medieval lore, a satyr once accosted St. Anthony Abbot, declaring, "I, too, am a mortal," and begged him to pray for his soul. Some such plaint may account for the unhappy mien of Riccio's satyrs.

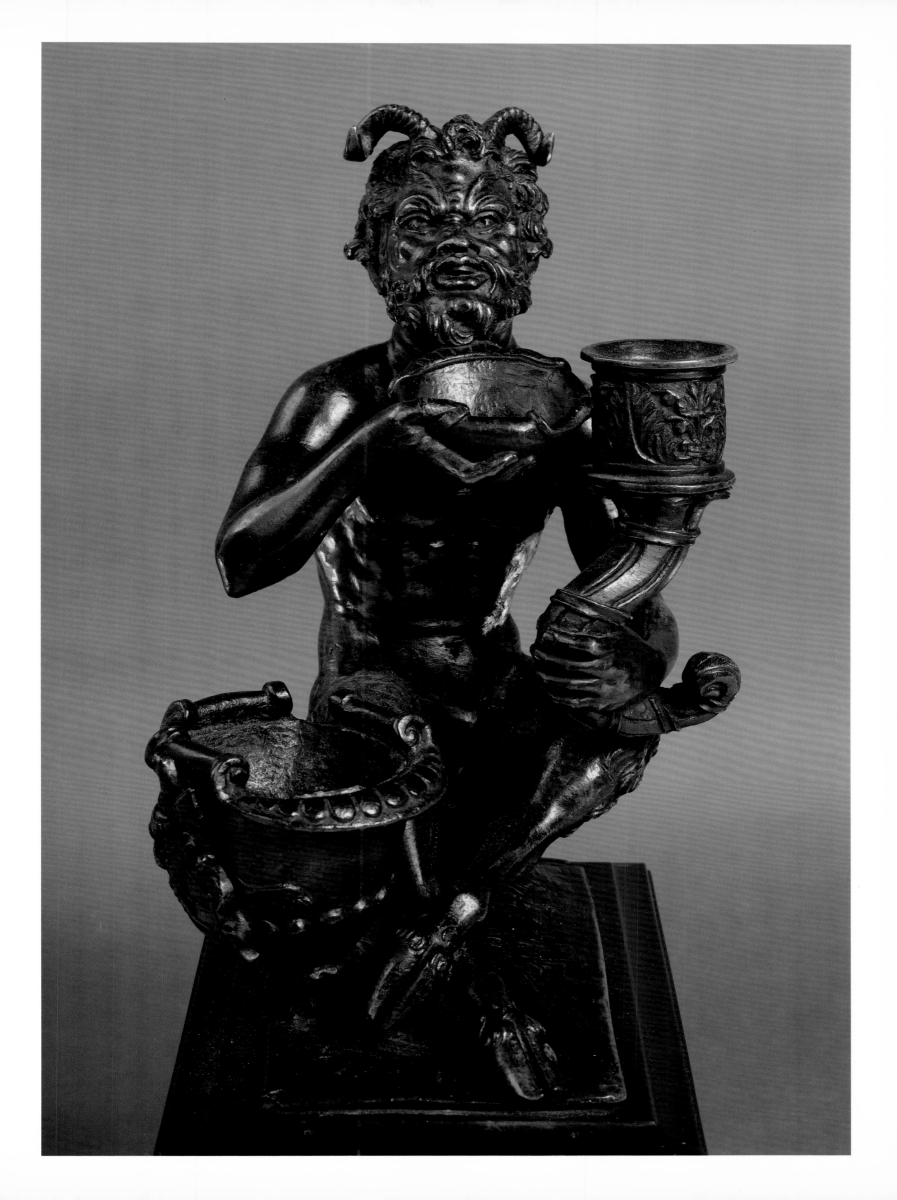

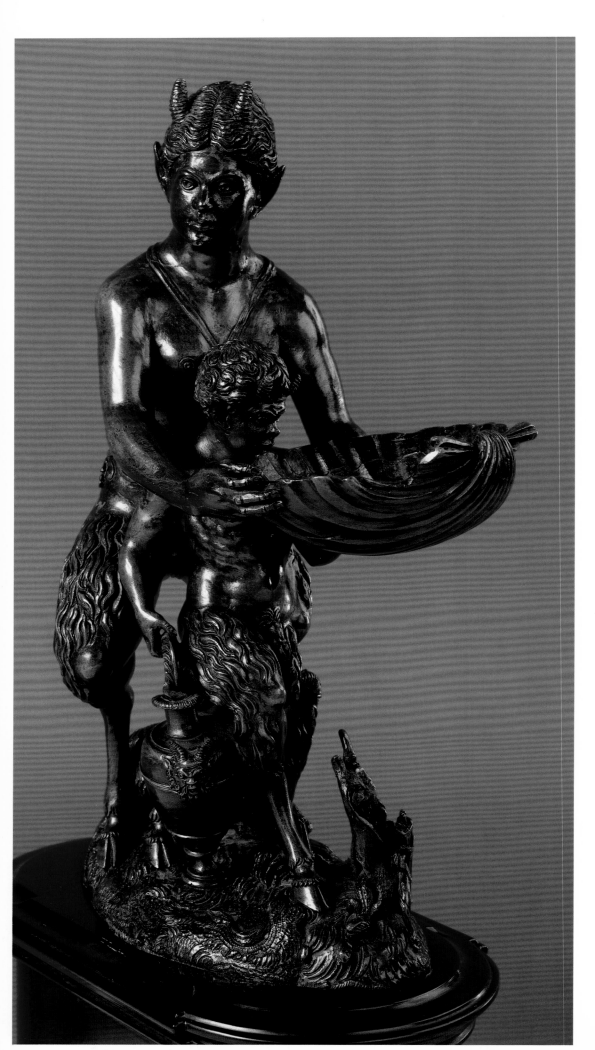

NUREMBERG

Last quarter of the sixteenth century

SATYR MOTHER WITH A CHILD SATYR

Date unknown. Bronze
H. 10 5/16 in. (26.2 cm.)
Acquired in 1916

Riccio's influence spread in many directions, as had Pollaiuolo's—not only to other Italian centers, but also across the Alps. His satyr subjects won lasting popularity, as the *Satyr Mother with a Child Satyr* testifies. Once attributed to Riccio himself, it is now believed to resemble more closely the work of such Nuremberg sculptors as Wenzel Jamnitzer (1508–85).

The figure types and faces clearly reveal the artist's knowledge of Riccio's bronzes, but the many naturalistic touches seem more characteristic of German taste. One thinks of drawings by Dürer, Hans Hoffman, and others, that describe quite ordinary animals, insects, birds, reptiles, or plants in vibrant detail. The sculptor of the satyr pair reveled in naturalistic embellishments. A lizard descends the gnarled tree stump, over which a quiver is slung. Slithering among the long grasses curling over the rocky base are another lizard and two snakes, proper denizens of a satyr's habitat. A reclining goat has a wild animal's wary look, as though poised to flee from intruders.

The tangled grouping of the two figures, with their goat and ewer, is further encumbered by the large shell from which the thirsty young satyr is preparing to drink. It has been suggested that the bronze was intended as a table ornament, and the shell designed to hold salt. If so, the scowling expression on the young satyr's face betrays his disappointment, and the bronze would be meant to entertain dinner guests with a sly joke.

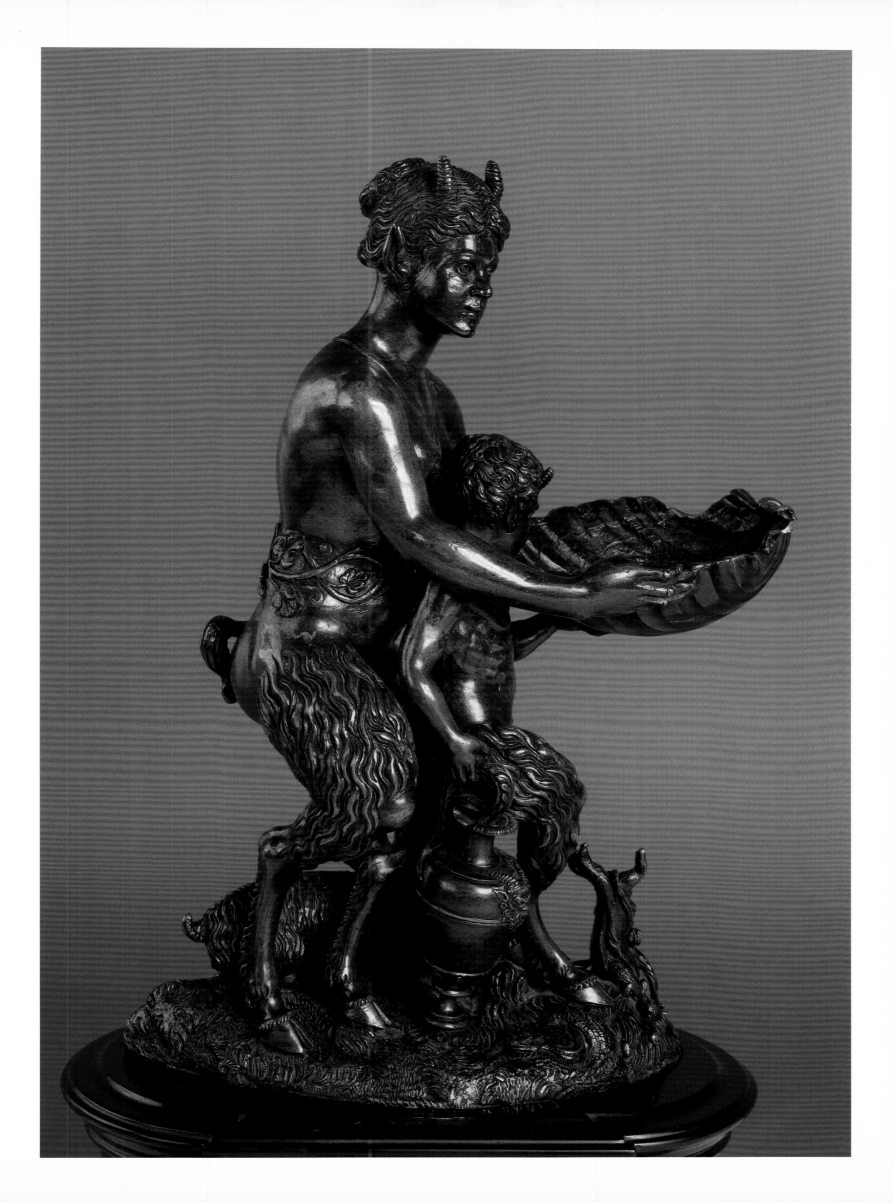

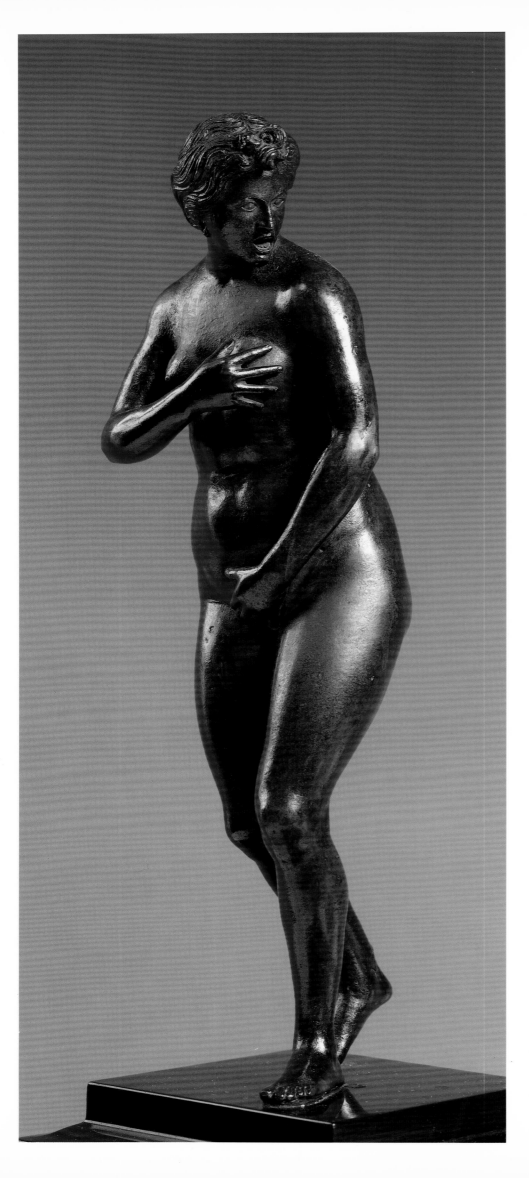

MANTUAN (?)
Early sixteenth century

Naked Female Figure

Date unknown.
Bronze, with green patination and silver inlay
H. 10 ½ in. (26.7 cm.)
Acquired in 1916

Although this figure was once attributed to Riccio, certain of its technical features would be unique in his work and are more characteristic of bronzes from the circle of the Mantuan sculptor Antico. The bronze seems to have been designed as a pseudo-antique, with traces of a green patination that emulates natural corrosion and silver inlaid eyes and nipples such as can be found in Hellenistic bronzes or Mantuan imitations of them. The pose echoes the classical gestures of a *Venus Pudica*. No known sculpture by Riccio attempts such a deceptively antique guise. The startled, angry face of the woman suggests familiarity with Mantuan art, for she strongly resembles the often impassioned figures painted by Andrea Mantegna.

The subject of the bronze has sometimes been identified as Susanna surprised at her bath by the elders, but a Biblical heroine seems an unlikely source for such a classicizing bronze. Diana surprised by Actaeon at *her* bath would be more appropriate to both the form and character of the figure. Her nudity, pose, and expression befit an outraged goddess and infuse this antiquarian bronze with energizing naturalism. The modeling and finish are exceptionally refined, as can be seen in the delicately detailed hair, fingers, and feet.

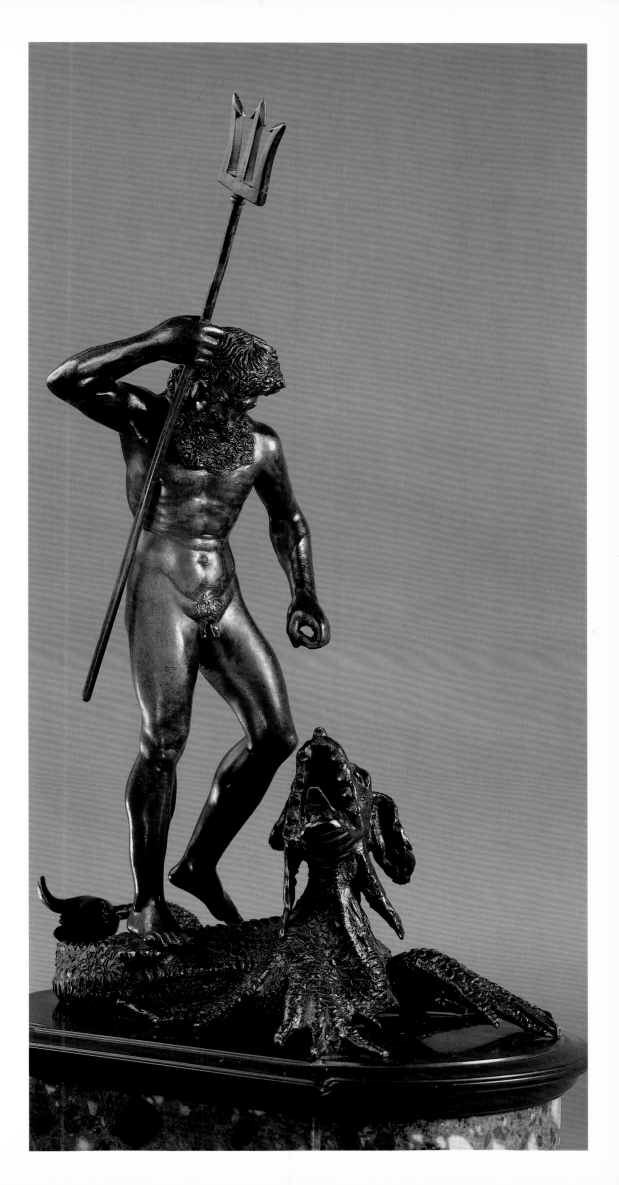

SEVERO CALZETTA DA RAVENNA

active 1496–d. before 1538

Severo, son of a Ferrarese sculptor, was probably born in Ravenna, where he is first documented in 1496. By 1500 he had moved to Padua, but he left in 1509, when Maximilian I attacked that city. Returning to Ravenna, Severo apparently remained there, establishing a hugely successful and prolific shop that turned out countless repetitions of his own designs as well as imitations of contemporary and ancient bronzes. His few authenticated and best works seem to date from his years in Padua.

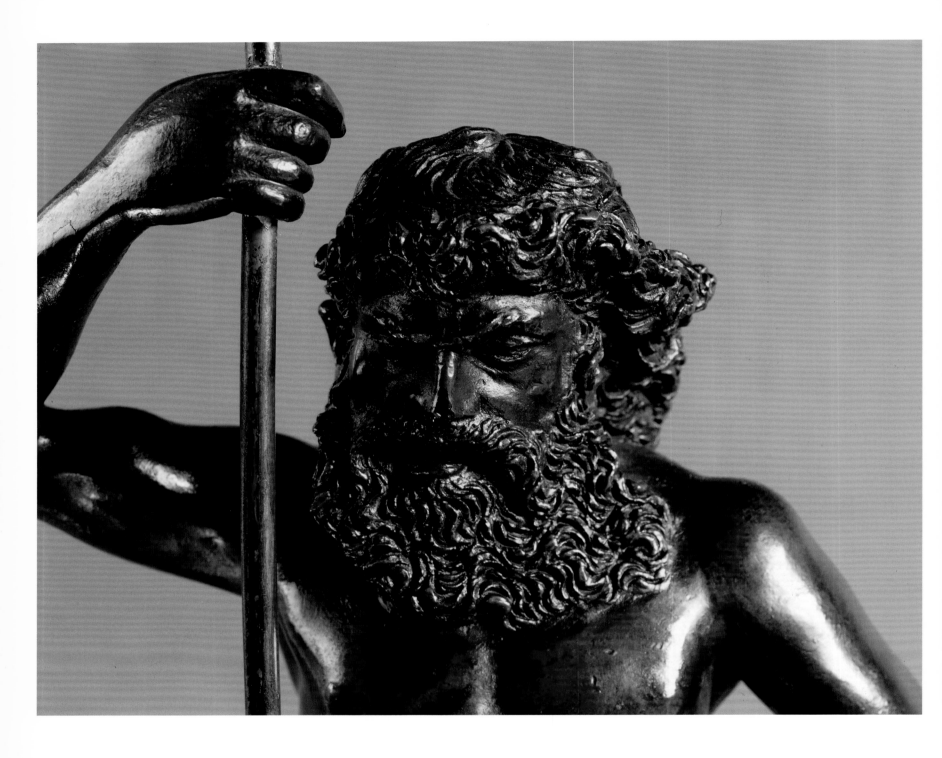

Neptune on a Sea-Monster

Date unknown. Bronze
H. to top of figure 13 ⅜ in. (33.9 cm.);
H. to top of trident 16 ⅞ in. (42.9 cm.);
L. overall 11 ½ in. (29.1 cm.)
Acquired in 1916

Praised by Gauricus, a writer who knew him, as a sculptor excellent in all media and as a painter, Severo was highly regarded in his lifetime but has long been neglected. Only recently have scholars begun to sort out the innumerable bronzes hitherto attributed to Bellano or Riccio or simply to the Paduan School. In the process they have come to suspect that a great many of these pieces actually were produced by Severo and his assistants. It has also grown obvious that a notable difference in quality distinguishes Severo's best works from the per-

functory later efforts of his shop, which continued to thrive after his death. Although the lost-wax method of casting was prevalent in Paduan workshops, Severo seems to have learned more complex casting techniques that enabled him to turn out series of closely related bronzes; these were basically reproductions, but they could be varied in detail so that each purchaser might consider his bronze in a way unique. It was—to judge from the evidence of quantity —a very successful factory.

In general, Severo's repertoire resembles Riccio's. He too made many useful, decorative objects, such as lamps and inkstands, often attended by satyrs. But perhaps his finest and most ambitious surviving bronze is The Frick Collection's *Neptune on a Sea-Monster*, comprising two separate figures that are bolted together. It belongs to a group of related pieces, most of them reduced to a single figure: either Neptune

or, more often, some variant of a sea-monster or dragon. One of these dragons, in a New York collection, is signed, thus providing the attribution for the Frick bronze and other comparable works.

The sea-monster that supports Neptune —a splendid beast, worthy of his popularity —may have been inspired by Mantegna's engraving of the *Battle of the Sea-Gods*. His body and thrashing tail are covered with rough scales. His splayed, finger-like claws, sharp fangs, and snapping tongue are fearsome. Yet the dragon's eyes are almost human, and he twists upward toward his master with the frisky playfulness of a dog on a leash. (The reins once held by Neptune are missing.) Neptune, stern and powerful, moves ahead purposefully, hair flowing behind, trident thrusting. Neptune portrayed as master of the seas, bringing peace in his wake, was a subject that held particular and obvious attraction for rulers and admirals.

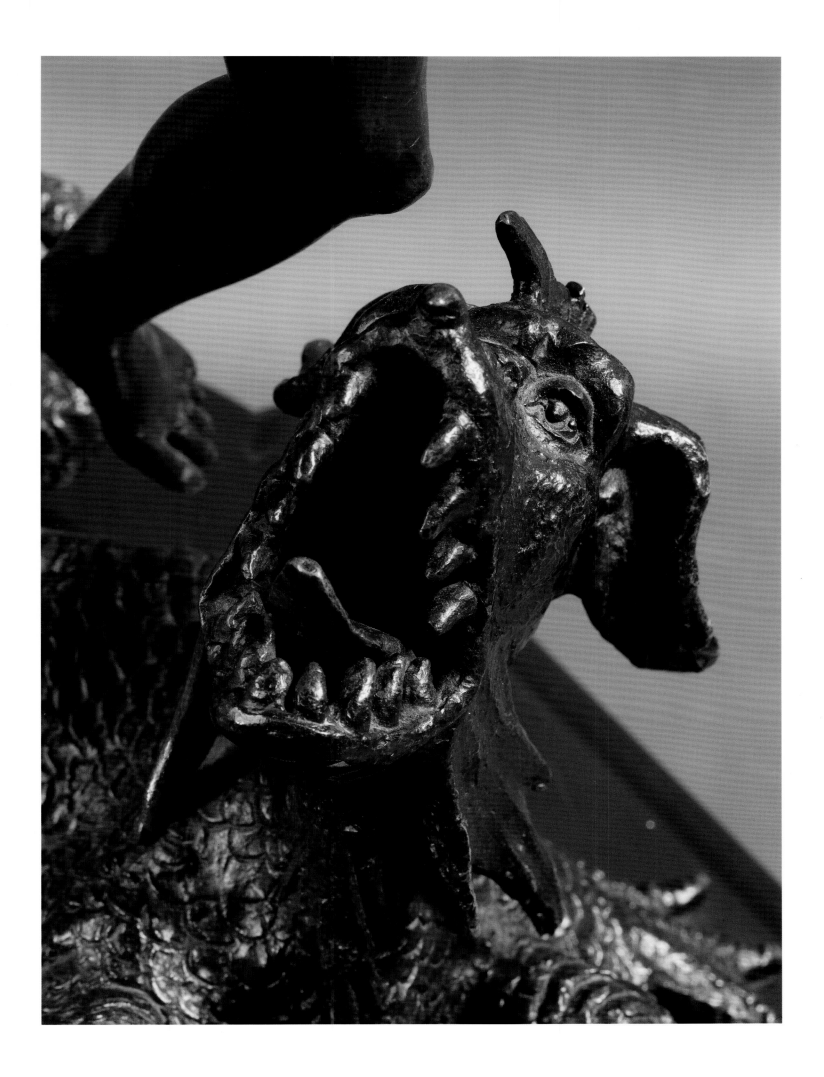

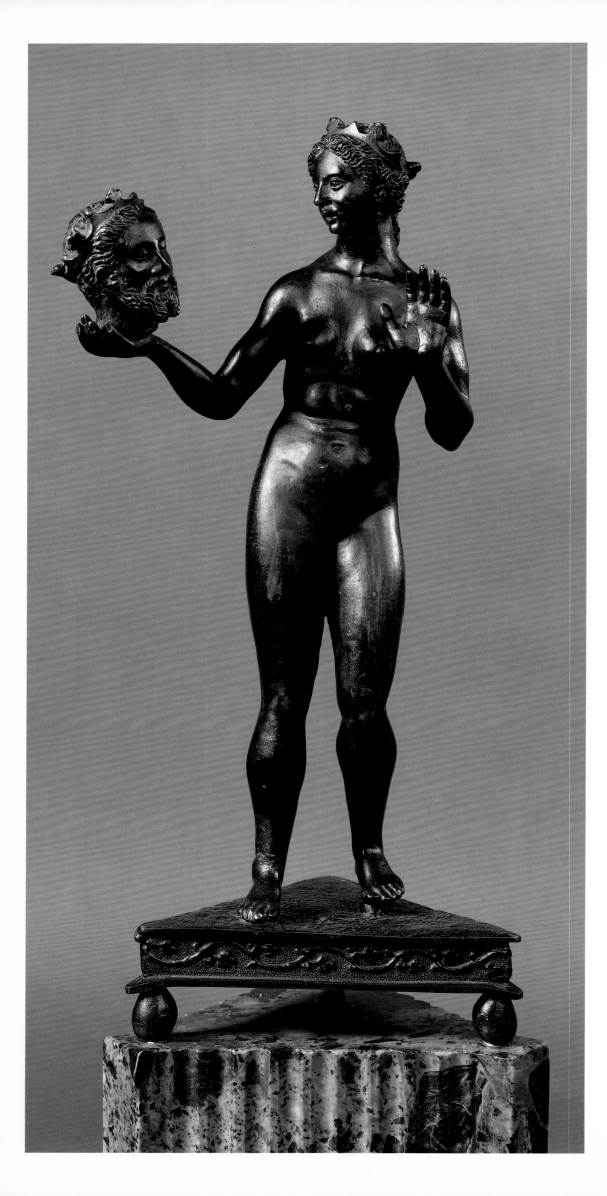

SEVERO CALZETTA DA RAVENNA

QUEEN TOMYRIS WITH THE HEAD OF CYRUS

Date unknown. Bronze
H. 12 ⅛ in. (30.8 cm.)
Acquired in 1916

Severo made several statuettes of saints and the crucified Christ but also many figures from ancient legend and history, including such women as Cleopatra and nude female subjects who have not been identified. *Queen Tomyris* shares with these bronzes of women a number of characteristics, and although none are signed, the group relates stylistically to other works that are.

Like the figure of *Neptune, Queen Tomyris* reveals that Severo had an insecure grasp of anatomy. Her torso and especially her hips are awkwardly articulated, her stance is uneasily poised, and her hands are enormous. Compared with The Frick Collection's Mantuan *Naked Female Figure* possibly representing Diana, her body, gestures, and open-mouthed stare are singularly ambiguous. The widowed Tomyris, queen of the Massagetae, a Scythian nation, led her troops to battle against the Persian king Cyrus, who had invaded her land and captured her son. She conquered his army, killed Cyrus, and cut off his head. Severo's portrayal of the vengeful warrior-queen is so stylized in movement and expression it seems stage-like, resembling a balletic performance more than the climax of a bloodthirsty melodrama.

ANTICO (PIER JACOPO ALARI BONACOLSI)

c. 1460–1528

Antico's life was centered in and around Mantua, where he worked for various members of the ruling Gonzaga family. Probably trained as a goldsmith, he earned a reputation for his knowledge of ancient art—and hence the nickname Antico—early in his career. He both restored antiques and purchased them for the Gonzagas, making more than one trip to Rome. But the chief justification for his sobriquet derived from his numerous small, elegantly finished bronze figures inspired by ancient marble sculptures, with subjects from classical myth and history. He also produced bronze busts with classical subjects, roundel reliefs, and portrait medals. After Mantegna's death in 1506, Antico became artistic advisor to the wife of Marchese Francesco Gonzaga, Isabella d'Este.

HERCULES

Made probably in 1499.
Bronze, with gilding and silver inlay
H. 14 ⅝ in. (37.1 cm.)
Gift of Miss Helen C. Frick, 1970

While little is known about the patronage for most small bronzes—who, if anyone, commissioned them, their date, or how they were meant to be displayed—Antico's work for his Gonzaga patrons is abundantly documented through inscriptions, letters, and inventories. Three bronze figures of a standing Hercules by Antico are mentioned in such early sources. One appeared in the 1496 inventory of Gianfrancesco Gonzaga, a second was cast for Bishop Ludovico Gonzaga in 1499, and the third was made some twenty years later for Isabella d'Este. Three statuettes of *Hercules*, closely similar in appearance and considered to be works by Antico or his workshop, have survived: the one in The Frick Collection; a second in the Museo Arqueológico, Madrid; and a third in the Kunsthistorisches Museum, Vienna. Based on stylistic comparison with other Antico bronzes, it has been proposed that the Frick bronze, the finest of the versions, may be the one made in 1499 for Bishop Ludovico.

Antico was able to produce exact replicas of his models through a complex method using piece molds that allowed him to cast hollow bronzes and to preserve his original waxes and molds for repeated use. Figures made from a single wax model could be varied in finish and detail. The most richly embellished of the three surviving figures of *Hercules* is the Frick version, which has gilded hair and lion skin and silver inlaid eyes that glitter against the dark, smoothly polished bronze. The refinements of the surface finishes—the sparkling eyes, crisp curls, striations of the lion's pelt—are

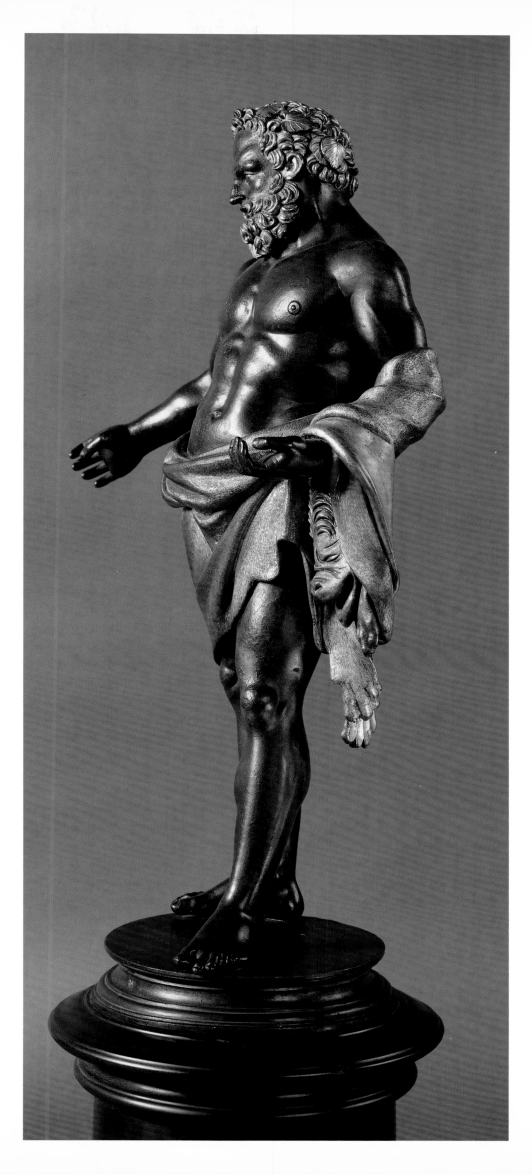

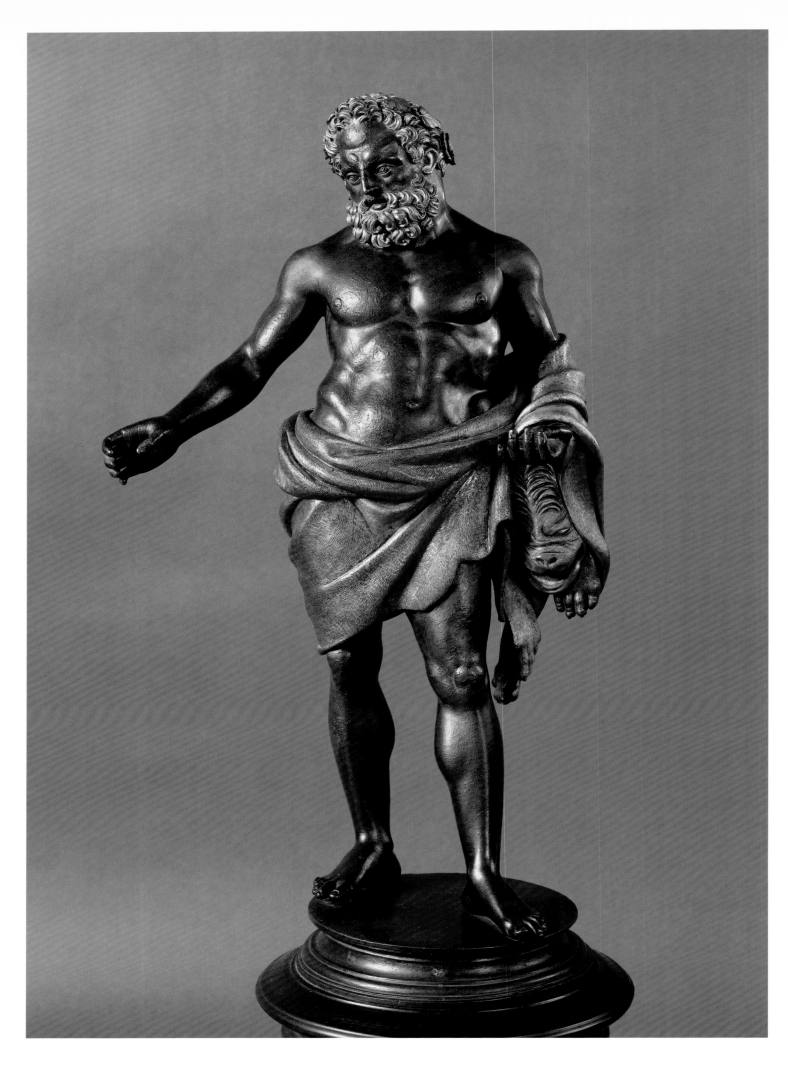

jewel-like in their precision. Antico's bronzes are luxury products, virtuoso achievements of a goldsmith's craftsmanship, rendered doubly appealing to his aristocratic, humanist patrons through their revival of the classical past.

The Frick *Hercules* lacks the club grasped in the right hand of the other two versions, and all three probably once held in their left hands the golden apples of the Hesperides, which Hercules stole from a tree guarded by

a dragon at the western end of the world. Like most of Antico's statuettes, the figure is no doubt derived from an ancient marble, but it is not precisely dependent on any known example of a standing Hercules.

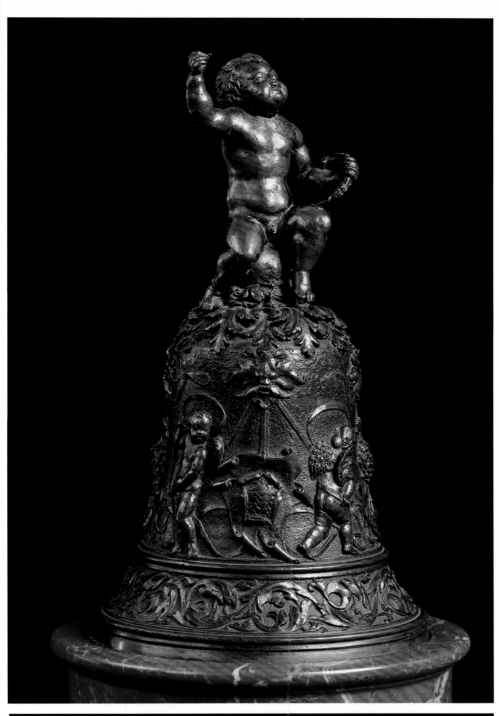

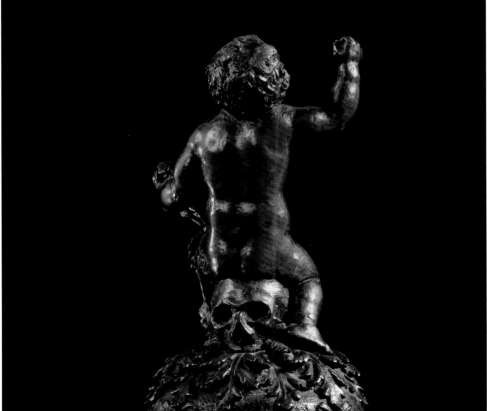

GIAN GIROLAMO GRANDI
1508–1560

The Grandi family workshop began production in Padua during the lifetime of Riccio, who was a major influence on their sculpture. With his uncle Vincenzo, Gian Girolamo also undertook commissions in Trent; among works made there by the Grandi between 1532 and 1542 were a portal and chimneypiece for the Castello di Buonconsiglio and a cantoria for S. Maria Maggiore. After returning to Padua, they executed decorative marble reliefs for the Cappella del Santo in S. Antonio and various funerary monuments.

HAND BELL

Date unknown. Bronze
H. 6 ⅝ in. (16.9 cm.)
Acquired in 1916

Like Riccio, who made lamps, candlesticks, and inkstands for his educated clients, the Grandi too supplied their connoisseur patrons with decorative bronze objects, such as buckets, bells, and doorknockers. The bells were especially in demand, and a number of them are related in design to the Frick example, which is considered the most refined and imaginative of this group. Not surprisingly, it was once attributed to Riccio.

The body of the hand bell is decorated with lively motifs, including pairs of putti flanking unidentified coats of arms in cartouches, leaves, masks, bunches of fruit, scrolls, and ribbons, all disposed in a crisp, lacy pattern over the surface. The handle of the bell is in the form of a seated infant who holds in his left hand the stem of a grapevine which curls down over his leg. At his feet are two small bunches of grapes, and he may once have held aloft another in his now-empty right hand. Seen from the front, this putto appears to be a hedonistic bacchanalian figure, reminiscent of many a tipsy Dionysus seated on a wine keg. But if one turns the bell around, the image is transformed into a memento mori, for the putto is seated not on a keg but on a human skull. The iconographic motif of a child with a skull was familiar and popular in the Renaissance. It was intended to remind the viewer that the span of life from infancy to death is nothing compared to eternity.

Such a subject would be particularly appropriate to a bell because hand bells were associated with the office of the priest and were rung during the Mass at the Sanctus to announce the advent of Christ in the Eucharist. The grapes on the bell refer then to the Eucharistic wine and the blood of Christ, who offers salvation and eternity following the death represented by the skull. The unknown prelate for whom Grandi made this intricately designed hand bell must have been a cultivated man of subtle tastes.

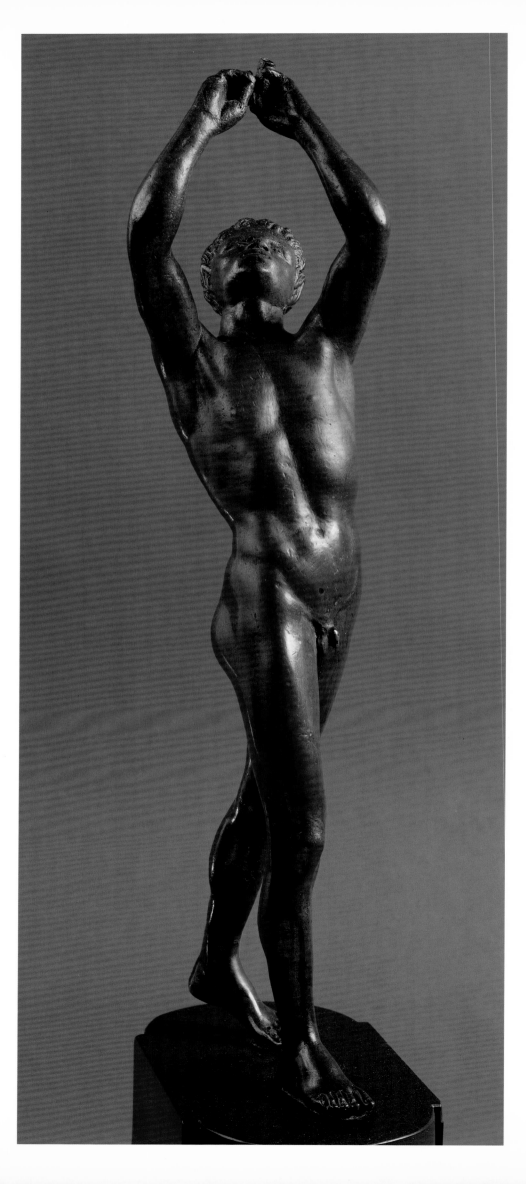

CAMELIO (VETTOR DI ANTONIO GAMBELLO), ATTRIBUTED TO

c. 1455/60–1537

Camelio appears to have spent most of his life in Venice, where he was appointed Master of the Dies at the Mint in 1484. Two bronze reliefs in the Ca' d'Oro, Venice, are signed by him, as are several medals. He also worked as a jeweler and armorer.

FAUN PLAYING THE FLUTE

Date unknown. Bronze
H. 13 ¼ in. (33.6 cm.)
Acquired in 1916

Venice was later than Padua to develop a local school of sculptors producing bronzes, and few attained a comparable reputation. Perhaps the proximity of Padua made such efforts seem redundant. Furthermore, signed or documented works by Venetian bronze sculptors are exceedingly rare much before the middle of the sixteenth century, making attributions difficult.

Attributions to Camelio, for example, are suggested only on the basis of signed reliefs, which offer less than satisfactory support for comparison with three-dimensional statuettes. A number of bronzes ascribed to Camelio, including the *Faun Playing the Flute*, have also been claimed as the work of an early sixteenth-century Paduan goldsmith, Francesco da Sant'Agata, whose style, however, is perhaps even less clearly defined. Both artists seem to have produced small, gracefully proportioned male nudes derived from antique models and with classicizing subjects. However, similar figures also were made by other early sixteenth-century North Italian sculptors.

The present faun, who has pointed ears and a neatly curled tail, represents a popular model derived from antique precedents and known in several variants. This version has lost its flute except for a fragment remaining in the left hand. Nevertheless, the faun's lithe, dancing body seems to twist and turn to the ghostly sound of pagan pipes.

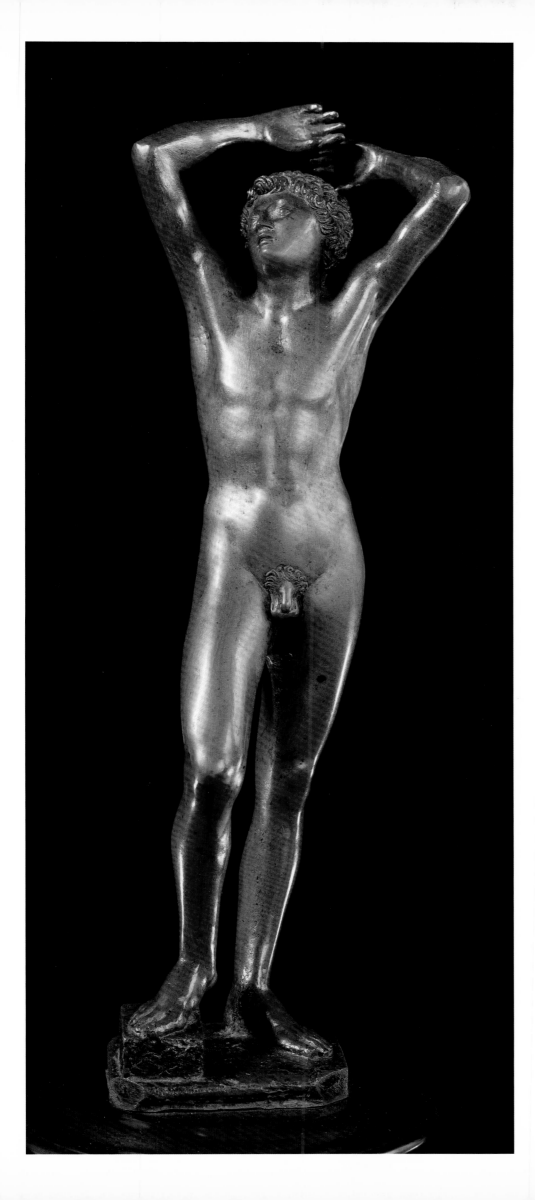

VENETIAN
Sixteenth century

NAKED YOUTH
WITH RAISED ARMS

Date unknown. Bronze
H. 10 in. (25.3 cm.)
Acquired in 1916

Like the preceding *Faun Playing the Flute*,
this *Naked Youth with Raised Arms* has been
attributed by some to Francesco da Sant'A-
gata. However, the two bronzes differ stylis-
tically, the faun being rounded and robust in
form, the naked youth more elongated and
attenuated, with more finely finished detail.

The naked youth is one of numerous
derivations based on a famous Greek bronze
which arrived in Venice from Rhodes in 1503.
Because the upraised arms of the original
(now in the Staatliche Museen, Berlin) had
broken off beyond the shoulders, sculptors
of the many dependent versions completed
and identified their subjects variously, as
anything from a *St. Sebastian* to a *Niobid* or,
more generically, a *Supplicant*. The model
was also transformed into a female nude.
The Greek bronze was known in Venice as
the *Adorante*, and perhaps something of a
prayerful significance lingers in the upward
yearning stretch of the slender youth.

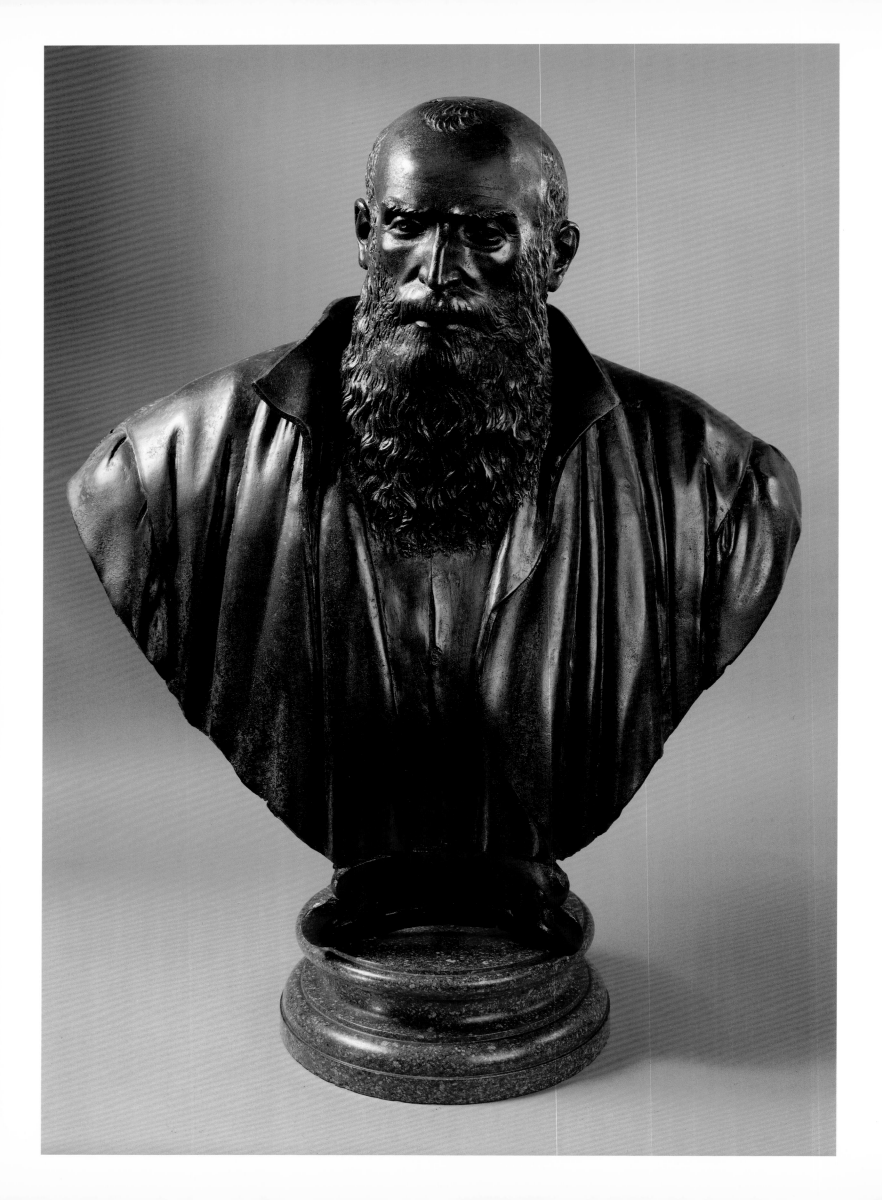

DANESE CATTANEO

c. 1509–1572

*Born probably at Carrara, renowned for
its marble quarries, Cattaneo went to Rome
as a youth and entered the workshop of
Jacopo Sansovino. After the sack of the city
in 1527, both sculptors left for Venice, where
Cattaneo built an independent career.
His funerary monuments and portrait busts
in marble and bronze earned him a place
as one of the leading sculptors of the city.
Cattaneo also worked on major commissions
in Padua and maintained contacts with
friends and patrons in his native Tuscany.*

BUST OF A JURIST

Date unknown. Bronze
H. 27 ⅜ in. (69.5 cm.)
Acquired in 1916

Just as any Rembrandtesque painting of an
old woman was once said to portray Rem-
brandt's mother, so Venetian portraits of
bearded men often are claimed to represent
Titian. This bronze bust by Cattaneo was
even inscribed, perhaps during the eigh-
teenth century, with Titian's name and the
date 1540. The portrait, however, does not
resemble Titian. Nor does the subject's face
look anything like the fleshy features of
Pietro Aretino, with whom he has also been
identified, as a glance at the Frick portrait of
Aretino by Titian (see p. 51) will confirm.
The unknown man may instead have been a
jurist at the University of Padua, to judge

from similarities to another portrait by Cat-
taneo of such a personage.

Cattaneo, who was reputed to have
been a poet, describes his sitter with poetic
economy and a masterful choice of emphases.
Clearly, this jurist was an austere man of
keen intellect and probity. The thatched
brows cast a deep shadow over his fiercely
intense eyes. The jutting nose, the slight
twist of the thin lips, the tensions in the
brow and the planes of his face convey a
nervous energy. Even the sharply incised
ripples of the stiff beard and the columnar
folds of the robe contribute to the overall
impression of a severe, upright character,
one not easily swayed from his opinions or
purposes. Like Titian in his portrait of
Aretino, Cattaneo in his *Bust of a Jurist* con-
veys the subject's personality through a
telling manipulation of forms, shapes, lines,
and surfaces.

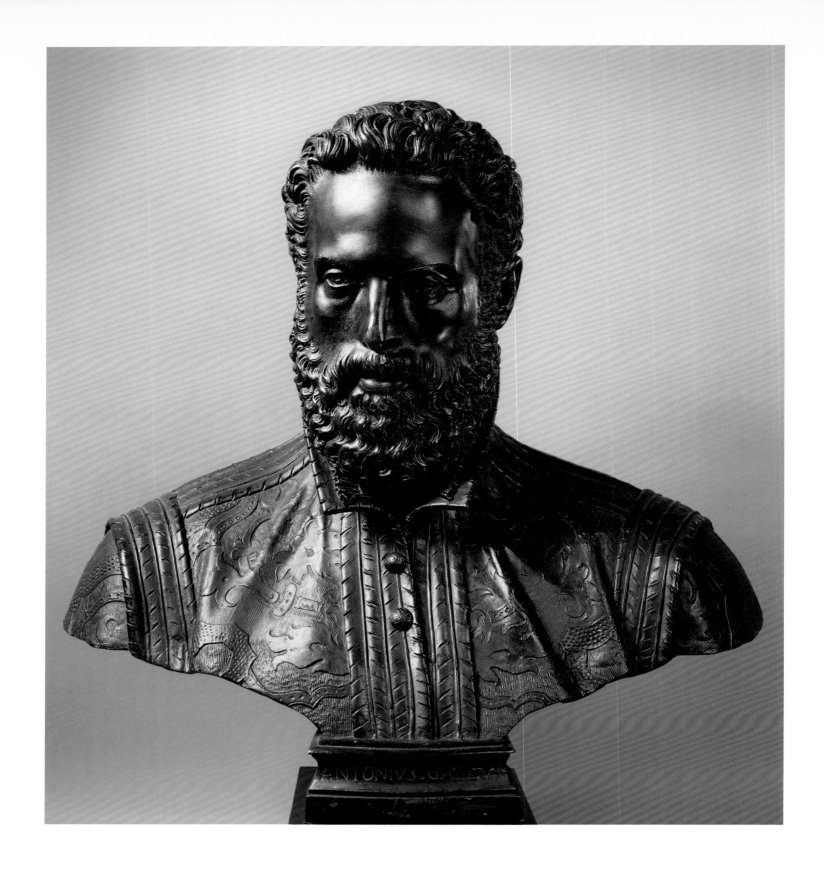

FEDERICO BRANDANI, ATTRIBUTED TO
c. 1522/25–1575

Brandani is believed to have been born and trained as a sculptor in Urbino, where he worked at the Palazzo Ducale and in various churches. He probably spent 1552–53 in Rome, executing stuccoes at the Villa Giulia for Pope Julius III. Later in his career he worked in Piedmont.

ANTONIO GALLI

Date unknown. Bronze
H. 23 ¼ in. (59 cm.)
Acquired in 1916

The portrait is identified as Antonio Galli (1510–61) by an inscription on the base, added at a later date. A distinguished diplomat, poet, and humanist, Galli served Guidobaldo II della Rovere, Duke of Urbino, as tutor to his son and as his ambassador at prestigious posts in Rome and Venice. As poet he wrote sonnets, odes, pastorals, and a version of the Psalms. Galli knew Pietro Aretino, Ariosto, Tasso, and other literary notables of his day.

The essentials of this man's nature and status are delineated in his bronze portrait with a precision and restraint to match the subject's own character. His carefully detailed costume, with its brocaded doublet, stiff collar framing a ruffled shirt, and woven buttons, is rich but not ostentatious. His head recalls classical portraits of noble leaders or philosophers such as Marcus Aurelius. The brow is lofty, the eyes with their deeply cut pupils and slight circles sagging beneath them are reflective. The full lower lip, brushed by a softly waving moustache and beard, seems sensuous. The poet-courtier is portrayed as the dignified, intelligent, and sympathetic personality he must have been.

The attribution of the bust to Brandani was made on the basis of similarities to his sculpture in stucco and terracotta, especially to his masterpiece, the *Nativity* group in the Oratory of S. Giuseppe, Urbino. No other portrait or work in bronze has yet been ascribed to Brandani.

MICHELANGELO BUONARROTI, AFTER

1475–1564

Unequalled as architect, painter, and sculptor, Michelangelo both inspired and daunted his contemporaries, who could neither surpass his achievements nor evade their challenge. His early training as a sculptor is clouded in myth, but the examples of Pollaiuolo, Verrocchio, and Bertoldo were surely significant to his formation. Noted for works in marble—projects ambitious in scale, such as the David, *the tomb for Pope Julius II, and the Medici tombs in S. Lorenzo—Michelangelo himself never produced bronze statuettes. But countless small reproductions after his celebrated works were made in bronze, marble, and terracotta, and they are still manufactured today.*

SAMSON AND TWO PHILISTINES

Date unknown. Bronze
H. 14 ½ in. (36.7 cm.)
Acquired in 1916

Michelangelo's original project for a marble group to serve as pendant to his *David* in the Piazza Signoria, Florence, began in 1508 as a *Hercules and Cacus*. Political upheavals and professional rivalry sabotaged this commission, which was revived only in 1528, with the subject changed to represent *Samson and Two Philistines*. Although Michelangelo never executed the marble, he evidently made models for it, which were intensely admired and much reproduced. By the 1550s copies of the group began to multiply in drawings, paintings, and bronze statuettes. Some dozen sculptural versions, varying in quality and often in detail, are believed to date from the sixteenth century.

Designed for a public space, to be viewed from all sides, this remarkable composition of three men engaged in deadly combat was to have a profound influence. The tautly entwined spiral of figures compels the spectator to circle the group, for although every angle is brilliantly composed, each is incomplete in itself. To see and understand the individual figures, one must move around the piece, skillfully led by the arrangement of limbs and torsos, to seek out the sequence of actions. This complexity of forms seeming to move in space and time is a far step from any sculpture by earlier Renaissance masters.

The fierce energy of the combatants twists upward from the Philistine crushed underfoot, to his comrade who bites Samson's buttock, through Samson's upraised arm to smash his attacker's head with the ass's jawbone. The fresh, vigorous working of the material reinforces the immediacy and vitality of this drama, with many marks of the sculptor's actions—the shap-

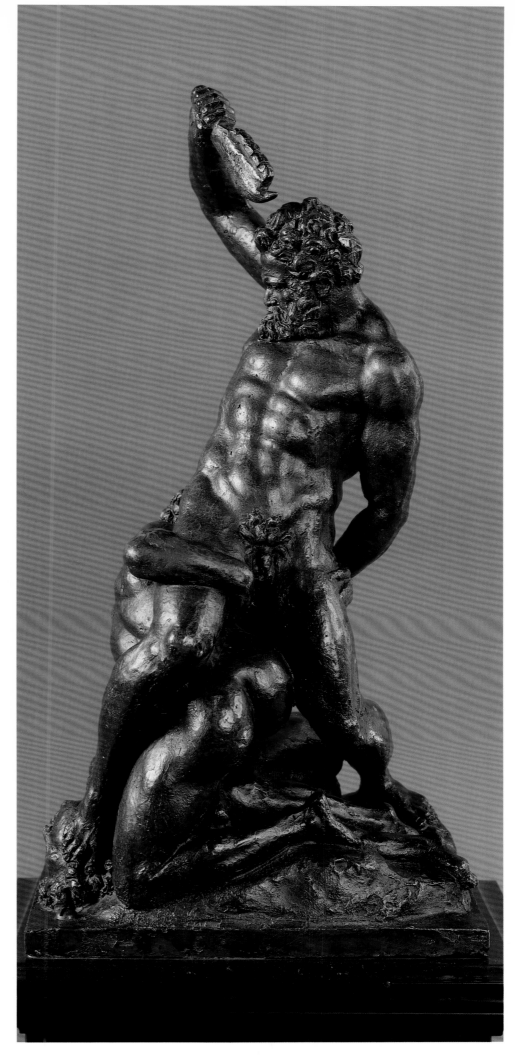

ing, smearing, and scraping of the model, which may have been made in plaster or clay—left visible in the surface. This small bronze seems to preserve much of the lega-

cy of Michelangelo's unfinished project. The Frick version of *Samson and Two Philistines* is generally agreed to be the best of the bronze replicas.

161

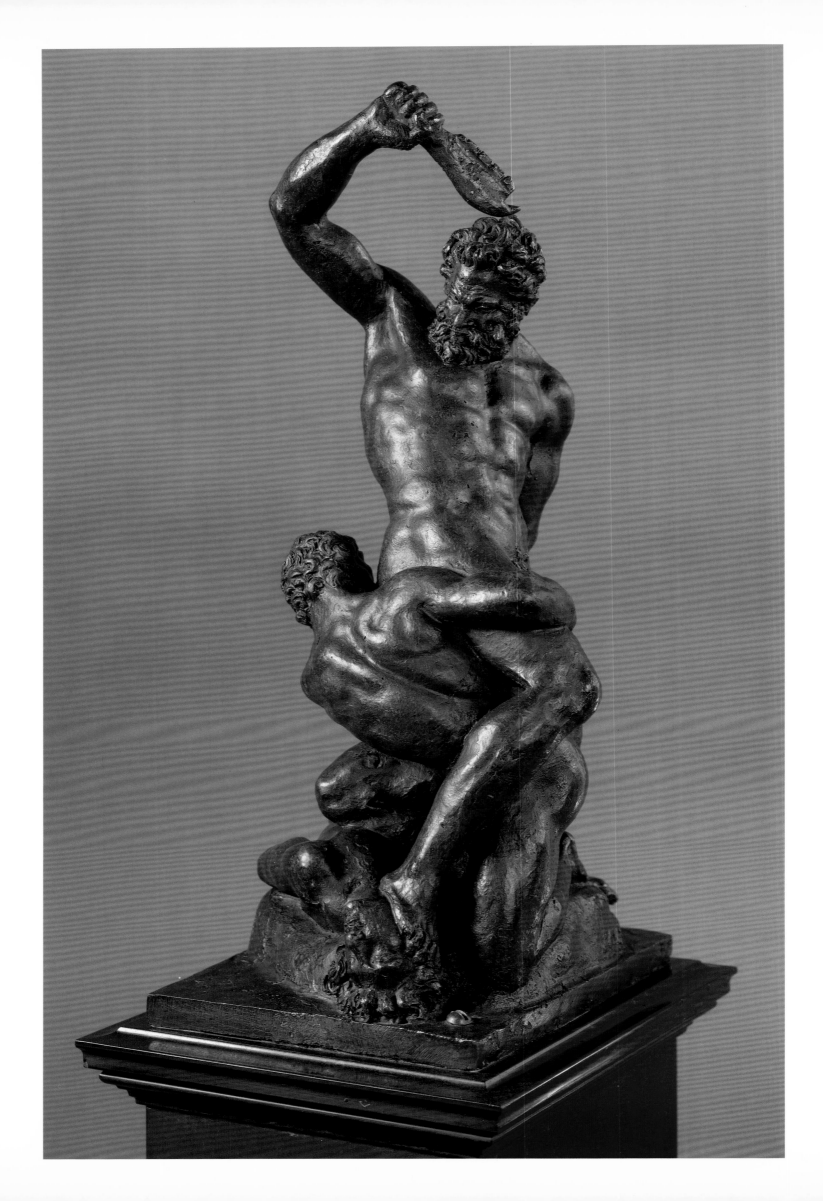

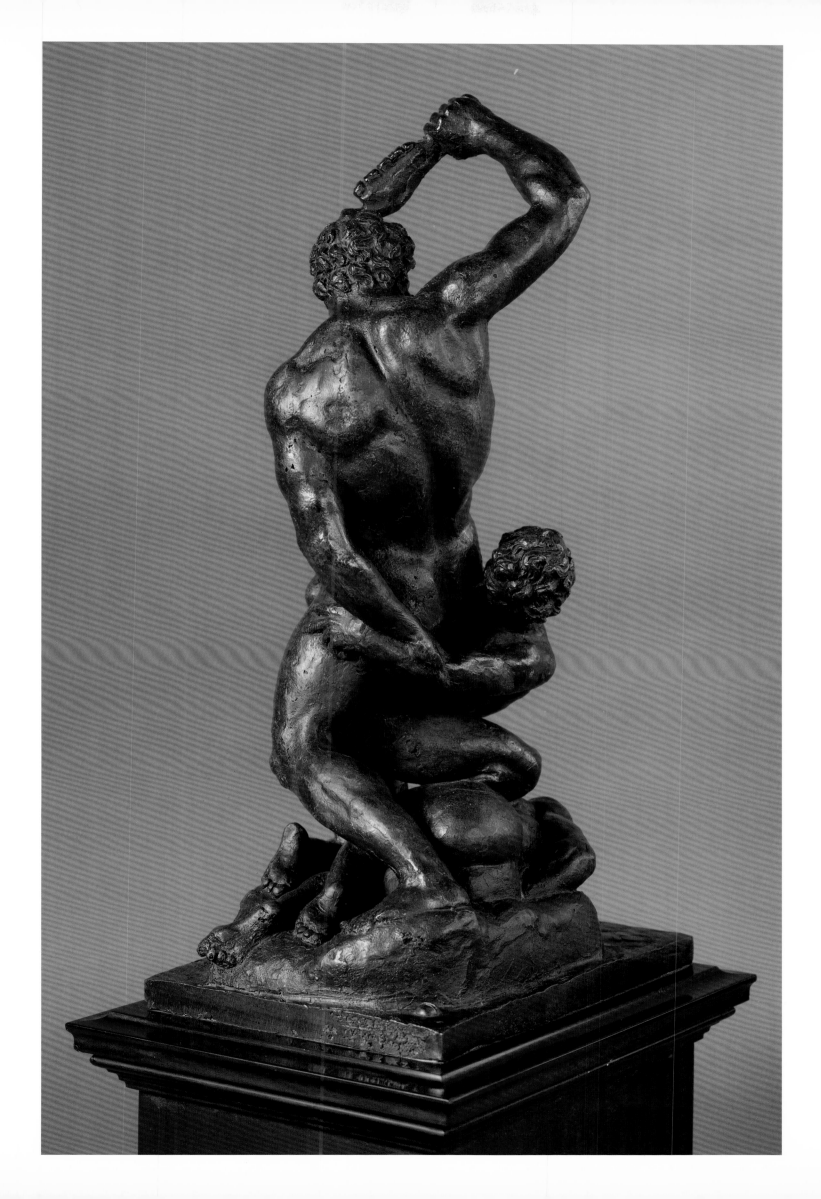

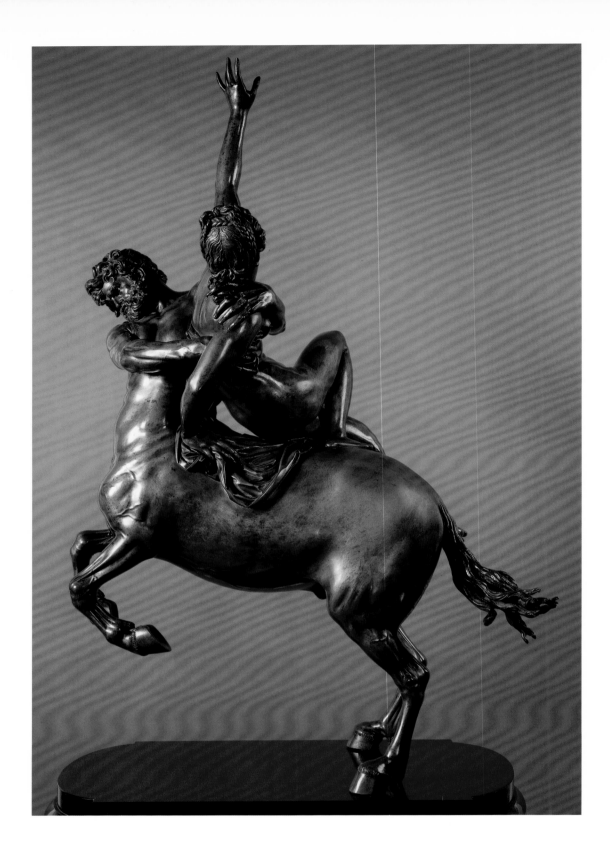

GIOVANNI BOLOGNA, AFTER
1529–1608

Giovanni Bologna (born Jean Boulogne), who came from Douai in Flanders, spent two years in Rome before settling in Florence in 1553 for the remainder of his life. He entered the service of the Medici, becoming their official sculptor, and acquired an international reputation for his statues both in marble and in bronze. His great celebrity necessitated a workshop with assistants so skilled that they could execute his sophisticated designs in the style and with the technical expertise of their master.

NESSUS AND DEIANIRA

Date unknown. Bronze
H. 34 ¾ in. (88.3 cm.)
Acquired in 1915

The first documented example of this famous bronze group was made by Giovanni Bologna between 1575 and 1577 for the Salviati family of Florence. The three casts signed by him differ slightly from each other, as well as from the Frick model and the many other variants, chiefly in the pose of Deianira and the arrangement of drapery; they are also only half the size of the later variants. These bronzes are an amazing tour de force of casting, with a balance so delicate it is hardly surprising that the centaur's rear legs in all three signed versions have broken in the same place—or that at some time in its past, the Frick bronze was strengthened by a lead insert in the rear right leg. Giovanni Bologna's *Mercury*, one of the best-known sculptures in history, is poised miraculously on the toes of one foot, but the abduction of Deianira is even more daring and dramatic. One cannot but wonder how such a minor myth, so obscure, so difficult to produce in bronze, came to be chosen for sculpture. The closest antecedent was Pollaiuolo's painting of the abduction, now in the Yale University Art Gallery. The same subject, according to his biographer Condivi, had once been proposed to Michelangelo, but he evidently never undertook such a project. Perhaps Giovanni Bologna, who seems always to have dared the seemingly impossible, deliberately sought comparison with his illustrious Florentine precursors.

According to legend, the centaur Nessus tried to abduct Hercules' wife, Deianira,

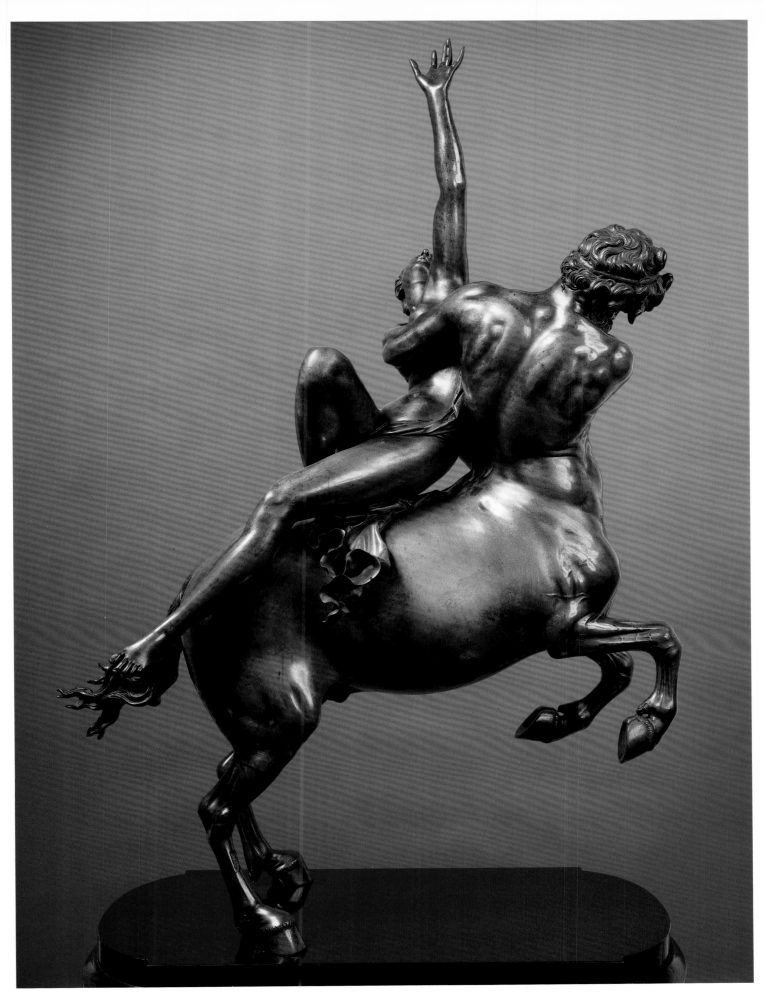

after offering her a ride across a turbulent river. For his treachery, Hercules killed Nessus with an arrow. The explosive outward movement of the sculpted figures is tightly contained by equally dynamic forces twisting in midair as the two struggle against each other: the terrified Deianira straining back toward her husband while the centaur leaps forward.

Understandably popular, variants of this model were produced over and over by assistants and followers of Giovanni Bologna, many of them made during his lifetime and with his approval. The Frick version has been attributed variously to two of these sculptors: formerly to Adriaen de Vries, but more recently to Pietro Tacca. Tacca (1577–1640) was the last and one of the most gift-

ed sculptors to join Giovanni Bologna's shop, in 1592. A native of Carrara, he nurtured close personal and professional ties to his master, whom he succeeded as court sculptor. Tacca was an exceptional technician, particularly noted for equestrian statues, such as those for Henri IV of France, Grand Duke Ferdinand I of Tuscany, and Philip III of Spain.

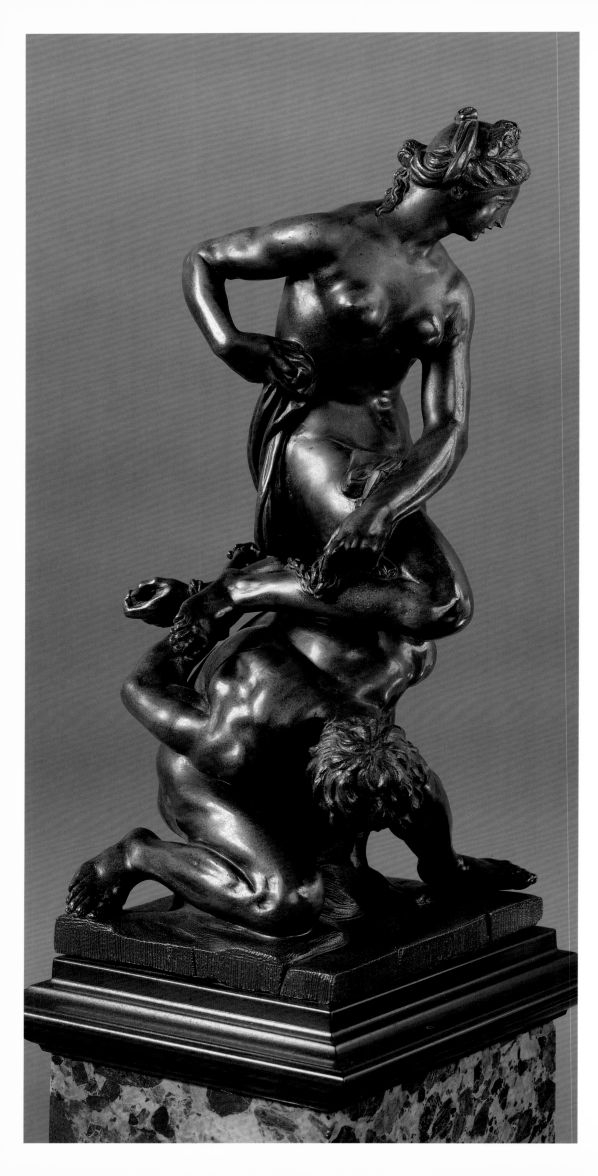

MASSIMILIANO SOLDANI
1656–1740

Born at Montevarchi, near Florence, Soldani attracted the patronage of Grand Duke Cosimo III, who had him trained as a medalist and sent to Rome to study. After further training in Paris, Soldani returned in 1682 to Florence, where he was appointed head of the Mint and built an enormously successful career, providing bronzes not only to the Medici but to other Italian collectors and illustrious clients in Germany, England, Malta, and elsewhere. Soldani represents the last great chapter in the long history of Florentine bronze sculpture.

VIRTUE TRIUMPHANT OVER VICE

Date unknown. Bronze
H. 11 ¾ in. (29.8 cm.)
Acquired in 1916

Like Severo da Ravenna, Soldani was an enterprising supplier of bronze sculpture, not only original work but also reproductions of antique and earlier Italian subjects, prominent among them those of Michelangelo and Giovanni Bologna. Soldani was heir to the grand Florentine lineage and an extremely skilled and refined sculptor, whose medals and reliefs cast from his own designs were highly accomplished, as were his reproductive bronzes. He is not known to have worked in marble.

Virtue Triumphant over Vice is a miniature version of Giovanni Bologna's marble group *Florence Triumphant over Pisa*, which was commissioned in 1565 by Francesco de' Medici as a companion to Michelangelo's earlier marble statue of *Victory*. Only a few years before accepting the challenge to provide a pendant to the *Victory*, Giovanni had carved another marble group, *Samson Slaying a Philistine*, which also, of course, demanded comparison with Michelangelo and his earlier project for the same subject.

Although Giovanni Bologna took inspiration for *Florence Triumphant over Pisa* from Michelangelo's powerfully kinetic sculpture groups, he transmuted their energies into a purely aesthetic arrangement of cool yet sensuous nudes, harmoniously composed. Like its marble source, Soldani's bronze is designed to be viewed from all sides; but unlike the *Samson and Two Philistines* after Michelangelo, which drives the viewer into continuous motion, the views of the marble and of Soldani's bronze are composed serially in a sequence of frozen facets, suavely connected but each perfect and satisfying as a design in itself. The bronze was produced in several slightly differing models and is known by various titles: *Virtue Triumphant over Vice*; *Honor Overcoming Falsehood*; and *Beauty Chaining Strength*. The precise subject was secondary because, as one of Soldani's princely patrons explained to another sculptor, what mattered was not the subject but that the work should consist of "belli nudi e belle idee."

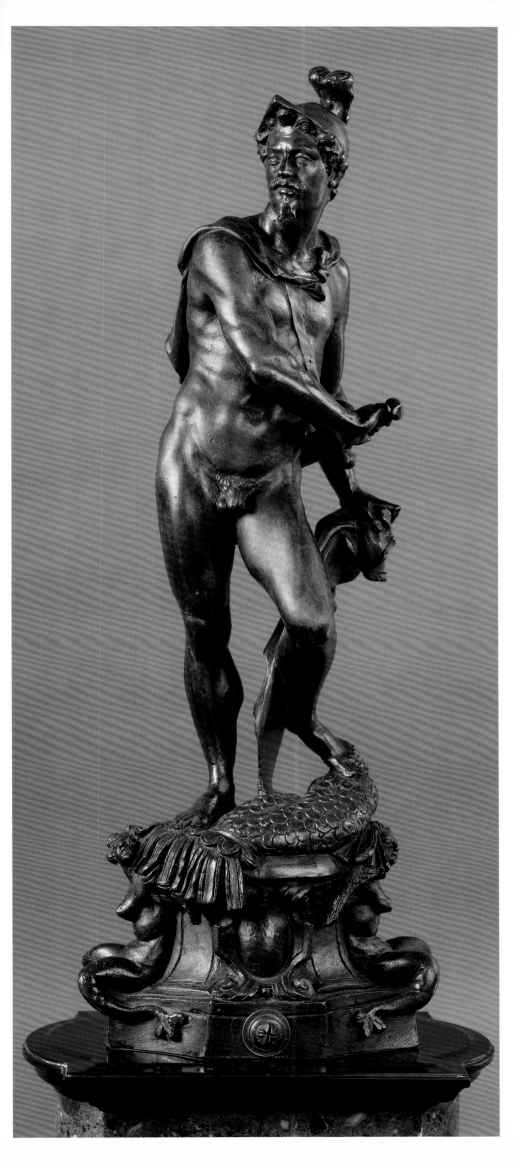

TIZIANO ASPETTI, STYLE OF

c. 1559–1606

Aspetti, who came from a Paduan family that included sculptors and bronze casters, moved to Venice in his youth to assist Girolamo Campagna, one of the best sculptors of that city. He received commissions there and in Padua and worked in both marble and bronze, producing notable figures and reliefs for the Palazzo Ducale and S. Francesco della Vigna, Venice, and S. Antonio, Padua. During his later years Aspetti settled in Tuscany, working chiefly in Pisa and Florence.

MARS

Date unknown. Bronze
H. 22 ¹¹⁄₁₆ in. (57.6 cm.)
Acquired in 1916

While the Venetian sculptors Alessandro Vittoria and Girolamo Campagna played influential roles in forming Aspetti's style, long before he moved to Tuscany he seems to have been strongly attracted by Florentine sculpture, and especially by Giovanni Bologna. The spiraling pose of the *Mars* reflects contemporary Florentine taste for elegant, convoluted patterns, wherein the head turns on the torso, the arms swing counter to the torso, and the legs often make swaying, unstable contact with the ground. The sense of coiled movement implied by the god's pose is further propelled by his action as he reaches back to draw his sword while gazing forward over his right shoulder toward an unseen foe. The modeling of the bronze contributes to the liveliness of the sculpture. Light seems to flicker up over the surface as the form swells and diminishes like a flame. One is strongly reminded of paintings by a Venetian contemporary, Tintoretto.

Other versions of this *Mars* exist, some paired with Venus and Cupid and some mounted as andirons.

167

JACQUES JONGHELINCK
1530–1606

A native of Antwerp, Jonghelinck came from a family of medalists and masters of the Antwerp Mint. By 1552 he had moved to Milan, where he joined the workshop of Leone Leoni, an internationally renowned sculptor. After his return to the Low Countries, probably in 1553, Jonghelinck quickly began receiving important posts and sculpture commissions—including the tomb of Charles the Bold in Bruges—from members of the Spanish court and royal family, to whom he remained loyal throughout the civil and religious wars. After appointment as warden to the Antwerp Mint in 1572, Jonghelinck found little time for major sculpture, but he continued producing medals.

THE DUKE OF ALBA

Dated 1571. Bronze
H. 45 ⅞ in. (116.5 cm.)
Acquired in 1916

Jonghelinck was unfortunate in that one of his last major works of sculpture, a full-length, over-lifesize bronze statue of the Duke of Alba, erected within the citadel of Antwerp in 1571, was destroyed only a few years later. But his subject happened to be the most hated man in the Netherlands: Don Fernando Álvarez de Toledo, third Duke of Alba (1507–82). Monuments to tyrants seldom survive for long.

Fanatically devoted to the Catholic Church and the Spanish throne, Alba commanded the Spanish armies, winning victories for his sovereigns, Charles V and Philip II, against the Turks and the Protestants. He was sent as viceroy to Naples and on various diplomatic missions, and in 1567 he was appointed governor-general of the Low Countries. There, his arrogance, tyranny, and merciless suppression of civil and religious opposition were so extreme that even his employers found his cruelty unacceptable. He was recalled to Madrid two years after Jonghelinck made the bronze statue and the portrait bust in The Frick Collection.

Jonghelinck's inscribed, signed, and dated bust of Alba adheres to standards of restraint and decorum typical of the international court style, which was so pervasive in portrait painting and sculpture of the late sixteenth and early seventeenth centuries. Like Adrian de Vries in his portrait of Emperor Rudolph II or Leone Leoni in his of Charles V, Jonghelinck renders details of the costume—the armor, ruff, and Order of the Golden Fleece—with scrupulous precision. In Jonghelinck's portrait, the stiffness and sharpness of these outward appearances seem a perfect match to the sere and forbidding aspect of the Duke, whose rigid posture, aristocratic mien, and fierce expression so unequivocally reveal the man's character.

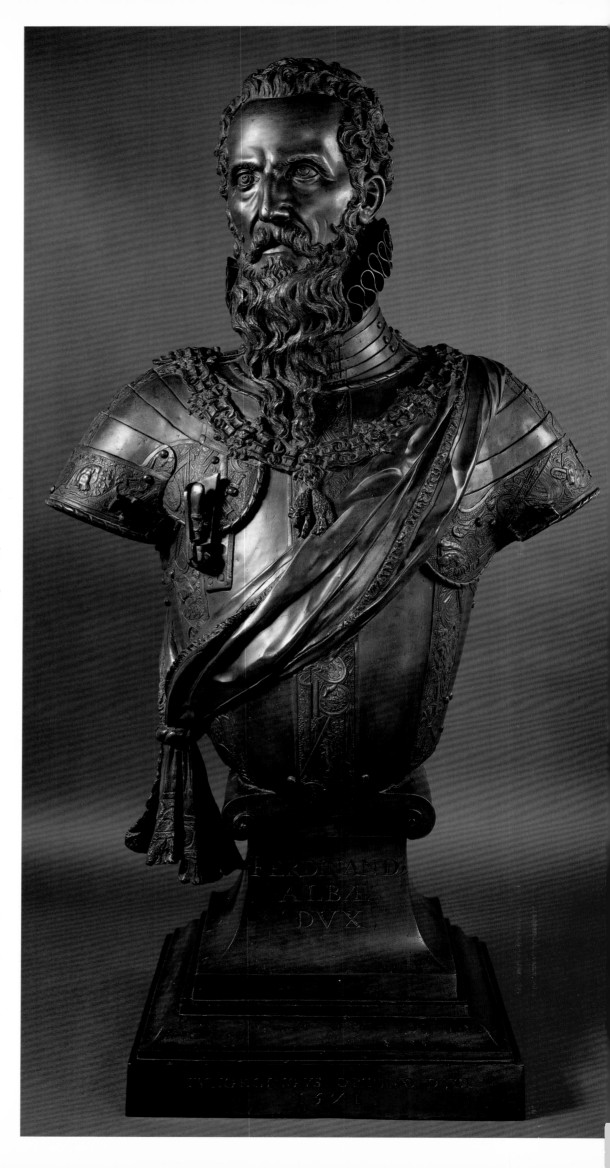

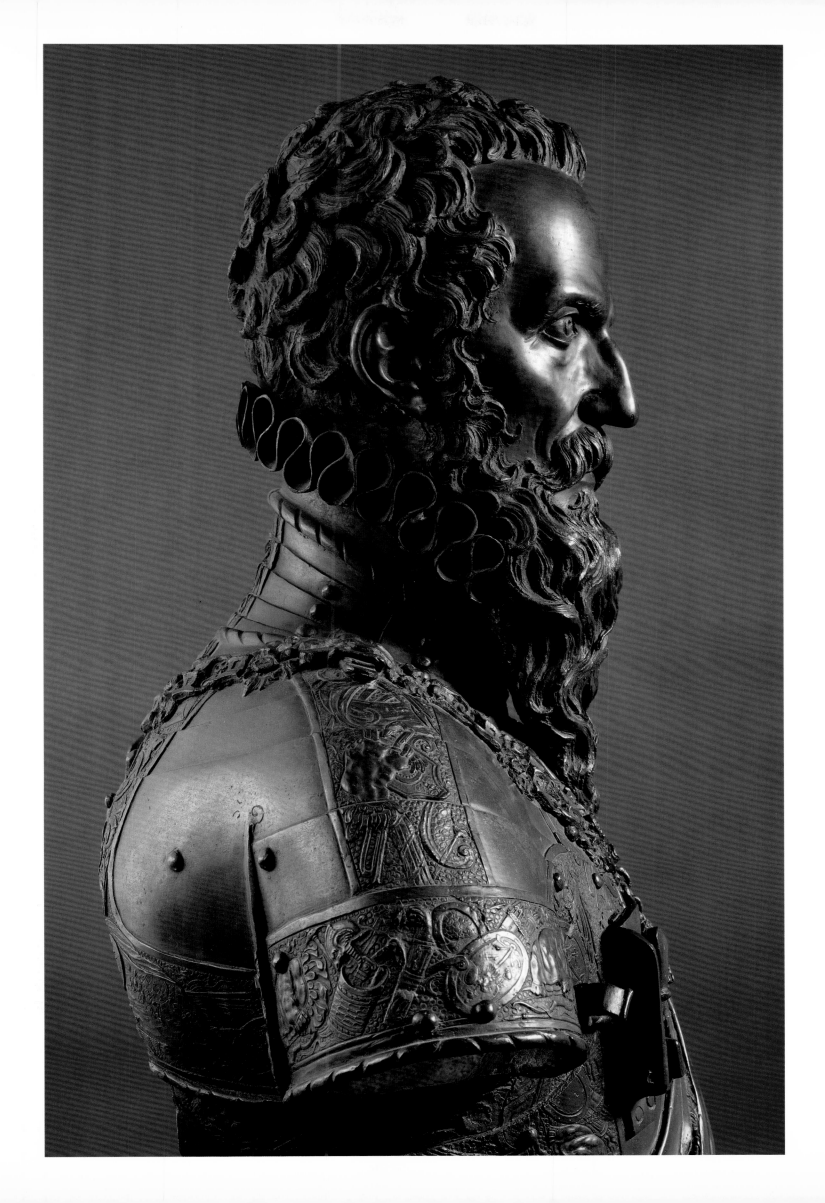

HUBERT GERHARD, ATTRIBUTED TO
c. 1550–1622/23

Like so many of his Dutch compatriots, Gerhard left Holland at an early age to pursue his career further south. Although no Italian sojourn is recorded, he is believed to have gone to Florence and studied with Giovanni Bologna. By 1581 he had traveled northward again, finding employment with the Fugger family at Kirchheim; he was also active at Augsburg, Munich, and Innsbruck. Best known for his fountains, Gerhard worked primarily in bronze and clay.

TRITON AND NEREID

Date unknown. Bronze
H. 25 ½ in. (64.8 cm.)
Acquired in 1916

Following Giovanni Bologna's example, the vogue for pairing male and female figures grappling in postures of passion or hostility grew and spread. Sometimes, as with the *Triton and Nereid*, it is not entirely clear whether love or war has been declared, or perhaps only a lusty flirtation is intended. While the inspiration for this bronze was Florentine—and the Triton's pose was borrowed from Giovanni Bologna's bronze relief of the *Rape of the Sabines*—the conception does not seem Italian. The Italian invention of offering multiple, spiraling views of a sculpture as one circles it seems to have resisted exportation. The front view of the bronze is the dominant one, partly perhaps because of its origins in Giovanni Bologna's relief, while the sides and back are less satisfactory, and nothing much happens in between.

The proportion of realism to abstraction has tilted strongly toward the first, transforming the geometric shapes and perfected surfaces of Italian prototypes back into rather fleshy nudes, who thrust and pull at strained and awkward angles rather than spiral together in the flowing curves of the Florentine mode. These figures remind one of such contemporary Dutch painters as Wtewael or Cornelis van Haarlem, whose mannered compositions are peopled with nudes arranged in even more exaggeratedly difficult poses.

Although the Frick model is not currently fitted as a fountain, it appears that the group originally was designed for that purpose.

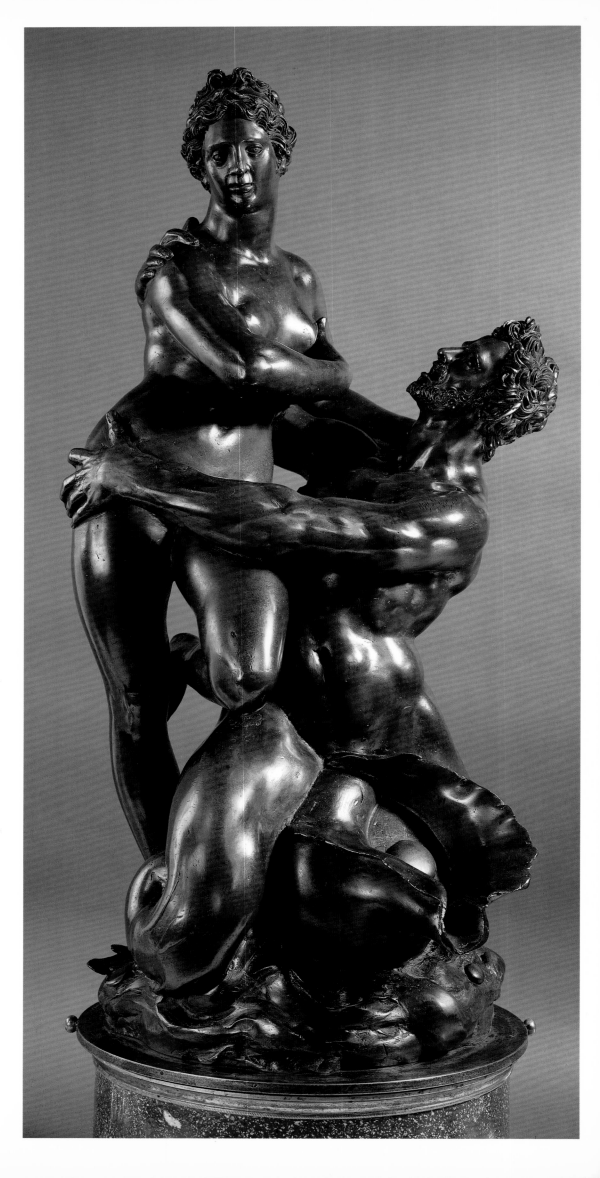

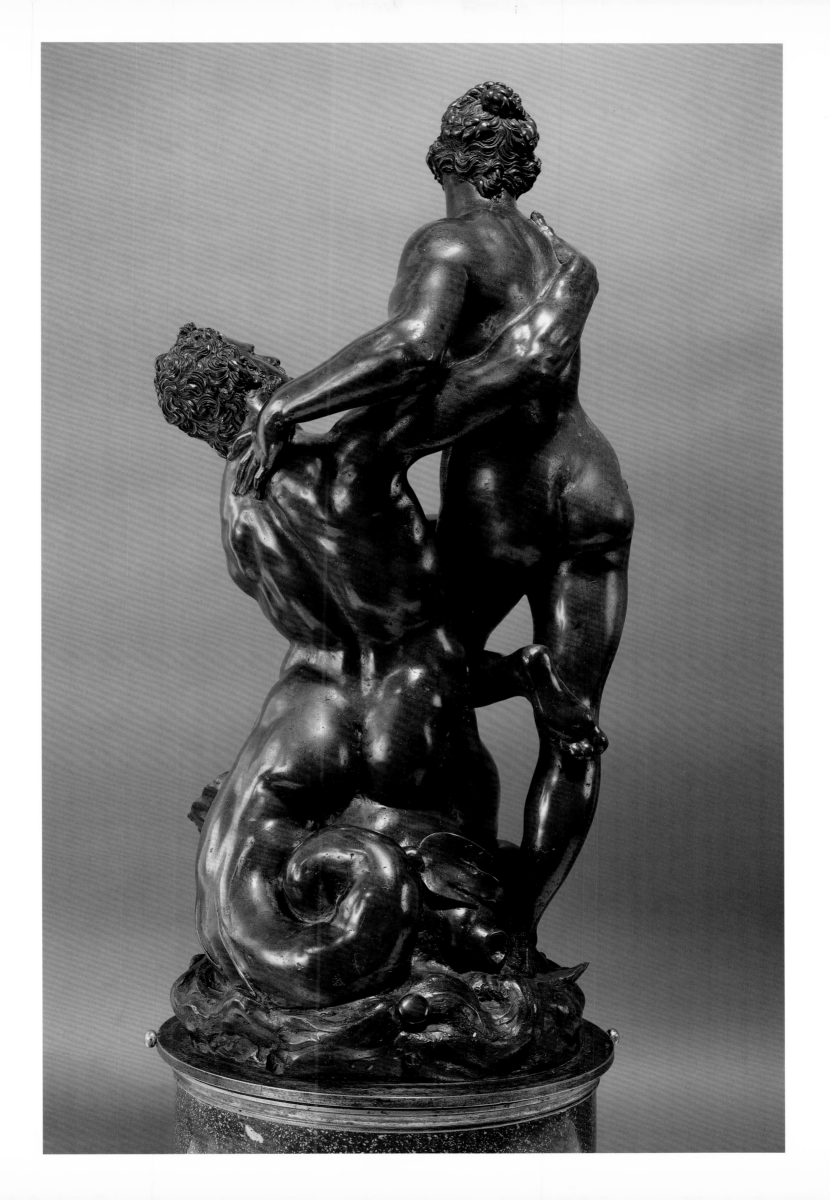

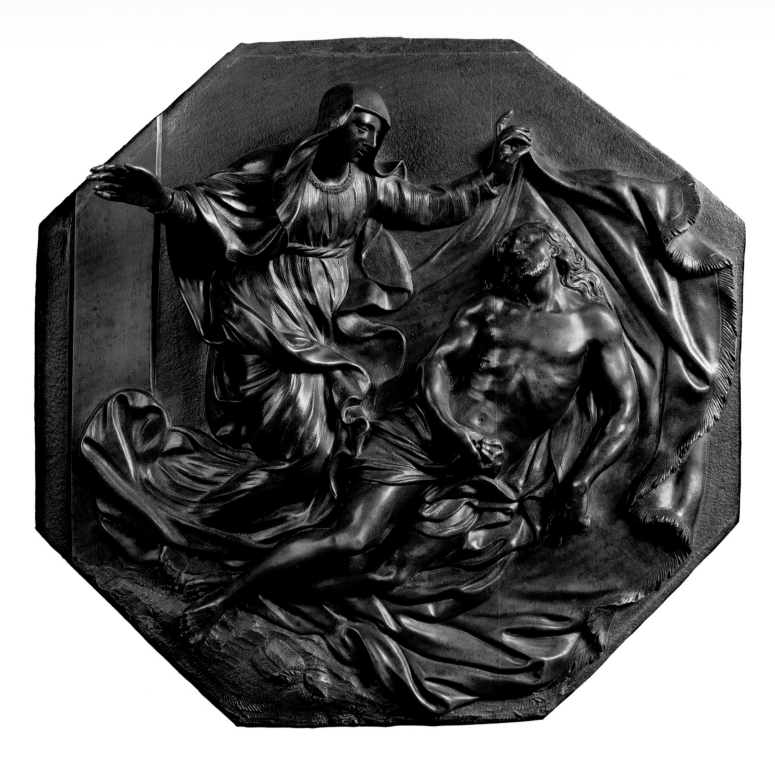

ALESSANDRO ALGARDI
1598–1654

Born in Bologna, Algardi studied at the academy of the Carracci and with minor local sculptors. He served Ferdinando Gonzaga in Mantua for a few years, but in 1625, after a brief detour to Venice, he moved to Rome, where he remained for the rest of his highly successful career. Like his rival Gian Lorenzo Bernini, Algardi sought commissions from churches and the nobility, soon winning a roster of illustrious patrons for his religious and mythological subjects and portrait busts. After Bernini's champion Pope Urban VIII was succeeded by Innocent X in 1644, Algardi also received many important papal commissions.

PIETÀ

Made probably in the 1630s.
Bronze relief, octagonal
Dimensions excluding flange: H. 11 ¾ in.
(29.8 cm.); W. 11 ¾ in. (29.8 cm.)
Purchased with funds from the bequest of
Arthemise Redpath, 1992

Algardi learned his profession in an area of Italy where marble is scarce and terracotta was more often used for sculpture as well as for architectural ornament. On his arrival in Rome he at first found himself at a disadvantage in competing with an established rival, Bernini, who had been working in marble—Rome's traditional medium—since childhood. But by the 1630s, the probable date of the Frick *Pietà*, Algardi had begun to receive major commissions, both in marble and in bronze, for tombs, altars, and statues in St. Peter's and other prominent locations.

Although he became expert at carving in marble, Algardi's preference for modeling, over the hammer and chisel of stonework, led to more pictorial effects in his sculpture, to refinements of surfaces and textures, to quiet elegance of line, and to delicate, intricate patterns of movement. His bronze sculptures preserve the sensitive touch with which he formed the clay or wax models. These qualities are abundantly evident in the *Pietà*, where burnishing, tooling, and punchwork detach figures from background, distinguish one type of fabric from another, and describe details with a crisp clarity that seems to lose none of the freshness of the artist's original model.

Algardi presents the *Pietà* in lyric, moving language. The pathos of the moment when Mary lifts the shroud from the face of her dead son is only intensified by the restraint of her classic gesture of despair. Billowing waves of drapery flow around the figures, which seem to hover in a detached realm belonging neither to earth nor to heaven. The body of Christ, its wounds exposed, is presented as it may once have been on some altar, with Eucharistic significance. The relief does not illustrate an event from biblical narrative, but is a devotional image intended to inspire meditation on Christ's sacrifice.

ANTOINE COYSEVOX

1640–1720

*A native of Lyon, Coysevox moved in
1657 to Paris, where he studied with various
sculptors and at the Academy. In 1666 he
was named "sculpteur du roi." After
working in Alsace from 1667 to 1671 for
the Bishop of Strasbourg, he settled in Paris,
spending brief intervals at Lyon. Coysevox
won many important commissions for
portraits and monuments, received an
apartment at the Louvre, and was employed
at Versailles, Marly, and Saint-Cloud. Louis
XIV named him to a succession of posts,
and he was elected Director of the Academy.
Coysevox became the leading French
sculptor of his time.*

ROBERT DE COTTE

Date unknown. Bronze
H. 21 ⅜ in. (54.3 cm.)
Acquired in 1945

In Robert de Cotte (1656–1735), Coysevox
found a subject to inspire his finest efforts. A
close friend and colleague, de Cotte was a
highly successful architect, as eminent in his
career as Coysevox was in the profession of
sculptor. Brother-in-law and assistant to
Jules Hardouin-Mansart, de Cotte succeed-
ed the latter as "premier architecte" to Louis
XIV. He designed numerous official build-
ings in France and several major palaces
elsewhere in Europe. He and Coysevox
sometimes collaborated on commissions.

With fluent skill and sensitive under-
standing, the sculptor translated his friend's
appearance and character into bronze, creat-
ing a masterpiece of portraiture. The bust
captures the energy and confidence of the
architect who could so capably direct vast
enterprises of diverse sorts at widely scat-
tered locations. Every detail of the sculpture
contributes to a description of this complex
personality. The rich abundance of the
peruke, with its fat, springy curls, the round-
ed ripeness of the flesh, the open gaze, the
distinguished nose, all portray a command-
ing but sympathetic and intelligent man of
the world. The vigorous turn of the head,
emphasized by the twisting sweep of tum-
bling locks, is a far cry from the decorous
frontal busts of the Italian Renaissance, when
even the slightly tilted head of Verrocchio's
young lady seemed a daring, novel engage-
ment of the sitter with the external world. It
was above all Bernini, briefly employed in
France in 1665, who with his dynamic por-
trait busts such as that of Louis XIV led the
way for Coysevox and other French baroque
sculptors. Movement, Bernini claimed, could
best express a sitter's unique qualities. In
Coysevox' vibrant portrait, Robert de Cotte
seems to move freely, with the assured yet
receptive air of a man at ease in his world.

A marble version of Coysevox' bust in
the Bibliothèque Sainte-Geneviève, Paris, is
dated 1707.

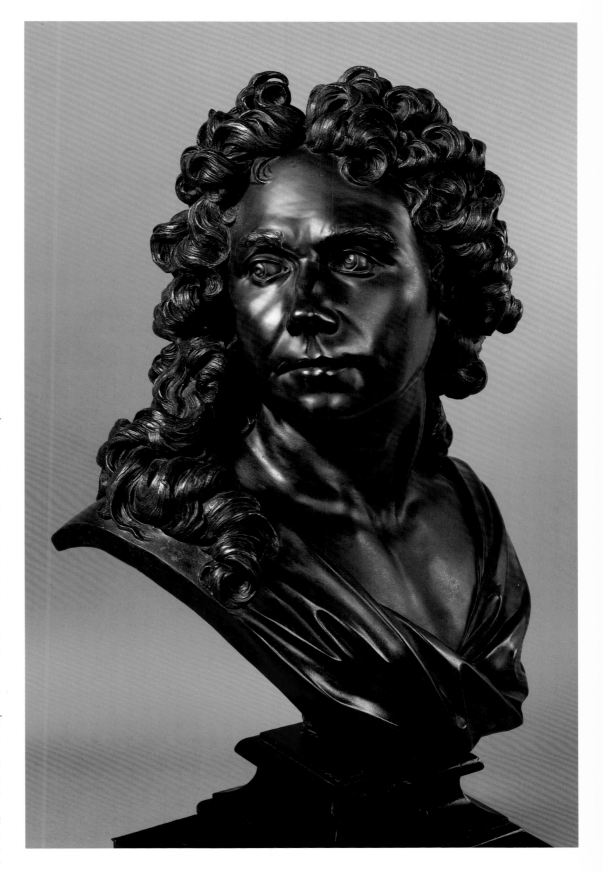

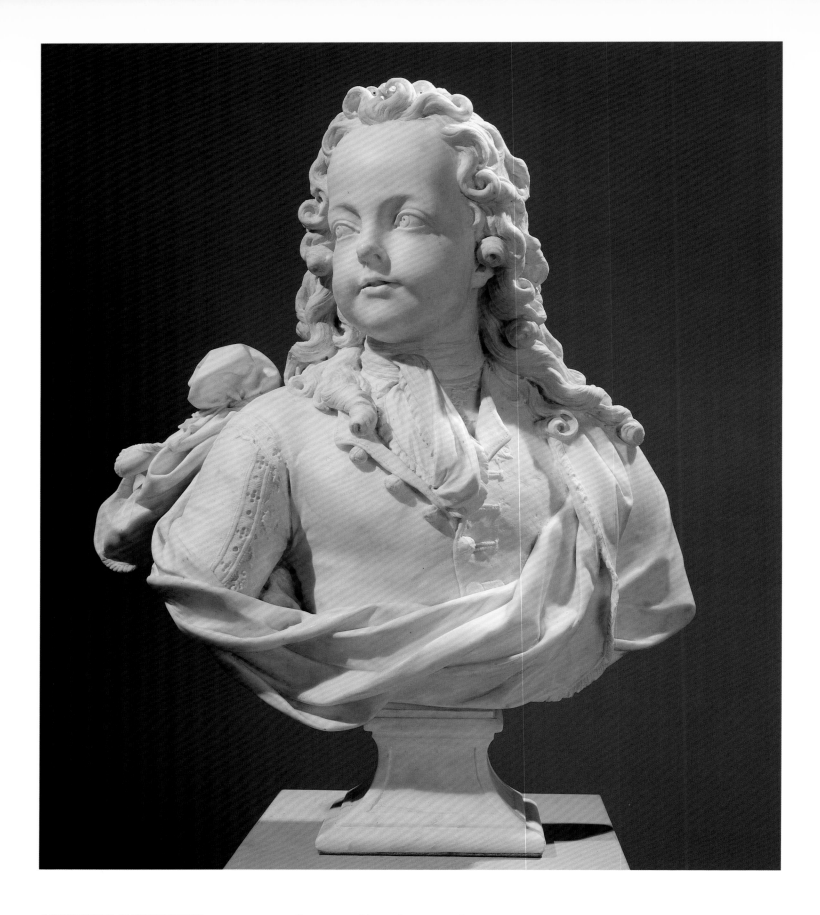

ANTOINE COYSEVOX

LOUIS XV AS A CHILD OF SIX

Dated 1716. Marble
H. 23 ½ in. (59 cm.)
Gift of Dr. and Mrs. Ira H. Kaufman, 1990

The six-year-old subject of this regal bust became king the preceding year, at the death of his great-grandfather, Louis XIV. The infant's grandfather, father, mother, and elder brother had all died earlier, leaving him under the regency of his cousin, the Duc d'Orléans. The young king's plump features could not be expected to register any trace of experience, but Coysevox has given him a lively expression, with wide-open eyes and parted lips. His subjects claimed the child to be as beautiful as Cupid.

Following traditions of international court portraiture of the late sixteenth and the seventeenth centuries, when even mature persons often were defined chiefly by their clothes, the sculptor has relied on costume, wig, and pose to endow the child with majesty. The portrait derives much of its interest from the bravura carving of costume details and surface textures. The soft, fringed stock, frogged coat, and bold sweep of cloak are elaborately finished, in striking contrast to Coysevox' bust of Robert de Cotte, with its simple, casual fall of drapery in the antique mode. Even the king's wig is stiffer and more formal than the architect's. Coysevox' ability to change his approach, to select for emphasis what might be appropriate to his subject, helped make him the most popular as well as the greatest portrait sculptor of his period in France.

Several variants of this portrait of Louis XV, which is signed and dated on the back of the base, have survived. All were made within a few years of the Frick bust, thought to be the earliest of the series. The Frick Collection also owns a miniature Sèvres porcelain bust of the king (see p. 194) depicted as a mature man, aged about fifty, based on a sculpture by Jean-Baptiste Lemoyne.

JEAN-ANTOINE HOUDON
1741–1828

With Coysevox, the art of portrait sculpture reached a new level of brilliance in France; Houdon, however, has been claimed as the greatest portrait sculptor of all time. Houdon studied sculpture in Paris, winning prizes even as a child, and at the age of twenty took the Prix de Rome. Although he executed a few important non-portrait subjects while in Rome, from 1764 to 1768, once back in Paris he specialized in portrait busts, producing the occasional full-length portrait as well. To prepare a marble standing figure of George Washington, Houdon traveled to the United States in 1785. His seated portrait of Voltaire was so successful that he turned out numerous variants in different sizes, costumes, and materials. Houdon studied his subjects by making careful measurements and casts, employing an expert understanding of anatomy and the various techniques of sculpture. His work was much in demand among the statesmen, literary figures, and social leaders of his day.

THE COMTESSE DU CAYLA

Dated 1777. Marble
H. of bust 21 ¼ in. (54 cm.);
H. of stand 5 ⅝ in. (14.3 cm.)
Acquired in 1916

In 1772 Élisabeth-Suzanne de Jaucourt (1755–1816) married her cousin François-Hercule-Philippe-Étienne de Baschi, Comte du Cayla. Five years later Houdon portrayed her as a carefree nymph with grape leaves circling her breast and windswept hair. The guise of a bacchante may make playful reference to her husband's last name, Baschi, which was linked by creative etymology to Bacchus; Bacchus and a bacchante supported the family coat of arms. A plaster version of Houdon's portrait was shown in the Salon of 1775; the present bust, exhibited two years later, is signed and dated 1777 on the back of the stand.

Through long tradition from ancient times, portraits, especially those carved in marble, were intended to confer upon the subject an approximation of immortality. Hence it was important to convey a notion of permanence and durability, in addition to the sitter's high character. Houdon's portrait of the Comtesse du Cayla seems deliberately to seek for opposites of these traditional desiderata. Lightness and movement, the fragility of time and substance are captured here in lacy stone. The frothy hair pinned with leaves and roses and the vine leaves worn over the shoulder are deeply undercut, emphasizing the brittleness and translu-

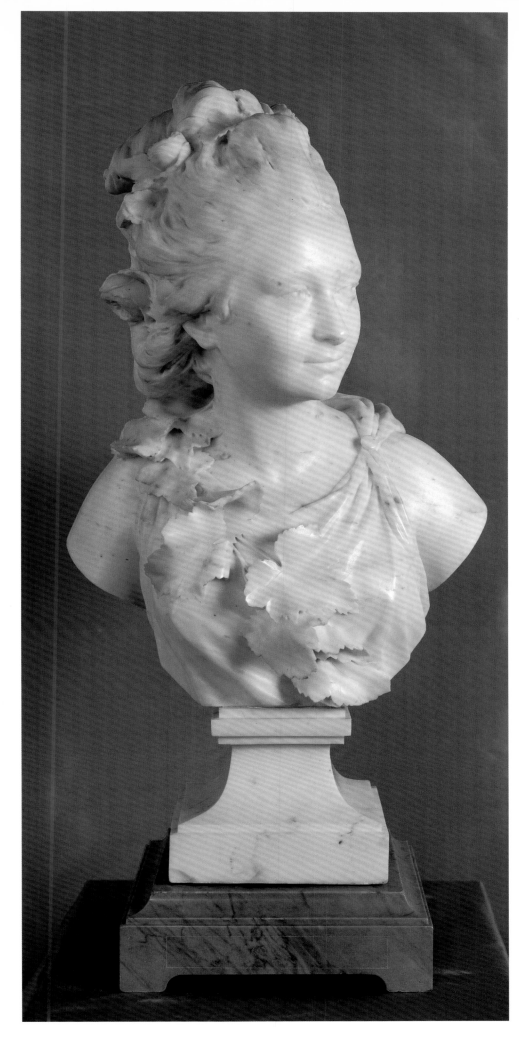

cent qualities of marble. The young woman turns, a fleeting come-hither expression on her still-demure, slightly smiling face. Her eyes appear to sparkle; the irises are dark holes above which a sliver of marble gives the illusion of bright reflection. Houdon obviously had studied the marble portraits by Bernini during his years in Rome, but his consummate technique, refined imagination, and subtle interpretation of personality seem specifically products of eighteenth-century France.

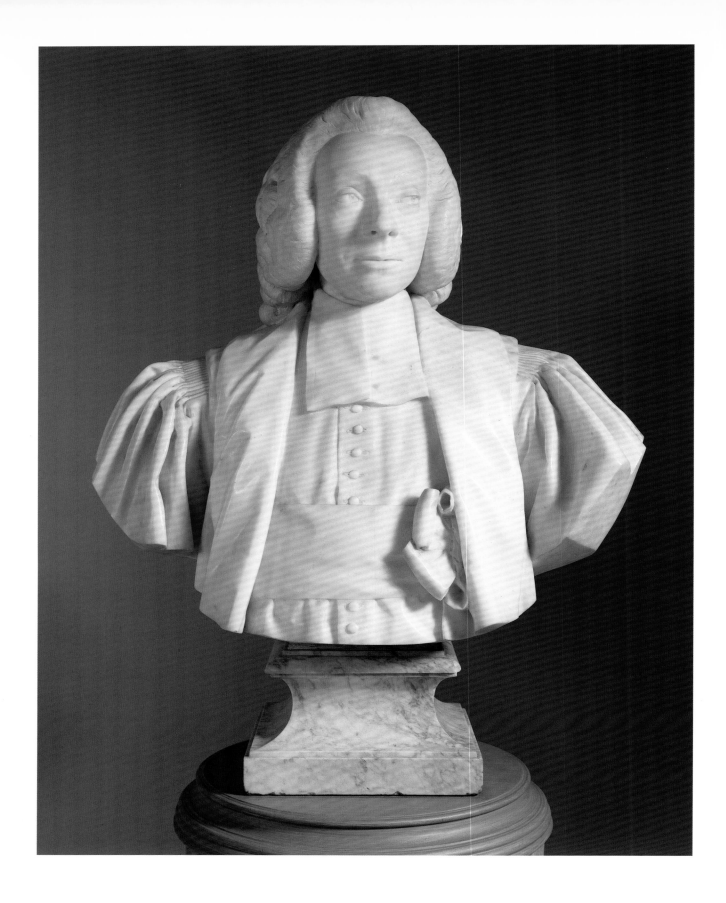

JEAN-ANTOINE HOUDON

ARMAND-THOMAS HUE,
MARQUIS DE MIROMESNIL

Dated 1777. Marble
H. of bust 25 ½ in. (64.8 cm.);
H. of stand 6 ¾ in. (17.2 cm.)
Acquired in 1935

The Marquis de Miromesnil (1723–96), of Norman stock, was appointed "premier président" of the Norman parliament at Rouen in 1757. He served in that post until Louis XVI named him "Garde des Sceaux" (Minister of Justice) in 1774. During the Revolution he was briefly imprisoned. It was probably during those years that his title MARQUIS was effaced from the inscription on the back of the Frick bust: A. T. HUE . . . DE MIROMENIL. FAIT PAR HOUDON EN 1777. Three other versions of the portrait survive, two in marble, one in plaster, all very similar and presumably dependent on the same model, which the sculptor would have done from life.

Houdon has suggested the importance and rectitude of this supreme magistrate of French justice through the stability and solidity of his shape and clothing. The layers of stiff, heavy cloth, the ample sleeves swelling from pleated shoulders, the high, tight collar falling in straight lappets, the neatly buttoned cassock all represent the uniform of office. The head as well as the body is encased, the huge, formal wig seeming to inhibit the turn of his attention. But then in exquisite contrast, the face is all mobility and subtle nuance. As one moves around the bust, the expression changes. The sensitive lips seem about to comment with ironic wit on these encumbrances of office. The supple flesh hints at a smile. The eyes, not quite matched in shape, appear to shine, thanks to the sculptor's virtuoso wielding of the chisel.

The Frick bust of Miromesnil is dated the same year as Houdon's portrait of the Comtesse du Cayla. The contrast between them illuminates the range and genius of this master of sculptural techniques, who captured with such acute understanding the special qualities of his subjects.

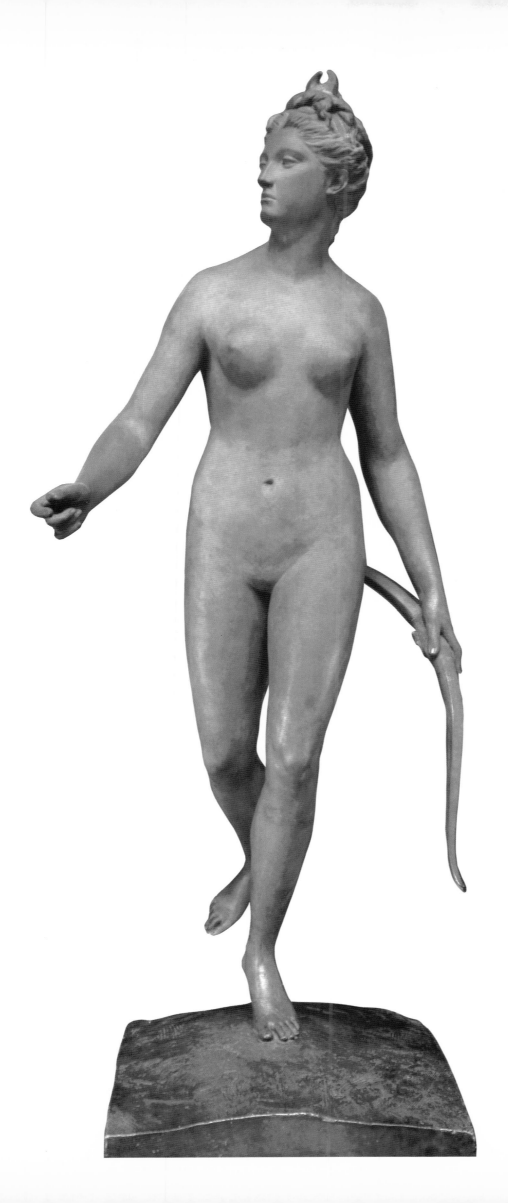

JEAN-ANTOINE HOUDON

DIANA THE HUNTRESS

Made probably between 1776 and 1795.
Terracotta
H. overall 75 ½ in. (191.8 cm.);
H. of figure 68 ⅛ in. (173 cm.)
Acquired in 1939

Swift virgin goddess of moon and hunt, Diana alights poised on one foot, a technical tour de force. The life-size terracotta, supported by interior metal armatures, is constructed of at least ten separately fired sections. Many versions of the *Diana* were made by Houdon and his workshop, in plaster, metal, and marble, life-size, reduced, and of the bust alone. Probably the earliest surviving example is a plaster dated 1776, in the Schlossmuseum, Gotha. The Frick piece, which is signed but not dated, is believed to have been produced several years later. The arrow once held in Diana's right hand is now missing, and her wooden bow is a replacement.

Houdon thought about famous antecedents when designing his regal goddess, crowned with a crescent moon. He remembered the *Apollo Belvedere,* several well-known classical examples of Diana, and images of the sixteenth-century favorite of Henri II, Diane de Poitiers, who inspired so many similarly elegant, long-limbed Dianas. The pose of Giovanni Bologna's *Mercury* also became absorbed into the delicate equilibrium of his daringly balanced statue. Indeed, French and Florentine mannerism seem to dominate Houdon's ideal of an aloof beauty, with her blank-eyed mask and smoothly abstract, elongated body. Not even a wisp of cloth interrupts the sleek nudity, to Houdon's contemporaries a shocking indecency only intensified by the flesh tones of the surface.

Large-scale terracottas were common in antiquity and in certain regions of Italy, such as Bologna (where Algardi learned his métier). In eighteenth-century France, the pastel hues and subtle malleability of baked clay made it a popular medium for small sculptures, but a terracotta statue so large and so precariously posed as this *Diana* was unprecedented. As in the virtuoso carving of his marble portrait busts, Houdon explored the frontiers of his chosen medium, again reaching beyond their traditional limitations.

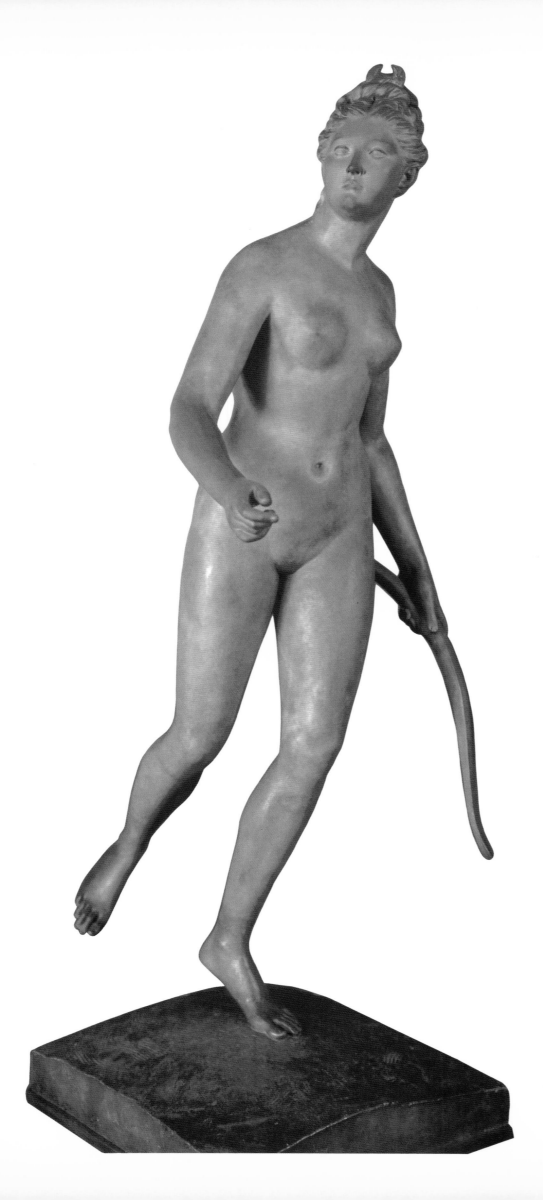

(Opposite)

CLODION (CLAUDE MICHEL)
1738–1814

Born in Nancy to a family of well-known sculptors, Clodion went in his youth to Paris to work with an uncle, Lambert-Sigisbert Adam, and subsequently with Pigalle. After winning the Prix de Rome, he spent nine years in that city studying antiquities, Roman baroque sculpture, and the art of his contemporaries, from Piranesi to Sergel. While he was yet a fledgling at the French Academy in Rome, his prodigious talents, and his special aptitude for small terracottas, attracted an illustrious clientele, including Catherine the Great. On his return to Paris in 1771, Clodion's successes multiplied. He received major commissions for public and church monuments and produced countless models for vases, reliefs, clocks, and other decorative projects. A supporter of the monarchy, he fled Paris during the Revolution, returning about 1797. Clodion sought new patrons among Napoleon's entourage, but his style appealed more to the world of Fragonard than to the admirers of David, and demand for his work diminished.

ZEPHYRUS AND FLORA

Dated 1799. Terracotta
H. 20 ¾ in. (52.7 cm.)
Acquired in 1915

Winged Zephyrus, god of the west wind, embraces his bride Flora, crowning her with a wreath of roses. Three cupids nudge them together and scatter roses from a basket. More blossoms garland the breast of Flora, whose "lips breathed vernal roses"; this tenderly embracing couple, wrapped in a light breeze, realizes the Arcadian imagery of Ovid's *Fasti*, which describes the perpetual spring and gentle winds of the garden the lovers inhabited.

By the final year of the eighteenth century, when Clodion signed and dated this work, the freestanding sculpture group had developed into a work of art that differed greatly from the sixteenth-century pioneering examples of Michelangelo and Giovanni Bologna. Space itself becomes a major element in this piece, as the forms seem to rise and turn around openings that spread within the frame of slender figures and fluttering silhouettes. The lightness of terracotta, in both substance and color, and the extraordinary refinement of details, surfaces, and textures contribute to the airy delicacy of the statuette.

Clodion, like Houdon, referred to antiquity and other early sources. His terracotta is a remote descendant of the marble

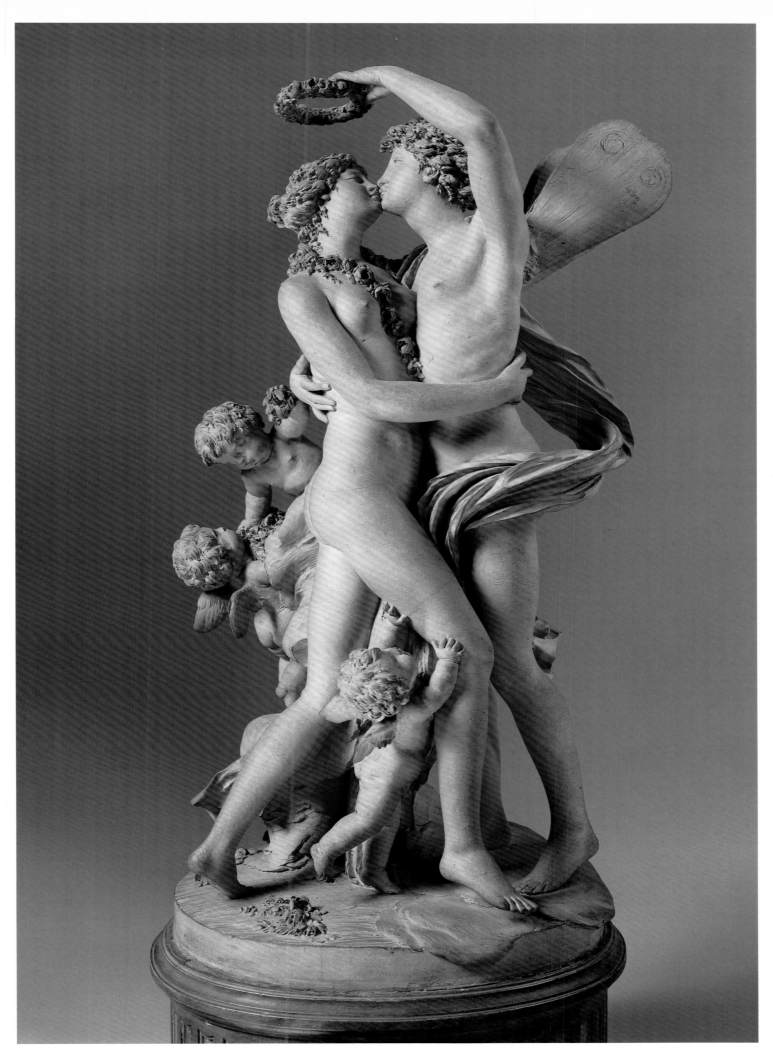

Cupid and Psyche taken from Rome by Napoleon and paraded triumphantly with other booty through Paris in 1798. Raphael's *Psyche Borne by Cupids* painted in the Villa Farnesina, Rome, also contributed to Clodion's Flora, as did Houdon, whose popular, much replicated bust of kissing lovers must have been known to him. The buoyant, long-limbed figure of Flora may even reveal a debt to Houdon's *Diana*. But despite the classical allusions and the hints of neoclassicism, Clodion's *Zephyrus and Flora* represents above all a last joyous chord closing the eighteenth century and, with it, a period of exceptional brilliance in French art.

DECORATIVE ARTS

By Susan Grace Galassi

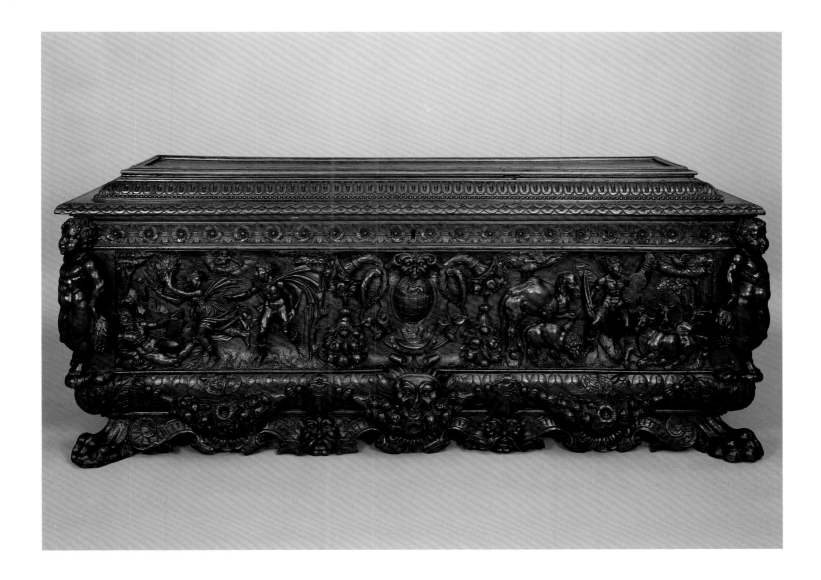

ITALIAN
Third quarter of the sixteenth century

PAIR OF CASSONI
WITH RELIEFS OF APOLLO

Date unknown. Carved walnut
H. 28 ⅛ in. (71.4 cm.); W. 66 ¾ in. (169.5 cm.);
D. 22 ⅜ in. (56.9 cm.)
Acquired in 1916

The Renaissance *cassone* was an ornately decorated chest originally used to hold clothing or linens, often a bride's dowry; it could also serve as additional seating in a bedroom. In fifteenth-century Florence, *cassoni* were often embellished with painted panels. Other common decoration included *pastiglia* (panels ornamented with low-relief patterns in a painted or gilded gesso paste) and *intarsia* (inlaid wood). It was in the third

quarter of the sixteenth century that *cassoni* bearing elaborate carved wooden panels came to the fore. Walnut, with its rich brown color, was the favored wood for this type.

Although the tradition of decorated chests can be traced back to ancient Egypt, where examples have been found in tombs of the pharaohs, the form of the Frick *cassoni* derives more directly from classical marble sarcophagi and from contemporary Renaissance tombs. Both in their shapes and in their ornamentation and narrative panels the chests reflect the Renaissance revival of antiquity. Scenes from Ovid's *Metamorphoses* are depicted in the carved panels of both *cassoni*: on one the scenes closely follow the story of the Contest of Apollo and Marsyas and the Flaying of Marsyas, while on its companion (illustrated) appear Apollo and Daphne and Apollo playing to the beasts. These compositions are based in part on woodcut illustrations that appeared in editions of the *Metamorphoses* published at Lyon in French in 1557 and in Italian two years

later, indicating that the chests cannot have been produced before the third quarter of the sixteenth century. The style of the carved panel figures, with their dramatic flying draperies, suggests comparison not only with book illustration but also with contemporary relief sculpture in bronze, reflecting the strong interrelation in the Renaissance between the applied and fine arts. On the central panel of each chest is an elaborate escutcheon with the arms of one of the families who commissioned them, and at the front corners are large, almost freestanding putti.

The Apollo *cassoni* are among nineteen pieces of Italian furniture purchased by Mr. Frick between 1915 and 1918, all of them dating from the Renaissance—although some have been substantially restored. Consisting of eight carved walnut *cassoni*, three long center tables, and eight folding Savonarola chairs, they are displayed in the West Gallery, as they were during Mr. Frick's lifetime.

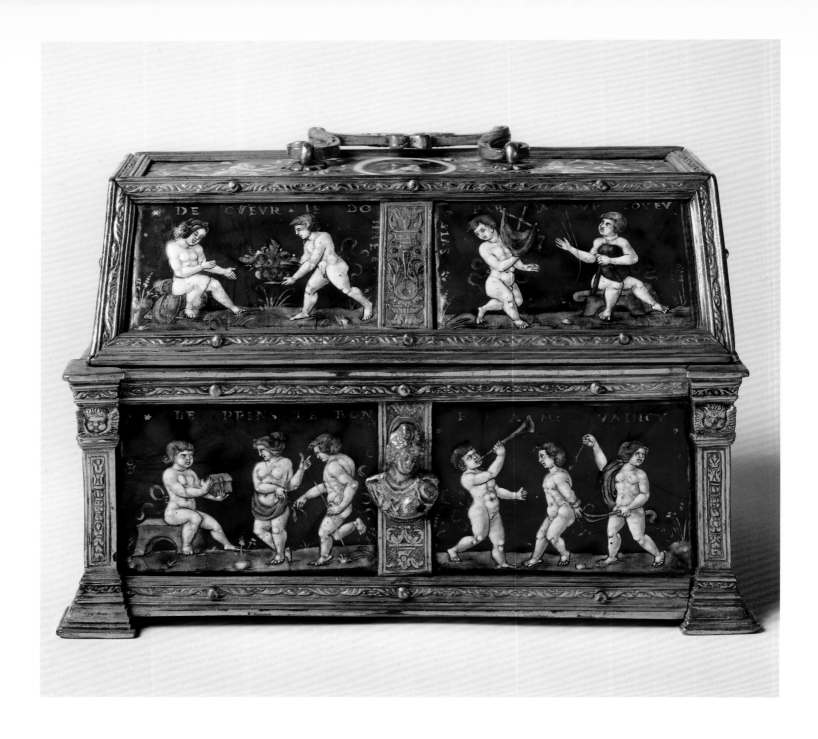

COLIN NOUAILHER

active 1539–1574

Colin Nouailher (also known as Couly Noylier) produced caskets mounted with plaques inscribed in the Limousin dialect or in Latin. Consul of Limoges in 1567, he was still recorded as an enameler in 1574.

Casket with Putti and Mottoes of Courtly Love

Date unknown. Enamel on copper
H. 4 ⅝ in. (11.8 cm.); W. 7 ⁵/₁₆ in. (18.6 cm.);
D. 4 ¾ in. (12.1 cm.)
Acquired in 1916

Limoges had been a center of enameling in the Middle Ages, but the workshops were destroyed in 1370 by Edward, the Black Prince. Production was revived in the third quarter of the fifteenth century under Louis XI, who limited the rank and title of guild master to a small circle of local families.

During this second phase, which extended through the early seventeenth century, the traditional form of champlevé enameling—a method of filling cut-away areas of metal with a fused glass paste—gave way to a new technique of painting in enamel on copper covered with a white or black ground. As each color (derived from ground minerals in solution) fused with the copper at a different temperature, successive firings were required. These later enamels have been aptly described as translucent paintings.

The Renaissance Limoges enamelers drew their patterns and motifs from a wide array of graphic sources, among them German, French, and Italian prints and book illustrations; eventually, not only the graphic artists' subject matter but also their methods of rendering form were adapted. The sacred themes executed in brilliant colors that dominated early Limousin enamelwork gave way by the sixteenth century to secular subjects, often painted in *grisaille* on dark grounds.

The Frick casket, composed of thirteen plaques mounted in a gilt-copper frame, is characteristic of the luxury ware produced in Limoges in the mid-sixteenth century at the height of the city's international fame. In twelve of the plaques, naked putti at play are painted in *grisaille* with glazes of light red against a brilliant translucent ruby background. The figures play musical instruments, engage in mock battles, and woo young girls. Above each vignette is a motto inscribed in gold alluding to fidelity, the brevity of life, or the transitory delights of love. The theme of sporting putti, common in Roman wall paintings and sarcophagi, was probably transmitted to the enamelers at Limoges through Northern Italian engravings; scenes of this type are traditionally attributed to Colin Nouailher.

On the top of the lid, in a roundel flanked by putti holding leafy scrolls, is a female portrait bust in profile inscribed LVCRESE SVIS (Lucretia am I). As Lucretia is equated with chaste fidelity, the casket was probably a marriage gift.

The casket, which is one of the earliest of the Collection's holdings in the French decorative arts, is among a group of some forty enamels purchased by Mr. Frick from the estate of Pierpont Morgan. Together they form one of the finest assemblages in the country of the work of the Limoges artisans from the early sixteenth to the mid-seventeenth century.

SAINT-PORCHAIRE
POTTERIES
Sixteenth century

EWER WITH INTERLACE DECORATION AND APPLIED RELIEFS

Date unknown. Fine earthenware
H. including handle 9 in. (23 cm.);
W. including handle and spout 4 ½ in.
(11.5 cm.); D. of foot 3 ¼ in. (8.3 cm.)
Acquired in 1918

The rare and distinctive earthenware cera-
mics of Saint-Porchaire, a village in west-
central France, were prized during the
Renaissance and then largely forgotten.
When these mysterious emissaries from the
past returned to light in the mid-nineteenth
century, they acquired the name "faïence
de Henri II," as a number of them bore his
coat of arms. Only about sixty pieces of this
fragile work are recorded today. Made pure-
ly for decorative purposes, Saint-Porchaire
wares, with their elegant mannerist forms,
subdued range of earth tones, and rich
ornamental vocabulary, have been aptly
described as miniature monuments.

Exactly when production of Saint-Por-
chaire earthenware began cannot be ascer-
tained. It is known that potters were well
established in the area by the mid-sixteenth
century as the village is mentioned in con-
nection with "beaux pots de terre" in a
French guidebook of 1552, and evidence
suggests the existence of studios there as
early as the fifteenth century.

Saint-Porchaire pottery is distinguished
by its range of decorative motifs, fine-
grained, off-white paste, extraordinarily light
weight, and unusual methods of production.
The pieces consist of two layers. Patterns
were impressed into an outer layer of fine,
wet clay, and the cavities were filled with
clays of contrasting colors. This layer was
then transferred to an inner core of coarse
clay, and any decorative relief elements were
attached with slip. After a first firing at a
high temperature, the piece was covered
with a lead-base flux and fired again at a
lower temperature, rendering it lustrous.

The Frick ewer displays the eclectic
mix of Near Eastern and Western decorative
motifs that gives Saint-Porchaire pottery its
distinction in the ceramic field. Its tall,
rounded form reflects the metalwork fla-
gons of the French Renaissance, while the
zones of geometric interlace patterns cover-
ing the foot, body, shoulder, and neck evoke
Arabic decorative art. The handle, by con-
trast, is painted in a marbleized pattern. In
the applied ornaments, grotesque motifs
mix gracefully with architectural elements,
and mythological creatures cohabit with
salamanders. Many of the same decorative
schemes, such as the small amphibians and
marbleized patterns, appear in the earthen-
ware work of Bernard Pallissy (c. 1510–90),
whose production is sometimes confused
with Saint-Porchaire pottery.

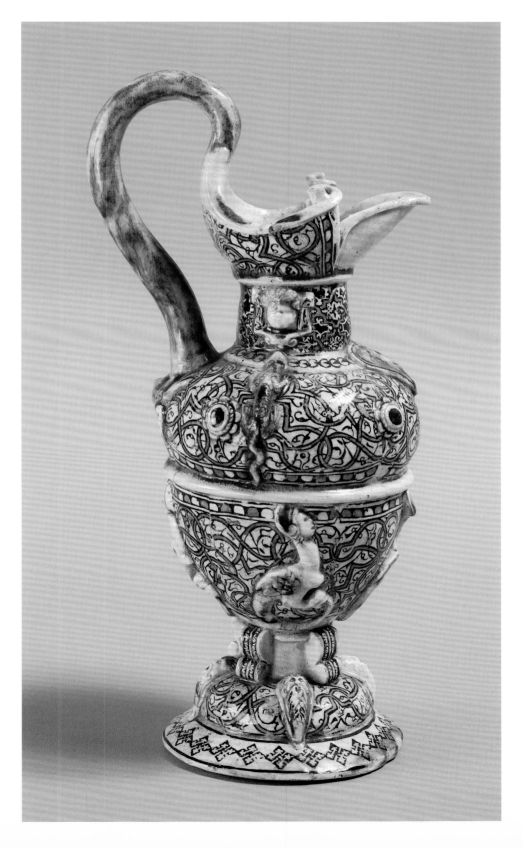

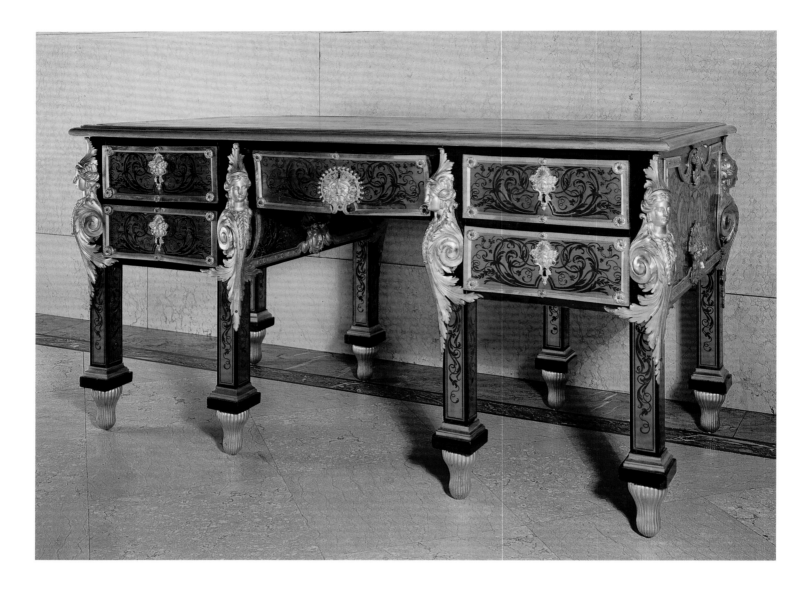

ANDRÉ-CHARLES BOULLE
1642–1732

A past master at veneered furniture, Boulle stands foremost in the long line of great French cabinetmakers of the late seventeenth and eighteenth centuries. Born in Paris, he was recorded as a marqueteur *(marquetry specialist) after 1664 and was appointed "ébéniste du Roi" (cabinetmaker to the King) in 1672, under Louis XIV. Boulle worked principally for the Crown, especially at Versailles, but his clients also included French nobles and foreign princes. He produced for them an uninterrupted succession of extraordinary works.*

KNEEHOLE DESK WITH TENDRIL MARQUETRY

Made c. 1700.
Oak, fir, and walnut veneered with tortoiseshell and brass marquetry and mounted with gilt bronze
H. 30 ¾ in. (78.1 cm.); W. 57 ⅞ in. (147 cm.); D. 29 ⅛ in. (74 cm.)
Acquired in 1918

All of the vertical surfaces of this eight-legged desk are veneered with panels of Boulle's distinctive tortoiseshell and brass marquetry, framed by ebony. Although Italian in origin, this sumptuous style of marquetry was brought to perfection in Boulle's workshop and soon became synonymous with his name. In this technique, sheets of brass and tortoiseshell are temporarily glued together, and the design is cut out with a marquetry saw. Each material can thus serve as background for the other; here, Boulle's characteristic design of scrolling vines is executed in engraved tortoiseshell on a ground of brass.

The ornate marquetry panels harmonize with eight exquisitely modeled gilt-bronze mounts set diagonally at the corners of the two lateral drawer-cases, representing busts of acanthus-crowned nymphs rising from leafy scrolls. These large projecting figures, the smaller masks of laurel-wreathed nymphs, and the two central satyr-mask keyhole escutcheons, all probably produced in Boulle's atelier, continue the sylvan motif of the tendril marquetry. The character of the piece links it convincingly with the workshop of Boulle, although there is no secure documentation. One of the last in a series of remarkable eight-legged bureaux, the desk reflects the grandeur and formality of the time of Louis XIV.

Furniture in the style of Boulle continued to be produced well into the nineteenth century, and his original works have long been prized as collectors' items. In the Living Hall of The Frick Collection, along with a pair of octagonal pedestals and a writing table from Boulle's workshop, all with tendril marquetry, are several pieces done by other cabinetmakers in his style. Of special interest are two nineteenth-century copies of Boulle's famous "sarcophagus" chests made for Louis XIV at Versailles.

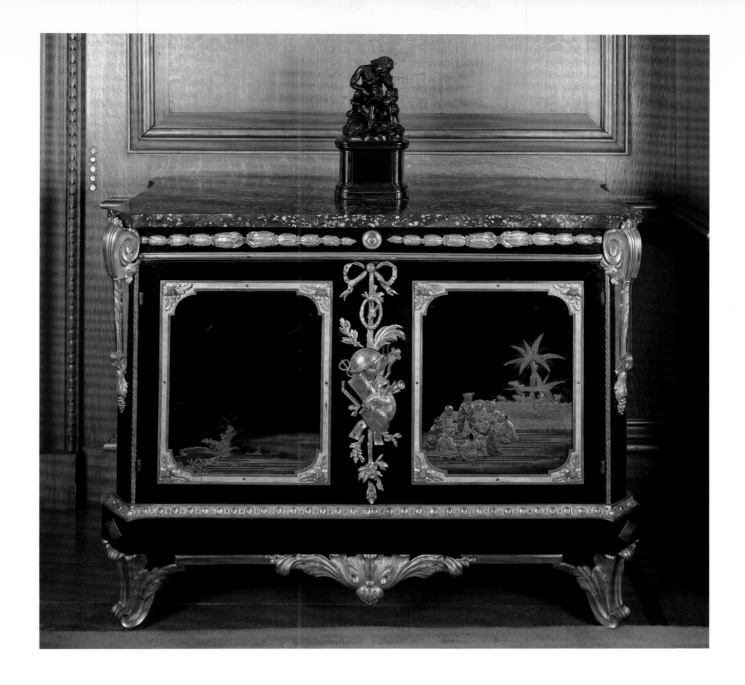

BERNARD VANRISAMBURGH II AND III

Bernard II d. before 1767;
Bernard III d. 1800

Little is known of the life of Bernard Vanrisamburgh II, one of the great cabinetmakers of the eighteenth century. Son of a cabinetmaker of the same name who emigrated to Paris from Holland, Bernard II was admitted to the guild of menuisiers-ébénistes before 1730 and for some twenty-five years was among the most important suppliers to the Crown. In 1764 he sold his workshop to his son Bernard III.

PAIR OF CABINETS WITH JAPANESE LACQUER PANELS

Made c. 1764.
Oak veneered with ebony, inset with panels of late seventeenth-century black-and-gold Japanese lacquer, and mounted with gilt bronze
H. 35 ¼ in. (89.6 cm.); W. 47 ¼ in. (120 cm.);
D. 22 in. (55.9 cm.)
Acquired in 1918

The visits in 1684 and 1686 to the court of Louis XIV by embassies of Siam, laden with porcelain, textiles, and lacquered objects, stimulated a long-growing fascination in France for the exotic wares of the East. By the eighteenth century, rare Japanese *taka-makie* lacquered cabinets, chests, and screens, with their smooth backgrounds and raised, elegant designs, were especially prized by French collectors. Under the direction of Paris *marchands-merciers*—the furniture dealers and interior decorators who served as intermediaries between artisans and wealthy clients—these items were frequently taken apart and their panels supplied to cabinet-makers for mounting onto furniture, a fashion that began in the late 1730s. Almost as costly as porcelain plaques, which were also used at this time to embellish furniture, lacquer panels imparted a luxurious and exotic quality to locally made pieces. Bernard Vanrisamburgh II is the most celebrated of the French cabinetmakers who specialized in furniture mounted with lacquer panels.

The simple, rectangular shape of the Frick cabinets reflects the austere neoclassical idiom that by the 1760s was replacing the lighter and more graceful style of the rococo. Veneered in black-stained ebony, each cabinet is inset on the front and sides with four *takamakie* panels decorated with landscape scenes. Mounted at center on the front is an elaborate gilt-bronze trophy with emblems of the Arts and Sciences suspended from a crimped ribbon. In their incorporation—or indeed cannibalization—of foreign elements with markedly asymmetrical designs into works of a distinctly neoclassical idiom, the cabinets illustrate the interplay of East and West that typifies an important aspect of the decorative arts in eighteenth-century France.

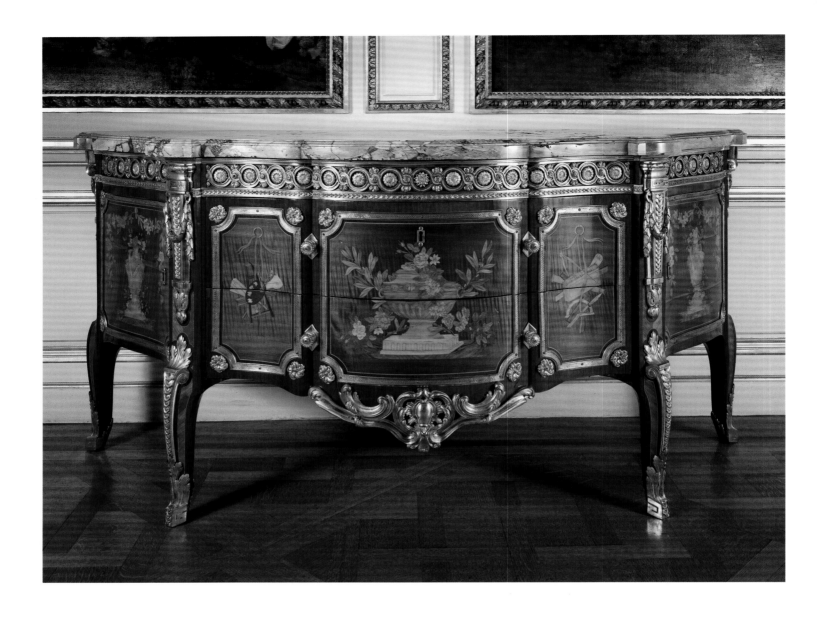

GILLES JOUBERT
1689–1775

One of the most important cabinetmakers of the eighteenth century, Joubert was employed by the Crown continually from 1748, serving as "ébéniste du Roi" under Louis XV from 1763 to 1774. Despite his enormous productivity, few of his known works survive.

ROGER LACROIX
1728–1799

A highly successful ébéniste of Flemish descent, Lacroix was admitted to the cabinetmakers' guild in 1755 and became known for his marquetry. In addition to work for the Crown, he produced furniture for the Duc d'Orléans and Madame Du Barry.

COMMODE WITH PICTORIAL MARQUETRY

Made in 1769.
Oak veneered with marquetry of various woods and mounted with gilt bronze
H. 35 ¾ in. (90.8 cm.); W. 73 ½ in. (186.7 cm.); D. 26 ½ in. (66.1 cm.)
Acquired in 1915

Introduced around 1700, the commode, or chest of drawers, became the most characteristic furniture type of the eighteenth century. This large, serpentine-front example with splayed side cupboards and short cabriole legs—commissioned for the bedchamber of Mademoiselle Victoire (the fourth daughter of Louis XV) at the Château de Compiègne and delivered by Joubert on July 5, 1769—is considered one of the finest in existence.

The central marquetry panel, depicting a classical urn adorned with a floral garland and olive branches, and the two flanking panels, representing hanging trophies emblematic of Painting and Architecture, exem-

plify the illusionistic style of marquetry that evolved in the 1760s. To enhance their realism, many different types of wood were used, and the variety of their natural colors was augmented with staining. Traces of the original green stain that survive in the rose leaves and olive branches on the central panel testify to the once-colorful appearance of the commode. The intricate designs of the veneered surfaces are complemented by the brilliant, double-gilded mounts, which appear to have been modeled expressly for the commode in a style associated with Jean-Claude Duplessis, goldsmith to the King from 1758 to 1774 (see also p. 192).

It cannot be determined whether the Frick piece was actually designed by Joubert, who was simultaneously carrying out three royal commissions for commodes, or whether he sought assistance from another cabinetmaker. The stamp on all four stiles of Roger Lacroix, to whom Joubert often consigned work, proves his involvement in the piece, but he may only have executed the marquetry panels.

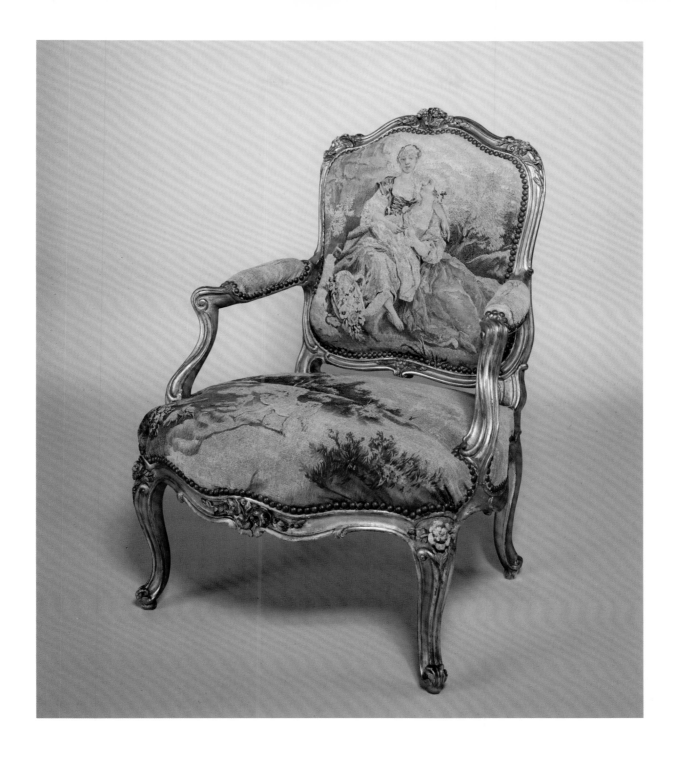

NICOLAS HEURTAUT

1720–1771

Heurtaut trained in his father's workshop, becoming a master carver in 1742 and later, in a departure from custom, a master chairmaker as well. He is ranked among the most important craftsmen in his field in the eighteenth century.

FAUTEUIL WITH BEAUVAIS TAPESTRY COVERS

Frame made c. 1760, painted and gilded walnut; covers made in 1765, wool and silk
H. 36 ¼ in. (92.1 cm.); W. 26 ¼ in. (66.7 cm.); D. 27 in. (68.6 cm.)
Acquired in 1918

While eighteenth-century Parisian joiners and cabinetmakers belonged to the same guild, the *Corporation des Menuisiers-Ébénistes,* their areas of specialization remained distinct, and each was broken down into further subdivisions. In the area of chairmaking *(menuiserie),* one craftsman normally carved the pieces of the frame (legs, arms, rails, etc.) and another assembled them into a whole. Heurtaut was one of the few guild members who were both master carvers and master chairmakers. His exceptional achievement is attributed to his ability to conceive of the finished product from a carver's point of view.

The present chair is part of a signed set of four *fauteuils* (armchairs) and three *canapés* (sofas) in The Frick Collection with curvilinear frames and cabriole legs. Commissioned by a government minister under Louis XV, these pieces represent the elegance and grace of the rococo style at its height. The undulating movement of their gilded walnut frames is enhanced by promi-

nent ribs that follow and define their edges. At various points on the frames—the shoulders of the cresting rails and the knees of the front legs, for example—floral sprays painted in soft pastel colors emerge from the scrolling ribs.

The organic forms and floral imagery of the carved frames are complemented by the pastoral scenes on their tapestry covers, dominated by the popular soft blues and pinks of the period. The scenes of shepherds and shepherdesses in landscapes on the backs of the chairs were woven at the Beauvais manufactory in the mid-1760s after Boucher's tapestry series *Les Beaux Pastorals.* The seats are decorated with wildfowl and hunting dogs; at least three are based on compositions by the animal painter Jean-Baptiste Oudry.

On display in the Fragonard and Boucher Rooms, the Heurtaut suite represents one of the rare examples of eighteenth-century furniture in which the tapestry covers have remained upholstered to their original frames.

189

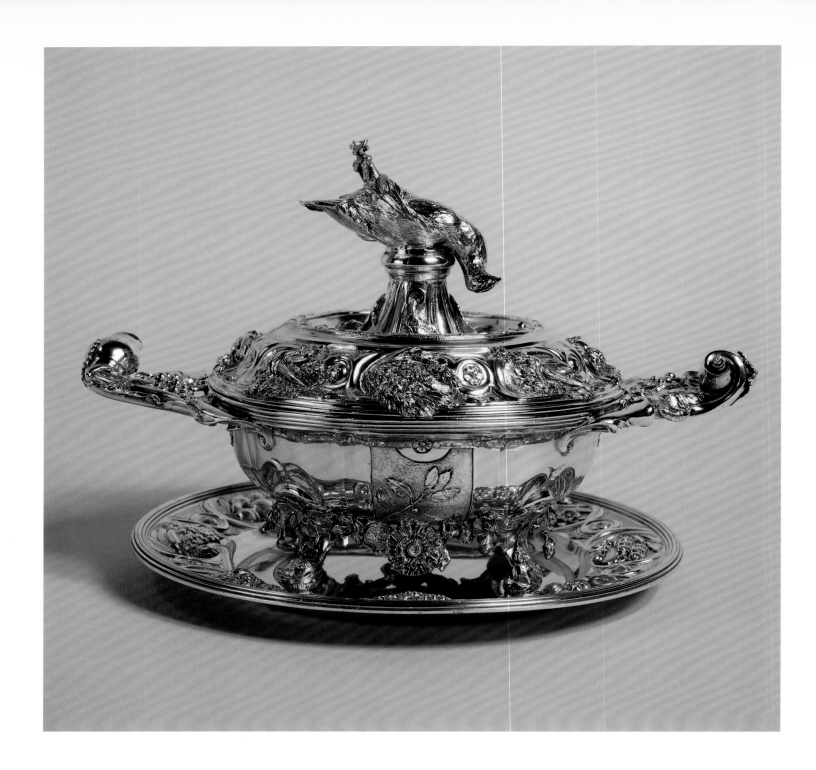

PAUL DE LAMERIE
1688–1751

De Lamerie was born in the Netherlands, the son of Huguenot émigrés apparently of the minor French nobility. As a child he moved with his family to London, where he registered his first mark in 1712 after an apprenticeship with a Huguenot silversmith. In 1716 he was appointed goldsmith to the King. He also produced pieces for the Duke of Sutherland, the Goldsmiths' Company of London, and the Russian imperial court.

ÉCUELLE

Dated 1739/40. Silver gilt
H. overall 6 ¾ in. (17.2 cm.); L. overall 9 ¾ in.
(24.8 cm.); D. at rim 6 ¹⁄₁₆ in. (15.4 cm.)
Acquired in 1916

With the revocation of the Edict of Nantes in 1685, London became home to many Huguenot silversmiths. Paul De Lamerie is the most renowned of the émigrés working during the reigns of the first two Georges.

The exiled Huguenots brought a new wealth of French forms into the repertoire of English goldsmiths, as exemplified by De Lamerie's lavish piece. Nevertheless, the vessel known as an écuelle—a shallow bowl with two horizontal handles and a raised lid surmounted by a finial—while popular in late seventeenth- and eighteenth-century France, is rarely encountered in English silver; in fact, the Frick piece appears unique in De Lamerie's production. Its rich profusion of natural forms reflects De Lamerie's interpretation of the French rococo style, of which he was the principal exponent in England.

The alternating panels of vegetables and herbs spilling over the molded edge of the lid and the trussed game bird on the finial indicate that the dish was intended to hold meat porridge or stew. Naturalistic motifs are continued in the decoration of the bowl: the upper surfaces of the hollow handles, which terminate in shells, are overlaid with leaves and tendrils, and a baseboard or skirt of trailing leaves and flowers in full relief encircles the bowl below.

Until recently, an unmarked ladle that accompanies the écuelle, pierced with the symmetrical cypher AC below a ducal coronet, was thought to be the work of an anonymous eighteenth-century English silversmith. However, the similarity of motifs found on the ladle to those on some of De Lamerie's marked pieces, and the fact that the object fits snugly through the notch in the écuelle's cover, strongly suggest an attribution to the master.

The écuelle rests on a circular plate dated 1797/98 and signed by an unidentified London silversmith who used the monogram IS, an imitator of De Lamerie. The decoration on the rim of the plate repeats, with variations, the pattern on the cover.

All three pieces are coated with a very thin layer of gold (most visible in the interior of the ladle), a technique used since ancient times to prevent tarnishing and enhance the beauty and richness of silver.

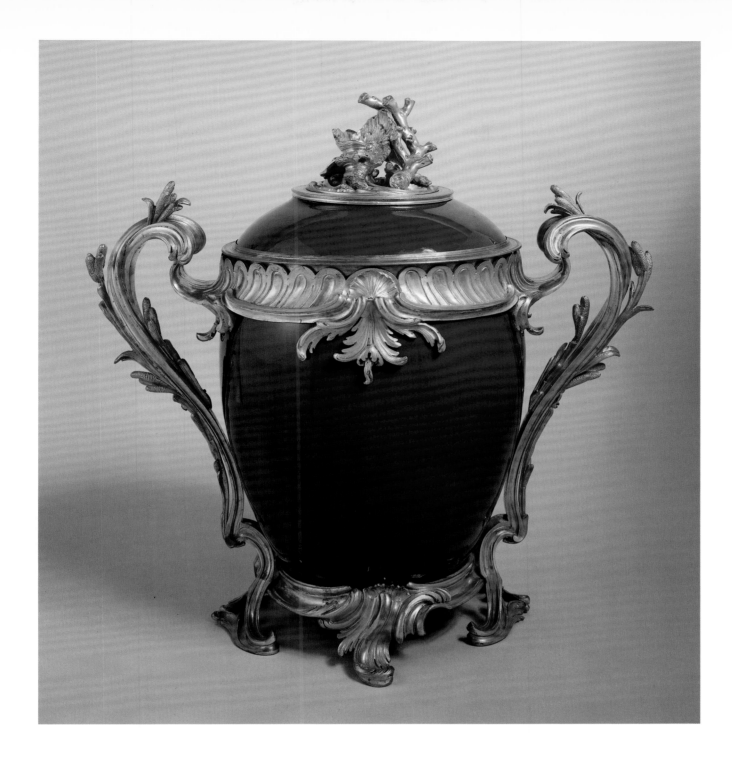

FRENCH AND CHINESE

Second quarter of the eighteenth century

PAIR OF MOUNTED PORCELAIN JARS

Porcelains made in China probably during the reign of Yung-cheng (1723–35) or Ch'ien-lung (1736–96); gilt-bronze mounts made in France about 1747
H. 18 ½ in. (47 cm.); W. 18 ¾ in. (47.6 cm.);
D. 10 ¾ in. (27.3 cm.)
Acquired in 1915

Mounted porcelain belongs to a long tradition, begun in the Orient, of setting exotic objects in supports of precious metal. Before Oriental artworks became more widely available in the West by the middle of the seventeenth century, European collectors often displayed beautiful porcelains in silver mounts to enhance their rarity.

In mid-eighteenth-century France such mounts, paradoxically, served the opposite purpose: to integrate porcelains into the overall décor of a room. By then, Oriental wares were relatively easy to obtain on the European luxury market, and porcelain manufacture was already widespread in the West. During this period, the use of precious silver for mounts gave way to less expensive gilt bronze.

The rise of the rococo style in the early years of the century also brought greater unity between the settings of rooms and their furnishings. Gilt-bronze mounts had the advantage of harmonizing porcelain with furniture and wall paneling, on both of which gilding was used liberally. At the same time, the shapes of the mounts grew more elaborate, reflecting the flowing lines, asymmetrical design, and organic imagery derived from nature that were the hallmarks of the rococo.

The Frick lidded jars represent mounted porcelain at the peak of its popularity.

Their deep cobalt-blue glaze and the simplicity of their ovoid Chinese porcelain elements, which have been cut down from larger pieces, set off brilliantly the elaborate, ear-shaped scrolled handles comprised of cattails and foliage. The finial, a composite of conch and oyster shells, coral, and aquatic plants, rises from a base that suggests swirling water. The bronzemaker, undoubtedly the preeminent figure in the field of porcelain mounts of his time, has yet to be identified.

Two additional pairs of mounted Chinese porcelains with cobalt-blue glazes are on display at The Frick Collection, one of them in the North Hall atop the blue marble side table (see p. 199). Above that table hangs Ingres' 1845 portrait of the Comtesse d'Haussonville (p. 104), in the background of which a similar pair of mounted Chinese jars can be discerned, showing that while the taste for mounted porcelain may have waned after the Revolution, it had revived by the mid-nineteenth century.

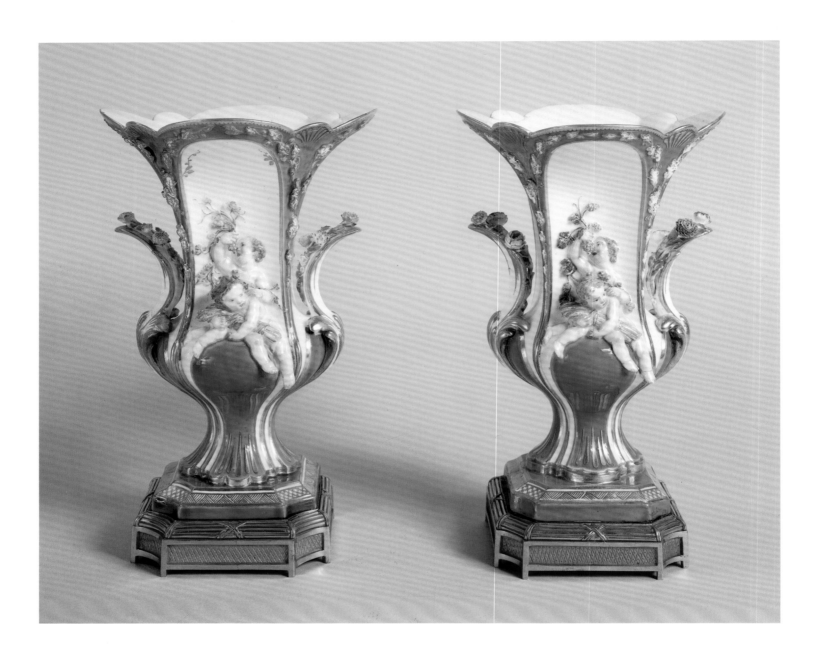

VINCENNES MANUFACTORY

PAIR OF DUPLESSIS VASES WITH CHILDREN AND FLOWERS IN RELIEF

Dated 1753. Soft-paste porcelain
H. excluding gilt-bronze plinth 8 ⅜ in.
(21.3 cm.); W. at top 5 ⅝ in. (14.4 cm.);
D. at top 5 ¾ in. (14.6 cm.)
Acquired in 1918

The manufacture of porcelain was launched in France around 1673 in Rouen and spread to Saint-Cloud, Lille, Chantilly, and Mennecy. At this time, French potters, lacking the necessary raw materials for making true or hard-paste porcelain—that is, porcelain which was white, brilliant, and vitrified like that of the Far East—were restricted to an artificial or soft-paste porcelain. Around 1740 production began at Vincennes, and in

1756 the factory was moved to Sèvres, which was closer to the court at Versailles. Louis XV and his mistress, Madame de Pompadour, had taken an active interest in the native porcelain industry from the early 1750s, and in 1759, when the factory threatened to fail, the King bought it and placed it under royal protection. The Frick vases belong to the end of the period of manufacture at Vincennes, where only soft-paste porcelain was produced. After deposits of kaolin were discovered in France around 1769, hard-paste porcelain gradually became the dominant type produced at Sèvres, although soft-paste work continued.

This pair of vases bears the name of the creator of its prototype, Jean-Claude Ciamberlano, called Duplessis (d. 1774), the foremost designer associated with Vincennes production and the early years at Sèvres. The strong, undulating form of the vases, with their S-shaped handles and bodies that

curve upward from a square base to terminate in a flaring rim of alternating large and small lobes, epitomizes the elegance of the rococo style. The sculptures of children, modeled in high relief and applied to the front and back, represent the Four Seasons and are almost certainly after drawings by François Boucher, the leading painter of the rococo school; on one side Summer is paired with Autumn, and on the other are Winter (seen warming his hands over a pile of glowing twigs) and Spring. The rich turquoise ground of the vases, a color strongly associated with Sèvres, was discovered in the same year as the manufacture of these vases.

Inside the base on one of the vases are the interlaced L's of Vincennes and Sèvres enclosing the letter A, designating the year 1753, when datemarks were introduced. Surmounting these is a six-pointed star, the mark of the figure painter Antoine Caton.

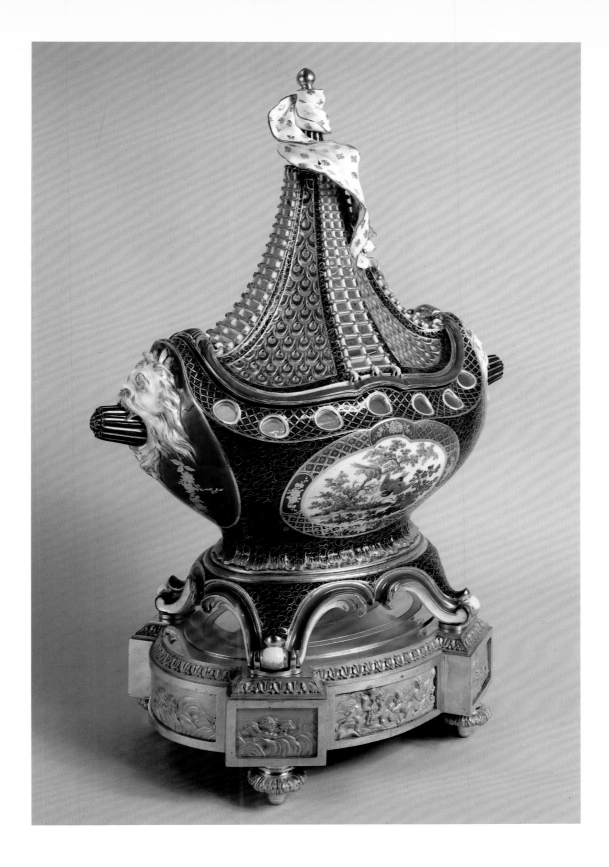

SÈVRES MANUFACTORY

POT-POURRI IN THE SHAPE
OF A MASTED SHIP

Made c. 1759. Soft-paste porcelain
H. overall excluding gilt-bronze plinth
17 ½ in. (44.3 cm.); W. 14 ⅞ in. (37.8 cm.);
D. 7 ½ in. (19 cm.)
Acquired in 1916

The pinnacle of formal invention and tech-
nical brilliance reached in the early years of
the Sèvres manufactory is demonstrated by
this rare pot-pourri in the form of a masted
ship. Inspired by earlier metalwork ship-
shaped vessels intended as table ornaments,
the pot-pourri had a practical as well as dec-
orative function: it was used to hold fragrant

plants and flowers, which emitted an aroma
through its perforated lid.

In the Frick pot-pourri, the "hull"
floats above a line of puckered forms sug-
gesting waves, while the circular openings
below the rim evoke portholes. At either
end bowsprits emerge from lion masks. The
openwork lid resembles a ship's sails, taper-
ing inward as they ascend the single mast; a
pennant decorated with fleurs-de-lis flaps
and twists around the masthead. The con-
ception of the fanciful ship has been linked
with the designer Jean-Claude Duplessis,
although there is no model or working
drawing in the Sèvres archives to confirm
the attribution.

Accompanying the pot-pourri are a
pair of ovoid *vases à oreilles* (ear-shaped vases;
not illustrated), so named for the contour of
their notched and curved lips, which turn

down at each side to suggest the profile of a
human ear. Together, the pot-pourri and
vases form a three-piece garniture; their
gilt-bronze plinths are later additions.

On both the pot-pourri and the vases,
the painter's skill complements and rivals
that of the designer. The juxtaposition of
opposing ground colors, such as blue and
green or pink and blue, was fashionable dur-
ing the period of 1758–60. The cobalt-blue
ground used here is overlaid with gold trac-
ery in elliptical *caillouté* (pebbled) shapes,
while the apple green is ornamented in a
geometric pattern called *mosaïqué*, a term
applied primarily to lacework. The central
panels reserved in white on all three pieces
contain paintings of exotic birds in lush
landscapes, a motif that reflects a growing
interest in the natural sciences during the
second half of the eighteenth century.

SÈVRES MANUFACTORY

BISCUIT BUST OF LOUIS XV
ON A GLAZED PEDESTAL

Made c. 1760. Soft-paste porcelain
Bust: H. 4 ¾ in. (11 cm.), W. 3 ½ in. (9.1 cm.);
pedestal: H. 6 in. (15.3 cm.), W. 3 ¼ in. (8.1 cm.)
Given in memory of Guy Bauman
by his friends, 1991

Along with decorative vessels and tableware, the Sèvres manufactory produced small sculpture in the form of figures, animals, and portraits. These works were often left with a matte biscuit finish after a preliminary firing.

The soft-paste biscuit porcelain bust of Louis XV (1710–74) in The Frick Collection depicts the monarch garbed as a Roman emperor. Shortly after Louis assumed financial responsibility for the factory at Sèvres in 1759, a number of miniature portraits of both him and his queen, Marie Leczinska, were produced; few, however, have survived.

The model for the Frick bust is traditionally thought to have been based on Jean-Baptiste Lemoyne's lost equestrian monument of Louis XV installed at Bordeaux in 1743. The unknown sculptor at Sèvres may have known the image through the intermediary of a print by Dupuis after a drawing by Cochin *fils*. Although under 5 inches tall, the bust conveys the regal bearing of the mature monarch, while recording his aging features with unflinching realism. The fine-grained texture of the white clay is set off by the elegant glazed, apple-green pedestal, gilded and tooled with trophies symbolizing painting, architecture, music, and war. The bust and pedestal, which apparently both date from around 1760, have been together only since 1987.

Louis XV is the subject of another portrait in The Frick Collection, Antoine Coysevox's marble bust of 1716 depicting him as a child of six (see p. 174). His stamp as a patron of the arts, as well as those of his mistresses Madame de Pompadour and Madame Du Barry, can be detected in many of the finest works in the Collection, including Fragonard's suite of paintings called *The Progress of Love*, the two sets of paintings by Boucher, furniture by Riesener, Lacroix, and Carlin, and other fine examples of Sèvres porcelain.

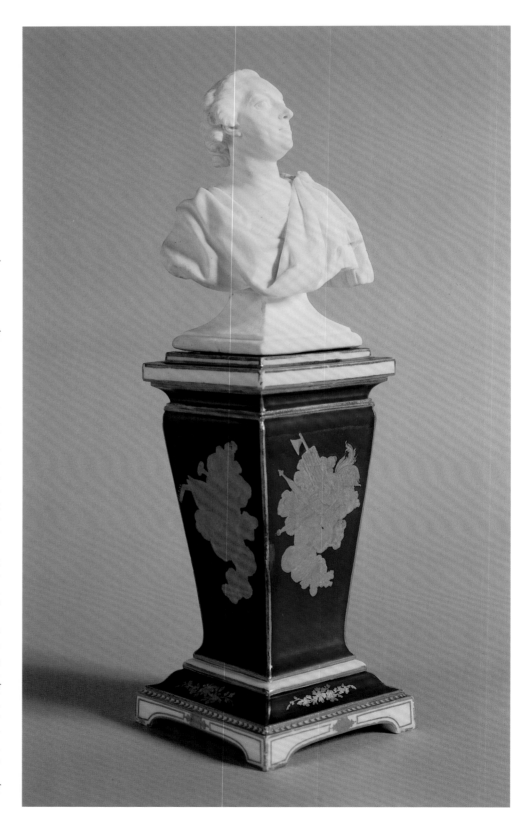

FRENCH
Last quarter of the eighteenth century

PAIR OF CANDELABRUM VASES WITH SEATED SATYRESSES

Made c. 1780. Gilt bronze
H. including marble plinth 38 ¼ in. (97.2 cm.);
W. 17 in. (43.2 cm.); D. 12 ¾ in. (32.4 cm.)
Acquired in 1915

Used extensively in seventeenth- and eighteenth-century France for furniture and porcelain mounts, bronze was also employed as a primary material for decorative objects. Bronze works of special importance, such as this exquisite pair of candelabrum vases, were usually gilded to add a rich, lustrous appearance and to reflect light. In the expensive and highly toxic process used at the time, a mixture of mercury and gold powder was applied to the object, which was then fired; during firing the mercury evaporated, while the gold fused to the surface.

In the neoclassical Frick candelabra, a flaming torch emerges from the mouth of a tall urn-shaped vase, surrounded on the front and sides by five curvilinear candle branches. The artistry of the pieces resides in the remarkable harmony of their parts and in the level of conceptualization required to envision the whole from the outset. Each candelabrum is comprised of over seventy separately cast solid and hollow elements. After casting, the surfaces of the pieces were filed to remove defects and chased to embellish details. The elements were then gilded and either burnished to a high polish or left matte. An iron rod 20 inches long, extending through the hollow core of the candelabrum from its base to the handle of the torch, connects the major components. Other elements, including the two satyresses seated on the shoulder of the urn, the wreaths they hold between them, and the satyr masks on which they rest their hooves, are secured to the urn with bolts welded to their backs and fastened by nuts from within.

The graceful design, variety of classical ornament and decorative techniques, and superb craftsmanship of these objects rank them among the finest achievements of the bronzemaker's art in the Louis XVI period. Yet no documentation has come to light on which to base a secure attribution. The most likely candidates are Pierre Gouthière and François Rémond—two of the leading craftsmen in their field—perhaps working on commission from the *marchand-mercier* Dominique Daguerre.

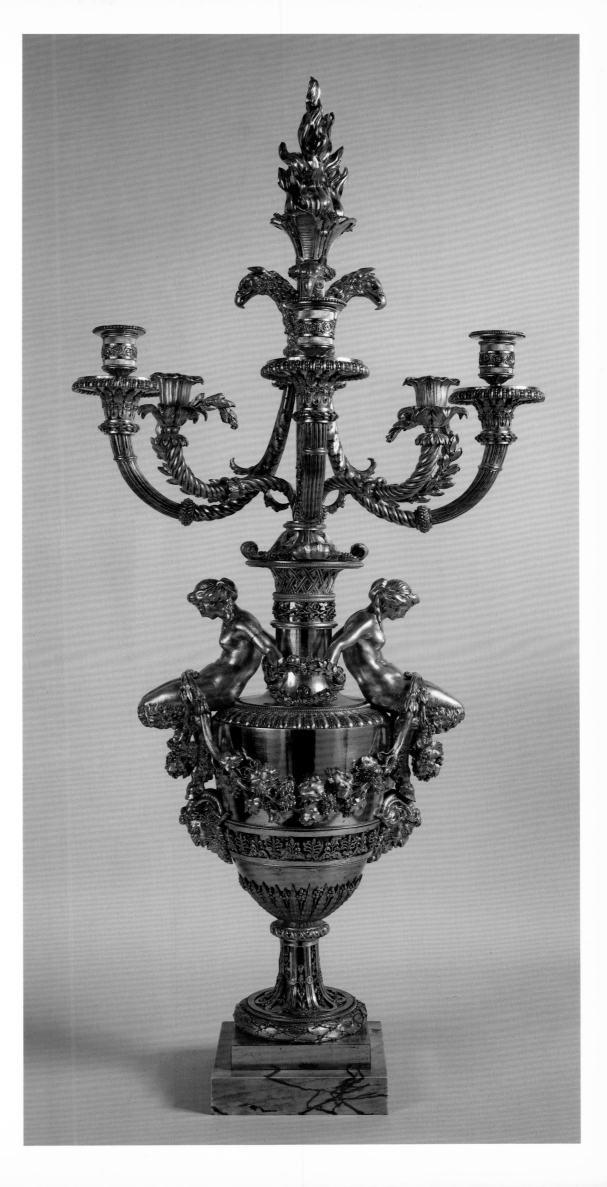

MARTIN CARLIN

c. 1730–1785

Of German origin, Carlin was in Paris by 1759 and entered the guild of menuisiers-ébénistes in 1766. Working mainly through the marchands-merciers, he supplied pieces for such notables as Madame Du Barry and the daughters of Louis XV. Carlin is known primarily for small, refined furniture mounted with Sèvres porcelain.

MECHANICAL TABLE WITH SÈVRES PORCELAIN PLAQUES

Made c. 1781.
Oak veneered with sycamore maple, inset with plaques of soft-paste Sèvres porcelain, and mounted with gilt bronze
H. closed 30 ⅜ in. (77.2 cm); H. fully extended 45 ¾ in. (116.1 cm.); W. 14 ⅛ in. (35.9 cm.); D. 10 ¾ in. (27.3 cm.)
Acquired in 1915

This small, elegant table, onto which are mounted nine soft-paste Sèvres porcelain plaques painted with scattered roses and cornflowers, typifies the refined pieces of the Louis XVI period that were made especially for women. Its size, multiple functions, and portability reflect the smaller scale of rooms and more flexible arrangement of furniture during the later eighteenth century.

The practice of enriching the surfaces of furniture with intricate and often colorful designs took many forms beginning under Louis XIV. Simon-Philippe Poirier and his successor, Dominique Daguerre, two of the most successful *marchands-merciers* of the second half of the eighteenth century, are credited with popularizing the mounting of porcelain plaques onto small pieces of furniture. Not only did they order the materials from the Sèvres factory, but they also selected the cabinetmaker to execute the piece, often supplying him with designs in the form of detailed drawings. Carlin worked primarily for them, and it was under Daguerre's supervision that the Frick table, which bears Carlin's brand, was made.

The rectangular case of the table, comprised of a movable upper section over two drawers, houses concealed mechanisms that adapt the piece to various purposes. The porcelain top can be tilted up at an angle to support a book, and the entire upper section can be raised some 15 inches and turned on a swivel to serve as a music stand. The top drawer contains a removable writing slide and compartments for writing implements, and the bottom drawer, which springs open with a hidden catch, has space for papers.

The vogue for mechanical pieces, which revolutionized the basic furniture forms, apparently began in England in the 1730s and gained momentum in France at mid-century in the workshop of Jean-François Oeben, Carlin's brother-in-law. It remained a strong innovative force in cabinetry up until the Revolution.

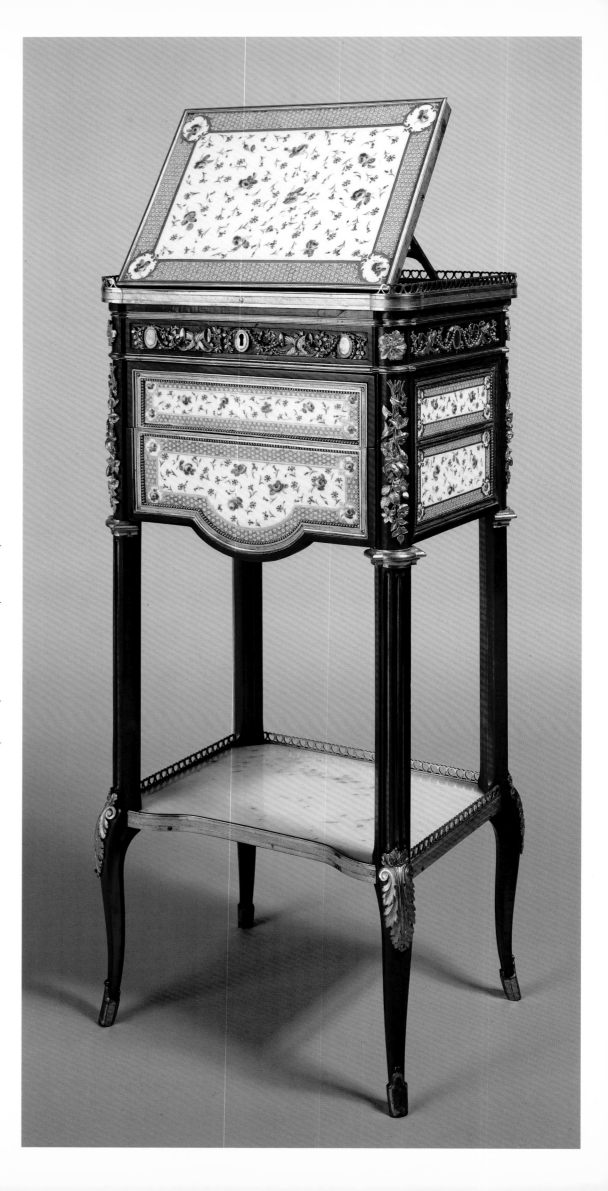

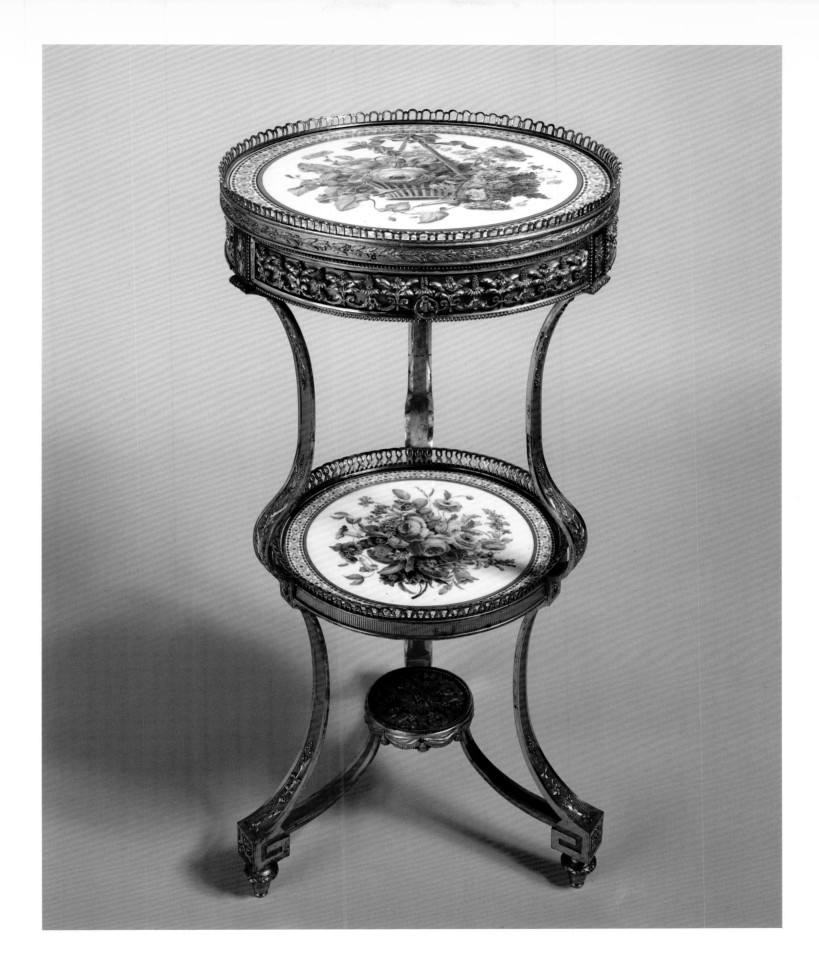

MARTIN CARLIN, ATTRIBUTED TO

TRIPOD TABLE WITH SÈVRES PORCELAIN PLAQUES

Made c. 1783.
Gilt bronze and oak surfaced with plaques of soft-paste Sèvres porcelain
H. 29 ½ in. (75 cm.); D. 14 ⅝ in. (36.4 cm.)
Acquired in 1918

While versatility of function is emphasized in Carlin's mechanical table, aesthetic qualities take precedence in this jewel-like *guéridon*, regarded as "arguably the finest small porcelain table of the Louis XVI period." Three curvilinear, gilt-bronze strapwork legs rise to support a shallow drum-shaped case containing a single drawer. A porcelain plaque ornamented with a basket hanging from a crimped ribbon and overflowing with flowers—among them roses, morning-glories, and chrysanthemums—forms the table's top. A second, smaller plaque, simi-

larly embellished with a sumptuous bouquet of cut flowers, is mounted onto the shelf below. These roundels have been attributed to the painter Edme-François Bouilliat (active 1758–1810).

The table was produced for the *marchand-mercier* Dominique Daguerre. The extraordinary quality of both its bronzework and its painted plaques, and its similarity to some of Carlin's signed porcelain-mounted pieces, link the table with this master, who may have served, however, only as the coordinator for the project.

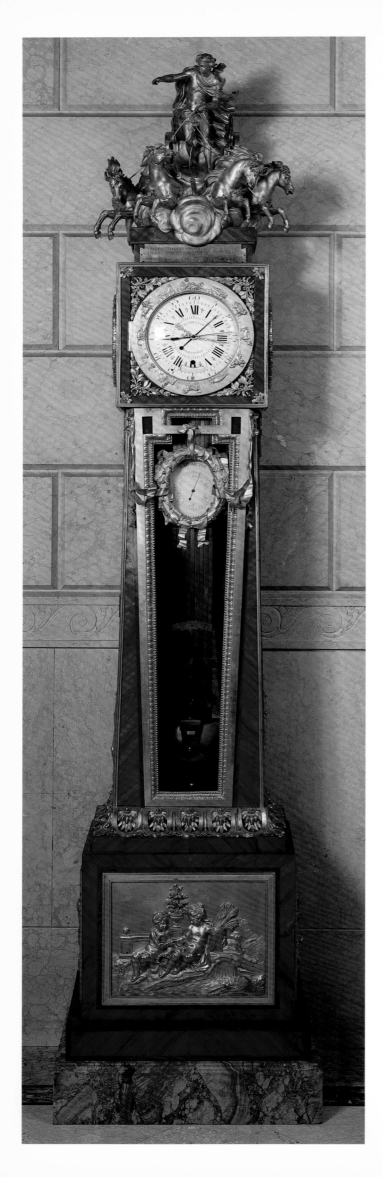

BALTHAZAR LIEUTAUD
d. 1780

From the third generation of a family of ébénistes, Lieutaud became a master in 1749, specializing in luxurious clockcases. His works rank among the finest of his era.

FERDINAND BERTHOUD
1727–1807

Arriving in Paris in 1745 from his native Swiss canton of Neuchâtel, Berthoud became a master clockmaker in 1754 and "horloger du Roi" (clockmaker to the King) before 1773. One of the great clockmakers of his day, he wrote extensively on timekeeping and is credited with many horological innovations.

PHILIPPE CAFFIÉRI
1714–1774

Caffiéri was born into a family of sculptors and trained as a sculptor himself before specializing in bronze-making. He worked as a partner in his father's atelier until the latter's death in 1755, when he took over the shop and became a master bronzemaker. He was one of the first to supply furniture mounts in the neoclassical idiom emerging at mid-century.

LONGCASE REGULATOR CLOCK WITH MOUNTS EMBLEMATIC OF APOLLO

Dated 1767.
Oak veneered with various woods and mounted with gilt bronze
H. overall 100 in. (254 cm.); W. of marble plinth 23 ¾ in. (60.3 cm.); D. of plinth 14 ⅝ in. (37.2 cm.)
Acquired in 1915

Executed during the finest period of French clockmaking, this longcase clock, the most sumptuous surviving neoclassical example, is both technically and artistically a tour de force.

With the invention in 1658 of the pendulum by the Dutchman Christiaan Huygens, timekeeping had changed from an approximate to a more exact science. The long pendulum, introduced in 1670, added significantly to the degree of precision, and the development of the deadbeat escapement in 1715 by the Englishman George Graham marked a further step in the quest for greater accuracy. With the addition of a maintaining-power mechanism, the essential elements for a regulator were in place.

Berthoud's advanced movement lies concealed behind the signed enameled dial of the Frick regulator, on which both solar and mean time, as well as the day and month of the year, are shown. But the clockmaker's variation of the gridiron pendulum is proudly displayed through the glass door in the tapering shaft, below the dial of a barometer. In the pendulum, alternating rods of steel and brass are arranged so that the rate of contraction and expansion of one metal at a given temperature is compensated by that of the other.

The passage of time is the leitmotif of Caffiéri's gilt-bronze mounts, which are signed above the dial. The Four Seasons are represented on the cubical base in three gilt-bronze plaques in high relief, with Summer and Spring together on the front. The Signs of the Zodiac encircle the dial, while the case is crowned by a magnificent freestanding bronze sculpture representing Apollo, the sun god, driving his chariot on his daily round through the skies. The modeler of this sculptural group, which is based on Jean-Baptiste Tuby's gilt-lead sculpture in the Apollo Basin at Versailles, is not known. A passage from Ovid's *Metamorphoses* inscribed in Latin below the group refers to Phaëton's disastrous attempt to take over his father's chariot. Further references to the *Metamorphoses* appear on the sides of the clockcase: two nymphs, Daphne and Clytie, one loved and the other spurned by Apollo, are depicted in bronze in relief.

Although the luxury of the Frick clock and the fact that two of its three collaborators were Crown artists would suggest a royal commission, the piece evidently was created for a private individual. It appeared at auction in Paris among the effects of Antoine Feyt on June 21, 1790.

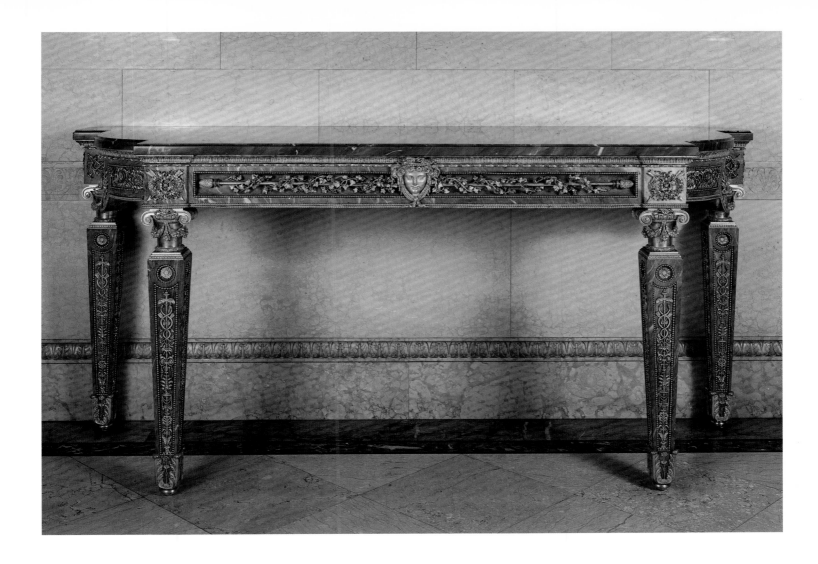

FRANÇOIS-JOSEPH BELANGER
1744–1818

An architect and landscape designer, Belanger was influential in the development of the Louis XVI style. His most important commission was the construction and decoration of the Château de Bagatelle in the Bois de Boulogne.

JEAN-FRANÇOIS-THÉRÈSE CHALGRIN
1739–1811

Winner of the Prix de Rome for architecture in 1758, Chalgrin was appointed inspector of works in Paris in 1763. He began designs in 1772 for the church of Saint-Philippe-du-Roule. His last major task was the commencement in 1806 of the Arc de Triomphe de l'Étoile.

PIERRE GOUTHIÈRE
1732–1813

The greatest chaser and gilder of bronze during the Louis XVI period, Gouthière carried out commissions for Madame Du Barry, the Duchesse de Mazarin, and the Duc d'Aumont. Because of a series of reversals and wasteful expenditures, he was forced into bankruptcy and died in poverty.

BLUE MARBLE SIDE TABLE WITH NEOCLASSICAL MOUNTS

Made in 1781.
Marble mounted with gilt bronze
H. 37 ½ in. (95.2 cm.); W. 81 ⅛ in. (206 cm.);
D. 27 in. (68.6 cm.)
Acquired in 1915

Executed after designs by Belanger and Chalgrin, two of the leading architects of the day, and ornamented with exquisitely crafted gilt-bronze mounts by Gouthière, this lavish *bleu turquin* marble table represents the artistic culmination of late eighteenth-century furniture-making.

Commissioned by Louise-Jeanne de Durfort, Duchesse de Mazarin, the table was to be part of the furnishings for the *grand salon* of her seventeenth-century Paris man-

sion on the Quai Malaquais, which she was renovating under Belanger's supervision. It would stand on a long wall under a mirror, opposite a blue marble chimneypiece also designed by Belanger. The sudden death of the Duchess in 1781, at age forty-five, brought the renovations to a halt, and the table, still unfinished, was never installed. It became the subject of litigation that lasted eight years.

The use of marble as a material for furniture reflects the nostalgia in the last decades of the eighteenth century for the luxury and formality of the reign of Louis XIV, when mounted hardstones were popular. Six other late eighteenth-century tables made entirely of stone and mounted with gilt bronzes are recorded, but only one survives.

The simple shape of the Frick table, with its tall, square, tapering legs, is characteristic of the neoclassical style that had become fully established by the 1770s. The mounts display a rich array of classical ornament, including the beautifully modeled central bacchante mask, the long, double-ended thyrsus fitted within the recessed frieze on the front apron, Ionic capitals at the tops of the legs, vertical panels outlined in pearl moldings descending the legs, and feet shod with tall acanthus leaves. The contrast of the matte finish—which was introduced into the mercury-gilding process by Gouthière—with the burnished highlights on the finely chased mounts attests to this bronzemaker's complete mastery of his craft, one in which he reigned supreme during the period of Louis XVI.

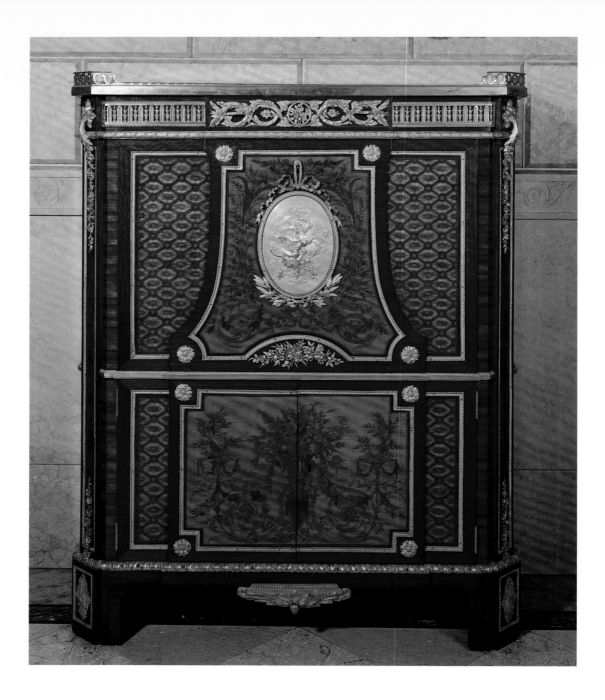

JEAN-HENRI RIESENER
1734–1806

Born in the Westphalian town of Gladbeck, Riesener entered the Paris workshop of his fellow countryman Jean-François Oeben at the age of twenty-one. He married Oeben's widow in 1767, and was accepted as a master into the guild of menuisiers-ébénistes the following year. In 1774 he became "ébéniste du Roi" under Louis XVI, and for the next ten years he was a principal supplier of veneered furniture to the Crown. After 1785 the royal treasury could no longer afford him, but he carried out commissions for Marie-Antoinette until the Revolution, retiring in 1800.

SECRÉTAIRE WITH PICTORIAL AND TRELLIS MARQUETRY

Dated 1790 (see below).
Oak veneered with marquetry of
various woods and mounted with gilt bronze
H. 56 ⅜ in. (143.2 cm.); W. 45 ½ in. (115.5 cm.);
D. 17 ¼ in. (43.8 cm.)
Acquired in 1915

The secrétaire and a matching commode, both of which are displayed in the South Hall of The Frick Collection, are among the masterpieces of the greatest cabinetmaker of the Louis XVI period. Commissioned by Marie-Antoinette in the 1780s and remodeled to give them a trimmer appearance in 1790 and 1791, they are signed in the marquetry by their maker, signifying their importance. It is not known for which of the royal residences the pair were executed, but they probably were remodeled for the Tuileries, where the royal family was forced to take up residence after the beginning of the Revolution in 1789.

The tall, upright form of the secrétaire allowed it to fit comfortably into the smaller rooms of the Louis XVI period. Its drop-front could be lowered to serve as a writing surface and restored to the upright position to conceal, under lock and key, documents in its drawers and pigeonholes. Between 1774 and the 1790s, Riesener executed a superb series of drop-front secrétaires made especially for women.

The simple rectangularity of the Frick secrétaire is offset by the dazzling virtuosity of its marquetry and its brilliantly modeled and chased gilt-bronze mounts. Enjoying a privilege granted to only a few "ébénistes du Roi," Riesener had benches in his atelier for bronzemakers, who were normally segregated by guild regulations from cabinetmakers, and thus had complete control over the appearance of his pieces.

On the upper and lower sections of the secrétaire a central marquetry panel of flowers, fruit, and scrolling vines gives the illusion of overlaying a continuous ground of trelliswork enclosing stylized flowers. Superimposed in turn on the upper marquetry panel is a large, oval, gilt-bronze plaque depicting in relief two billing doves against a ground of swirling clouds, with Cupid's bow and quiver below. The plaque appears to be suspended from the keyhole by a looped bow of crimped ribbon. The remarkable realism of the mounts, executed by unknown craftsmen, complements the verisimilitude of the marquetry; together they create a tour de force of illusionistic effects.

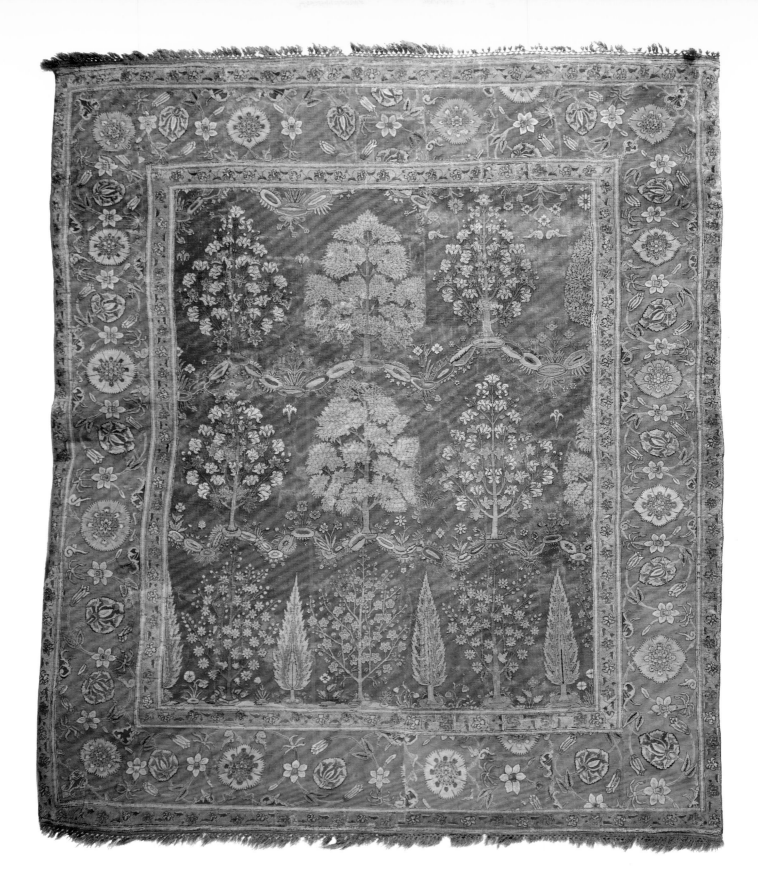

MUGHAL
Reign of Shah Jahan (1628–1658)

TREE RUG

Date unknown. Wool and cotton
7 ft. 5 ½ in. x 6 ft. 3 ½ in. (227 x 192 cm.)
Acquired in 1916

In India, the production of pile carpets with intricate designs began during the reign of the Muslim emperor Akbar the Great (1556–1605), under the supervision of craftsmen probably brought in from the Persian rugmaking centers of Tabriz, Kashan, Herat, and Kerman. Initially the designs of the local Hindu weavers depended strongly on Persian models, especially the floral rugs of Herat, but gradually a distinct Mughal style evolved.

Under Akbar's successor, Jahangir (1605–28), naturalistic Indian landscape elements and flower motifs were introduced into all forms of the decorative arts and architecture, and during the reign of Shah Jahan (1628–58), builder of the Taj Mahal, the flowering plant became a hallmark of a more formalized period of rugmaking.

This Mughal tree rug is one of two in The Frick Collection, both produced under Shah Jahan. Made up of sections from a larger carpet, it comes from the tomb mosque of Shaikh Safi in the Persian city of Ardebil and was probably a gift of the Shah. Against a wine-red background, three rows of alternating flowering and leafy trees rise from conventionalized terrain, with carnations and tulips set between them. While the tree rug is a familiar Persian type, the naturalistic motifs, delicate nuances of color, and subtle methods of shading—innovations of Hindu weavers—give Mughal rugs a distinctive character. Here, the open field contrasts with the intricate floral scroll of the border, recalling the disposition of Herat rugs. The harmonious balance of Hindu and Persian elements typifies the work of the royal weavers under Shah Jahan, when Indian rugmaking became fully developed.

Mr. Frick's interest in the decorative arts of Asia was limited to porcelains and rugs bought essentially as room furnishing, rather than as *objets d'art*. This rug is one of eight Persian and Indian examples.

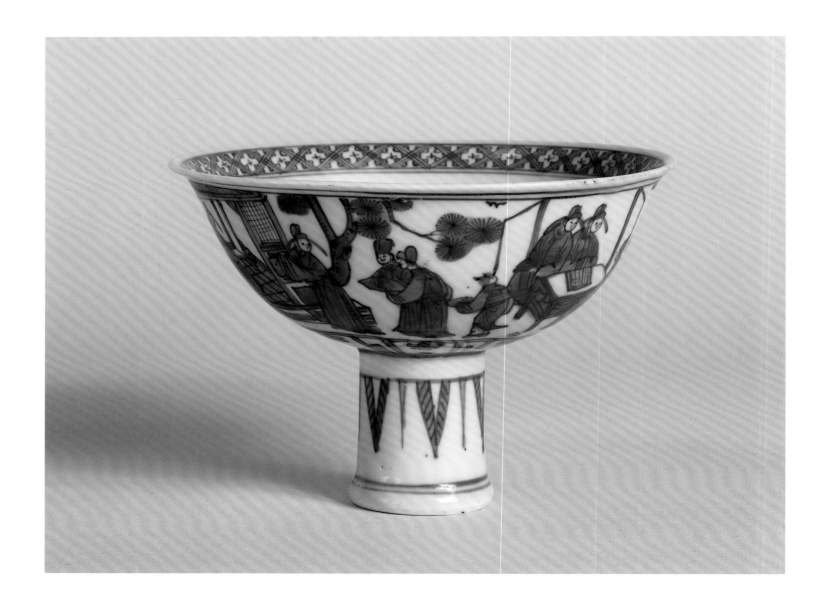

CHINESE
Wan-li reign (1573–1620)

STEM CUP

Date unknown. Porcelain
H. 4 in. (10.2 cm.); D. 5 ⅞ in. (15 cm.)
Bequest of Childs Frick in memory of
Frances Dixon Frick, 1965

A continuous band of scenes from the everyday life of scholars is painted around the outside of the stem cup, a traditional Chinese ceramic form. The figures converse, read, admire a scroll, and engage in the ancient board game of *wei-ch'i*. The tall stem is embellished with stylized leaves, and on the interior of the bowl is painted a solitary scholar seated in a landscape under a moon.

In the roughly 1500-year history of porcelain manufacture in China, blue-and-white ware dominated the industry from the fifteenth to the eighteenth centuries. The immense popularity of blue-and-white, both in China and in the export trade, lay in the stark contrast of the brilliant sapphire blue designs with the fine white porcelain body—a mixture of kaolin (white China clay) and petuntse (a feldspathic stone); adding to its appeal were sensuous glazes and a rich repertoire of lively decorative motifs. The relative efficiency of the technique of painting in underglaze blue allowed for objects to be produced in great quantity. Ground cobalt oxide mixed with water was painted directly on the dried,

porous porcelain body, which was then covered with a glaze and fired, only once, at a high temperature. It was during the Ming dynasty (1368–1644), the period from which the stem cup dates, that blue-and-white reached its artistic and technical zenith.

In eighteenth- and nineteenth-century Europe and America, Chinese blue-and-white porcelain was prized both as tableware and for its purely decorative contribution to interior design. Among the passionate devotees of blue-and-white was the artist James McNeill Whistler, who amassed a large collection.

The stem cup is among 220 pieces of blue-and-white bequeathed to The Frick Collection in 1965 by the founder's son, Childs Frick. A selection is on permanent display in the Reception Hall.

CHINESE

Kangxi reign (1662–1722)

TWO FIGURES OF LADIES ON STANDS

Date unknown. Porcelain
H. 38 in. (96.5 cm.)
Acquired in 1918

With the decline in popularity of under-glaze blue-and-white porcelain in the mid-eighteenth century, the technique of painting in overglaze enamels began to dominate the Chinese ceramic industry. In overglaze painting, the dried porcelain body is first coated with a transparent glaze and fired. Enamel colors, derived from metallic oxides, are then applied over the glaze, and the piece is fired again at a lower temperature. Sometimes, underglaze and overglaze colors are combined on a single piece.

These ladies on stands are relatively large for figurative work. The model was probably made exclusively for export, as no examples of this type exist in the National Palace Museum in Taipei. Their richly ornamented garments resemble those worn by wealthy ladies during the Kangxi period, and they may once have held a lotus flower or some symbolic object in their left hands. The predominating translucent green enamel of the color scheme, set off by red, yellow, and aubergine, connects the pair with the category of Chinese decoration known in the West as *famille verte* (green palette).

The figures stand on tall pedestals with openwork swastika patterns on the sides and a simulated cloth draped over the top. The slightly differing color schemes of the pedestals raise the question whether they were made to go with the figures or were simply united with them at a later time.

In selecting Chinese ceramics to display on tabletops and mantlepieces in the major rooms of his residence, Mr. Frick favored polychrome enameled porcelains from the Qing dynasty. The majority of his acquisitions—tall vases ornamented with flowers and trees on black or green grounds and large covered jars with designs in reserve on rose-pink grounds—were acquired from the estate of Pierpont Morgan between 1915 and 1918. Like most of his contemporaries, Mr. Frick was interested in Oriental enameled wares essentially as decorative elements that would contribute to the cosmopolitan ambience of his rooms.

INDEX